# THE ROCK AND ROLL HALL OF FAME

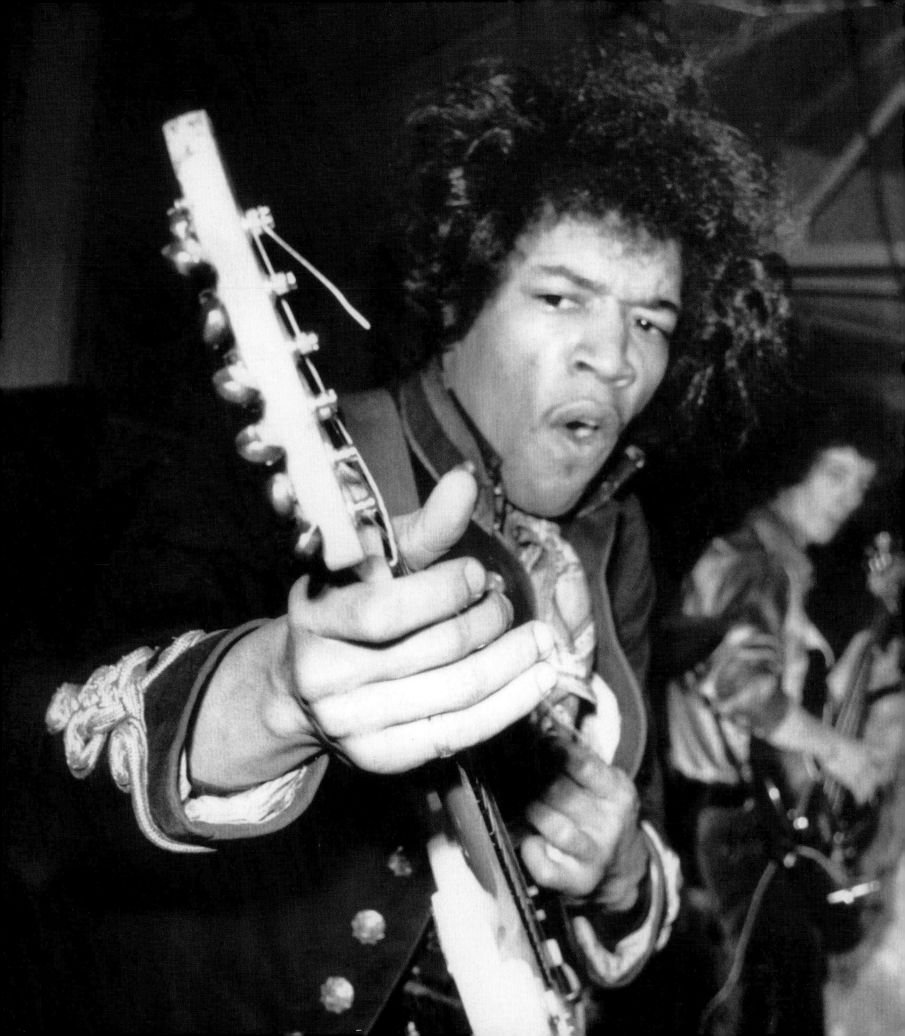

# THE ROCK AND ROLL HALL OF FAME

## THE FIRST 25 YEARS

### THE DEFINITIVE CHRONICLE OF ROCK & ROLL AS TOLD BY ITS LEGENDS

FOREWORD BY JANN S. WENNER
EDITED BY HOLLY GEORGE-WARREN

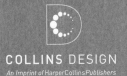

COLLINS DESIGN
An Imprint of HarperCollins Publishers

# CONTENTS

# "HAIL, HAIL ROCK & ROLL DELIVER ME FROM THE DAYS OF OLD."

—CHUCK BERRY

# FOREWORD

**E**ach year, the extended family of rock & roll gathers at our annual induction dinner to celebrate as a new class is inducted into the Hall of Fame, joining the legends and music makers who have enriched our times and given voice and understanding to our lives and our ideals.

For twenty-five years, these ceremonies have been held at the Waldorf-Astoria Grand Ballroom in New York, where we celebrate one-time rebels and social outlaws amidst the old-world glory of this historic hotel. We have also done the dinner in Los Angeles and twice now in Cleveland.

Why does the world watch what we do at this ceremony each year? Because rock & roll speaks all the languages of the earth. Because it calls out around the world, "Are you ready for a brand new beat?" Because it crosses boundaries of race and religion, politics and generations, and no one can stop it. The Rock and Roll Hall of Fame was created and a stunning architectural gem was built to remind us of that energy and that power. Those of us who founded the Hall of Fame and those of us who joined along the way to manage it all feel that we are blessed to devote so much of our lives to something that's so uplifting, that celebrates the human spirit, that ennobles man, that has brought so much joy and hope and beauty to the lives of so many.

For the last twenty-five years, we've gathered because we've been given the opportunity to create this music or to be a midwife to it; to promote or sell it; to report on it or critique it; to be near it; to hear it; to love it; and to live in times filled with music. We come to honor the songs about love and loneliness, songs that ask us to give peace a chance or how it feels to be on your own with no direction home. We come to reflect on the debt that we owe rock & roll, and to honor its historical, social, and artistic importance—whether it's for a kid listening to a radio in his bedroom or four old friends taking the stage before vast crowds in giant stadiums.

For many of us, that blend of instrument, voice, and rhythm has illuminated emotions within us that we can't always fathom, that will be our voice long after we are gone. In the Rock and Roll Hall of Fame Museum, we collect—before they are lost—the artifacts, documents, images, and work of the kings and queens of rock & roll and the godfathers of soul. Those collections serve to remind us of the power of innocence, rebellion, and youth, as well as the value of maturity, growth, and perspective, because both young and old have a place in this building.

The music inspires; it unites; it lifts us up.

For those of you who assemble each year—and those of you who can be there in spirit only— I thank you with all of my heart. And to Ahmet Ertegun, my dear friend and mentor, who was the founding father of the Rock and Roll Hall of Fame, I dedicate this book. May you stay forever young.

—Jann S. Wenner

# INTRODUCTION

In the early eighties, Madonna kicked off her music career by playing drums to Elvis Costello records in the basement of an abandoned synagogue in Brooklyn. Two decades earlier, John Fogerty, his brother, and their pals created the Golliwogs after deciphering Ventures licks in a garage in El Cerrito, California. Across the Atlantic, Eric Clapton dreamed up Cream after seeing Buddy Guy's trio at the Marquee club in London; a man of many musical desires, Clapton later traveled to Woodstock, New York, in the hope of auditioning for the Band. Around the same time, Bruce Springsteen and his bar band made converts of hecklers in a Jersey dive by covering Fogerty's Creedence songs.

These are some of the autobiographical nuggets confided by the world's rock & roll legends when appearing—as inductees or presenters—at the Rock and Roll Hall of Fame's annual induction ceremony. Since 1986, a small gathering of music's elite have witnessed hilarious roasts (Pete Townshend's acerbic wit loosed upon the Rolling Stones) as well as incredibly moving testimonies (Paul McCartney's bittersweet "letter" read aloud to fallen comrade John Lennon). For the first time, these once-in-a-lifetime accounts can be read on the printed page.

*The Rock and Roll Hall of Fame: The First Twenty-Five Years* opens the curtain on the ceremony where everyone from Little Richard to Michael Jackson, from Ronnie Spector to Deborah Harry has had their say. There, Bruce Springsteen and Bono have created spoken works every bit as masterful as their most brilliant songs. And who knew Billy Joel was so funny? What follows are on-the-scene accounts of this extraordinary annual event, and excerpts from the speeches—sometimes nasty, sometimes nice; sometimes illuminating, always entertaining—by its celebrated participants. For the past quarter century, these gatherings have yielded unique artistic pairings, as acolytes such as Alicia Keys have described how their heroes—in her case Prince and Isaac Hayes—have changed their lives. We discover what inspired these artists to get into music and find out how they arrived. These are the stories left out of press releases and magazine articles and are often the true expressions of the artists' inner selves, offering another facet beyond their lyrics and music. As the world's leading authorities on popular music describe the contributions of our great artists, we get a history lesson from those who have *lived* the music.

"Since that day in the spring of 1983 when we started to plant the seeds of what would become the Rock and Roll Hall of Fame, it has been the ever-present spirit of these great musicians and their remarkable music that has been our guiding light," Ahmet Ertegun, the late Atlantic Records cofounder and chairman and the founder of the Rock and Roll Hall of Fame, said in 1996. Ertegun put together a group he called "the Funky Nine," which included *Rolling Stone* publisher and editor Jann S. Wenner, Sire Records cofounder and president Seymour Stein, producer and manager Jon Landau, legendary producer and music man Jerry Wexler, music attorney Allen Grubman, record executive Bob Krasnow, and others, to devise a means of honoring the men and women who created rock & roll. As the Rock and Roll Hall of Fame Foundation, the original board determined that an artist would become eligible for nomination

twenty-five years after the release of his or her first recording. The criteria for consideration would be those artists whose work has had a long-lasting significance and made an impact on the history of rock. Board members also decided to honor those whose work predated rock & roll but had influenced its creation. In addition to these great blues, jazz, gospel, and country artists, other honorees could include DJs, producers, journalists, songwriters, inventors, and music executives—nonperformers whose work perpetuates rock & roll. In 1999, the Sideman category was added to the mix. Since the first group of inductees was chosen in 1985, 243 have been inducted into the Rock and Roll Hall of Fame (as of 2009).

At the 2005 ceremony, Ertegun reminisced about the Foundation's genesis and mission: "It's been twenty-two years since [attorney and music fan] Suzan Evans walked into my office with a group of people, asking me to form the Rock and Roll Hall of Fame. I chased them out of my office, but I eventually relented, and tonight is our twentieth induction ceremony. I relented when I thought of the tremendous pleasure I've had listening to the various kinds of music subsumed under the general heading of 'rock & roll,' and of the many great musicians and singers that performed it, and of the fabulous people who inspired it. Many people in those days made a distinction between 'good music' and rock & roll. 'Good music' was Perry Como, Doris Day, any classical music, Gershwin or Cole Porter, Sinatra, et cetera, and then there was R&B and rock & roll. So I and my colleagues in the music industry, who supported me from the very beginning, wanted to celebrate this 'no-good music,' whose antecedents and roots were the very noble black American blues, gospel, and jazz music, American folk, and country music, and various European and South American influences. From the beginning, we were concerned with dignity, and we were celebrating the music of our great stars. We were, from the outset, making statements about love, statements about anger, statements about social responsibility, statements about freedom, statements about injustice, statements about happiness, and statements about revolt. And throughout all of this, we certainly continue to make those statements, and we continue to boogie, and boogie with laughter and joy, because we *are* rock & roll. And we've even come to the point where we think and believe that we really are good music."

If only Ahmet Ertegun, who died in December 2006, could have lived to see the Foundation he loved so much reach its twenty-fifth anniversary, it's certain he would have been leading the celebration boogie. But through the words in this book and the music given to us by those honored herein, his spirit lives on. And, of course, the Rock and Roll Hall of Fame and Museum, established in Cleveland, Ohio, in 1995, stands as a monument to Ertegun's dream. More biographical information on all of the inductees can be found at the Rock and Roll Hall of Fame and Museum and on its Web site (www.rockhall.org). A portion of the proceeds from the sale of this book will go to further the mission of the Rock and Roll Hall of Fame.

Remembering that initial gathering that honored the original class of Hall of Fame inductees, Ertegun said, "We had a great time, and our first induction ceremony was beyond anything we could have hoped or dreamed." The goal of this book is to shine a light and reflect the richness of that momentous occasion and those that followed.

—Holly George-Warren

**PERFORMERS** Chuck Berry ✦ James Brown ✦ Ray Charles ✦ Sam Cooke ✦ Fats Domino
The Everly Brothers ✦ Buddy Holly ✦ Jerry Lee Lewis ✦ Little Richard ✦ Elvis Presley
**EARLY INFLUENCES** Jimmie Rodgers ✦ Robert Johnson ✦ Jimmy Yancey
**LIFETIME ACHIEVEMENT** John Hammond
**NONPERFORMERS** Alan Freed ✦ Sam Phillips

After more than a year of planning, the debut induction of musicians, music executives, and pioneers into the Rock and Roll Hall of Fame took place in the Waldorf-Astoria's Grand Ballroom in New York City on January 23. The Foundation initially created a nominee list of forty-one, which was put forth to a larger group of two hundred pop music experts who voted on the inductees. The first group of ten performers was selected in 1985, with all but three performers still living and performing. Early on, plans were in the works to construct a museum, whose location was under discussion, with possibilities including Cleveland, Memphis, Philadelphia, Chicago, and New Orleans.

Each of the premier class was required to have made his or her first recording no later than 1960. Represented were the major strains of music that merged to form rock & roll: rockabilly, R&B, blues, country, and gospel. Those doing the inducting came from both behind the scenes, such as influential DJs Norm N. Nite and Scott Muni (for Alan Freed), and the spotlight, including Billy Joel (for Fats Domino) and Steve Winwood (for James Brown). Many of the attendees would become regular participants over the next decade of inductions, including Billy Joel, Keith Richards, Neil Young, and John Fogerty—all of whom joined in the free-for-all jam at night's end. Legendary promoter Bill Graham orchestrated the off-the-cuff performances, shouting direction and coercing reluctant artists onstage to join in. Fogerty belted out "Proud Mary," the first time he'd performed a Creedence Clearwater Revival song in public since 1972.

Another music standard-bearer providing backup was Paul Shaffer with the World's Most Dangerous Band (from *Late Night with David Letterman*), which then included saxophonist David Sanborn, guitarist Sid McGinnis, bassist Will Lee, and drummer Steve Jordan. Music executives who were members of the original Rock and Roll Hall of Fame Foundation Board of Directors served as the evening's emcees: Chairman Ahmet M. Ertegun, President Seymour Stein, Executive Vice President

Jann S. Wenner, Secretary/Treasurer Allen Grubman, and Bob Krasnow (then chairman of Elektra-Asylum Records). Ertegun kicked off the evening, calling rock & roll "a triumph of the native subculture of America over the Establishment."

The first induction ceremony was a joyous but rather unorganized affair: Though most everyone dressed in their tuxedos and sequins, a kind of frisky abandon kept things loose, quite different from traditional awards shows like the Grammys and Oscars. Inductions got underway with a festive Keith Richards ripping off his tux jacket and exposing a flashy leopard-print jacket underneath, appropriate for inducting Chuck Berry: "It's very difficult for me to talk about Chuck Berry 'cause I've lifted every lick he ever played—this is the gentleman who started it all!" Berry duckwalked across the stage to the podium. Billy Joel recalled how playing Fats Domino's "Ain't That a Shame" resulted in his father smacking him upside the head. Known for pummeling each other in the past, the Everly Brothers, who'd recently ended a ten-year feud, appeared harmonious together onstage.

In these first inductions, most speeches were brief and casual rather than written, except for *New York Times* writer and music historian Robert Palmer's overview on blues legend Robert Johnson. Roberta Flack, who inducted Little Richard, absent because of injuries sustained in a recent car accident, was the only woman onstage that night—a point she made by naming female artists she hoped to see inducted soon. And his infirmities didn't prevent Little Richard from sending a taped proclamation that he was a rock & roll royal: "You've heard of me through the years. The original rock & roll singer!"

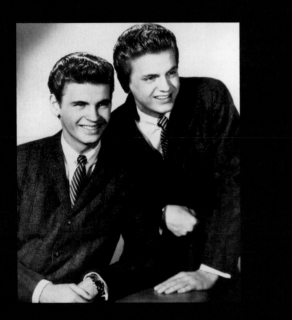

## "ROCK & ROLL'S BEEN GOOD TO US. WE HOPE IT'S BEEN GOOD TO YOU."
### —DON EVERLY

### AHMET ERTEGUN ON RAY CHARLES:

"Ray Charles Robinson knew the essence as well as the matter of the blues. We had a very great association—a historic association—and a string of hits too long for me to mention. Whereas we thought that we were producing Ray Charles when we were first starting out, I realized by the third session that he was not only teaching me about music, but he was showing me how to make records. A true musical genius, Ray Charles had a wide range of tastes, going from jazz to gospel to country and to the blues. He is probably the greatest all-around singer-musician in America. He is my friend, and a great inspiration."

## "IF NOT FOR THE PEOPLE WHO LISTENED TO MY MUSIC AND LOVED IT, THIS COULDN'T HAVE HAPPENED."
### —RAY CHARLES

### HERB ALPERT ON SAM COOKE:

"One of the great rewards in my life was knowing Sam [Cooke] and being a friend of his. He taught me so much about the music business in a way that I'm sure he didn't realize. He taught me how to listen to a record. He said, 'Forget about your ears, forget about looking, forget about all the intellectual things; just listen with your stomach, and if it moves you, great. If it doesn't, that's all you need to know.' His lessons came so simply, but so poignantly. I really loved and admired him, 'cause he was a generous, genuine person, and he was a gentleman. He was a genius. Sam would take his guitar out of the case, and all of a sudden lyrics [he'd just written] would turn into magic. He said, 'People don't care if you're black or white, or what kind of echo chamber you use, or how long it took you to record, or how long you've practiced. They're listening to a cold piece of wax, man, and it either makes it, or it don't.' *Amen.* Of all the songs that Sam recorded, 'A Change Is Gonna Come' is the one that really gets me the most. [He was] an incredibly beautiful human being."

### NEIL YOUNG ON THE EVERLY BROTHERS:

"When I was about fifteen—or maybe twelve—I started playing in a band in school. We got together in my garage, four guys with some beat-up pieces of equipment that really didn't work too good. We started playing, and we did instrumentals for about a year or so, and then I got up enough nerve to start singing. Some people say maybe I shouldn't have started that. Anyway, then the other guys in the band started singing with me, and we were trying to get that sound that we heard and loved so much—the harmony that the Everly Brothers put out from their beginning on Cadence Records. We never did get it, but we worked really hard at it. We used to listen to their records over and over again, and just try and try. It never really worked. But years later, I found myself in Los Angeles with [Stephen] Stills and [Richie] Furay, and we were putting together a band [the Buffalo Springfield], and we were working on the vocals, and it was just like the same thing over again, trying to get that sound. But we still couldn't get it."

Previous, page 2: Jimi Hendrix. Page 10: Hall of Fame induction ceremony, 1986: (from left) Neil Young, Jerry Lee Lewis, and Chuck Berry. This page: Phil and Don Everly. Opposite: Ray Charles.

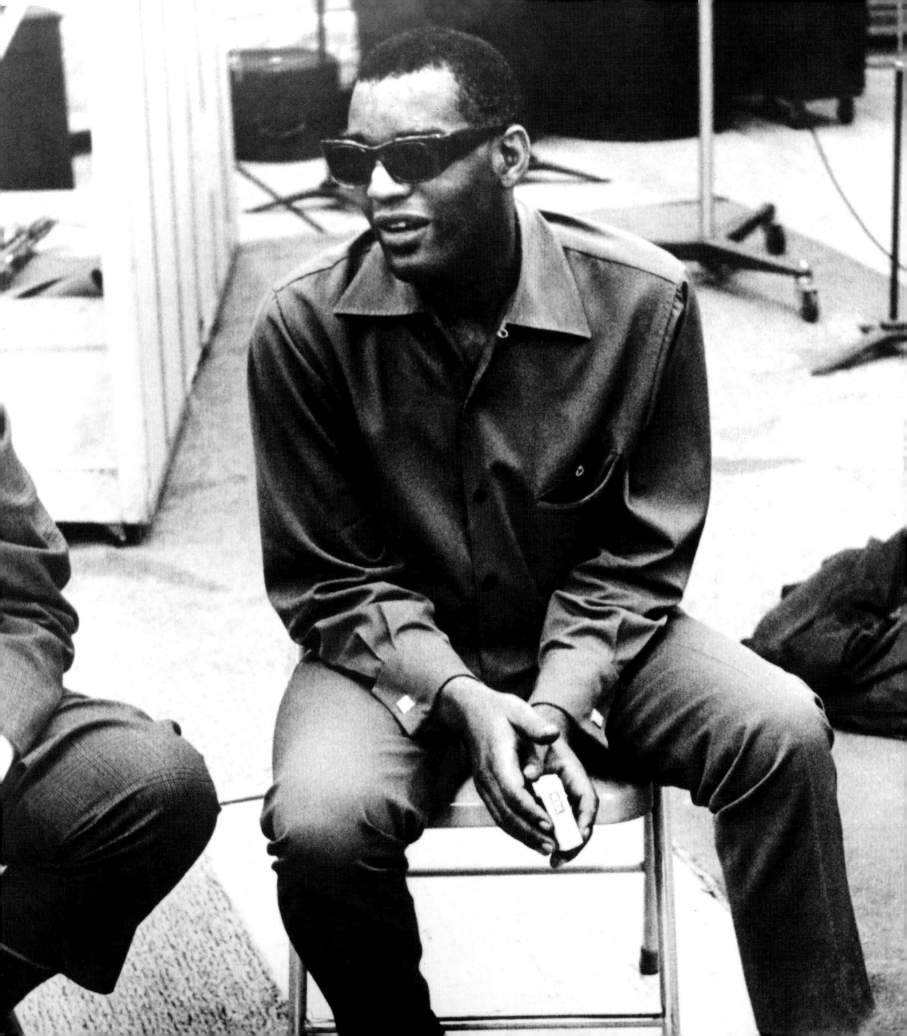

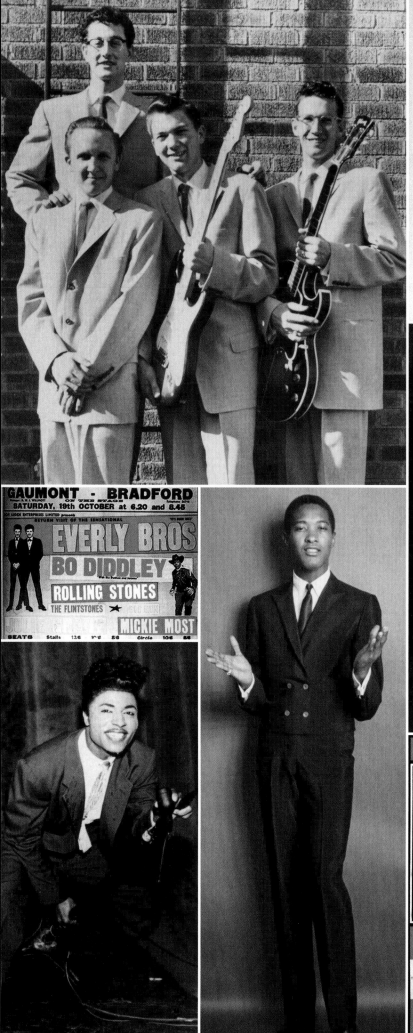

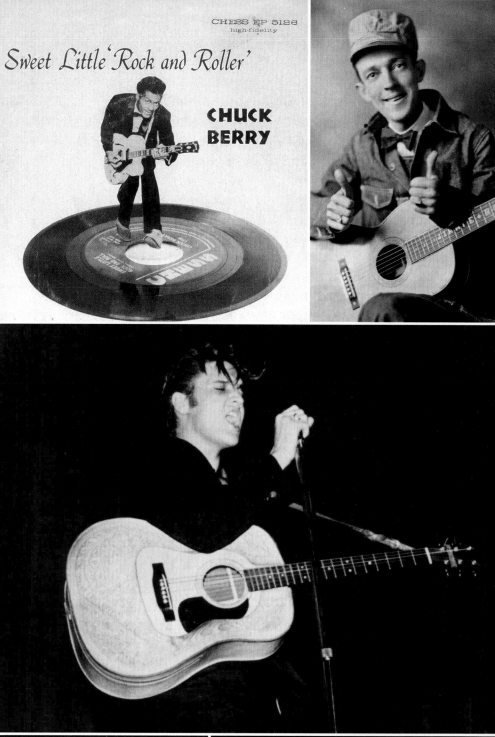

Clockwise from top left: Buddy Holly and the Crickets; an early Chuck Berry album; Jimmie Rodgers; Elvis Presley; a King Records promotional poster; Sam Cooke; Little Richard; package tour poster, 1963. Opposite: (from left) Julian Lennon, Sean Lennon, Billy Joel, Neil Young, Keith Richards, and Don Everly, January 1986.

### JOHN FOGERTY ON BUDDY HOLLY:

"What an honor it is to be part of the first gathering of the Rock and Roll Hall of Fame. I just want to tell you what Buddy Holly meant to me. I was twelve years old, and I was working at a beach resort, and that voice and guitar came up over the PA. I went out and bought 'That'll Be the Day,' started learning the words. A few months later, I bought the album, and that album set a course in musical history. There was a group pictured on the cover, and it was the first time you saw a group in rock & roll. I thought, 'I'm gonna have a group.' Over in Liverpool, the same thing was going on with four other guys. They named their group the Beatles because Buddy Holly's group was called the Crickets. In 1963, these four guys chose to end their great song 'I Want to Hold Your Hand' with the little syncopation Buddy Holly used in the chorus after the solo. About twenty years later, a kid was writing a song about how it feels to be back [Fogerty's 'Centerfield'], and he ended his song with the same riff—came from the same place. I think my point is that each of us [is] made up of the people we love and the people we admire. We take those reflections and hopefully grow from them."

### JERRY WEXLER ON JIMMIE RODGERS:

"I'm pretty certain nobody here ever saw Jimmie Rodgers perform onstage. I didn't. But I heard a lot of his records. Did you know that Jimmie Rodgers sometimes used the trumpet and the clarinet? As a matter of fact, Louis Armstrong and Earl Hines played on some of Jimmie Rodgers's records. Jimmie had a tremendous appreciation of the blues. Jimmie did a mysterious thing called the 'blue yodel.' Jimmie, who came from Meridian, Mississippi, worked around people who came from Bavaria, Germany, the yodel came in probably from people in East Texas, and he put it into the blues.

"It's a strange story: He was a brakeman, and he traveled the United States as a brakeman in the Depression, and it was a time when the soul was very close to the bone. Somebody said about soul, you had to feel bad before you could feel good. And Jimmie Rodgers felt plenty bad before he could feel good, because he contracted tuberculosis, and only began his recording career after he had to quit the railroad 'cause he had the TB. He had a very short recording career, and in six years, Jimmie Rodgers had made hundreds of records, and his last session, he made practically on his deathbed. If you want to pick up on the ethos of Jimmie Rodgers, listen to Willie Nelson and Merle Haggard today, and you'll see the reference and the root. And it's good for us, as we get further and further into highly evolved rock music, to keep one eye on the root—and Jimmie Rodgers was the root."

### ROBERT PALMER ON ROBERT JOHNSON:

"Every one of Robert Johnson's records [beginning in 1936] launched a whole school of musicians and a whole train of thought in music. Robert Johnson belongs in the Rock and Roll Hall of Fame not only as a forefather, but because his influence didn't fade after he died in 1937—it got bigger and bigger, and so did his legend. As the years went by, English musicians and American musicians started picking up on what he could do. Eric Clapton and Cream, when they did 'Crossroads,' the Rolling Stones, when they recorded 'Stop Breaking Down' on *Exile on Main Street*, up to people like Captain Beefheart and Ry Cooder and Taj Mahal, and right on up to the present, into an entire generation of punk or new-wave musicians who are just as aware of Robert Johnson as anyone in the sixties was. The man's message and his image lives on.

## "MY FATHER ONCE SAID ABOUT ELVIS: 'THOSE PEOPLE WHO PICKED UP PAINTBRUSHES, LIKE VAN GOGH, PROBABLY WANTED TO BE A RENOIR. . . . I WANTED TO BE ELVIS.'"
### —JULIAN LENNON

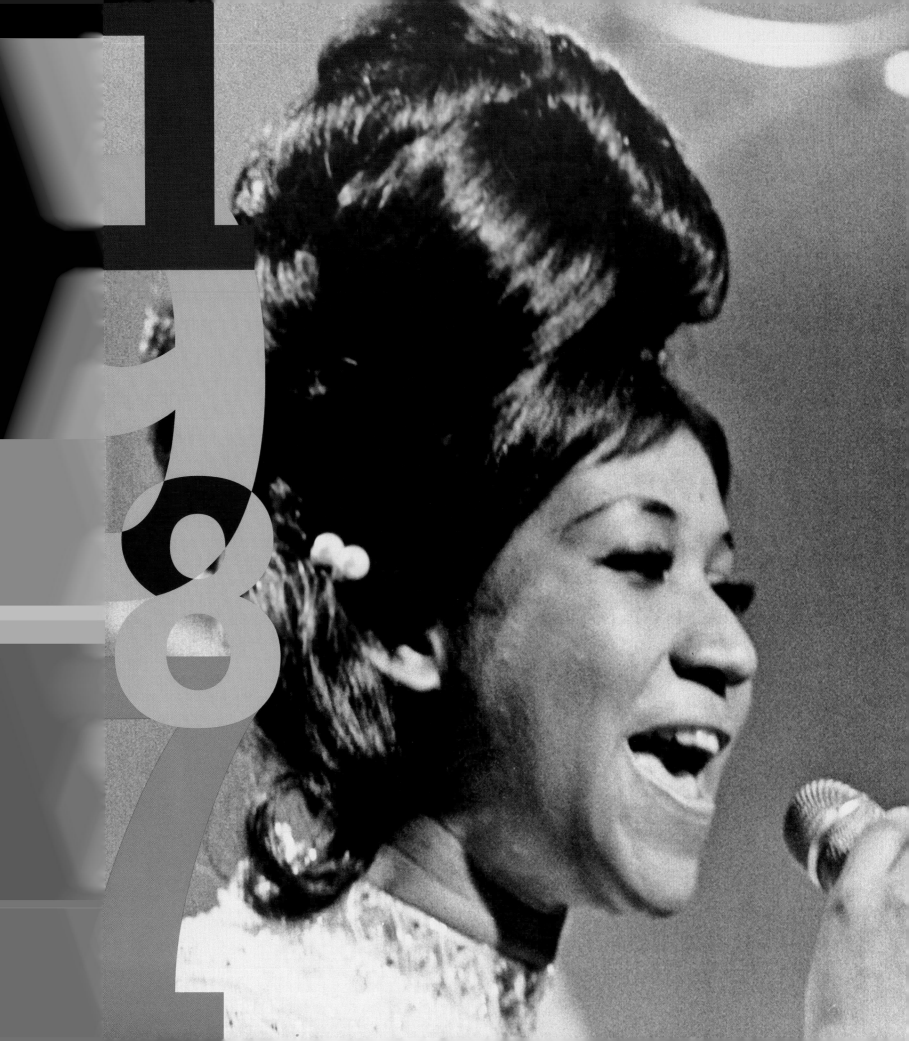

## INDUCTEES

**PERFORMERS** The Coasters ✦ Eddie Cochran ✦ Bo Diddley ✦ Aretha Franklin ✦ Marvin Gaye ✦ Bill Haley ✦ B.B. King ✦ Clyde McPhatter ✦ Ricky Nelson ✦ Roy Orbison ✦ Carl Perkins ✦ Smokey Robinson ✦ Big Joe Turner ✦ Muddy Waters ✦ Jackie Wilson
**EARLY INFLUENCES** Louis Jordan ✦ T-Bone Walker ✦ Hank Williams
**NONPERFORMERS** Leonard Chess ✦ Ahmet Ertegun ✦ Jerry Leiber and Mike Stoller ✦ Jerry Wexler

On January 21, the largest number of inductees in Hall of Fame history—twenty-two—was inducted, voted on from an original list of forty nominees. As Seymour Stein wrote in the induction program, "The plethora of awards tonight is due in part to our tremendous job of catching up, which perhaps would not have been necessary had we started the Hall of Fame at an earlier time."

When inducting B.B. King, just days after the second-ever Martin Luther King Jr. Day, Sting made a disparaging reference to Arizona's refusal to recognize the holiday. Chuck Berry gave a heartfelt induction to his fellow road warrior Bill Haley. Sam Phillips made a long, rambling argument for having the Rock and Roll Hall of Fame building established in Memphis, rather than the recently announced Cleveland. And when Bruce Springsteen hit the stage, he put in his druthers for Asbury Park. Carl Perkins wore his blue suede shoes, and Berry a blue sequined jacket. Keith Richards, who duckwalked with Berry, inducted Aretha Franklin, "the first lady to be inducted into the Hall of Fame." Franklin, who refuses to fly, was unable to attend when a snowstorm prevented her from being driven to New York. Brian Wilson, who'd barely been seen in public for years, showed up looking fit and alert when he inducted songwriters Jerry Leiber and Mike Stoller. Just over a year after his death in a plane crash, inductee Ricky Nelson was represented by his daughter, Tracy, and twin sons, Gunnar and Matthew, then rising teen idol stars. And when Smokey Robinson approached the podium, the audience spontaneously serenaded him with "ooh, baby, baby," a line from and the title of one of his greatest songs.

The jam was another explosive, unplanned event, featuring Robinson, Berry, blues harpist Paul Butterfield, Foreigner's Mick Jones, Roy Orbison, Carl Perkins, Keith Richards, Bo Diddley, Ben E. King, and members of the Coasters. Perhaps most enthusiastic was Bruce Springsteen, making the first of what would be nearly an annual appearance. After giving a stirring induction of Orbison, he played guitar and shared the mic on several songs during the jam. Sting and Daryl Hall split a piano bench, and two members of the Coasters sang along with Leiber and Stoller, the men who'd written their biggest hits.

Just before the jam, Bill Graham urged the artists to gather onstage for a group portrait. "We must have a picture of all of you together!" he shouted. "Please, all of you, B.B., Ben, Chuck, Sting, Bruce, Keith, everybody . . . please come on up! Who knows what's going to happen tomorrow!"

> ## "SHE IS THE QUEEN OF SOUL. SHE IS THE QUEEN OF MUSIC!"
>
> —CLIVE DAVIS,
> ON ARETHA FRANKLIN

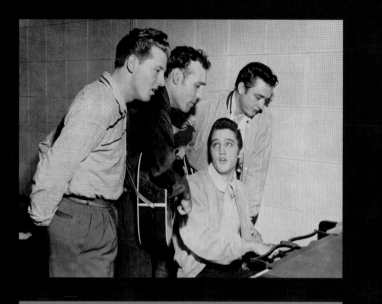

## "ALL THAT WE DO, OR ALL THAT ROCKABILLY IS, IS BLACK RHYTHM WITH SOME WHITE WORDS."

—CARL PERKINS

### AHMET ERTEGUN ON ARETHA FRANKLIN:

"She grew up in a world of gospel music, a world of Mahalia Jackson, Clara Ward, and Sam Cooke, touring the evangelical circuit. John Hammond brought her to Columbia in 1960, and in 1966 Jerry Wexler signed her for Atlantic Records and made some of the most incredible records in the history of rock & roll. Jerry, along with Arif Mardin and Tommy Dowd, made records with Aretha that became historical classics in the annals of rhythm & blues, rock & roll, and American pop music. Her version of Otis Redding's 'Respect' is quintessential."

### REV. CECIL FRANKLIN, ARETHA FRANKLIN'S BROTHER, ON ARETHA:

"Many accolades have been paid, many tributes have been given, many awards have been received, and certainly we are appreciative of them all. However, we feel that tonight is the greatest night in the life of Miss Aretha Franklin, the Queen of Soul, Soul Sister Number One, Lady Soul…whatever you'd like to call her. We feel that this is the greatest night of them all because tonight Aretha has been written into history."

### NICKOLAS ASHFORD AND VALERIE SIMPSON ON MARVIN GAYE:

**Nickolas Ashford:** "They say imitation is the sincerest form of flattery. On many occasions, I tried to imitate Marvin singing."
**Valerie Simpson:** "There are singers that we say have that indefinable quality, something called 'it,' and Marvin definitely had 'it.'"
**Nickolas Ashford:** "He inspired my life and he changed my life."

### STING ON B.B. KING:

"A few days ago, those of us fortunate enough not to live in Arizona, celebrated Martin Luther King Jr. Day. Tonight we're here to celebrate another great King. Someone whose contribution to culture and music, not only to America, but to the world and England, is enormous. The thrill has not gone. The King of the Blues, B.B. King."

### BEN E. KING ON CLYDE McPHATTER:

"Clyde McPhatter was not only an inspiration to me, but he was an inspiration to many, many great singers. I found him to be a very kind, sensitive, proud young man, and he left behind great songs. He was an inspiration to many great tenor singers in the world today. I am proud to say that he is still the foundation for me."

### JOHN FOGERTY ON RICKY NELSON:

"Like most of you, I watched Rick grow up on TV. He was actually our first TV phenom, and week after week, we watched the kid next door grow up and become a superstar in rock & roll and—what was most important to me—a good guy. In fact, I can still remember the moment when I was searching around for how I wanted to be in music, what kind of persona, and of all the people, I decided I wanted to be most like Rick Nelson, who seemed to be handling 'show biz' in a way that most fascinated me. I finally met him in real life in the mid-seventies, and it turns out that it was all real. He was a really good guy.

"He was influenced very much by the same people that grabbed me. In fact, his head turned toward Memphis and he loved rockabilly. As far as I'm concerned, he made some of the greatest rockabilly records of all time. Sam [Phillips], he gave you a run for your money, I think. And throughout his career he had something else in common with me. He wrote the lines to 'Garden Party,' a couple of which were, 'If memories were all I've seen, I'd rather drive a truck,' and it's what he firmly believed. I saw Rick for the last time singing one of my songs. It's something that will touch me forever."

Previous, page 18: Aretha Franklin, c. 1968. This page: the Million Dollar Quartet: (from left) Jerry Lee Lewis, Carl Perkins, Elvis Presley, and Johnny Cash at Sun Studio. Opposite: B.B. King's first publicity picture.

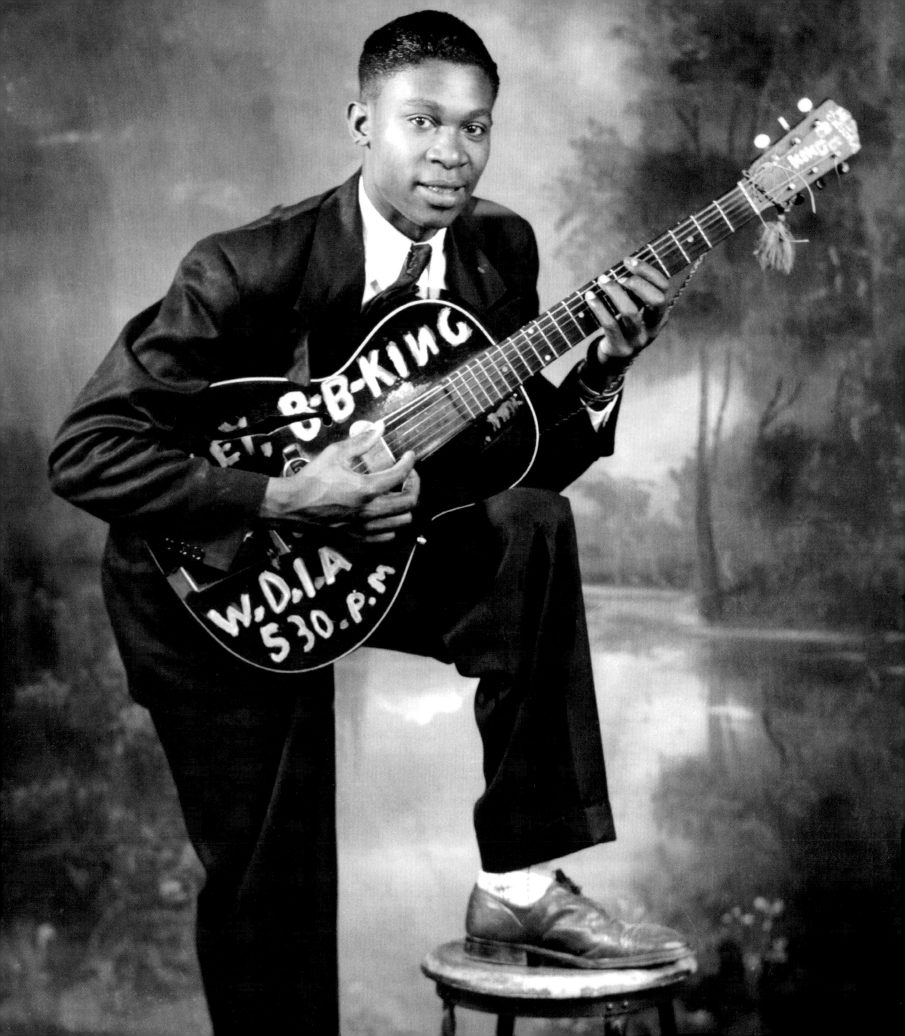

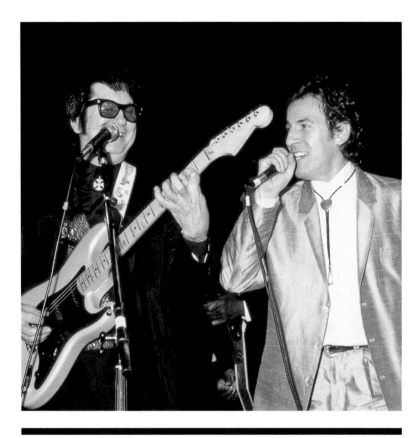

## BRUCE SPRINGSTEEN ON ROY ORBISON:

"In 1970 I rode fifteen hours in the back of a U-Haul truck to open for Roy Orbison at the Nashville Music Fair. It was a summer night, I was twenty years old, and he came out in dark glasses, a dark suit, and he played some dark music.

"Some rock & roll reinforces friendship and community, but for me Roy's ballads were always best when you were alone and in the dark. Roy threw out the idea that you needed a verse, a chorus, a verse, a chorus, a bridge, a verse, a chorus to have a hit. His arrangements were complex and operatic, but they had rhythm, they had movement, and they addressed the underside of pop romance. They were scary. His voice was unearthly. He had the ability, like all good rock & rollers, to sound like he dropped in from another planet, and yet could get to the stuff that was right to the heart of what you were living every day. And that was how he opened up your vision. He made a little town in New Jersey feel as big as the sound of his records."

## AHMET ERTEGUN ON CARL PERKINS:

"Carl Perkins was born in Lake City, Tennessee, in 1932. By the time he was twenty, he was a part-time disc jockey and a full-time country singer with a lot of feeling for the blues. So naturally, he signed with Sun Records in Memphis, and along with Elvis Presley, Jerry Lee Lewis, and Johnny Cash, he established the sound that was to rock the world. Carl's music is Southern rocking, boogie, and blues, and his influences included great blues singers such as Arthur 'Big Boy' Crudup and Blind Lemon Jefferson. 'Blue Suede Shoes' was the rock & roll anthem and a rockabilly masterpiece. Carl's songs have been covered by the Beatles and many other English groups, and he has been the inspiration for many young rock & roll stars."

## SAM PHILLIPS ON CARL PERKINS:

"Carl Perkins came from meager means. When Carl Perkins and two of his brothers came down to a little studio of mine, there's no way that you could turn a person like that down. After listening to him for just a little while in the studio, I knew that we had something that was worth working with, and he proved it."

## CARL PERKINS:

"What a thrill, what a night it is for a sharecropper's son to stand here in this beautiful building. If I have one wish tonight that would come true, it would be that I hope that my life the rest of the way will be lived in such a way that the people at the Rock and Roll Hall of Fame Foundation will never be ashamed that they placed Carl Perkins among the elite."

## DARYL HALL AND JOHN OATES ON SMOKEY ROBINSON AND THE MIRACLES:

**John Oates:** "The music of Smokey Robinson and the Miracles definitely represents a lot of good times for me."

**Daryl Hall:** "Yeah, I remember when I used to go to the Uptown Theater in Philadelphia, and watch all those groups up there playing. Everybody would be grooving, they'd be clapping, screaming, and when Smokey came on, the girls did some strange things. I said, 'Ah, there's something here to watch!'"

**John Oates:** "Every band that Daryl and I have ever been in had some Smokey songs in our set lists."

**Daryl Hall:** "Yeah, in fact we got together because we said, 'How many Smokey songs do you know?'"

> "I THINK ALL OF US WHO ARE IN THE BUSINESS SING FOR MANY REASONS. ONE OF THEM IS TO BELONG, AND I FEEL LIKE THAT TONIGHT, SINCE MY INDUCTION INTO THE HALL OF FAME."
>
> —ROY ORBISON

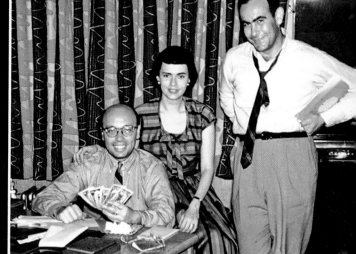

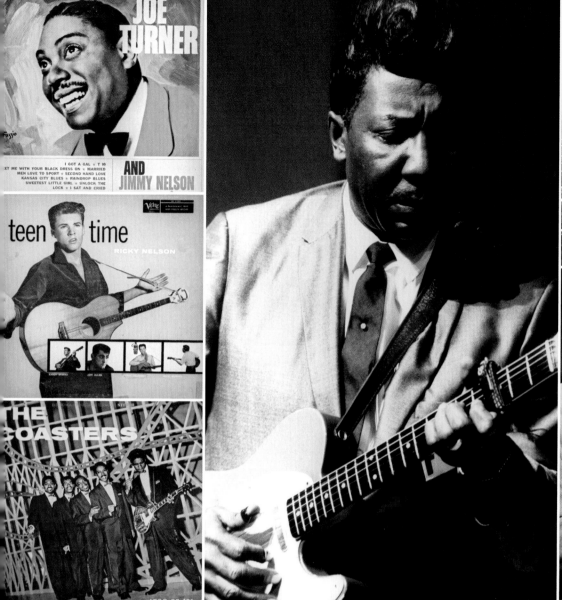

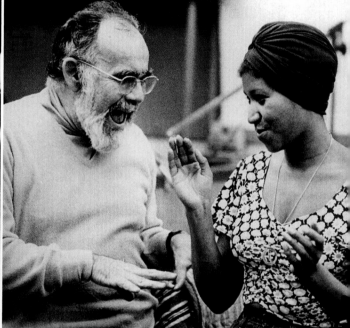

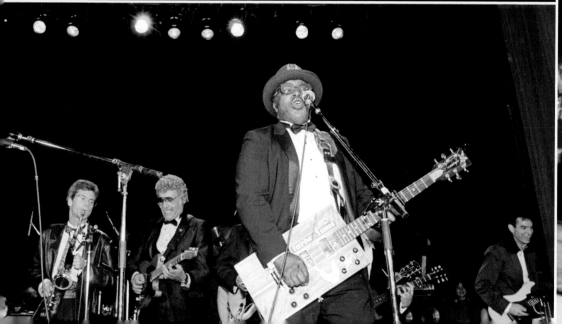

Opposite: Roy Orbison and Bruce Springsteen, January 1987. Clockwise from top left: a Joe Turner LP; Muddy Waters; (from left) Atlantic Records' Ahmet Ertegun, Miriam Abramson, and Jerry Wexler, c. 1955; Jerry Wexler and Aretha Franklin; Jackie Wilson; (from left) David Sanborn, Carl Perkins, Bo Diddley, and Sid McGinnis, January 1987; an early Coasters LP; an early Ricky Nelson LP.

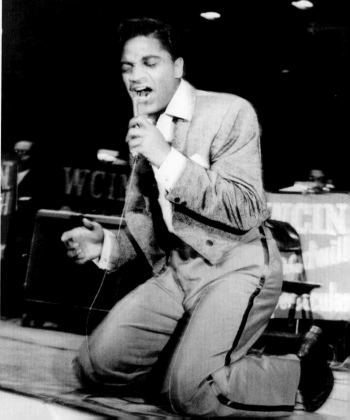

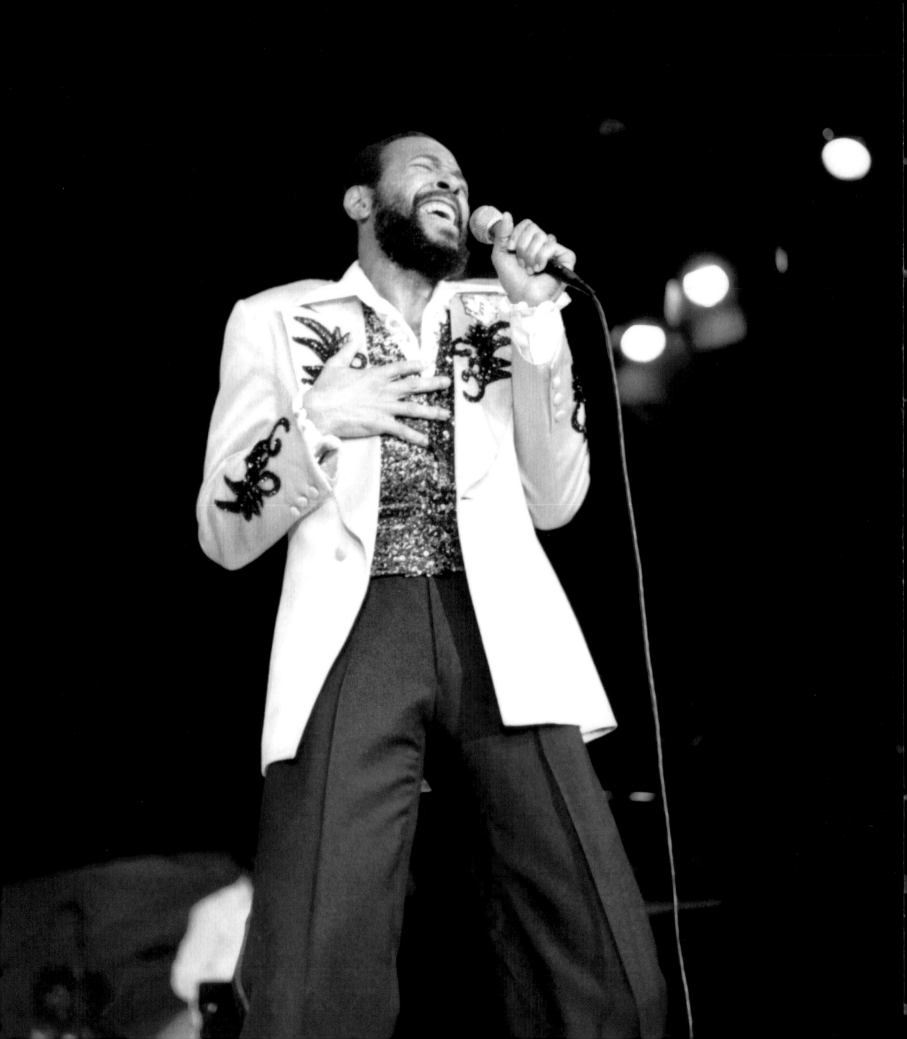

## SMOKEY ROBINSON:

"Before I say anything else, I have to say, 'Thank God,' because I've had the chance to live my life doing something that I absolutely love. And that's such a great blessing. I've had so many highlights in my life. The first major musical highlight that I ever had was the day I met Berry Gordy, who has been really everything to me, and who has created a musical dynasty of which I have been, once again, blessed enough to be a part of. To be inducted into the Rock and Roll Hall of Fame with all these wonderful artists who have been inducted into it for the past couple of years—people who, growing up, I absolutely idolized—like Clyde McPhatter, Jackie Wilson, Sam Cooke. It's an unbelievable dream to me and to receive such an honor as this in what I feel is—and what I really hope is—only the midstream of my life. It is the most wonderful thing that's happened to me so far."

## DOC POMUS ON BIG JOE TURNER:

"Joe would call me every other week and say, 'Cuz, I'm in a world of trouble!' And I would say, 'If you weren't in a world of trouble, what would you have to sing about?' Could you imagine what a world of trouble we'd all been in if we didn't have Joe Turner? He was the man who brought together swing and jazz and finally rock & roll."

## PAUL BUTTERFIELD ON MUDDY WATERS:

"Muddy Waters was probably the greatest inspiration, musically, to me. I knew him since I was, like, fourteen years old, and the one thing that I've always remembered is when I was getting discouraged learning how to play my instrument, Muddy Waters was the one person who would always say, 'Paul, don't let anything get in your way—go ahead and go for it!'"

## PETER WOLF ON JACKIE WILSON:

"I remember once seeing [Jackie Wilson] at the Apollo Theatre. The revue would start…the comedians would come on, and just before Jackie Wilson hit the stage, the women would start coming in. Big women, small women, and Jackie started working the stage, and people would just go, '*Whoa!*' and the place would go crazy. He would go, '*Whoa!*' and the place would go doubly crazy. He decided to undo his tie and he threw it out and it happened to fall right on my lap, and I never had so many women in my lap. He was one of our great, great, great treasures."

## SEYMOUR STEIN ON THE EARLY INFLUENCE INDUCTEES LOUIS JORDAN, T-BONE WALKER, AND HANK WILLIAMS:

"Rock & roll is a hybrid, constantly changing and evolving, but after thirty-five years, it's still center stage of the pop music scene worldwide. From the beginning, two basic ingredients in rock & roll were rhythm & blues and country & western. Tonight, then, it is very, very fitting that in the Early Influences category, we honor two legendary rhythm & blues stars who were rocking & rolling long before the word *rock & roll* was invented, categorized, or identified: Louis Jordan, who with his band the Tympany Five, had a string of over thirty hits in the late forties, and T-Bone Walker, perhaps most famous for 'Call It Stormy Monday,' a man who was really raised on the blues. Both men were tremendous influences on many of the people who are being inducted tonight, and many of last year's inductees as well. We also honor the father of country music, Hank Williams, who was one of the great songwriters and singers of the twentieth century."

Opposite: Marvin Gaye, July 1980. This page: Smokey Robinson and the Miracles, c. 1961.

"YOU WANT TO KNOW ABOUT THE POWER OF MUSIC, YOU OUGHT TO THINK ABOUT THE RESPONSE YOU GAVE TO SMOKEY AND THAT'S WHERE THAT'S AT. IT'S AN AMAZING THING THAT HAPPENS TO US."

—BILL GRAHAM,
REFERRING TO THE AUDIENCE SINGING "OOH, BABY, BABY"

> "WHEN JESSE STONE WROTE 'SHAKE, RATTLE AND ROLL' FOR BIG JOE TURNER, THAT BECAME ONE OF THE FIRST MILESTONES IN THE NEWLY EMERGING ROCK & ROLL MUSIC. HIS GLORIOUS VOICE WILL ALWAYS LIVE IN THE MEMORY OF THOSE WHO KNEW THIS SWEET AND GENTLE GIANT OF A MAN."
>
> —AHMET ERTEGUN

This page: (front, from left) Jerry Wexler, Alan Freed, and Ahmet Ertegun with (back, far left) Buddy Johnson and (back, third from right) Big Joe Turner. Opposite, Hall of Fame induction highlights, January 1987. From top: (from left) David Sanborn, B.B. King, Sid McGinnis, and Keith Richards; (from left) John Fogerty, Smokey Robinson, Ben E. King, Bo Diddley, Bruce Springsteen, and Paul Shaffer; (from left) Fogerty, Robinson, Diddley, King, and Shaffer.

### JANN S. WENNER ON AHMET ERTEGUN:

"How many people here do not know that Ahmet's father was a Turkish diplomat? In 1947, with Herb Abramson, Ahmet founded Atlantic Records, America's foremost rhythm & blues record label. Ahmet was raised in the United States from the age of thirteen, when he developed a fascination with American jazz and blues music. After starting Atlantic, his first major hit was Stick McGhee's 'Drinking Wine, Spo-Dee-O-Dee.' He went on to cultivate his roster of stars such as Ray Charles, Ruth Brown, Joe Turner, LaVern Baker, Clyde McPhatter, the Coasters, and the Drifters, and he often produced these artists' records for them and he continued writing songs for them. Having made R&B a mainstream musical force, Ahmet presided over Atlantic's expansion into soul music, with Aretha, Otis, Wilson Pickett, Etta James, Solomon Burke, and then into the new breed of rock, which is exemplified by Led Zeppelin; Crosby, Stills and Nash; Cream; and eventually the Rolling Stones. There are many things to say about Ahmet, but he provided a home for black music when most companies thought it was too vulgar. He built Atlantic into a major, contemporary label. And alone among all his peers, he's still on the job today."

### WALTER YETNIKOFF ON AHMET ERTEGUN:

"When I was asked to make this presentation, the first thought that came to mind was to accuse Ahmet Ertegun of being a genius—a term somewhat overused in the music business. I'm merely echoing the feelings of songwriters and artists, performers, musicians, and producers and other record executives, engineers, and in fact virtually everyone who has ever worked with him. Ahmet comes from a tradition that is unfortunately disappearing. The man came into this business with a total love of music, and to ensure that he was able to do the utmost with the creative talent he believes in, made himself into a great businessman also. Ahmet combines the heart and the soul of a fan with the intellect and the commitment and dedication and judgment of a music professional. Creative talent needs those qualities to make it in this world. Without him, it's real safe to say, a lot of the great music we've been listening to for the last thirty or forty years would not have been recorded, would not have reached a wide audience. If it's part of the artist's responsibility to use his or her talent to communicate, it's part of the responsibility of people like Ahmet Ertegun to make sure that that communication takes place."

### AHMET ERTEGUN:

"I'm both proud and embarrassed to have been chosen by my peers to be inducted into the Rock and Roll Hall of Fame. I'm proud because it's such an outstanding honor to be in the company of some of the greatest artists of our time. I'm embarrassed because more than myself, it is all the artists who have been responsible for the music we have released on Atlantic Records who really deserve the recognition I'm getting."

### BRIAN WILSON ON JERRY LEIBER AND MIKE STOLLER:

"When I was asked to make this presentation, I remembered back to the fall of 1963. It was a bright, sunny California day and I was driving in my car and a song came on the radio that went [*sings*], 'They say the neon lights are bright on Broadway.' It was such a New York kind of a record that I just flipped out in my car and pulled over and listened to the rest of it. It modulated up half a step every verse, so it modulated five times. 'On Broadway' is such a brilliant, exciting song—the kind that can always put you in a cold sweat. . . . [Their] songs always made me very happy, and everybody that ever heard them, it made them very happy, too. They're anthems of an age filled with feeling, rhythm, and an extraordinary marriage of words and music. I love this music, and I love the guys who wrote it!"

## JANN S. WENNER ON JERRY WEXLER:

"Jerry went from writing about music to getting it made and heard. He studied journalism in college and he dreamed of writing fiction—poor Jerry—before signing on at *Billboard* magazine, where, among other things, he helped get the name of the black music chart changed from 'Race Music' to 'Rhythm & Blues.' At *Billboard*, Jerry became friends with Ahmet Ertegun and Herb Abramson of Atlantic Records, and in 1953, Jerry joined the company as Ahmet's partner. He and Ahmet worked together on all the great acts on the Atlantic roster in those great beginnings of R&B. Over the years, Jerry produced records for Ray Charles, Aretha Franklin, Wilson Pickett, Dusty Springfield, Delaney and Bonnie, and Bob Dylan, among many, many others. He moved Atlantic in the direction of soul music in the sixties by signing a Stax-Volt distribution deal. He was instrumental in the signing of Led Zeppelin. He's a man who has helped us all. One of the record industry's foremost raconteurs, he is a supremely articulate and dedicated component of great American music."

## JERRY WEXLER:

"We were making rhythm & blues records, black music by black musicians for black adult buyers, perpetrated by white and Turkish entrepreneurs. And the next thing you know, white people started buying these records by mistake! I just can't say enough because inexpressible is the twenty-five-year trip of madness, euphoria, experiment, gambling, insanity, and an intense love of the music that I took with the man who somehow has been the quintessence and the essence of all the best of us—my partner, Ahmet."

## MUSICAL HIGHLIGHTS

The jam at night's end was another grouping of legendary rock & roll pioneers in full flower. Highlights included Chuck Berry and Keith Richards in a guitar/vocal duet of "Roll Over Beethoven," and a raucous "Bo Diddley," with Bo Diddley authoritatively handling vocals and guitar, and Carl Perkins, Keith Richards, and Foreigner's Mick Jones adding six-string flourishes. Perkins took center stage on "Blue Suede Shoes," as did Smokey Robinson on "Going to a Go-Go," with Daryl Hall, John Oates, and Sting joining in. An emotive "Stand by Me" was performed by Bruce Springsteen and Ben E. King, but the emotional high point had to be the Roy Orbison–Springsteen duet on "Oh, Pretty Woman." The show closed with a blazing "In the Midnight Hour," with John Fogerty on vocals and B.B. King playing distinctive lead on his guitar Lucille.

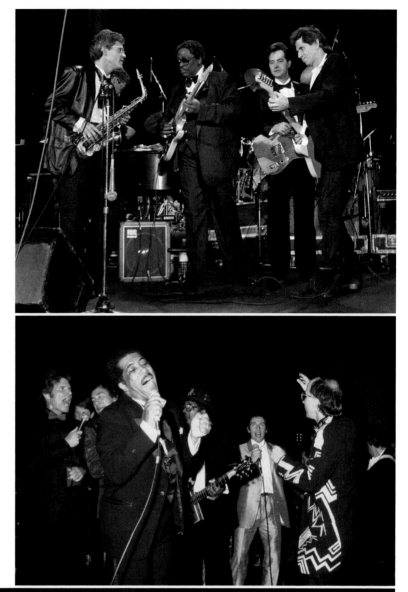

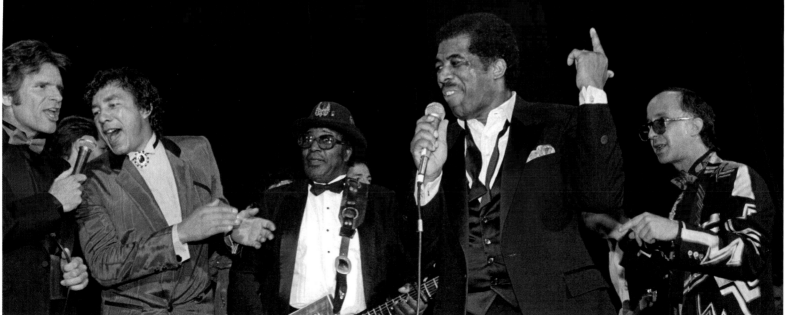

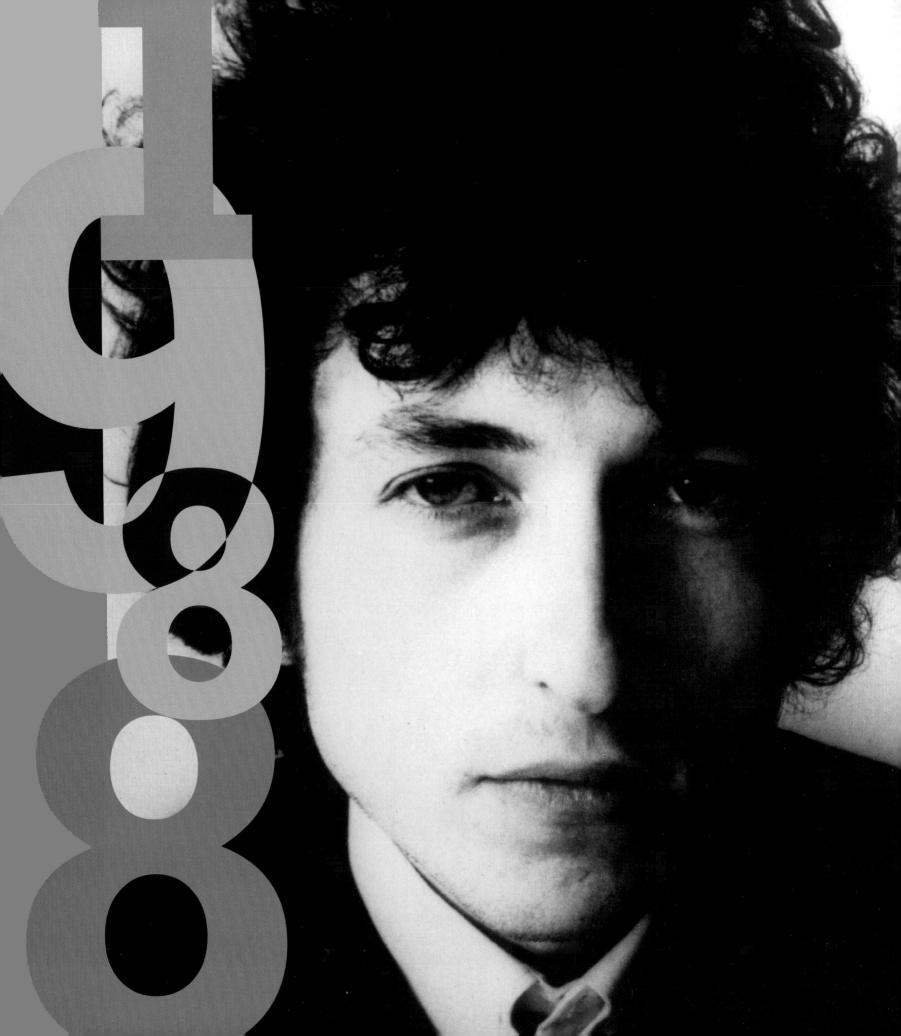

## INDUCTEES

**PERFORMERS** The Beach Boys ✦ The Beatles ✦ The Drifters
Bob Dylan ✦ The Supremes
**EARLY INFLUENCES** Woody Guthrie ✦ Lead Belly ✦ Les Paul
**NONPERFORMER** Berry Gordy Jr.

On January 20, twelve hundred guests gathered at the Waldorf-Astoria, and by night's end some of them were dancing on the tabletops. This may have been the best jam of all time. But there was plenty of behind-the-scenes intrigue that charged the night's proceedings. Disputes or discord between group members impacted all four groups being inducted: Diana Ross, who'd just had a baby, didn't come, and may have been miffed by fellow Supreme Mary Wilson's 1986 memoir, *Dreamgirl*, and the hit Broadway show *Dreamgirls*. (Ross, who went solo in 1970, had earlier had a child with Motown founder Berry Gordy Jr., also an inductee.) Paul McCartney was a no-show due to a royalty dispute filed against him in December 1984 by the surviving Beatles and Yoko Ono, who were quibbling with the fact that McCartney was receiving a higher royalty on the group's recordings than his band mates. The Beatles' former rivals the Beach Boys had suffered through numerous clashes, as well as Brian Wilson's erratic membership and the death of Dennis Wilson, who drowned in 1983. Even the venerable Drifters—surviving members Ben E. King, Johnny Moore, Bill Pinkney, Gerhart Thrasher, and Charlie Thomas—were embroiled in a lawsuit over the rights to the group's name.

This vibe may have worn off on others attending that night. Just before the proceedings got underway, Elton John arrived with his then-wife, Renate, and his songwriting partner Bernie Taupin. They proceeded to their table, only to discover that George Harrison had given one of their seats to Bob Dylan, so there was no room at the table for Bernie. In a fit of pique, Elton stormed off to his hotel suite. In the meantime, Mick Jagger, seated with Little Richard and his entourage, had been continuously jostled by harried waiters carrying massive trays and decided to follow Elton and his gang to his chambers. Eventually, after the ceremony had started, Ringo Starr went to the suite and jocularly encouraged his mates to accompany him back to the ballroom—just in time for Elton to induct the Beach Boys.

What happened next took everyone by surprise. After Beach Boys' Brian Wilson, Al Jardine, and Carl Wilson uttered a few words, remembering the late Dennis Wilson, Mike Love elbowed his way to the mic and let loose a rambling rant, baiting his fellow inductees and other musicians: "It's sad that there are other people who aren't here tonight—people like Paul McCartney, who couldn't be here because he's in a lawsuit with Ringo and Yoko. That's what he sent in a telegram to some high-priced attorney in this room. . . . Now that's a bummer. The Beach Boys have their own interstacine [sic], or whatever you call it, squabbles. But that's a bummer when Ms. Ross can't make it. . . . I'd like to see some people kick out the jams. I challenge the Boss to get up onstage and jam, and I wanna see Billy Joel, see if he can still tickle the ivories. *Lemme see!* . . . [Mick Jagger's] always been chickenshit to get on a stage with the Beach Boys!"

Paul Shaffer and the band upped the volume on "Good Vibrations," which helped maneuver Love off the stage, and a sheepish Carl Wilson afterward approached Ahmet Ertegun to inquire, "Is our career over?" Elton John darted back onstage to shout into the mic, "Thank fuck he didn't mention me!" "Well, that's rock & roll," was the unruffled but bemused Ertegun's response.

But the "night took on a magical tone," reported Kurt Loder in the March 10, 1988, issue of *Rolling Stone*, once Mick Jagger "strolled onstage, totally relaxed and charming" to induct the Beatles. "His speech was a small revelation. Never before had Jagger seemed so guilelessly appealing." Bruce Springsteen, dressed in a silk suit and bolo tie, also made a heartfelt speech to induct Bob Dylan, who thanked Mike Love for not mentioning him in his "speech."

# "IT WAS A BEAUTIFUL REUNION. BOB DYLAN SAID IT WAS A BEAUTIFUL EVENING. BRUCE SAID THE SAME THING. MICK SAID IT SEEMED LIKE OLD TIMES. I DON'T THINK IT'S GONNA GET NO BIGGER THAN THAT."

## —LITTLE RICHARD

### ELTON JOHN ON THE BEACH BOYS:

"In England, we had all our own bands, and we had all the American R&B music, but the Beach Boys were the first white band I can ever remember in England who were summing up America. If you lived in England, all you ever wanted to do was go to America, and everything you ever dreamed of was American. And this band not only wrote great songs, initially writing surf music, but they did more than that. As a musician, you graduated from just listening to pop songs, to bands that produced new sounds and records. This band were geniuses. They made me love America so much more; they've influenced my writing. They are, for me, what America is—a very, very wonderful place to be."

### MICK JAGGER ON THE BEATLES:

"We were doin' Chuck Berry songs and blues and things and we thought that we were totally unique animals. And then we heard there was a group from *Liverpool* [*mock sneer*], and they had long hair, scruffy clothes. But they had a record contract. And they had a record on the charts, with a bluesy harmonica on it, called 'Love Me Do.' When I heard the combination of all these things, I was almost sick. . . . We were playing a little club in Richmond and suddenly there they were right in front of me—the Fab Four. John, Paul, George, and Ringo. The four-headed monster. They never went anywhere alone at this point. And they had on these beautiful, long black leather trench coats. I could really die for one of those. And I thought, 'Even if I have to learn to write songs, I'm gonna get this.' We went through some pretty strange times. We had a lot of rivalry in those early years and a little bit of friction. But we always ended up friends, and I'd like to think we still are. 'Cause they were some of the greatest times of our lives."

Previous, page 28: Bob Dylan, 1966. This page: the Beach Boys: (from left) Al Jardine, Mike Love, Dennis Wilson, Brian Wilson, and Carl Wilson, 1964. Opposite: the Beatles: (clockwise from top left) Paul McCartney, Ringo Starr, John Lennon, and George Harrison.

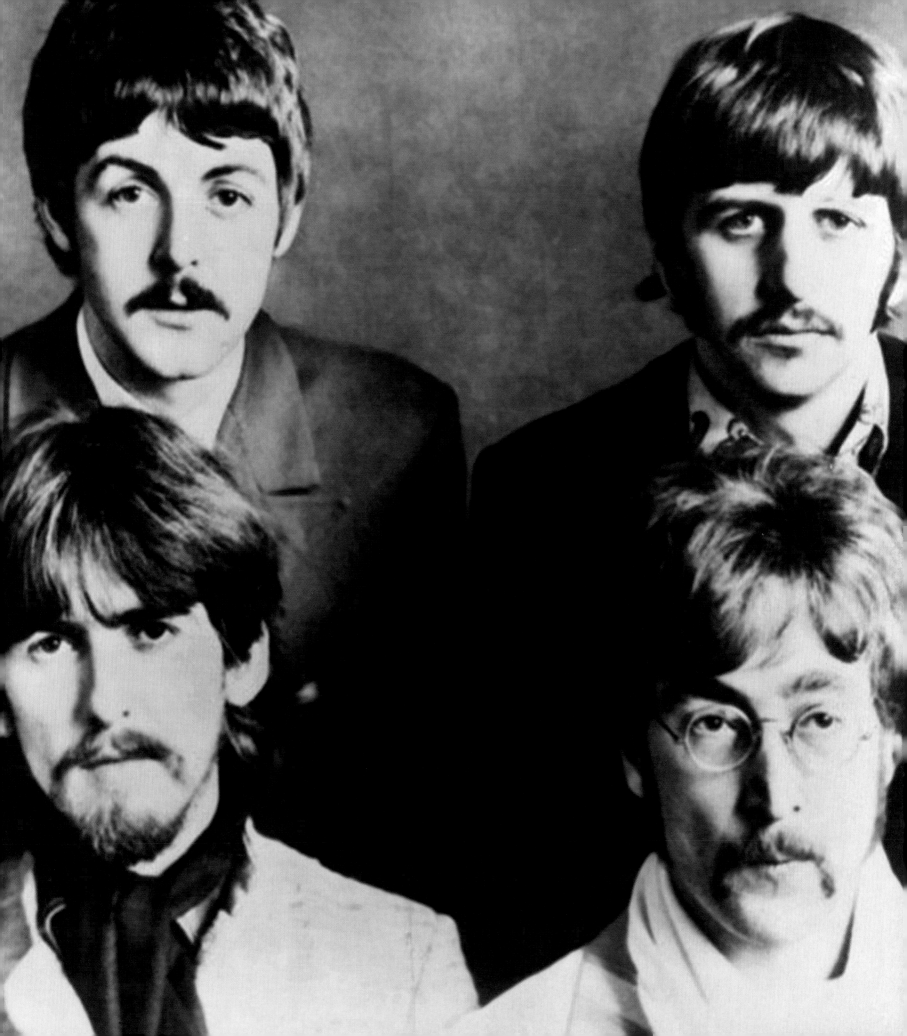

## THE BEATLES:

**George Harrison:** "I don't have much to say 'cause I'm the quiet Beatle. It is unfortunate that Paul's not here, 'cause he was the one who had the speech in his pocket. Anyway, we all know why John can't be here, and I'm sure he would be. And it's hard, really, to stand here supposedly representing the Beatles. It's what's left, I'm afraid. But we all loved him so much. And we all love Paul very much. And it's certainly wonderful to be here and certainly a thrill."

**Paul McCartney,** in a statement distributed by his publicist: "I was keen to go [to the induction ceremony] and pick up my award, but after twenty years, the Beatles still have some business differences which I had hoped would have been settled by now. Unfortunately, they haven't been, so I would feel like a complete hypocrite waving and smiling with them at a fake reunion."

> ## "DURING THE YEARS OF THE BEATLES, THERE WERE PROBABLY ABOUT FIVE HUNDRED 'FIFTH BEATLES,' BUT THERE WERE ACTUALLY ONLY TWO REAL FIFTH BEATLES—AND THEY WERE DEREK TAYLOR AND NEIL ASPINALL."
>
> —GEORGE HARRISON

## BILLY JOEL ON THE DRIFTERS:

"I grew up in a housing development here in New York, out on Long Island, called Levittown. I was in a gang—everybody joined a gang so they could be different than the kids who were in the other gangs. Back then, this made a lot of sense. This was in the early sixties. Now, this is when a roof was just a top of a house, and a boardwalk was just a long stretch of wood. Broadway was this street in New York City where people with blue hair went to see plays. Saturday night, you went to the movies, just to see the movie. And the last dance was something you never hung around for.

"The Drifters changed all this for my gang. Before President Kennedy was shot, before the British Invasion, before the counterculture, before all hell broke loose, really, the Drifters offered my gang an alternative lifestyle. They gave us The Word. And The Word was this: 'Don't just stay in the house and stare at the ceiling. Go up on the roof and look at the stars. (And even Levittown looked good from up there. It looked like Syosset.) Don't just shuffle down the boardwalk looking for ice cream. Go take a look underneath the boardwalk. You might find something that tastes better. Go to the movies on a Saturday night. But who cares about the picture? You meet

your friends, you might meet some girls (from Syosset), make out a little. And the last dance isn't just for losers. The last dance is also for lovers.'

"This was a romantic revolution. The Drifters gave us the last really good hot dogs and French fries we ever had. They were really magic moments, and they were the last moments of innocence for me and my gang. We all got kicked into the late sixties after those songs. I lost track of most of the guys in that gang since then. But every time I hear, [*sings*] 'There goes my baby, movin' on down the line . . .' I can see these guys' faces. I can see these guys struttin' down Levittown Parkway. I'm only one guy out of one gang, but I was chosen to represent every person in every gang, who ever loved the music of the Drifters."

## BRUCE SPRINGSTEEN ON BOB DYLAN:

"The first time that I heard Bob Dylan I was in the car with my mother, and we were listening to, I think, WMCA, and on came that snare shot that sounded like somebody kicked open the door to your mind, from 'Like a Rolling Stone.' And my mother, who was no stiff with rock & roll—she liked the music, she listened—she sat there for a minute, she looked at me, and she said, 'That guy can't sing.' But I knew she was wrong. I sat there, I didn't say nothin', but I knew that I was listening to the toughest voice that I had ever heard. It was lean, and it sounded somehow simultaneously young and adult, and I ran out and I bought the single. I played it, then I went out and I got *Highway 61,* and it was all I played for weeks. I looked at the cover, with Bob, with that satin blue jacket and the Triumph Motorcycle shirt. Bob's voice somehow thrilled and scared me. It made me feel kind of irresponsibly innocent. And it still does. But it reached down and touched what little worldliness I think a fifteen-year-old kid in high school, in New Jersey, had in him at the time.

"Dylan was a revolutionary—the way that Elvis freed your body, Bob freed your mind. He showed us that just because the music was innately physical, it did not mean that it was anti-intellect. He had the vision and the talent to expand a pop song until it contained the whole world. He invented a new way a pop singer could sound. He broke through the limitations of what a recording artist could achieve, and he changed the face of rock & roll forever and ever. Without Bob, the Beatles wouldn't have made *Sgt. Pepper*, maybe the Beach Boys wouldn't have made *Pet Sounds*, the Sex Pistols wouldn't have made 'God Save the Queen,' U2 wouldn't have done 'Pride (In the Name of Love),' Marvin Gaye wouldn't have done 'What's Going On,' Grandmaster Flash might not have done 'The Message,' and the Count Five could not have done 'Psychotic Reaction.' And there never would have been a group named the Electric Prunes, that's for sure.

"The fact is that, to this day, where great rock music is being made, there is the shadow of Bob Dylan over and over and over again. And Bob's own modern work has gone unjustly underappreciated for having to stand in that shadow. If there was a young guy out there writing 'Sweetheart Like You,' writing the *Empire Burlesque* album, writing 'Every Grain of Sand,' they'd be calling him the new Bob Dylan.

"About three months ago, I was watching TV, and the *Rolling Stone* special came on, and Bob came on, and he was in a real cranky mood, and he was kind of bitchin' and moaning about how his fans don't know him, and nobody knows him. They come up to him on the street and kind of treat him like a long-lost brother or something. And speaking as a fan, I guess when I was fifteen, and I heard 'Like a Rolling Stone,'

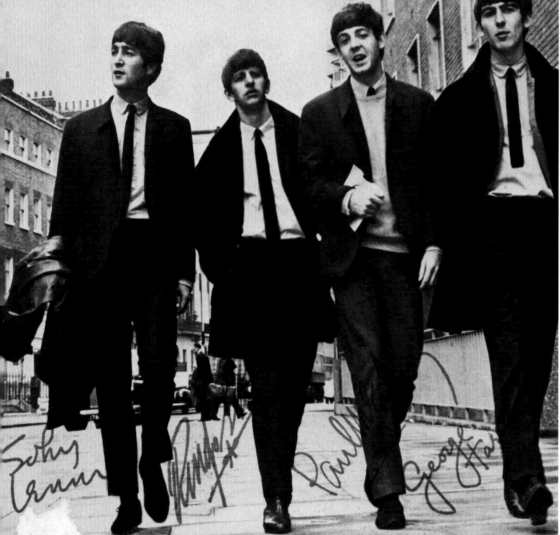

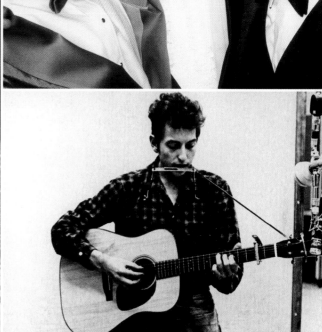

Clockwise from top left: the Beatles: (from left) Lennon, Starr, McCartney, and Harrison; the Drifters, January 1988; Bob Dylan, 1962; the Beach Boys in the studio: (from left) Carl Wilson, Bruce Johnston, Brian Wilson, and Al Jardine, c. 1966; Bob Dylan poster by Milton Glaser, 1967; Hollywood Bowl concert poster, 1965.

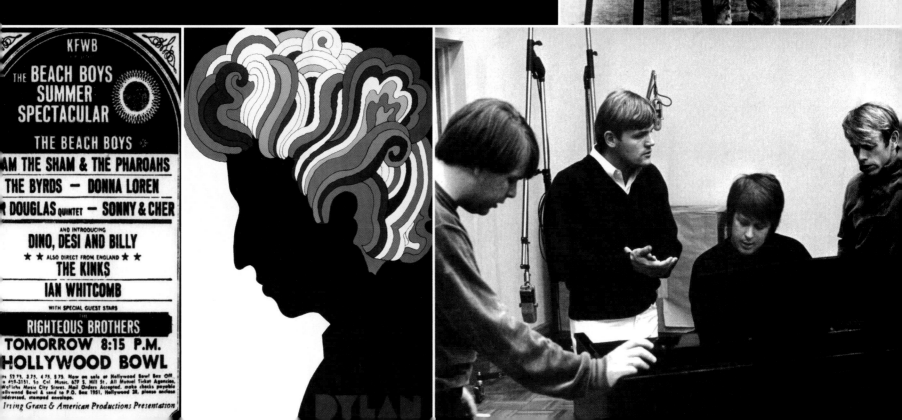

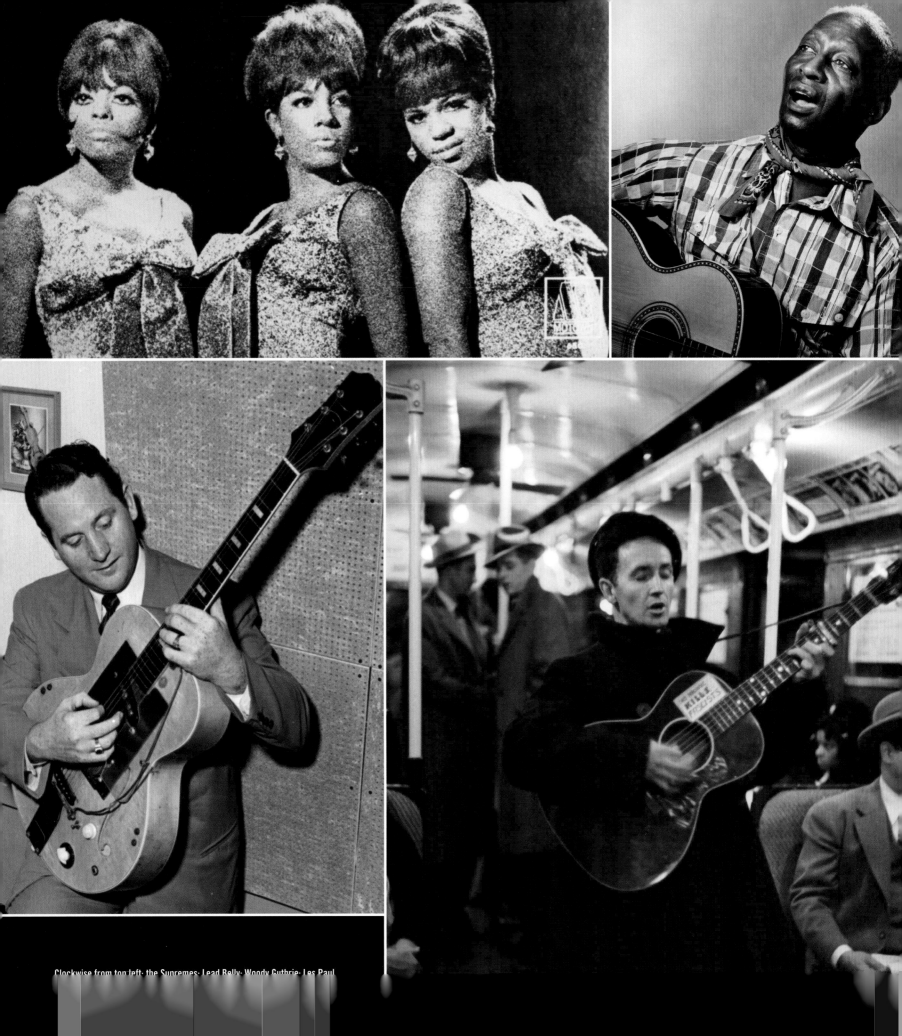

Clockwise from top left: the Supremes, Lead Belly, Woody Guthrie, Les Paul

I heard a guy like I've never heard before or since. A guy that had the guts to take on the whole world and made me feel like I had 'em, too. Maybe some people mistook that voice to be saying somehow that you were gonna do the job for 'em. We know, as we grow older, that there isn't anybody out there that can do that job for anybody else. So I'm just here tonight to say thanks, to say that I wouldn't be here without you, to say that there isn't a soul in this room who does not owe you their thanks. And to steal a line from one of your songs, whether you like it or not, 'You was the brother that I never had.'"

## BOB DYLAN:

"I'd like to thank a couple of people who are here tonight, who helped me out a great deal coming up. Little Richard, who's sitting over there; I don't think I would have even started out without listening to Little Richard. And Alan Lomax, who is over there somewhere, too. I spent many nights in his apartment house, visiting and meeting all kinds of folk-music people, who I never would have come in contact with.

"And I want to thank Mike Love for not mentioning me. I play a lot of dates every year, too, and peace, love, and harmony is greatly important indeed, but so is forgiveness, and we gotta have that, too."

## AHMET ERTEGUN ON THE SUPREMES:

"In the history of rock & roll, there are those moments when all the pieces fall together perfectly: the artist, the songwriter, the producer, the record company. When the combination was the Supremes; Holland, Dozier, and Holland; and Motown's Berry Gordy Jr., the result was musical history. The emergence of the Supremes provided the perfect American counterpoint to the British Invasion of the sixties. From mid-1964 to mid-1965 alone, the Supremes had no less than five consecutive Number One pop hits. Transcending racial and musical boundaries, they created timeless, soulful pop music that defied imitation. Diana Ross, Florence Ballard, and Mary Wilson were the jewels."

## LITTLE RICHARD ON THE SUPREMES:

"I love the Supremes so much 'cause they remind me of myself. They dress like me! Diana Ross been dressin' like me for years. You all know that! And they also do my holler: *whoo!* You know I started that, I am the first one who said *whoo,* everybody else was sayin' *wah!*"

## NEIL YOUNG ON WOODY GUTHRIE:

"In a lot of rock & roll bands, you see the one guy going crazy with the guitar and jumping around, and you see the other real serious kind of guy up there, and he's singing along. It's really effective. I don't know which one of those guys I tried to be. These guys, these singer-songwriters, they all came from the same place: It all seems to go back and start with Woody Guthrie. His songs are gonna last forever, and some of the songs of his descendents are gonna last forever. It gave me a great feeling last year at Farm Aid to be up there with Willie Nelson and Arlo [Guthrie], singing 'This Land Is Your Land.' You could see all those people just singing along—the farmers and thousands of people, singing this song. And I can't help but think that some day, that song's gonna be sung on other planets."

## ARLO GUTHRIE ON WOODY GUTHRIE:

"You can figure a lot of things in this world, but this isn't one of them. I am fairly positive that if my dad had been alive today, this is the one place he *wouldn't* be. Or he woulda showed up drunk. I was thinking of what to say, and the only thing I could really think of was that the one thing my dad would've really thought was that to be a human is to come and go sometimes; you don't have a body for long, but you have a spirit. And as long as there's people—and there's a lot of them in this room tonight—who care about other people around the world, who do the Farm Aid shows, and the shows for folks over in Africa, his spirit is still alive, still working, still singing, and I think this is why I had to come anyhow and say thank you."

## PETE SEEGER ON LEAD BELLY:

"'All our art is but water drawn from the well of the people. Let us give it back to them in a cup of gold, so in drinking they may recognize themselves.' These words by the Spanish poet [Federico] García Lorca say what needs to be said here, right now. It's a wonderful thing that this organization is crediting the people who started the music off. It's a long, long chain from many parts of the world and brought here together, combining music from Africa, from Europe, and who knows where else. I'd like to credit two particular people, without whom we'd have never known Huddie Ledbetter, better known as Lead Belly. Old John Lomax, a conservative Texan, who spent his life collecting cowboy songs and ballads, and later on found Huddie Ledbetter, a prisoner. And his son Alan, who in my opinion, more than any single person, is responsible for America's revival of interest in its own folk music. Alan brought Lead Belly up to New York; Lead Belly brought some of the greatest songs that we will ever know. I was a teenager at the time Alan introduced me to Lead Belly. I was just one of the first of many Yankee college students that fell in love with Southern folk music. I got to know Lead Belly and his wonderful wife, Martha, and his wonderful niece, Tiny Robinson, who is the person who is going to accept the award for Lead Belly tonight. And I'd like to simply repeat that if we realize that we are but links in a long, long chain, then by God, there will be links to come! And the people who wipe the human race off the map with their goddamn atom bombs and their goddamn toxic chemicals will be fooled, because love and music are gonna bring us together!"

> ## "MY LIFE HAS BEEN AN EMBARRASSMENT OF RICHES. EVERY DAY FOR THIRTY YEARS I'VE HAD THE LUXURY OF DOING WHAT I LOVE TO DO. THANK GOD FOR ROCK & ROLL!"
> —BERRY GORDY JR.

### JEFF BECK ON LES PAUL:

"I'm terrible at speeches, but I guess I've copied more licks off of Les than anybody else. I showed him the speech I was gonna read out, and he said, 'That's worse than a United Airlines meal.' So I didn't bother."

> ## "I HAVE BEEN CREDITED WITH INVENTING A FEW THINGS THAT YOU GUYS ARE USING OUT THERE. ABOUT THE MOST I CAN SAY IS, 'HAVE A LOT OF FUN WITH MY TOYS.'"
>
> —LES PAUL

## MUSICAL HIGHLIGHTS

Kurt Loder interviewed Paul Shaffer for the *Rolling Stone* article "Party of the Year" about what made the jam so spectacular that January 20 night. Unlike the loosely structured jams of the previous two years, this one had a modicum of advance planning—while musicians were having dinner. Said Shaffer: "We never did this in the previous two years. But this year, there were so many opportunities that we thought we'd better have a few ideas, because it would be silly to blow it if nobody could think of anything to play." Shaffer asked Billy Joel to sing "I Saw Her Standing There," and he said he would if he could also play a Hammond B-3 organ. No problem. Then Shaffer requested Neil Young to take part in the jam: "He said he'd maybe sing something of his own, but he ended up very happy just playing guitar for everybody else. Then I spoke to Ringo. I said, 'Would you participate in the jam?' He said, 'Absolutely not! There'll be *real* musicians up there.' But he ended up playing drums anyway." Dylan's answer to Shaffer's inquiry: "Anything you want..." Springsteen told Shaffer that he'd like to join in on "Like a Rolling Stone" if Dylan agreed to do it. "So then," according to Shaffer, "between me and Bill Graham, we made a sort of tentative list. And in our back pocket we knew we were going to do 'Like a Rolling Stone' last."

   The results: With Mick Jagger, George Harrison, Ringo Starr, Bruce Springsteen, Jeff Beck, Elton John, Billy Joel, John Fogerty, Neil Young, Dave Edmunds, Mary Wilson, and various Beach Boys and Drifters onstage, the first number, "Twist and Shout," was "wobbly," according to Loder. "All Along the Watchtower," featuring Harrison and Dylan, was a bit disjointed, with Shaffer's band playing the three-chord Jimi Hendrix arrangement, and Dylan sticking with his original two-chord version. Then, says Loder, Les Paul "took off on one of those skittering solos that have become his trademark, prompting gasps from most of the other guitarists in his vicinity. . . . Billy Joel kicked things up to another level when he took charge and tore into the lead on 'I Saw Her Standing There,' with Jagger and Harrison contributing hilarious head-waggling choruses. Springsteen jumped in to sing the bridge and then duetted with Jagger while Beck's screaming lines circled all around them."

   One of John Lennon's favorite songs, "Stand by Me," was sung by his son Julian and its originator, Ben E. King, with Dave Edmunds on guitar, and Elton John took center stage on "Whole Lot of Shakin' Going On" and "Hound Dog." The Beach Boys struggled through "Barbara Ann," then Shaffer asked John Fogerty to sing "Long Tall Sally. "I wanted to do it with Little Richard, but he's left," said Fogerty. "So I'll just do one of my own tunes, if that's okay." He launched into "Born on the Bayou," joined on harmonies by Springsteen, and with Neil Young and Chic's Nile Rodgers on guitar. Said Rodgers, "That was the most fun for me. I knew that one would sound perfect, 'cause I've been practicing that part since I was a kid."

   As for the climactic finale? It was "a long, thundering version of 'Like a Rolling Stone,' said Loder, "with Jagger and Springsteen flanking Dylan and roaring in on the chorus for a mightily massed '*How does it feel.*' According to Shaffer, "It was just a fabulous moment. The guitar section was ridiculous—George Harrison, Jeff Beck, and everybody. I don't think you could top it."

   But then Jeff Beck reignited the fire when the opening riff of "Satisfaction" rang out from his guitar. "I guess Jeff knew that Jagger hadn't really had a chance to shine yet," Shaffer opines. "I looked at Jagger's face, and he just loved it when he heard those opening notes. He just automatically took center stage and went to work. It was really a stroke of genius on the part of Jeff Beck. When I had approached Jeff before the show, he showed me his finger, which he'd jammed in a door or something—the nail was right off the picking finger of his right hand. He sort of tried to make an excuse, but then he said that maybe if he got drunk enough, he might play. And he turned out to be one of the most valuable players." When Springsteen joined Jagger at the mic, "The song became a study in charisma," Loder reports. "Nose to nose and eyeball to eyeball on a single microphone, they shouted out the chorus for all it was worth. Then, as if by instinct, each began lowering his voice to a hoarse croak, the one bobbing and weaving playfully against the other, building the tension, slowly bringing the volume back up and finally exploding for the finale."

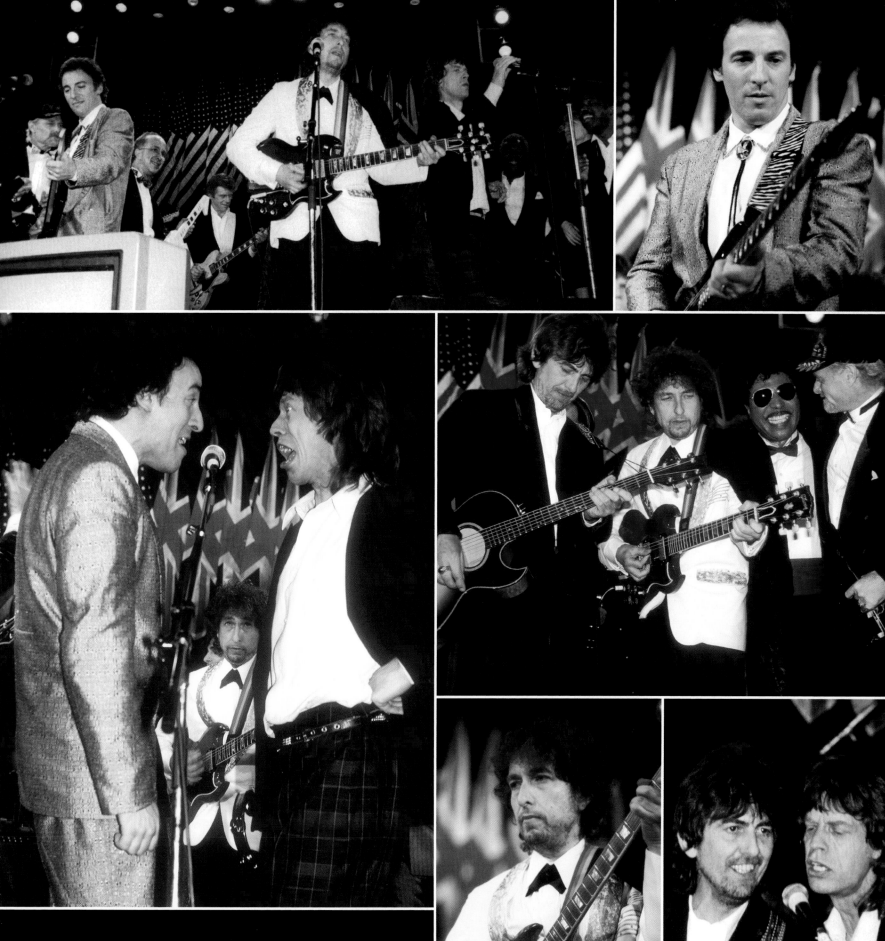

This page: Hall of Fame induction highlights, January 1988. Clockwise from top left: (from left) Bruce Springsteen, Bob Dylan, and Mick Jagger; Bruce Springsteen; (from left) George Harrison, Dylan, Little Richard, and Mike Love; Harrison and Jagger; Dylan; Springsteen, Dylan, and Jagger.

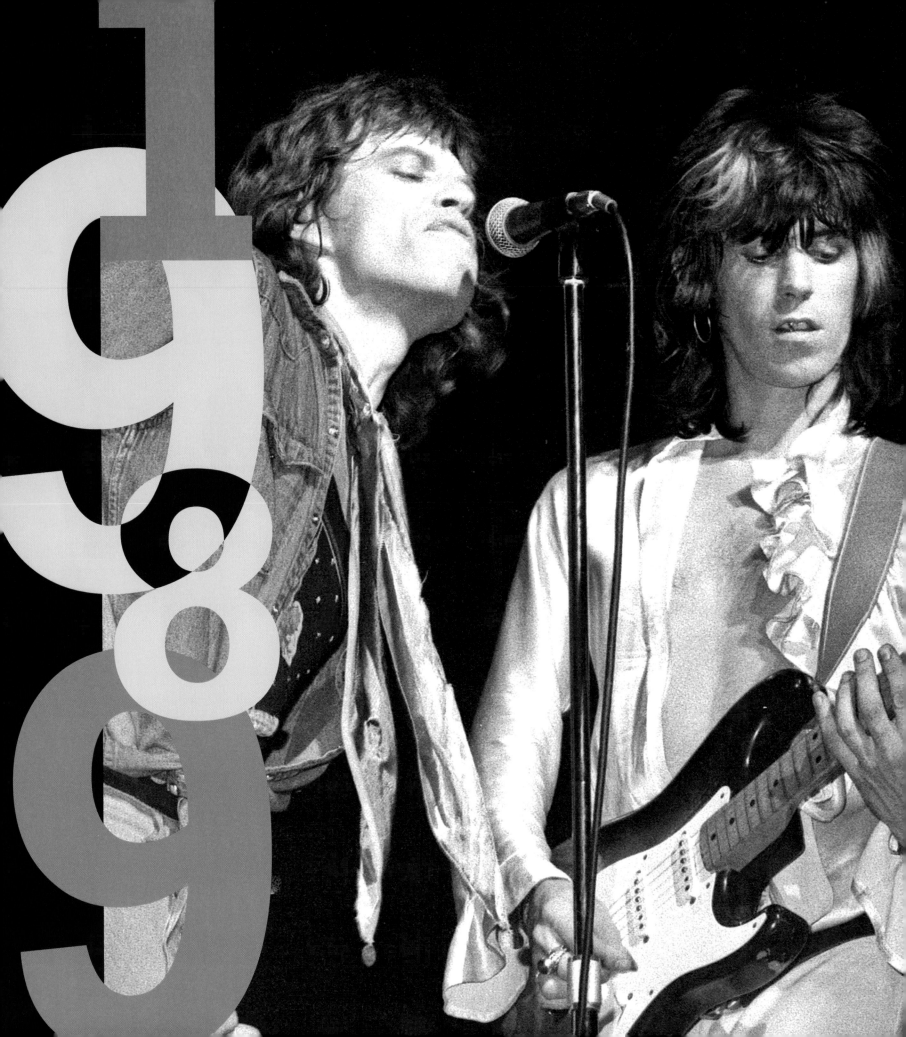

## INDUCTEES

**PERFORMERS** Dion ✦ Otis Redding ✦ The Rolling Stones
The Temptations ✦ Stevie Wonder
**EARLY INFLUENCES** The Ink Spots ✦ Bessie Smith ✦ The Soul Stirrers
**NONPERFORMER** Phil Spector

A cool rock & roll crowd gathered at New York's Waldorf-Astoria on January 18 to induct a new batch of artists, with the emphasis on R&B, including the second big British Invasion band. The sacred commingled with the profane (from the Soul Stirrers to the Stones), and much music emanated from the stage, lyrics sometimes replacing words during speeches. Hall and Oates crooned an a cappella "Don't Look Back" to induct the Temptations, whose surviving members (Eddie Kendricks, David Ruffin, Dennis Edwards, Melvin Franklin, and Otis Williams) spontaneously bounded onstage to harmonize beautifully. A perky Little Richard inducted his fellow Georgian Otis Redding by belting out the late soulman's "I Can't Turn You Loose," and eventually reviving his own primal hits like "Lucille," until then mostly absent from his performances since his second religious conversion. The "Georgia Peach" also regaled the audience with an innuendo-filled story about his first meeting with homeboy Redding: "I gave him fifty dollars at the Statler Hilton Hotel. I wanted him to come up to my room, but he was scared to come to my room. . . . He didn't want me to lock the door. I wasn't gonna do nothin'! I just wanted to hear him sing—*by myself!*"

Inductee Phil Spector seemed to have trouble in mind when he invited both Tina and Ike Turner (unbeknownst to one another) to induct him. Tina got to do the honors, while her ex-husband told *Rolling Stone* that "I'm happy to be here, but it made me kind of nervous that *she* was going to be here." As David Fricke and Sheila Rogers reported in the March 9, 1989, issue of *Rolling Stone*, "No doubt the feeling was mutual." Fricke and Rogers detailed Spector's induction: "Tina Turner described recording 'River Deep, Mountain High' with him in 1966. 'It looked like there were about forty musicians, twenty-five singers, and Phil was in the midst of tearing up what looked like an arrangement. I wish all of the people that I sing for could have seen Phil Spector in action working there with all those people and getting that sound.' Instead, what the Hall of Fame folks saw was the man who built the Wall of Sound bopping madly to the strains of the Ronettes' 'Be My Baby,' flanked by beefy bodyguards who practically elbowed Tina out of the way. He mumbled a few incoherent remarks about George [H.W.] Bush and the recent presidential inauguration and then his bodyguards hurried him away again."

The media had been on alert all week due to the Stones' Hall of Fame appearance. Keith Richards and Mick Jagger had been sniping at each other in the press—Richards had recently released his first solo album (with the X-Pensive Winos) that included a dis directed at Jagger titled "You Don't Move Me," and Jagger had issued his second solo effort a year earlier. The band hadn't toured in nearly eight years. The Stones rhythm section didn't show up at the Waldorf-Astoria, with bassist Bill Wyman telling a scribe he was too busy to attend. (Wyman—about to marry Mandy Smith, his girlfriend since she was thirteen—was opening a memorabilia-filled restaurant in London.) But the Glimmer Twins surprised everyone by displaying a genuine camaraderie onstage, as described by Fricke and Rogers, "with draped arms over each other's shoulders, digging elbows into each other's ribs, and cackling like errant school boys at the jokes in their respective acceptance speeches."

On a more somber note, the evening was dedicated to Roy Orbison, the first living inductee to pass away.

> "ALL OF YOU OUT THERE WHO HAVE BEEN MAKING MUSIC OVER THE LAST THREE DECADES, YOU DON'T KNOW WHAT YOU MEAN TO ME. YOU KEPT ME YOUNG AND RICH IN SPIRIT. WE USED TO THINK ROCK & ROLL WAS ONLY FOR THE YOUNG, BUT YOU CAN BE KICKING ASS AT SIXTY!"
>
> —DION

### JANN S. WENNER ON ROY ORBISON:

"As we meet again to induct new members into the Rock and Roll Hall of Fame, our first order of business tonight must be the very sad duty to note the passing of Roy Orbison. Death never comes at an opportune moment, and it was especially untimely in Roy's case. One purpose of the Hall of Fame is to bring recognition and attention to artists whose work may have been ignored or forgotten in recent years, and after his induction into the Hall of Fame two years ago and because of the eloquence and commitment of Bruce Springsteen, who inducted him into the Hall of Fame, Roy began to once again experience the success he so richly deserved. Despite everything he had already accomplished, Roy still had much to give. His talent was as undiminished as his spirit. The Traveling Wilburys and the upcoming solo album [*Mystery Girl*, which would go platinum and reach Number Five] are proof of this. We're very proud of the role we played in helping to reestablish Roy's career, and his death is personally painful, as well as an ongoing artistic loss. Roy Orbison was the first living member of the Rock and Roll Hall of Fame to pass, and he'll be dearly missed."

### LOU REED ON DION:

"It was 1958, and the cold winds of Long Island blew in from the ocean. They were a high-pitched howl mixing with the dusty, musty, mellifluous sounds of rock & roll—the sounds of another life, the sounds of freedom. As Alan Freed pounded a telephone book, and the honking sax of Big Al Sears seared the airwaves with his theme song, 'Hand Clappin,' I sat staring at an indecipherable book on plane geometry, whose planes and angles would forever escape me. And I wanted to escape it and the world of SAT tests and the college boards and leap immediately and eternally into the world of Shirley and Lee, Nolan Strong and the Diablos, the Paragons, the Jesters, Lillian Leach and the Mellows' 'Smoke From Your Cigarette,' Alicia and the Rockaways' 'Why Can't I Be Loved'—a question that certainly occupied my teenage time.

"The lyrics sat in my head like Shakespearean sonnets, with all the power of tragedy. 'Why don't you write me, darling?,' 'Send Me a Letter' by the Jacks.

"And then there was Dion. That great opening to 'I Wonder Why,' engraved in my skull forever. Dion, whose voice was unlike any other I had heard before. Dion could do all the turns, stretch those syllables so effortlessly, soar so high he could reach the sky, and dance there among the stars forever. What a voice that had absorbed and transmogrified all these influences into his own soul, as the wine turns into blood. A voice that stood on its own, remarkably and unmistakably from New York—Bronx soul. It was the kind of voice you never forget. Over the years, that voice has stayed with me, as it has, I'm sure, stayed with you. And whenever I hear it, I'm flooded with memories of what once was and what could be."

### AHMET ERTEGUN ON OTIS REDDING:

"Otis Redding was an artist for whom I had and still have a very special affection. He was big in many senses—big man, big heart, big love, and understanding of music and life, big voice, tough and vulnerable at the same time, and a sweet man and friend. He called me 'Omelet.' We had the good fortune to sign him up after he had made just one single. Between his first release for us in October 1962, 'These Arms of Mine,' and his last, the posthumous 'Dock of the Bay,' in January 1968, Otis created a body of work that defined the very essence of soul music. Just like Ray Charles before him, Otis became the inspiration for decades of musicians and singers."

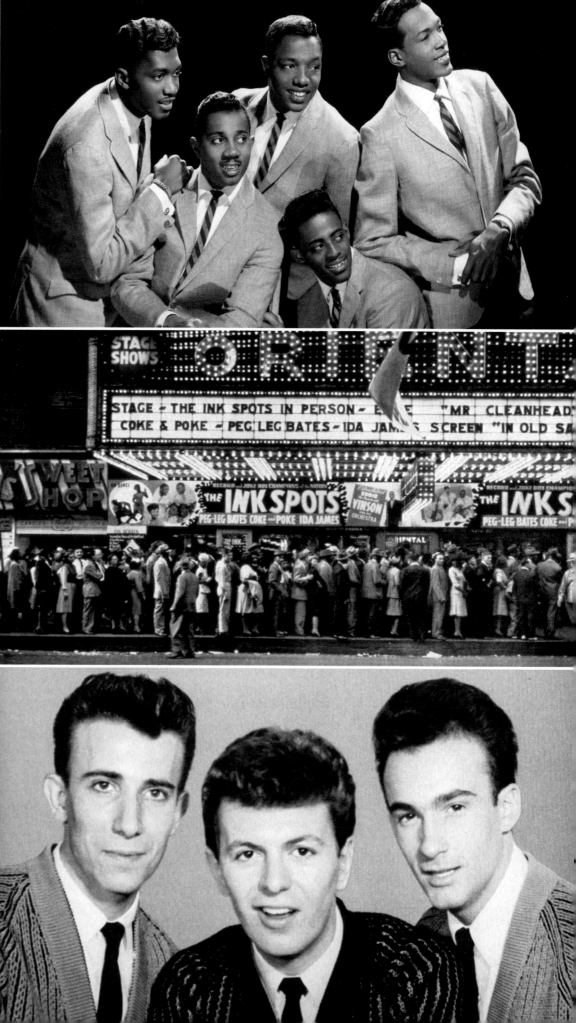

Previous, page 38: Mick Jagger and Keith Richards, 1972. This page, clockwise from top left: Otis Redding, 1965; the Temptations; Ink Spots concert, Chicago, 1947; Dion and the Belmonts; Roy Orbison album, 1963.

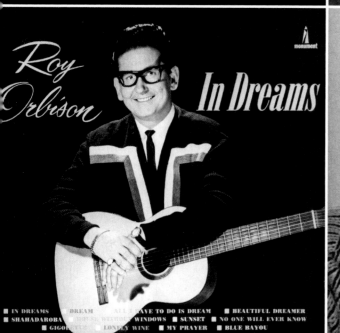

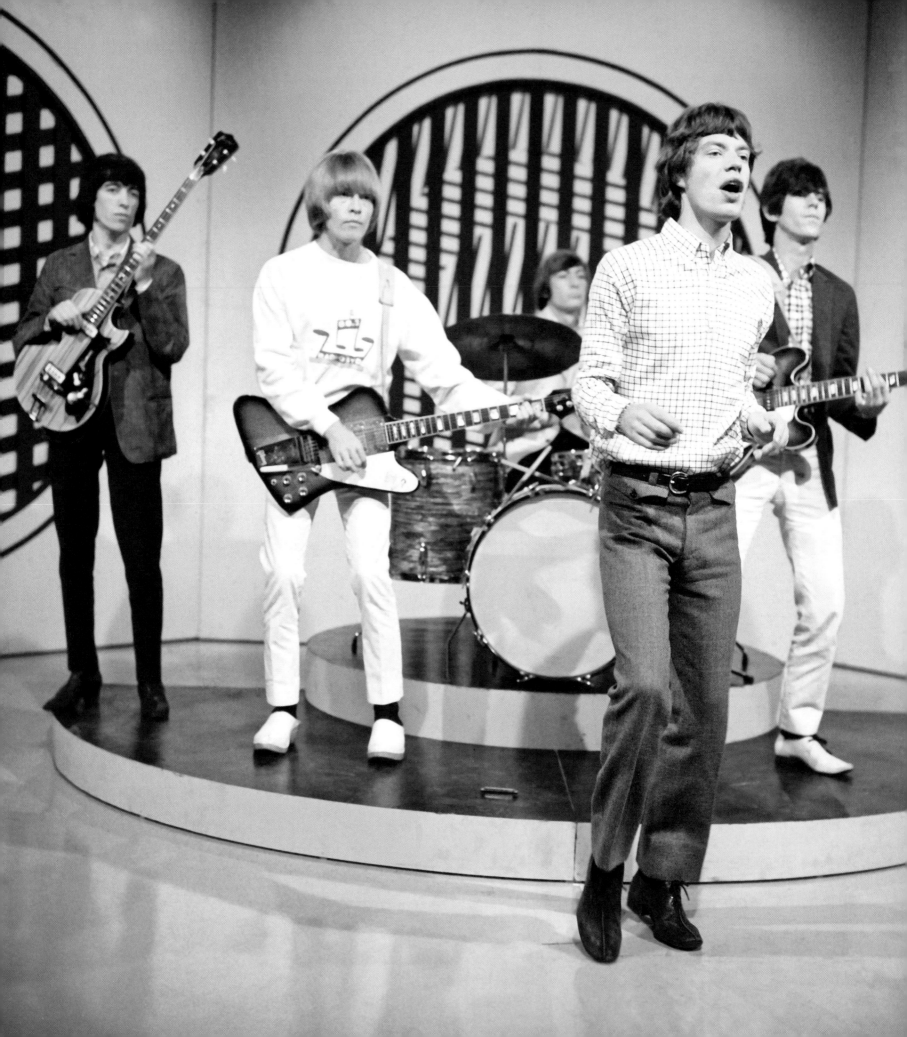

# "WHEN I HEARD [OTIS] SING 'LUCILLE,' I THOUGHT IT WAS ME!"

—LITTLE RICHARD

## PETE TOWNSHEND ON THE ROLLING STONES:

"Keith Richards once told me that I think too much. The truth is that I think, generally, that I talk too much. But I don't think first. And faced with *injecting* the Rolling Stones this evening, I realized that thinking isn't going to help me very much. I can't analyze what I feel about the Stones, because I'm really an absolute fan of the Stones, and always have been. Their early shows were just shocking and absolutely riveting and stunning and moving, and they changed my life completely. The Beatles were fun—there's no doubt about that. I'm talking about their live shows; I'm not demeaning them in anyway. But the Stones were really what made me wake up. At the Beatles shows, there were lots of screaming girls, but the Stones were the first to have a screaming boy. And the sheer force of the Stones onstage, and that perfectly balanced audience—a thousand girls, and me—it kind of singled them out. They're the only group I've ever really been unashamed about idolizing, and each of them in their own way has given me something as an artist, as a person, and as a fan. It would be crazy to suggest that any of the things they gave me were wholesome, practical, or useful.

"Bill Wyman hurt me—and not really because I'm jealous of the female company he keeps. He got such a big advance for this book he's doing about the Stones' life that the book is obviously expected to sell more copies than the last couple of Stones albums. Charlie wounded me in the last year by having a much more dramatic drug problem than mine. Keith had a much more dramatic cure. And Brian Jones hurt me by not bothering to take a cure. Because I loved him a lot. He was very, very important to me. He was the first real star who befriended me in a real way. I spent a lot of time with him before I really got to know Mick and Keith, who I love very much now. I hung out with him quite a lot, and I've missed him terribly, and I always felt then when he finally did collapse, that the Stones were a very different group. Mick gave me something, too. A bad case of VD. *Sorry, sorry, sorry*—no, no, that's wrong! A CD with a bad case. And Ronnie Wood, of course, is now a Rolling Stone; I can't help but think of him as the new boy. And it's wonderful to note that, due to his tender age, he still has his own teeth. But I did notice that tonight, they've been set into what looks like someone else's face.

"The Stones have made some great records, and everyone will know that it isn't easy to make great records. A few people here close to the Stones will know that sometimes it isn't easy to make records at all. But we have a great legacy from the Stones, and it remains primarily with Atlantic Records, despite the wonderful CBS deal a couple years ago for the Stones. It won't be easy for the Stones next time 'round, and if it wasn't for the vast sums of money they can make, they might not bother at all, really—or at least, Mick probably wouldn't. So it's lucky for us fans, then, that Mick has such expensive tastes. Because the Stones feel to me as though they still have a future, and this is at a time when most sensible artists their age are not doing this kind of thing. Seriously, whatever they do, they can only embellish an already sinister reputation for miracles.

"To Mick, Keith, Charlie, Bill, and Ronnie, to Mick Taylor, and of course, to the late Brian Jones, and to the late Ian Stewart—I offer thanks on all our behalves. Without you, there wouldn't have been a London R&B scene at all in the sixties. What there was of it wouldn't have come to much. And that's where I grew up, and then later, grew strangely down. But in a way, it's where a big part of me still is. Jimmy Reed and John Lee Hooker: Their musical blood runs in the veins of this band we honor tonight.

"And so to the Stones and all the as-yet-uninducted black R&B artists—and I've put here, 'they ripped off'—that they were influenced by, I offer solidarity. That's how I feel. It's been so great to see all these different threads come together, and for me, this evening, it's been, as I said, an education. So much of what I am I got from you, the Stones, and I had no idea most of it was already secondhand. Seriously, no more gags: There are some wonderful artists we've seen tonight, and many others inducted in the past, and many will be in the future. There are some giant artists here tonight. But the Stones will always be the greatest for me. They epitomize British rock for me, and even though they're all now my friends, I'm still a fan. Guys, whatever you do, don't try and grow old gracefully; it wouldn't suit you."

## THE ROLLING STONES:

**Mick Jagger:** "Pete Townshend said that 'now we're all his friends,' but I'm not so sure after that speech we are all his friends anymore. Next year, Pete—it's a sobering thought—you're going to be in this old hawk's shoe, so someone else is going to wind you up like that.

"I want to thank very much Ahmet, Jann Wenner, and the committee for letting us into the waxworks of rock. Now that Jann has finished his house in East Hampton, and Ahmet has finished his house in Turkey, I hope they can get down to building the phantom temple of rock in Cleveland.

"It's slightly ironic that tonight you see us on our best behavior, but we're being rewarded for twenty-five years of *bad* behavior. But I have to be slightly sappy, I suppose, and I must say I'm very proud to work with this group of musicians for twenty-five years. Tonight we have Mick Taylor with us, and we're very pleased to welcome him. Bill and Charlie couldn't make it, but we're pleased to be here, Ronnie, Keith, and myself. The other thing I'm very proud of are the songs that Keith and I have written over the last twenty-five years.

"I'd like to pay tribute to two people who can't be here tonight. One, Ian Stewart, a great friend, a great blues pianist, whose odd but invaluable musical advice kept us on a steady, bluesy course most of the time. And to Brian Jones, whose individuality and musicianship often took us off the bluesy course, with often marvelous results.

"Jean Cocteau said that 'Americans are funny people. First you shock them, then they put you in a museum.' Well, we're not quite ready to hang up the number yet, so on behalf of the Stones, I'd like to thank you very much for this evening."

**Keith Richards:** "A few disconnected thoughts: I'd like to say thank you to Leo Fender, for making the goddamn things we've gotta play. Those guitars, man, to me, being the guitar player, are very important. I'd like to say thank you, Mick and Mick [Taylor] and Ron, and Ahmet especially, for putting up with us for sixteen years. And also, of course, although Pete's beat me to the punch here, Ian Stewart, because I still feel like I'm working for him—it's his band."

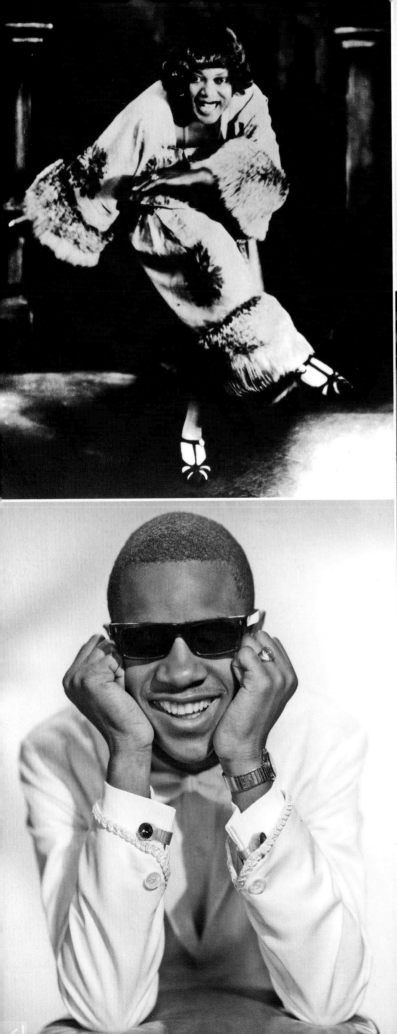

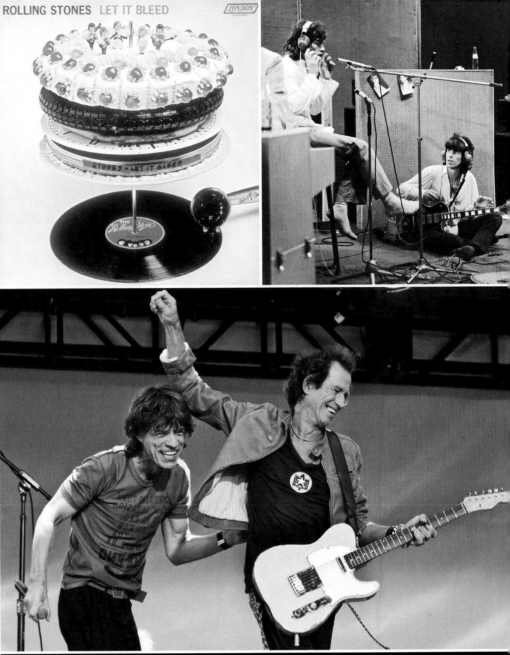

Previous, page 42: the Rolling Stones on television, 1965: (from left) Bill Wyman, Brian Jones, Charlie Watts, Mick Jagger, and Keith Richards. This page, clockwise from top left: Bessie Smith, 1924; the Rolling Stones' album *Let It Bleed*, 1969; Jagger and Richards, 1968; Jagger and Richards, 2005; the Soul Stirrers; Stevie Wonder in concert; Little Stevie Wonder, c. 1965.

> ## "HALL & OATES, WE HAVE A SPECIAL CAMARADERIE THAT GOES BACK TO THE SIXTIES, THE UPTOWN THEATER, IN PHILADELPHIA. THEY'RE LIKE LITTLE BROTHERS TO ME."
> ### —MELVIN FRANKLIN OF THE TEMPTATIONS

### HALL & OATES ON THE TEMPTATIONS:

**John Oates:** "In the mid-sixties, when Daryl and I got together, there were a million vocal groups. In those days, you had to have uniforms, right? The Temptations always had the best uniforms."

**Daryl Hall:** "They were the best dressed, man."

**Oates:** "And of course, you had to have steps. And the Temptations had the best steps. You had to sing—and you know that the Temptations could sing! We had Eddie Kendricks with his falsetto, which set the standard. You had David Ruffin, with the voice that sends chills up your arms. You had Otis Williams, who put the whole thing together. And you had Melvin Franklin, who is quite possibly the best bass singer of all time. And to us it was everything. We tried our best, and we still haven't even gotten close."

**Hall:** "Seeing those guys in the sixties was amazing, but you've got to remember that they never stopped: They're still gigging on. And through all the trials and tribulations, through all the personnel changes, and through all the personal problems, they're still out there. They're still working."

**Oates:** "That's what it's all about."

**Hall:** "That's what this is all about tonight. This isn't just about the past. This is about the past blending into the present and transcending it all. This isn't about old people—this is about people who are gigging right now.

"There's one person I'd like to talk about that can't be here tonight. I think in some ways he was the soul of the Temptations, 'cause he was the guy who was the original lead singer—he came up with all the steps, and I got to know him a little bit in the sixties when I was, like, seventeen years old. His name was Paul Williams, the late Paul Williams. I wish he could be here tonight, but I know he's here somewhere. He used to sing the song that they used to end the show with in the old days, 'Don't Look Back': [*sings*] 'If you just put your hand in mine/We're gonna leave all our troubles behind...'"

### PAUL SIMON ON STEVIE WONDER:

"Paul McCartney tells a story about Stevie, about the time that they were recording 'Ebony and Ivory.' Paul and Linda invited Stevie to dinner, and they said, 'How about tonight at eight o'clock,' and he said, 'Yeah, eight o'clock.' So eight o'clock came and went, and nine o'clock, and ten o'clock—dinner's getting cold; by midnight they said, 'Well, I guess he's not coming,' and they just went to sleep. Two days later, at eight o'clock precisely, Stevie Wonder showed up for dinner. It's like he said to Quincy Jones once, 'I'm going to show you some new dimensions in time and space.' And that he did, in his brilliant career.

"Can anyone imagine what the last twenty-five years of American popular music would be without Stevie Wonder? He is *the* composer of his generation. A melody writer of such effortless virtuosity that he is virtually incomparable. His voice is an incredible instrument—the perfect phrasing and intonation. Many people try to imitate Stevie Wonder, but there's only one Stevie Wonder. His keyboard playing and his synthesizer work revolutionized the way people approached the studio, and the guy plays harmonica better than everybody else.

"I remember a couple years ago when we were doing 'We Are the World,' and Stevie announced to everybody that he wanted us to sing one of the verses in Swahili, whereupon Waylon Jennings slipped out of the room, never to return. Stevie wasn't sure about the pronunciation of the words, so he said he knew this guy in Nigeria and he was gonna call him and make sure he had the right pronunciation. About three o'clock in the morning, a phone call came in from Nigeria, and Stevie came back and said, 'Well, if everybody's up to it, you think we can try these words in Swahili?' And Ray Charles said, 'Shit, man, it's three o'clock in the morning. I can't even sing in English.' And Stevie said, 'Just relax, we'll do it in one take, and then I'll drive you home.'

"We've been driving home with Little Stevie Wonder for twenty-five years now, and I want to thank him for being alive and on this planet. I look forward to hearing the next twenty-five years of his music."

### STEVIE WONDER:

[*Takes off sunglasses.*] "I would like for everyone to, for one moment, close your eyes as I take you through an experience of my life. My experience. The experience of hearing the sounds of many different voices from many different cultures throughout the world. Hearing the voice of, 'Hey, hey, you, you, get off of my cloud.' Hearing the sounds of, 'If I could only touch the hem of his garment.' Hearing the many voices that we have talked about being inductees tonight, as well as many great people we have experienced throughout our lifetime.

"As we think about all those sounds and voices that we have heard tonight, and those that we know as very famous rock & roll stars, jazz musicians, classical musicians, gospel singers, country-western singers and musicians, so forth and so on, we hear the voices of people of many different colors and cultures. Through the eyes of our ears, we see the beauty of hope; we see the beauty of pain; we see the beauty of sorrow, because through all of those, through even the pain and sorrow, the hurt, the poverty, the war, the destruction, we see the beauty of the God within us that says, 'That voice, that instrument sounds so wonderful—that spirit is so beautiful. Why? Why should they suffer?'

"When we think about all that with our eyes closed, we think about all the sounds we hear. When we see the sounds of a baby crying, a baby laughing. When we see the sounds of someone saying, 'I love you.' When we see the sounds of someone saying, 'Imagine.' When I remember the sound of someone who is only expressive in their voice, and saying, 'I can't turn you loose.' When we hear the sound of a voice saying, 'What's going on?' When we hear somebody singing about 'Pretty Woman.' When we hear the sound of a man saying, 'Black men, white men, Jews, and gentiles.'

"When we hear all those sounds together, we hear the many artists that have come together to create the essence of something that might feed millions of people, or the voices of those who come together to help many farmers. In the laughter of the many comedians that came together; in the voices of those that came together to help to find the cure for AIDS. When we hear those voices, we say, 'Dear God, let us sing forever. Let us play forever. Let us know that being inducted into this, the Rock and Roll Hall of Fame, is our commitment to forever, until we die, to give as much as we can.'"

## ANITA BAKER ON BESSIE SMITH:

"We tend to think of Bessie as a great blues singer, basing our impressions on her records. She made 160 three-minute sides, which captured only one facet of her talent. Bessie, in fact, was a versatile entertainer, who regularly danced, acted, as well as performed comedy routines with her touring company. In 1922, Columbia Records shipped Bessie's first and most successful coupling, 'Gulf Coast Blues' and 'Down Hearted Blues.' It sold more than eight hundred thousand copies during the first six months of release. At the age of forty-three, Bessie was fatally injured in an automobile accident, but her potent voice and distinct style continued to inspire new generations of vocalists fifty-two years after her death. Bessie was the Empress of the Blues; she was a remarkable woman who rose to the top of her profession— higher than any black artist had gone before her."

## JON LANDAU ON THE SOUL STIRRERS:

"With the induction of the Soul Stirrers, the Hall of Fame begins to acknowledge the link between gospel and rock—possibly the most important connection of all, for it is gospel that gave rock its sense of abandon, exaltation, and joyfulness. Whether it's Aretha Franklin, so influenced by Clara Ward, Wilson Pickett and his love of Julius Cheeks, Little Richard, who started out listening to Alex Bradford and the sublime Marian Williams, or Sam Cooke, a lead singer in the Soul Stirrers before he became a rock singer, it's fair to say that without gospel, there could be no rock. The Soul Stirrers began more than fifty years ago and were blessed with many giants of gospel singing. Sam Cooke, of course, but then there was founding member Jesse Farley, S.R. Crain, Johnnie Taylor, and the great Paul Foster. But perhaps the group was at the greatest in the forties, when their lead singer was R.H. Harris, and we are especially honored to be in his presence tonight. He catapulted old-fashioned quartet singing into the modern age. With his dynamic, melodic leads, his ad-libs and improvisations, his rhythmic syncopation, and his precise and meaningful phrasing, he helped create contemporary lead singing, both gospel and rock."

## MUSICAL HIGHLIGHTS

Like a preacher at his pulpit, Stevie Wonder was perched behind his keyboards to lead his onstage "congregants" into a nonstop fifteen-minute medley of selections

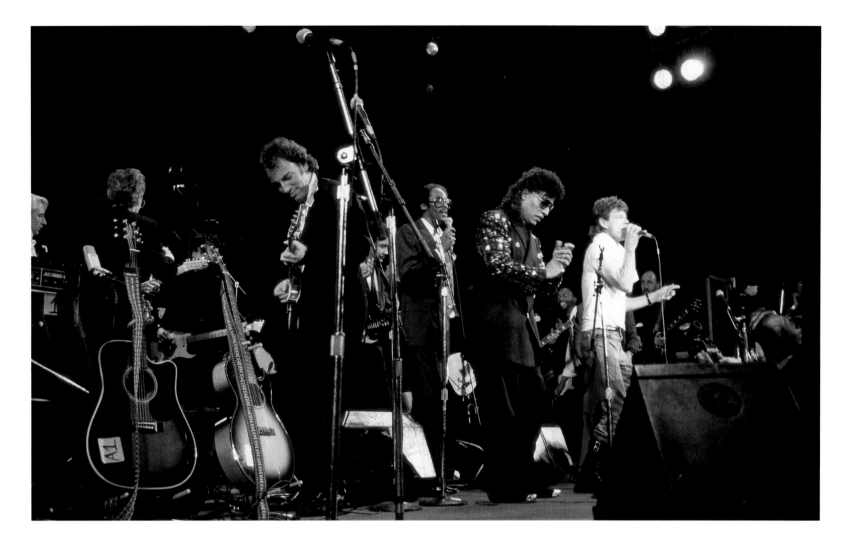

by Hall of Famers: "Uptight (Everything's Alright)," "Respect," "Be My Baby," and a reprise of "Lucille" by Little Richard. Then the guitar army took over: Keith Richards, Bruce Springsteen, Pete Townshend, Lou Reed, former Stone Mick Taylor, and Foreigner's Mick Jones, with Wonder, Shaffer, and Daryl Hall manning pianos, and Mick Jagger, Tina Turner, Dion, the Temptations, Anita Baker, Little Richard, Ben E. King, and Paul Simon gathered around mics. Jagger and Wonder duetted on "(I Can't Get No) Satisfaction," the Tempts' David Ruffin and Jagger on "Ain't Too Proud to Beg," and Dion on "The Wanderer." While Ruffin sang "My Girl," with Springsteen and Paul Simon adding background harmonies, Anita Baker and Ben E. King slow-danced on the side. The Temptations' "Get Ready" segued into "Honky Tonk Women" with "Jagger and Tina torching the song as Keith, Bruce, Mick Taylor, and Mick Jones played the song's last great lick in monster guitar unison," as described by *Rolling Stone*. Then Jagger stripped down to T-shirt, shedding his jacket and dress shirt, and joined Little Richard in a roaring "I Can't Turn You Loose," followed by the R&B nugget "Bonie Maronie," then a gleeful "Start Me Up," with Keith on guitar, and according to *Rolling Stone* "proving that after a couple of solo albums, the Stones' rock & roll telepathy is still intact."

Paul Shaffer had approached Springsteen during the dinner to request that the Boss take on Roy Orbison's "Crying" and "he wasn't sure whether he'd do it," Shaffer told *Rolling Stone*. "But it seemed like a good idea to him." Then, "Once Springsteen got onstage," *Rolling Stone* reported, "all it took was a brief review of the song's chord changes before he turned on that deep, tremulous tenor. He made up in emotive resonance what he missed in high notes. Just when it seemed things couldn't go any higher, Tina Turner took the center mic for a stunning if slightly chaotic version of 'River Deep–Mountain High.' She carried it off with power and aplomb." As Shaffer kicked off 'Under My Thumb,' Jagger dashed offstage and was overheard muttering, "That's enough of me." The ballroom began clearing out by 1 A.M., but celebrants continued the revelry at private parties in various Waldorf suites. At 4 A.M., Springsteen was spotted leaving a party, telling his fellow partiers, "It's the kind of night that you just don't want to end."

Hall of Fame induction highlights, January 1989. Opposite: Mick Jagger and Paul Simon. This page: Bruce Springsteen, Little Richard, and Jagger, joined by the Temptations, Hall & Oates, and Pete Townshend.

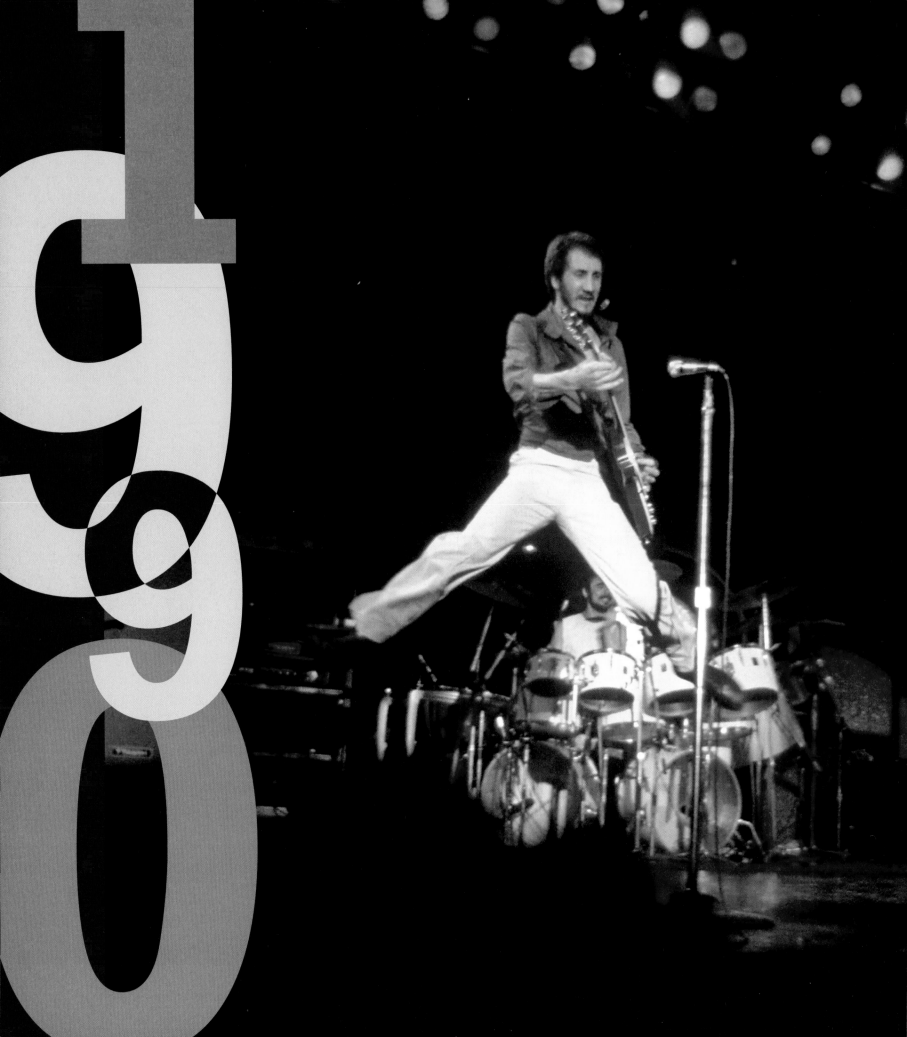

## INDUCTEES

**PERFORMERS** Hank Ballard ✦ Bobby Darin ✦ The Four Seasons ✦ The Four Tops
The Kinks ✦ The Platters ✦ Simon and Garfunkel ✦ The Who
**EARLY INFLUENCES** Louis Armstrong ✦ Charlie Christian ✦ Ma Rainey
**NONPERFORMERS** Gerry Goffin and Carole King ✦ Brian Holland, Lamont Dozier,
and Eddie Holland

On January 17, the Waldorf-Astoria ballroom was filled with music once again, with a mix of R&B, British Invasion rock & roll, and pop. Like the year before, the night veered from the moving to the maniacal. Rock & roll pioneer Hank ("The Twist") Ballard danced onstage after Boz Scaggs's induction, but then broke down when thanking his wife and manager, Theresa MacNeil, who had recently been killed by a hit-and-run driver. "Four years ago she swore she'd take me back to the stars where I used to be—I love you today and tomorrow, and I miss you," he said with tears running down his face.

Phil Spector's appearance was just as odd as the previous year's. As reported by Fred Goodman in *Rolling Stone*, "Phil Spector's wide-ranging induction of the Platters proved over the moon. Ambling onto the stage to introduce the Platters, he instead began to read an induction tribute to late night TV mail-order record heroes Zamfir, Roger Whittaker, and Slim Whitman. The rest of his ten-minute speech included a denunciation of the U.S. invasion of Panama, a call for the overthrow of the South African government, insinuations that Eric Carmen, Abba, and Bruce Springsteen had plagiarized his work, and a suggestion that rap musicians 'take melody courses.' A nudge from stage manager Bill Graham was required to direct the erratic producer back on track. After briefly recounting how he first caught the Platters on a L.A. radio station and tried to track them down, Spector again sidetracked to make his final introduction. 'Elvis Presley and John Lennon, God bless you. I think of you every day of my life. The Platters.' When they joined Spector onstage, the sophisticated vocal group seemed unfazed by the introduction."

Though the Hall of Fame inductions are no-holds-barred, the pall of censorship colored the opening remarks of Bob Krasnow, thanks to recent obscenity charges against rappers 2 Live Crew. Said Krasnow, "The way some people still perceive rock music hasn't changed since the days of Elvis, Chuck Berry, and Little Richard. We're still under siege, we're still under attack. Rock & roll continues to serve each generation as its own frontier. Our challenge is not only to give the music a forum, but more importantly, to let the music speak. Aldous Huxley, a man who certainly had a clear vision of a future out of control, wrote: 'Thanks to words, we have been able to rise above the brutes, and thanks to words, we have often sunk to the levels of demons.' Yeah, poetry is written in words, but legislation is written in words, and one exalts while the other confines, sometimes controls, and even destroys. So tonight while we celebrate the idea of rock & roll, tomorrow, we have to protect its future."

The Kinks were never one to censor their bad behavior toward one another. Noted Fred Goodman: "Inductor Graham Nash seized on the on-again, off-again feud between brothers Ray and Dave Davies, noting that he hoped there were enough awards because 'I don't want to see the brothers fighting again.'" The ribbing continued as the original quartet, including drummer Mick Avory and bassist Pete Quaife, stepped to the podium. "Don't fuck up!" Ray said to Dave and gave him something to read, and when Dave complained he couldn't read his brother's handwriting, a gleeful Nash exhorted, "They're fighting again!" Tension between Simon and Garfunkel trumped their harmony singing.

> ## "SEEING EVERYBODY HERE TONIGHT, IT MAKES ME REALIZE THAT ROCK & ROLL HAS BECOME RESPECTABLE. WHAT A BUMMER."
> —RAY DAVIES

### SEYMOUR STEIN ON THE INDUCTEES:

"Greater New York is very well represented tonight. We have the Four Seasons from Newark, Bobby Darin from the Bronx, Simon and Garfunkel from Queens, and Goffin and King from Brooklyn. The cutoff date for eligibility this year was 1964, a major one for music—the first year of the British Invasion, but really, one of the last years of New York's total dominance, or almost-total dominance of the music industry. Tonight, for me, and hopefully for you, this is a celebration of New York—the New York of the fifties and sixties. Those wonderful early years of rock & roll, when the accent was on music, not business, and everything was fun, or at least seemed that way."

### BOZ SCAGGS ON HANK BALLARD:

"I guess I was twelve or thirteen, and some of us used to get together between classes and bring our obscure records in to play for each other and turn each other on to new stuff. One of the little girls brought Hank Ballard's 'Work With Me, Annie' record, and she played it for me once, and she had a little smile on her face, and she asked me if I got it. I said, 'Well, yeah, I think I got it—that's very nice.' She played it for me again, and she had a bigger smile, and she was almost winking when she said, 'Did you get it *this time?*' And I knew something was happening, but I didn't know what it was. Eventually I got it!

"Hank Ballard was born in Detroit, grew up in rural Alabama, with relatives who were—to quote him—'heavy into religion.' They used to beat him if he sang the blues. So he wanted to get out of there fast. So first out the back window, he visited the local blues clubs, and picked up a lot of what he has carried to us ever since.

"One night he ran away for good. He was fourteen years old. He went to Detroit, got a job on the assembly line, and hung around some of the writers with the groups around King Records at that time. He got a job with a band, which eventually became Hank Ballard and the Midnighters. Nothing really clicked until Hank's first song, which was called 'Get It,' and it was a very sexually explicit song. It paved the way for things that Hank was to do later.

"The first song he went into the studio and wrote was called 'Sock It to Me, Mary.' He was told by the producer Ralph Bass that it was a bit 'heavy' and he would have to change it around a little bit. Hank was rewriting in the studio, and a woman, the wife of the engineer, came in. Her name was Annie, and Annie was about out to here—four or five months pregnant. Hank struck up a thing with Annie, and ended up writing a song right there, and it's called 'Work With Me, Annie.' Now, when 'Work With Me, Annie' came out in 1954, it stirred up a lot of controversy, and it was renounced by *Down Beat* magazine and *Variety* magazine as 'smut.' King Records almost recalled it, and radio didn't want anything to do with it. They were scared to death of Hank's record. In April it hit the R&B charts, and in May it was Number One. Within three months it was joined by two other songs, 'Sexy Ways' and 'Annie Had a Baby,' to occupy three of the Top Ten spots in the Top Forty. All without radio play.

"He went on to become a major touring attraction, and Hank's made a lot of history since then. One day someone flipped over a hit single and played the B-side, and it was 'The Twist.' Dick Clark heard it, had a then unknown Chubby Checker record it note-for-note, and the rest is history; it was probably one of the biggest single songs that ever came out. Hank went on from that. He never got the credit for performing it;

Previous, page 48: the Who in concert. This page: the Kinks: (from left) Pete Quaife, Mick Avory, Ray Davies, and Dave Davies. Opposite: the Who on British television, 1965: (from left) John Entwistle, Roger Daltrey, Keith Moon, and Pete Townshend.

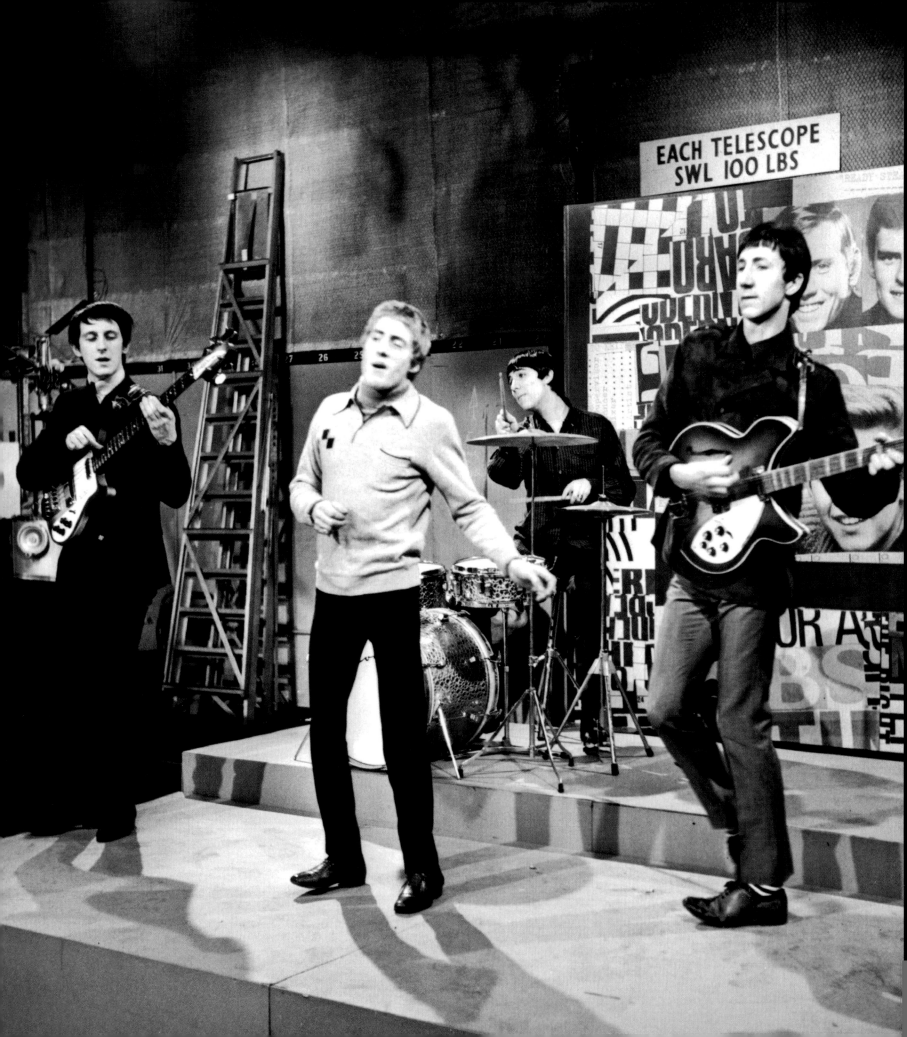

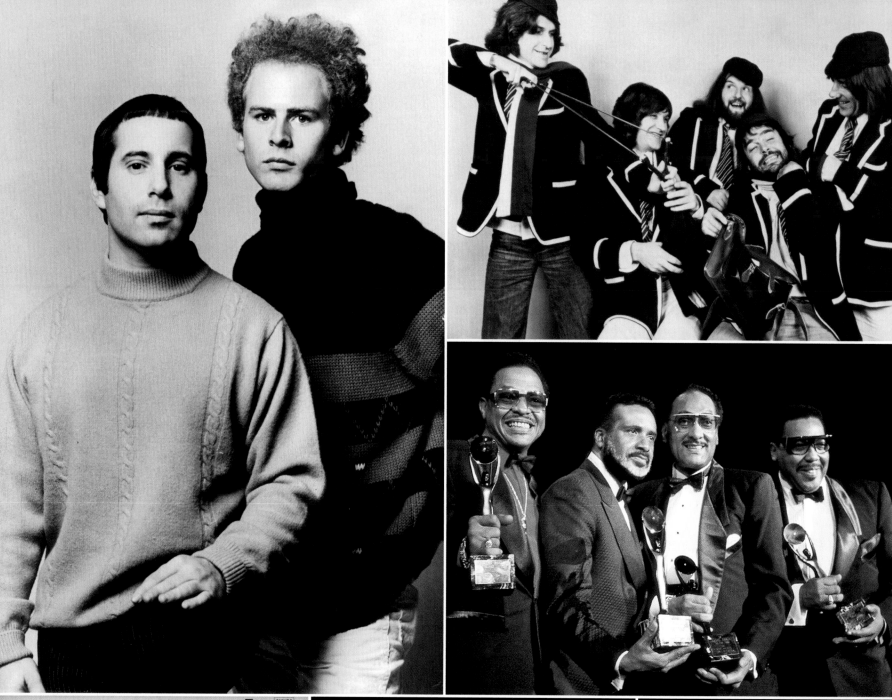

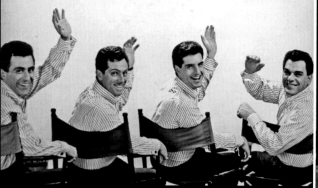

Clockwise from top left: Simon and Garfunkel; the Kinks; the Four Tops: (from left) Renaldo Benson, Lawrence Payton, Abdul Fakir, and Levi Stubbs, January 1990; Hank Ballard; Four Seasons' album, 1964.

he was always given credit for writing it. He has been the man with the dance, with the vitality, and the rhythm since those days. To talk to Hank is to meet a very vital, very positive, very dynamic man. To hear Hank tell about it, he says it's all about having a good time, and feeling good, and looking fine, and having some laughs, and getting others to do the same."

## BOB CREWE ON THE FOUR SEASONS:

"Frankie Valli, Bob Gaudio, Tommy DeVito, and Nick Massi—the original Four Seasons—were and continue to be an incredibly gifted group of great guys. *The Rolling Stone Encyclopedia of Rock & Roll* has this to say about them: 'During their twenty-year career, Frankie Valli and the Four Seasons have sold over eighty million records, making them the most long-lived and successful white male vocal group.' I can't help but look back with pride about a decision I made in February 1962, when I had the choice of either paying the rent, or paying for some studio time to produce a record called 'Sherry.' And I think I made the right choice."

## THE KINKS:

**Ray Davies:** "The first time we reached America and we were met from the airplane by these men in black suits and sunglasses, I was very intimidated by this country. But now I've learned to admire these very strange people who eat pizzas and pump iron. I wanted to serve my country as a musician or something; I don't think it would have been possible if it hadn't have been for America. Because I think it was this country that realized that you could build a career with rock & roll, whereas in England it was just disregarded.

"This is a very posh event and we're all tarted up to be here. I'm dressed up in this ridiculous way for the fans who bought our records when they sold twenty-five thousand copies. That's why I'm here tonight. Not for the so-called respectability, because anyone who knows anything about us knows that that would be a joke, to try and say we were respectable. Thank you very much—we really do deserve it."

## SIMON AND GARFUNKEL:

**Art Garfunkel:** "I have a very full heart, and a total identification with rock & roll, and the history of rock & roll. So, although I never felt like much of a joiner in any group, I would wear the T-shirt that says Rock & Roll any day, and have been wearing it most of my life. I can't tell you how much fun it was to make those records all those years. . . . I want to thank God for giving me this voice; it's been a lot of fun having it. And I want to thank, most of all, the person who has most enriched my life by putting these great songs through me, my friend Paul here."

**Paul Simon:** "Arthur and I agree about almost nothing, but it's true, I have enriched his life quite a bit, now that I think about it.

"Artie had the best voice in the neighborhood. It was SRO at his bar mitzvah. We fell in love with rock & roll when we were twelve, thirteen years old, when there was one station in New York, WINS. And we used to hear this music—one song would be Ray Charles, 'Hallelujah I Love Her So,' and then it would be Johnny Cash, 'I Walk the Line,' and then it would be Frankie Lymon and 'Why Do Fools Fall in Love,' and then Carl Perkins, and maybe Ruth Brown, the Moonglows, the Penguins, Joe

Turner, blues—a rich diversity of music that would be impossible to hear on any format radio today. And so, in a way, we used our imagination to fill in what was the connection between all of this music. We were so taken with this idea, that it became the dominant interest in our lives, and to this day it's still fascinating—the music, writing music, making records. I'm very grateful that for all of this time in my life, I've never been bored. It's been a thing that's sustained both of us. This is really a blessing for us.

"When we were fifteen years old, we made this record ['Hey, Schoolgirl,' under the name Tom and Jerry], and it became a big hit. Alan Freed played it every night. It cost two hundred dollars a week and the publishing on the next song. We thought it was a great deal, and to this day, I still think it was a very, very good deal.

"Thanksgiving Day, 1957, we appeared on *American Bandstand*, and the kids actually did say, 'I like it, I like it a lot, you can dance to it, I give it a ninety-five.' The other act on the show that day was Jerry Lee Lewis, and he was better than us, that particular day. That was our only hit in the fifties, and then we had a real argument, and we broke up—thereby setting a pattern that we were to reiterate in the years to come. We got back together again in 1964 when Goddard Lieberson signed us to Columbia Records, and we owe Goddard our thanks for that, and also for the fact that he interceded on our behalf, and stopped the A&R department from naming our group Catchers in the Rye. And he allowed us to use our real names, something which would have been an impossibility in the fifties, for somebody to use names that were so ethnically identifiable as Simon and Garfunkel.

"In fact, all our years at Columbia Records were really blissful. . . . 'The Sound of Silence,' 'Scarborough Fair,' 'The Graduate,' 'Mrs. Robinson,' 'The Boxer,' 'Bridge Over Troubled Water,' *wooosh*, then it was gone, it was over. And we just walked away from it, actually, like, 'Well, that was one thing that we did. We'll go and do another thing,' because we were so young that we didn't realize that that was the trip of a lifetime that we were on.

---

# "MICROPHONE HEIGHT—THAT'S WHAT SPLIT UP THIS GROUP."
### —ART GARFUNKEL

---

"Aside from the fact that, well, musically, we always had our differences, we had such a good time together; we used to laugh so much. We loved that we could rent cars, and drive to play in colleges, and take those towels, and stuff them into the cracks of the door, and light up those hidden reefers; and maybe the bed had that machine where you could put a quarter in and, like, be vibrated. It was great. I was with my oldest and my best friend; couldn't have had a better time. And then we had an argument. . . . Like, once we were riding to this show, and we got into such a screaming argument about the war in Vietnam. One of us was in favor of it. We had a big fight about the eleventh song on the *Bridge Over Troubled Water* album. Art wanted to do a Bach fugue, and I wanted to do a song I had written called 'Cuba, Si, Nixon, No.' We compromised, and there was no eleventh song on the album.

"We came back together again in 1981, in Central Park, and it was one of the most extraordinary evenings of our lives. But when we walked offstage, as we finished the last song of the encore, on the steps of the set, I turned to Artie and I said, 'What do you think? How did we do?' and he said, 'Disaster.' Overview was never our strong suit."

### AHMET ERTEGUN ON THE WHO:

"The Who embraced a range of contradictory extremes: spirituality and alienation, unity and rebellion, intelligence and passion. Onstage the quartet's volatile essential chemistry yielded explosive, often auto-destructive performances of unprecedented energy. With the death of Keith Moon in 1978, rock arguably lost its single greatest drummer. In 1989, after a seven-year hiatus, the Who celebrated their twenty-fifth anniversary with a series of brilliant concerts. In the process, they confirmed the extraordinary energy and enduring importance of one of rock's truly great bands."

### LARRY MULLEN ON THE WHO'S KEITH MOON:

"As you and I know, drummers are the heart of any rock & roll band. I say that with the humblest of hearts. You know, actually, that this is and has been known as the Larry Mullen Band. And from one drummer to another, I would like to pay special tribute to Keith Moon and the Keith Moon Band."

# "KEITH MOON CHANGED THE SOUND OF DRUMMING."
### —RAY DAVIES

### THE WHO:

**Pete Townshend:** "It was [inducting the Stones into the Hall of Fame] last year that made me realize not only that I wanted to get back and play in America again, but it made me realize how much I love this music, this city, very much. The Who have always had strong links with New York. But the music that we played, and messed around with, and busted up, and everything else over the years, has actually been rooted in and devoted to the more conventional, the more straightforward, and the more heart-oriented music that we've seen walk across the stage tonight. We've always felt an adjunct to rock & roll, as much as attempting to be a part of it. We've been an irritant to it, really, as much as being irritators, and today, as ever, we don't know what's going to happen next. We never have. But when Phil Spector talked about new music, particularly the [rap] music that is now being made on the streets, it's not up to us to try to understand it. It's not even up to us to buy it. We just have to get the fuck out of the way."

### RICKIE LEE JONES ON LOUIS ARMSTRONG:

"I had a speech, but the waiter took it away with the cobbler, so . . .uh . . . I made up another one. Satchmo was born in about 1900 or 1901, and he told everybody he was born on the Fourth of July, but he wasn't—he was born in August. I don't know why he did that. And his mother worked on a street called Jane Street with the other Janes. Louis said that he was never sure what she did there, but she had the respect of all the people in the neighborhood, and she gave him great strength: If she didn't have it, she did without it. And he said, 'I think that's where I got my strength and my ability, too.' I think it got turned into an attitude about life that nothing could stop him. When you see him smile, you feel like everything is right in the whole world. He was, I think, the first person recorded scatting. He was an innovator as a jazz trumpetist [sic], but more than that, I think what he left is a great spirit, and when you see it, it makes you smile—and there's nobody who can't do a Louis Armstrong impersonation. In fact, I know some people who make a living that way. So, God bless him, and I'm sure he's with us tonight."

### VERNON REID ON CHARLIE CHRISTIAN:

"I'm here basically to acknowledge a debt that I feel very deeply as a musician, and particularly as an electric guitarist, and that's a very important distinction—*electric* guitarist. There are many, many people that have done many great things with the guitar over the course of the years. . . . [But] it all starts with this one musician. The amazing thing about Charlie Christian is that he did so much in so little time. He was born in 1919, in Dallas; by the time he was a teenager he had already started playing professionally, and in 1937, he was sixteen years old, and he came across an instrument that was a novelty instrument. Nobody was taking it seriously, but it was around. Who knows how he heard it. An electric guitar. And try to imagine what he must have heard, or what he must have felt when he took that guitar, and plugged into what I guess must have been one of the first primitive amplifiers, and heard that sound. That's the sound that really changed music. Certainly, rock & roll wouldn't be rock & roll without the electric guitar.

"I'll tell you about the first time I heard him. When I was in high school, I wanted to learn about jazz and jazz guitar, and the teacher told me, 'You should check out Charlie Christian.' I picked up a record called *Solo Flight,* which is basically a collection. I don't know what I was expecting to hear—something kind of old-timey and corny—but when I put the record on, I was amazed at how modern and hip Charlie Christian sounded. It really changed my attitude toward older music, and I listened to it with a lot more respect. So here we are to pay tribute to somebody that, without whom, we wouldn't be rocking & rolling: Charlie Christian."

### BONNIE RAITT ON MA RAINEY:

"By inducting Ma Rainey into the Rock and Roll Hall of Fame, her lasting contributions to the world of pre-war blues and jazz are receiving long-overdue recognition. I have this vision of this great, live oak of a woman, dressed in satin, feathers, and pearls, belting out the songs of longing, humor, and regret, in her impossibly rich contralto—all that heartache soaring over some of the swampiest snake-hip music ever to be coaxed out of those instruments, all those fine tuxedoed men flickering those hot blues lines around her like she was some kind of Joan of Arc. It's a powerful tradition of women singers I feel a great pride and kinship with. It is my sincere hope that those of us lucky enough to make our living from the fruits of those early musical innovators will not only recognize their contributions here tonight, but work to elevate the awareness and appreciation of this music in schools, history books, and popular culture, so that kids don't think that all this just started with

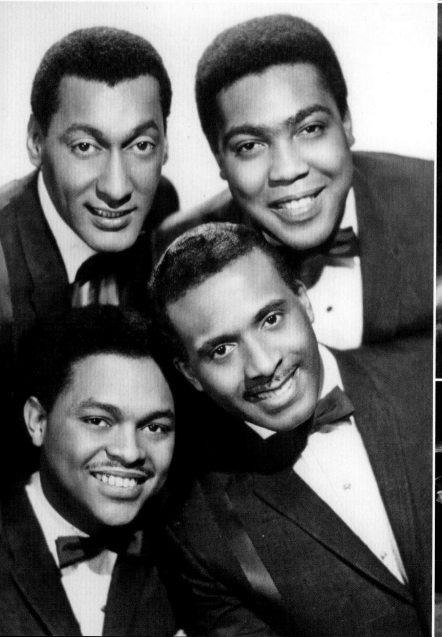

Clockwise from top left: Ma Rainey and Her Georgia Jazz Band; Carole King and Gerry Goffin; Bobby Darin; Louis Armstrong; the Platters; the Four Tops, c. 1966.

James Brown and Chuck Berry. I am very honored to have been asked to induct Ma Rainey into the Rock and Roll Hall of Fame tonight, and do so on behalf of all the women, past, present, and future, who give, get, write, and sing the blues, which is, after all, the inspiration for all this music to begin with. And as my friend, another great classic blues singer, Sippie Wallace wrote in one of her songs, 'When Adam and Eve ate from the tree, they got confused; and since that day, everybody has had the blues.'"

### JON LANDAU ON GERRY GOFFIN AND CAROLE KING:

"As songwriters, Gerry and Carole stand as a great bridge between Brill Building styles of the late fifties and early sixties and the modern rock era. And the fact is, they started looking forward with their very first hit. In 1961, they wrote a little song called 'Will You Love Me Tomorrow.' It was the first great sixties record to be written from a woman's point of view, it was the first great ballad to be directed to a new generation, which was soon to be labeled Baby Boomers, and for some of the people in this very room, it was the first song they slow-danced to, made out to, and made love to. It was perhaps the first sixties song about which you, your girlfriend, or boyfriend said, 'That's our song.' And, by the way, because it meant so much to so many, it is a song and a record, beautifully sung by the Shirelles, that will live on well into the next century. In 1962, the Drifters recorded their sublime 'Up on the Roof,' a song that expressed a sensibility that, a few years later, would be called 'sixties idealism.' And in 1963, Gerry and Carole extended that idealism with a romantically eloquent 'One Fine Day.' Then in 1965, they put themselves in the center of one of rock's most vital developments, the Phil Spector–Righteous Brothers collaborations. One of the two songs they wrote with Phil was the classic 'Just Once in My Life,' and the other was one of those great lost masterpieces, due for rediscovery, a great song called 'Hung on You.' By the time they wrote 'Don't Bring Me Down' for the Animals and 'Going Down' for the Byrds, they'd helped to start an approach that would affect every singer-songwriter to come after them, and in a nice epiphany, in 1967, they closed the cycle they began with 'Will You Love Me Tomorrow' with 'Natural Woman' for Aretha Franklin. But by then they had given us more than we could ever give back."

### DIANA ROSS ON BRIAN HOLLAND, LAMONT DOZIER, AND EDDIE HOLLAND:

"I'm really very excited to be here to honor three very special, great songwriters-producers who've made a great difference in the musical movement, which we called our Motown Sound. It doesn't seem like so long ago—it seems like just yesterday to me. If you bring up the sixties, right away the images come up for me, and I remember leaving high school, getting on a bus down West Grand Boulevard, and going up to Hitsville USA, 'cause that's where the action was. That's where Smokey was, that's where the Miracles, Martha Reeves and the Vandellas, the Four Tops, the Marvelettes, Marv Johnson, and Barrett Strong—everybody was there, and that's where we wanted to be. We wanted to be at Motown.

"At that time, the sixties, everything seemed possible; we thought that we could change the world through our music. And our music did not start with rebellion, or hatred, or anger. It really was coming out of love, and a togetherness, and working hard, and working together, and believing in ourselves. That was the spirit of Motown—our family atmosphere—which is what made the unit so special. Working with Marvin Gaye, singing background with any group that was making a record at that time. We laughed together, we cried together, we grew up together, and a lot of us traveled different roads.

"I'd like to offer a very special and personal thanks to Brian Holland, Eddie Holland, and Lamont Dozier. I remember coming to the studio and watching you play, and Brian was always the one that seemed to be at the piano all the time, and Lamont seemed to be getting all the backgrounds and melodic sounds together, and Eddie was writing the lyrics—not just for the Supremes, but for all of us at Motown."

> ## "IT'S VERY EXCITING FOR ME TO KNOW THAT OUR MUSIC HAS TRAVELED ALL OVER THE WORLD. PEOPLE CHERISH MOTOWN, THEY CHERISH HOLLAND-DOZIER-HOLLAND AND ALL THE SONGS THAT WERE WRITTEN IN THE SIXTIES, AND THE PRODUCTIONS THAT THEY DID, AND SO DO I."
> —DIANA ROSS

### MUSICAL HIGHLIGHTS

The jam opened with a tribute to Bobby Darin's "Mack the Knife," with vocals shared by Rickie Lee Jones, the Four Tops, and Sting, who sang the Brecht/Weill number in both English and German. Ma Rainey's "C.C. Rider" was a blues-drenched guitar duet between Bonnie Raitt and George Benson. "I Can't Help Myself" was crooned by Diana Ross and the Four Tops, and another nostalgic collaboration reprised James Taylor and Carole King on "Will You Love Me Tomorrow."

A double whammy of the British Invasion featured the Kinks on "You Really Got Me" and the Who on "Substitute," "Won't Get Fooled Again," and "Pinball Wizard." John Fogerty finally took on "Long Tall Sally," with Springsteen rather than Little Richard, and the show came to a bittersweet close with Simon and Garfunkel's wistful readings of "Bridge Over Troubled Water" and "The Boxer" (Simon didn't ask his partner how they sounded) and the Platters nugget "Goodnight, Sweetheart."

Later, Bono said of the night, "I came to induct the Who with a very irreverent attitude toward the proceedings. I was changed in very significant ways. Just being in the room, I realized how insignificant [U2's] story was so far. I thought, I'm going there! I want to be there!"

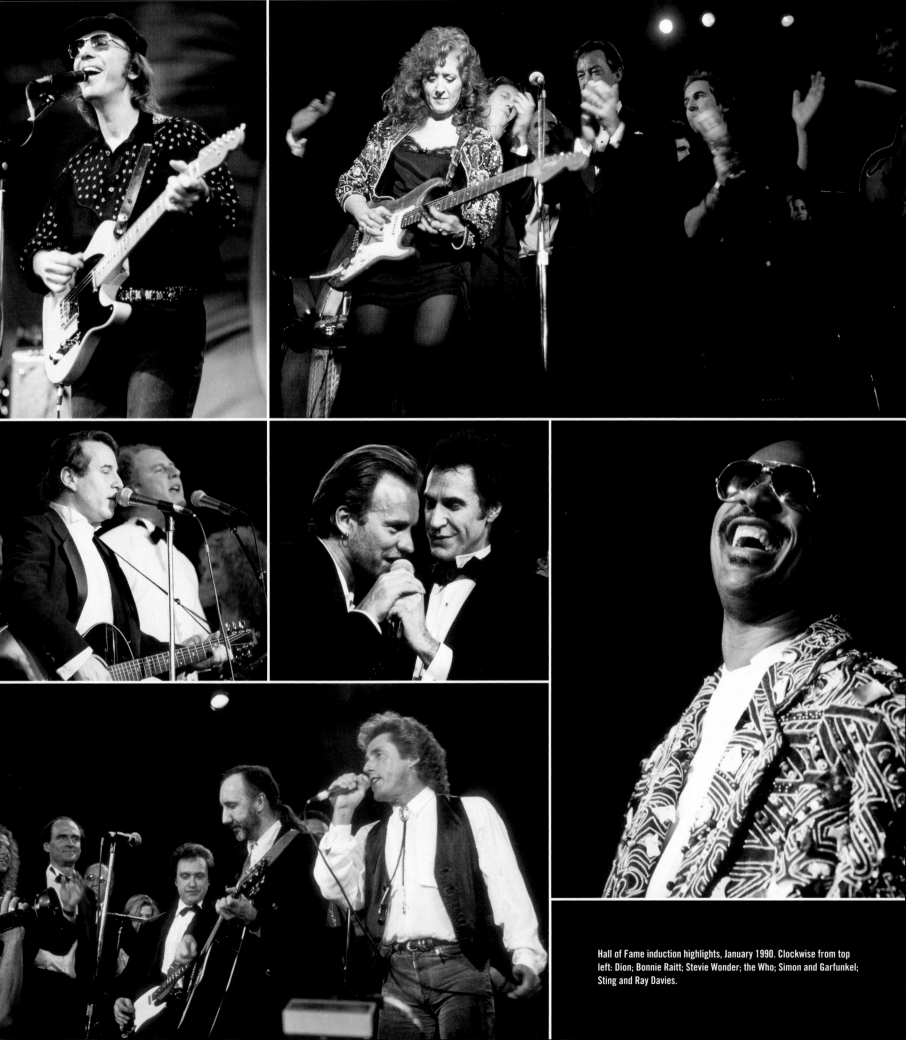

Hall of Fame induction highlights, January 1990. Clockwise from top left: Dion; Bonnie Raitt; Stevie Wonder; the Who; Simon and Garfunkel; Sting and Ray Davies.

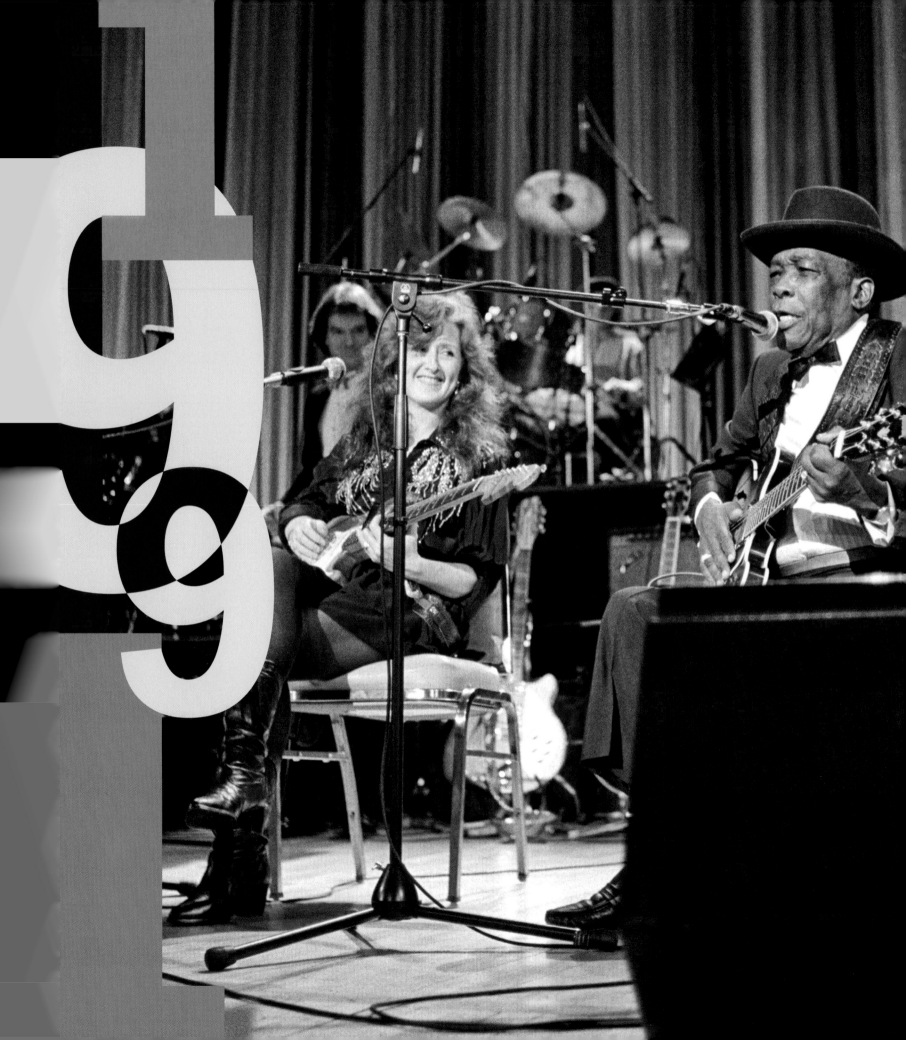

## INDUCTEES

**PERFORMERS** LaVern Baker ✦ The Byrds ✦ John Lee Hooker ✦ The Impressions
Wilson Pickett ✦ Jimmy Reed ✦ Ike and Tina Turner
**EARLY INFLUENCES** Howlin' Wolf
**LIFETIME ACHIEVEMENT** Nesuhi Ertegun
**NONPERFORMERS** Dave Bartholomew ✦ Ralph Bass

The atmosphere was charged at the Waldorf-Astoria, on January 16, with the Hall of Fame induction delayed due to a catastrophic event. President George Bush had initiated the bombing of Baghdad, and the decision was made to begin the ceremony after watching the telecast of his declaration of the (first) Gulf War on an installed screen. "I think the music will often articulate in the best way the feelings of the general public, and personally don't remember hearing a prowar song," remarked Bob Krasnow to the hushed audience. Jann S. Wenner recited the lyrics to Jackson Browne's "Life in the Balance," and throughout the emotional evening, several artists spoke out against war.

Adding to the pathos, the great singer-songwriter and guitarist Curtis Mayfield, who was being inducted as part of the Impressions, had been paralyzed from the neck down during a horrific stage accident in Brooklyn the previous summer. While his fellow musicians watched with tear-filled eyes, Mayfield gave his acceptance speech from his home in Atlanta via satellite. Great pioneering bluesmen and women were also saluted on this night, and old quarrels were healed when the original members of the Byrds gathered together onstage.

Everyone was spooked when a large portrait of inductee Ralph Bass, King Records' legendary A&R man, became dislodged from a high balcony wall and crashed into a table below, smashing wineglasses and nearly giving coronaries to a couple of record executives. But even Phil Spector was subdued this year, as he gave a heartfelt induction of Ike and Tina Turner, neither of whom showed up: Ike was incarcerated in California on drug convictions and Tina was in Europe.

The evening saw its fair share of gaffes, as reported by *Rolling Stone*: "The night's most surreal twist came with Quincy Jones's induction of the late, great record mogul Nesuhi Ertegun. The usually unflappable Quincy Jones—spewing out an interminable seventeen-minute speech during which he continuously gripped the podium for support—referred to Ahmet Ertegun as Ahmet Wexler and stated that Elvis was from Memphis, Texas. The bewilderment created by Jones's slurathon helped ease the embarrassment of the next presenter, Bobby

Brown, who inducted the incomparable Wilson Pickett, a performer whom Brown earlier had admitted knowing nothing about. 'I always knew the name,' Brown stammered. 'The music was around the house. That's all I really know about it.'" The Wicked Pickett didn't show; he was "fogged in," according to Seymour Stein. Referring to Jones's appearance, Don Henley started his presentation on the Byrds with the quip: "As Dexter Gordon said in *'Round Midnight*, 'I'll have whatever he's having!'"

> ## "I WAS SWEPT UNDER [BY] THE MISSISSIPPI DELTA BLUES. UNDER THE SPELL OF THE CRAWLING KING SNAKE, JOHN LEE HOOKER."
> —BONNIE RAITT

> "WE ALL MUST FOLLOW OUR DREAMS. THERE WILL BE PLANNING, SACRIFICE, AND SOMETIMES PAIN, BUT FOLLOW YOUR DREAMS. THEN YOUR WORK DOESN'T SEEM LIKE WORK; YOU'LL LOVE WHAT YOU'RE DOING."
>
> —RALPH BASS

## DON HENLEY ON THE BYRDS:

"Back in 1957, a ten-year-old boy sat with his parents in Hirsch Memorial Coliseum in Shreveport, Louisiana, looking at a Lawrence Welk concert. The boy didn't care very much for the music, but he sort of liked watching the drummer, and in fact, he got the drummer's autograph after the show was over. The boy remembered seeing Lawrence Welk with a big smile on his face, and a nun on each arm. The boy would take note of that for future reference. That doesn't have anything to do with this award, however, except that about eight years later, the boy was back in the same coliseum, and he watched very attentively as five lanky boys with very tight pants and bangs that almost covered their eyes ambled out onstage and began to play. And sat mesmerized as the chiming strains of 'Mr. Tambourine Man' floated out through the auditorium, and he experienced new and unfamiliar feelings as they sang a song called 'He Was a Friend of Mine,' about the murder of President John F. Kennedy in Dallas, Texas. The ringing sound of the electric twelve-string and the smooth, unusual harmonies, the thought-provoking lyrics, all this underscored by the rock & roll drumming and the tight bass guitar lines, combined into something completely different.

"It was a sound that the boy had never heard before. It was distant, and yet it was familiar. And it struck a chord deep within him. This mysterious, charismatic band sounded British, they sounded American, they sounded like folk (that spoke), they sounded like rock, there were jazz and country influences, and even classical influences. They sounded pretty and they sounded ominous. They sounded hard and yet they sounded soft and gentle sometimes. And woven through all this was a mystical quality that made the boy dream of faraway places and different kinds of people and a different kind of life. Unfortunately, the group only got through three or four numbers that evening, before they were mobbed by teenyboppers and had to leave the stage, but nevertheless, the boy's life had been changed forever. He wore out two copies of 'Mr. Tambourine Man' that year; he used to play 'Don't Doubt Yourself, Babe' for his beautiful fifteen-year-old cheerleader girlfriend, who sat and looked at him blankly like he had lost his mind. But he was trying to give her a message.

"The boy, if you didn't know by now, was me, and the group was the Byrds. The year was 1965, and the course of American rock & roll had been changed, had been altered forever. The Beatles had invaded America, a man named Bob Dylan was writing music that was much more challenging and thought-provoking than popular songs had ever been up to that time. And there was now in the music something for the head as well as for the heart, and the Byrds were at the very center of this new movement. The Beatles had influenced them, and they in turn had fascinated the Beatles, and Dylan had inspired both groups.

"We perhaps take it for granted now, but it was a wonderful, magical time. Music was playing, hair was growing, there were throngs of people in the streets, and the counterculture, which was the offspring of the Beat Generation, was being born, and the ethereal, mystical sound of the Byrds washed over them, washed over an entire nation, and on to Britain and other parts of Europe, and it was a wake-up call for a new generation, and a new era in rock & roll. The Byrds not only pioneered folk rock, but they went on to pioneer something called country rock as well. But I wouldn't know anything about that.

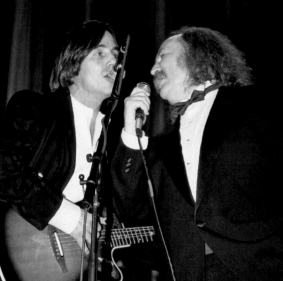

Previous, page 58: Bonnie Raitt and John Lee Hooker, January 1991. This page, clockwise from top left: the Byrds' debut album; the Byrds on television; Byrds (from left) Roger McGuinn, David Crosby, and Gene Clark in the studio; Byrds together again: (from left) Chris Hillman, McGuinn, Crosby, Clark, and Michael Clarke; Jackson Browne and Crosby.

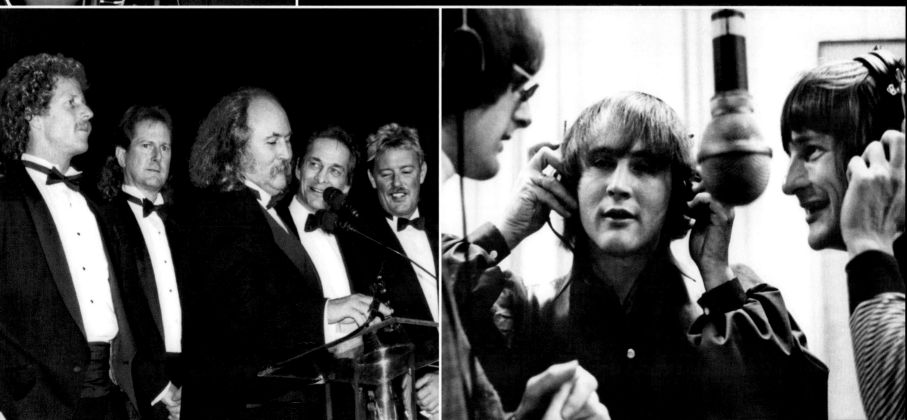

> "WHEN I SING THE BLUES, I'M SINGING FOR YOU, AND I LOVE THE BLUES. WHEN I SING SOMETIMES, I PUT ON DARK GLASSES, TO KEEP FROM CRYING. SEE THE TEARDROPS IN MY EYES—IT'S JUST HOW DEEP THE BLUES GO WITH ME, AND I CAN SEE IT IN YOUR FACE, TOO, WHEN I SING."
>
> —JOHN LEE HOOKER

"Just as an aside, I want to say that the mysticism, and the transcendence, and the peaceful spirituality and optimism of that kind of music is sadly missing from the airwaves today, and in light of the present situation, we could really use some of it now. Nevertheless, they have left a rich and varied legacy, fortunately for all of us, and they continue to be productive today."

### THE BYRDS:

**David Crosby:** "I have a lot of gratitude for these men, who helped me make some of the best music of my life. It occurs to me as I think about it, that there are a lot of us, some of the best of us, who are not here, and who will never make it here, and I'm incredibly grateful, after all the chances I've taken and all the trouble I've been through, to be here tonight to do this, and still able to play this music."

**Chris Hillman:** "It's taken me so many years to realize how incredibly lucky I was to be a part of this group. I was just a kid playing the mandolin in a bluegrass band in 1964, and I got asked to join. I treasure every moment working with these guys, the good and the bad. It was a wonderful time. I love all you guys, I really do. And it's such an honor to be in this Hall of Fame with all my heroes, all of the people who influenced me, and I thank you for keeping the Byrds' legacy alive."

### BONNIE RAITT ON JOHN LEE HOOKER:

"When I was a young teenager in the early sixties, I got bitten by the folk-music bug that was running rampant in the colleges and coffeehouses up and down the coast. I was too young to hang out in Greenwich Village, so I borrowed some records from my camp counselors and got my English ballad and protest thing down pretty good before somebody handed me an album called *Blues at Newport, '63*. It was on Vanguard Records and it changed my life. People like Reverend Gary Davis, Mississippi John Hurt were on the record, but there was one man who scared the pants off me, just like he still does. He sounded like nothing I had ever heard, and just with his voice, guitar, and foot-tapping, he stirred something deeper in me than even 'Twist and Shout,' 'Satisfaction,' and 'Fingertips' had made me feel. I couldn't really understand it then, but there was something so darkly erotic and yet so lonely and sad about his music, that it forged a permanent bond between me and blues, and, I was sure, with what goes on between a grown man and a woman. I played his songs over and over, and got every record I could after that.

"He's still healthy, active, and making new music—not just coasting. Maybe because he's been lucky enough to always make a living from his music, and he wasn't ripped off or ignored like so many others, or maybe just because some smiling King Snake angel decided to give him a break—the fact is that he never fell prey to the vicious cycle of drugs, alcohol, despair, and self-destruction that is the blues disease. And when I look out at you, John Lee, tonight, I just want to let you know how grateful I am to not only have your music and friendship, but to be able to see you get this recognition while you're still able to enjoy it. To see you backstage and upstairs with three women, if you want, and that's the truth, to know you have the money and recognition to be able to stop anytime you want and know you made a difference. And it certainly shouldn't have taken you seventy years to be at the height of your career. We're so blessed to have your funky, badass self here tonight to eat all

this up. You deserve it, John Lee, and on behalf of all the bluesmen and blueswomen who didn't get to have their cake and eat it, too, let's appreciate the pioneers of rhythm & blues by playing their music on something other than public radio. I love you, John Lee; you taught me that I can get into and out of the blues alive."

## TRACY CHAPMAN ON THE IMPRESSIONS:

"When the Impressions had their first single, 'For Your Precious Love,' I was minus six years old. However, by the time I did come into this world, I was listening to the music that my parents loved. I was listening to R&B and soul music; I was listening to the Impressions, to Curtis Mayfield, and Jerry Butler. By that time, they had four more singles, including 'Keep On Pushing,' which is one of my favorites. For those who think that folk music is the only music that deals with socially relevant issues, I suggest you pick up a Curtis Mayfield album. His songs gently encouraged people to make changes in the world and in their lives. I count him as one of my influences, as someone who inspired me. On a personal note, in light of the recent tragedy, I would like to say to Curtis Mayfield, to, in his own words, 'Keep on pushing.'"

## THE IMPRESSIONS:

**Jerry Butler:** "There are three things that I never believed. One is that I never believed that I would be inducted into anybody's Hall of Fame. Two, I never believed that my friend Curtis would be paralyzed from the neck down. And three, I never believed that I would live to see another war. But we did. Curtis, as you know, is paralyzed; and to show you what kind of a human being the little guy is, I was with him last week, and I said, 'Curtis, what we're going to try and do, man, is put together a fund-raiser—a big benefit—invite everybody who has touched your music, from Bill Cosby to Sidney Poitier, to Aretha Franklin, to the Impressions. You name it, we'll get 'em there.' He said, 'Jerry, that's awfully nice, but don't do it as a benefit for me. Rather, I would like to see us set up a foundation for all people who get injured in this way,' because there is so little known about spinal cord injuries, that there are really only three clinics in the United States that deal with it. He was just fortunate enough to live in one of the cities where one of those clinics happens to be. Though he is paralyzed from the neck down, his head is working, and men are usually measured from the shoulders up."

**Curtis Mayfield (via remote satellite):** "If it weren't for the Impressions, I would have never seen my dreams nor counted my blessings. I love you all. Everything's gonna be all right. And I'd like to say that I'm recouping, and we're still a winner. Peace and love be with all of you."

## ZZ TOP'S BILLY GIBBONS ON JIMMY REED:

"How do you begin talking about Jimmy Reed? Even today, I can't buy a car without first playing a Jimmy Reed tape before driving it. I can't buy a guitar—got to first play a Jimmy Reed song. And to really make matters intense, I go and buy a pair of shoes, I have to put a pair of headphones on it and play a Jimmy Reed record to the shoes before I can go for a walk. This great, beautifully simple music is something that we embrace, and it's something that we've been fortunate to continue to play ourselves."

> "A MAN ONCE TOLD ME THAT AN HONOR IS AS THIN AS THE WINGS OF A BUTTERFLY, AND I GUESS HE MEANT BY THAT, THAT IT PERISHES EASILY, ESPECIALLY IF YOU HOLD IT TOO TIGHT."
> —JERRY BUTLER

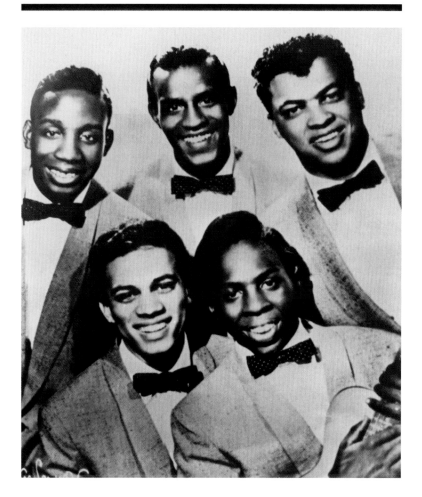

Opposite, from top: telegram from John Lee Hooker, 1963; the Crawling King Snake, John Lee Hooker. This page: the Impressions, c. 1958. Following, page 64: Ike and Tina Turner, 1972. Page 65: Bob Dylan with the Byrds.

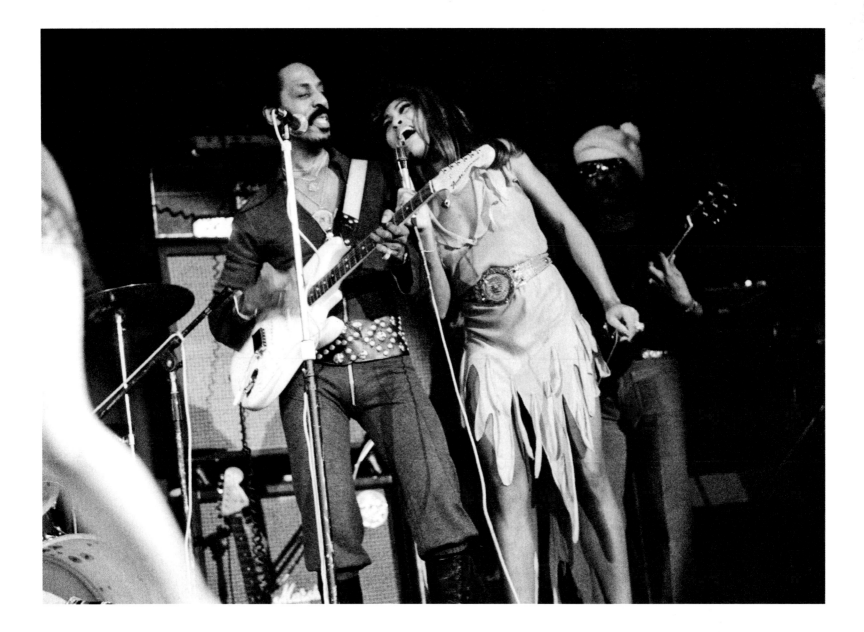

### PHIL SPECTOR ON IKE AND TINA TURNER:

"In America, where we don't treasure our artists, we have an American treasure in Tina. She's the closest thing to a gem I've ever seen. She has the roughness, the rawness, the beauty.... I'm sorry that Ike and Tina could not be here to receive all the adulation and charm and warmth. I know they appreciate it. And Ike Turner, I can only hope that this award marks the beginning of the best part of his life."

### JON LANDAU ON HOWLIN' WOLF:

"Chester Burnett, alias Howlin' Wolf was a big man: two hundred seventy pounds in his prime, and a big part of the electric blues story. He contributed a body of work that is among the darkest, most paranoid, and most intense—often sexually intense—of any blues artist. At his purest, he sounded positively unearthly, as if he were able to tap into sounds and feelings that were both preconscious and universal, and at his greatest, it is hard to think of many singers that could sound as compelling.

"Wolf sang starkly, directly, dynamically, and with great artistry. While he had a big voice on such blues masterpieces as 'Moanin' at Midnight,' 'Smokestack Lightning,' 'Evil,' and 'Wang Dang Doodle,' he used it with great range and control. Remarkably, he managed to sound guttural and coarse, clear and distinct all at the same time, and as a vocalist, he understood space and phrasing as well as any blues artist. As a performer, Wolf pioneered the extreme stage tactics and extroverted style that have been the hallmark of the rock & roll spirit for the past thirty-five years. Perhaps it was only onstage that he allowed the darkness of his obsessions to be fully matched by his raw humor and exuberance. He could appear as a pure force of nature and as a musical hypnotist at one and the same time. He was truly something else and something other."

### RALPH BASS:

"I was in Atlanta, Georgia—King had a branch there. And the branch manager said to me, 'I've got a dub for you, you've gotta listen.' And I listened to it, and I said, 'Where do I find this group?' And he said, 'Macon, Georgia.' I had a disc jockey

drive me down there, to see the group called the Flames. I called their manager, Sid Bradley, and told him I was there. He said, 'I'll tell you what to do. You meet me at eight o'clock tonight, at the railway station. Across the street is a barbershop. And when the lights go on, and the blinds go up and down, come on in.' This was the early fifties, and he had to work with the white power structure in the South, and he didn't want anybody to know that he was dealing with a strange white cat. He hemmed and hawed about signing the group, and I gave him two hundred bucks. He said, 'Come down to my club tonight and watch 'em work.' And sure enough, I went there at ten o'clock, and here they come out on stage—James Brown, with a microphone in his hand, on his stomach, crawling on the floor from table to table, where there was a pretty girl sitting, and he was singing, '*Please, please, please.*' I said, 'Oh, my. That's it, that's the one I want.'

"So I brought them to Cincinnati, paid for their expenses, and I record the song—we had to do four sides in three hours in those days. And I turned in my expenses, including the two hundred bucks. Well, three months later, [King's] Henry Glover found me in St. Louis. I lived on the road, out of the trunk of my car, looking for talent. He said, 'You'd better call the old man [label head Syd Nathan] up.' 'What for?' 'He said, when I found you, say, "You're fired."' 'For what?' 'I dunno.' So I called him. I said, 'Syd, you want to talk to me?' He said, 'Yeah. What kind of hit are you on?' I said, 'What in the hell are you talking about?' He said, 'You got to be on something, because how could anybody in their right mind record the worst piece of shit I ever heard in my life? Sounds like someone stuttering on the record. All he says is one word.' 'Oh, you mean, "Please, Please, Please?"' He said, 'Yeah.' I said, 'Look, Syd. Put it out in Atlanta, Georgia. If it don't sell in Atlanta, don't fire me—I quit.' Well, the rest is history."

## "RALPH BASS WAS THE STAR AT KING RECORDS. A STAR AMONG STARS OF A&R MEN."
—SEYMOUR STEIN

### MUSICAL HIGHLIGHTS
The Byrds kicked off the jam, following their induction, soaring through "Turn Turn Turn," "Mr. Tambourine Man," and "I'll Feel a Whole Lot Better," with Henley and Jackson Browne joining in. John Lee Hooker and Bonnie Raitt cozied up for "I'm in the Mood," with Robert Cray and John Popper adding their guitar and harmonica, respectively. Chaka Khan and John Fogerty shook the house with "Proud Mary," and LaVern Baker delivered her hit "Tweedle-Dee," with Patty Smyth and Raitt harmonizing. A moving version of Curtis Mayfield's "People Get Ready" came courtesy of Bruce Springsteen and Jackson Browne, and Paul Shaffer handed out lyric sheets for all to join in on the hymnlike anthem. Inductee Wilson Pickett's monster soul hits "Mustang Sally" and "In the Midnight Hour" enticed a pack of participants filling the stage to sing and play along, including Roger McGuinn, Popper, Fogerty, Raitt, Springsteen, and Khan, with Phoebe Snow's shimmering vocals rising above the din.

### BYRDS HITS WRITTEN BY BOB DYLAN
✦ ✦ ✦

The Byrds not only scored their first Number One covering Bob Dylan's "Mr. Tambourine Man" (on the album *Mr. Tambourine Man*), they also gave birth to a new genre of rock & roll: folk-rock. Previously, Dylan's songs had been primarily recorded by folkies like Peter, Paul, and Mary and Joan Baez, in an acoustic format. With Roger McGuinn's electric Rickenbacker and vocals, Chris Hillman's electric bass and vocals, Michael Clarke's drums, and the soaring harmonies provided by Gene Clark and David Crosby, the Byrds became the model for artists ranging from the Eagles to Tom Petty to R.E.M. In addition to their debut hit, other charting singles derived from Dylan's songbook include: "All I Really Want to Do," Number Forty, 1965, from *Mr. Tambourine Man*; "My Back Pages," Number Thirty, 1967, from *Younger Than Yesterday*; and "You Ain't Goin' Nowhere," Number Seventy-Four, 1968, from *Sweetheart of the Rodeo*. The Byrds also covered Dylan's "Positively 4th Street" and "The Times They Are a-Changing."

**PERFORMERS** Bobby Bland ✦ Booker T. and the MG's
Johnny Cash ✦ The Jimi Hendrix Experience ✦ The Isley Brothers
Sam and Dave ✦ The Yardbirds
**EARLY INFLUENCES** Elmore James ✦ Professor Longhair
**NONPERFORMERS** Leo Fender ✦ Bill Graham ✦ Doc Pomus

This January 15 induction ceremony goes on record as the longest running in the event's history. There were more written—and lengthy—speeches (rather than off-the-cuff remarks) than ever before, including tributes to deceased regulars who'd been onstage or in the Grand Ballroom over the past six years but were being inducted posthumously, namely concert promoter and impresario Bill Graham and songwriter extraordinaire Doc Pomus. Graham, killed in a helicopter accident in October 1991, had served as the unofficial stage manager since the first induction, and his enthusiasm and energy helped rally the troops for some exquisite jams at previous induction ceremonies. John Fogerty and Carlos Santana, both veterans of the San Francisco music scene that Graham helped to create, were on hand to give heartfelt testimonies about the larger-than-life concert promoter.

Pomus, who also died in 1991, held court from his wheelchair every year and inducted Big Joe Turner into the Hall of Fame in 1987. The event also included a practical guitar summit: Wielding axes were Jeff Beck, Steve Cropper (of Booker T. and the MG's), Robbie Robertson, B.B. King, Jimmy Page, Keith Richards, Carlos Santana, the Edge, Neil Young, and John Fogerty.

The always unpredictable Little Richard and Phil Spector also made return appearances to induct the Isley Brothers and Pomus, respectively. *Rolling Stone*'s Chris Mundy described what would be Spector at his most eloquent: "The speech, while lasting longer and incorporating more stories than most prime-time television programs, was the evening's most arresting extended moment. Spector movingly spoke of the death of both Pomus and his own son, Phillip Jr., blasted the Songwriters Hall of Fame for not recognizing Pomus, and railed against censorship of the arts." Spector's was not the only emotional speech: After he received a standing ovation (the night's first), Johnny Cash's voice broke as he said, "You made me see that I might actually belong in the Rock and Roll Hall of Fame," and Jimi Hendrix's father, Al, wept as he stood onstage with his son's drummer Mitch Mitchell and bassist Noel Redding.

Another trademark induction emotion, however, was tension among inductees, with this year's honor going to the Yardbirds, with its revolving lineup of top guitarists Eric Clapton, who didn't attend, Jeff Beck, and Jimmy Page. When inducted with the Yardbirds, Beck quipped, "Somebody told me I should be proud, but I'm not—because they kicked me out. So *fuck them!*" And for the Sam and Dave induction, Sam Moore took the stage separately from his former partner Dave Prater's widow, embroiled in litigation over her claim of being Prater's legal wife. The overall atmosphere, however, was joyous, particularly during the guitar-heavy jam session at night's end.

> "HIS MUSIC, HIS ARTISTRY, HIS POINT OF VIEW HELPED FORM AND DEFINE WHAT WE KNOW AS ROCK & ROLL."
> —LYLE LOVETT, ON JOHNNY CASH

> "WE DON'T WANT TO BE CLASSED IN ANY CATEGORY. IF IT MUST HAVE A TAG, I'D LIKE IT TO BE CALLED 'FREE FEELING.' IT'S A MIXTURE OF ROCK, FREAK-OUT, BLUES, AND RAVE MUSIC."
>
> —JIMI HENDRIX

### LYLE LOVETT ON JOHNNY CASH:

"'I Walk the Line' was the first song of his I ever heard. My aunt and uncle owned the record, and my cousin Wanda and I would wait until my mother left the house, and then we'd play it really loud. But I can't remember the very first time I heard 'I Walk the Line.' To me it was simply a part of the world as I knew it, like a part of nature. More like air and like water than like a song that someone, some man, actually sat down and wrote, and sang. But that's the way it seems with great songs and great artists. Their impact on people is such that you can't imagine what the world would be like or sound like without them."

### JOHNNY CASH:

"I would like to thank Sam Phillips, and I'd like to thank Jack Clement, who steered the career and directed recording activities of myself for sound, as well as the recording activities of a lot of other people, including Elvis, and Carl Perkins, Jerry Lee Lewis, and my dearest buddy Roy Orbison. I listened to WHBQ, and they had a program on there called *Red, Hot, and Blue*, where they played back then what they called race music, and there I heard some of my earliest heroes, and it was at the Home of the Blues record shop where I bought my first recording of Sister Rosetta Tharpe singing those great gospel songs. I can still see Sister Rosetta playing that Stella guitar. And I bought some of the recordings by Alan Lomax, who did some field recordings back in the thirties and forties. He took his wire recorder into the alleys and honky-tonks in Mississippi and South Carolina and Louisiana, and I listened to those by the hour and by the day, and the week, and the month, and they influenced a lot of my writing songs like 'Big River' and 'Get Rhythm.' Some of the earlier songs that I wrote were influenced by people like Sister Rosetta Tharpe and by Pink Anderson and Blind Lemon Jefferson, and some of the Carolina Street Singers.

"As Little Richard said at the beginning of this program—he and I were talking—he said, 'God is watching over things tonight,' and I feel that, Richard. I thank you for reminding me of that. And I asked June, 'What should I say when I get up there?' and she said, 'Just ask God to guide you and it'll be all right.' I find that works, not only tonight, but every day of my life."

### NEIL YOUNG ON THE JIMI HENDRIX EXPERIENCE:

"When you play guitar, you can play, or you can transcend—there are no boundaries, how far you can go in your own body and how far your mind can expand when you're playing it. Jimi showed me that; I learned that from Jimi. And he was at one with his instrument. Truly, one thing was happening, just—no technique that you could take note of, chords that I could recognize, no hand movements that I could go, 'I know what that is.' I didn't know what any of it was. I just looked at it, and I heard it, and I wanted to do it. I said to myself, 'Maybe someday I can go to that neighborhood and feel what that's like.' But you can't make it there by yourself, so lucky for me, I had Crazy Horse, and lucky for Jimi, he had the Jimi Hendrix Experience. Because without Noel and without Mitch, it's hard to say what would have happened, even though Jimi is a legend, and a groundbreaker, and everything everyone says and more, it's hard to say whether he could have done that without these other two guys. Because I know that it doesn't matter whether you can play or not, it doesn't matter whether you're together, or whether everybody hits it at the same time, or what key they're

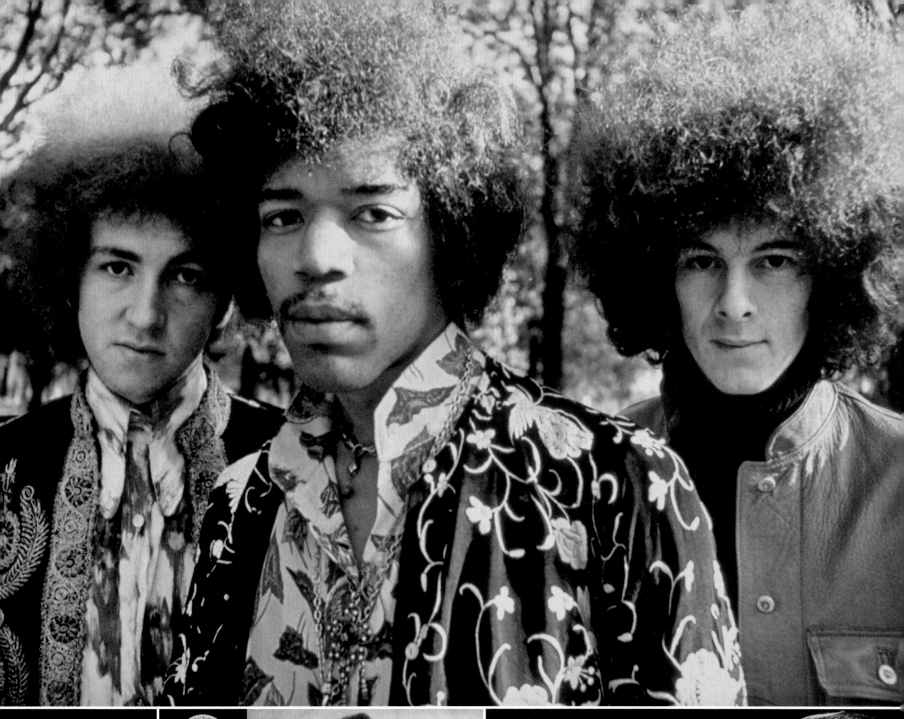

Previous, page 66: Johnny Cash in concert, 1972. This page, clockwise from top: the Jimi Hendrix Experience; June Carter Cash and Johnny Cash, 1975; Cash album, 1958.

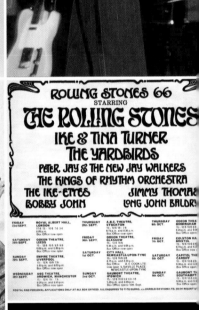

in or anything. It just matters if it's the right chemistry, and they had the right chemistry. Every time they played together, Jimi took off."

## LITTLE RICHARD ON THE ISLEY BROTHERS:

"I'm just so glad to have this opportunity to get up and say something. Most people don't give me that opportunity, because they're afraid I'm gonna say *something*, so they silence me by keeping me in my seat, but tonight I got a chance to speak, and stand on my feet, and I will be discreet, and I will be sweet. I'm so glad to be here tonight to talk about my good friends the Isley Brothers. They've always been good. I remember a long time ago when the Beatles were traveling with me, opening my show, they were singing all of the Isley Brothers' tunes. They had never made no records, remember that, and the Rolling Stones was opening the show, too. If you don't believe me, ask Keith—we were just talking about it over there. And they were just fantastic. And Jimi Hendrix was playing the guitar with my band. And I tell you, everybody was playing the Isley Brothers music. 'Twist and Shout,' because he had that scream just like me, that '*Wooooooo!*'—he had that. He just went a little higher—'*Wooooooo!*' It was up there. And I just loved it. *Shake it up, baby!* I was shakin', and I was twistin', and I was hollerin'. I was screaming just like a white lady. You know, a black lady says, '*Oh!*' A white lady says, '*Woo!*' And we was just having a ball. They was doing it all, the Isley Brothers–'This Old Heart of Mine.' I know about that heart, because I've had one all my life. They've always been in my heart; I think they're overdue.

"They were the first rock & roll group I ever heard in my life, before anyone started using the word *rock & roll*. Because, you know, rock & roll ain't nothing but the rhythm & blues up-tempo, that's all rock & roll is. Then they had 'Shout,' and boy, they had me shouting everywhere. The Isley Brothers is without a doubt the greatest and the first rock & roll group I ever heard. I don't think they even knew they was rockin' & rollin' at the time. They have the oddest rhythm I've ever heard in my life. Ain't nothing like it nowhere. They are the founder, they are the original, they are the creator, they are the emancipator, they are the architect!"

## THE EDGE ON THE YARDBIRDS:

"There's something I find personally very humbling about this whole evening. It's sort of odd, in a way, for me to be doing this. Let me tell you why. Some of you already know that I play a bit of guitar myself—mostly chords as it happens—though when I started out, and really, for the next decade, I spent a lot of my time trying to figure out how not to sound like *not* just one of the guitarists in this band, but three of the guitarists in this band. I wasn't alone. In a million garages from Culver City to Cork, young men in torn T-shirts were to be found hunched over Les Paul copies, trying to find any stray semitone that Beck, Clapton, or Page hadn't used. They cast a very long shadow, and between them I used a lot of those little black dots. It wasn't easy, and in the end, most of us gave up the struggle and took to playing open D very loud. That was a trick we learned from Pete Townshend, by the way.

"Twelve years on, twelve years of conscious reaction, of working out a different style, I think it's possible to get a kind of overview—to look again at the music, to reevaluate the legacy of the Yardbirds. So I can tell you now that the next U2 album is going to be full of extended blues solos, violin bowing, jazz fusion breaks,

and some very slow-hand Robert Johnson leads. The Yardbirds were a very pivotal group. It could be said that they invented the thing that we know today as the rock band. Before them, groups were basically recording artists or whatever, but after them, bands were *bands*—an endless stream of young men touring the world and deafening audiences.

"The Yardbirds were loud, and they were exciting, and most importantly, they were great live. Technically accomplished (I mean, they even had Jimmy Page playing bass for a while), they played a music that fused white pop ideas with soul and pop styles, and they were well capable of stretching out onstage and playing up an extended storm. Even the singles that they weren't too sure about—'Shapes of Things,' 'For Your Love'—they sounded different, they were darker, eerier; they felt like they were a foretaste of the music that was on its way in the later sixties, the music of bands like Cream, Zeppelin, and the Jeff Beck Group. They were seminal, crucial, and pivotal. For over a dozen years of rock's roughly forty-year existence, the influence of the Yardbirds was all-pervasive. For another decade, rock music was driven by a conscious reaction to their style. Either way, rock & roll, the people who play and the people who listen, have cause to be grateful."

---

# "[THE YARDBIRDS] LAID THE WAY FOR BARBARISM."
## —JEFF BECK

---

## JANN S. WENNER ON ELMORE JAMES:

"We have an outstanding lineup of guitarists that are present here tonight. The electric guitar is, of course, the instrument of rock, and tonight we'll be honoring the memories of two men whose names are synonymous with the instrument. Rock & roll was originally a sound that was born of pianos, saxophones, stand-up basses, and amplified semi-acoustic guitars. Rock was the sound of Leo Fender's electric solid-body guitar. Jimi Hendrix was perhaps rock's greatest guitarist, a musician who pulled sounds out of that instrument that Leo Fender probably had no idea could be obtained. And if Jimi Hendrix's imagination was adrift in the universe, his feet were firmly rooted in the blues and blues territory, for no rock guitarist can ever stray too far afield from the blues, and still remain true to the music. Tonight we should also note the passing last year of the late, great Stevie Ray Vaughan. He was surely one of the greatest practitioners of the arts of Leo Fender and Jimi Hendrix. In that vein, our first inductee—Elmore James—is one of the towering giants out of whose shadows the rock & roll guitarist emerged. Without Elmore James's blues-based rock, it's practically unimaginable that there would be rock guitar. In his passion and urgency, Elmore James was the direct link between Robert Johnson and the modern rock era. Elmore James never lived to see the great influence his music would have. In 1963, the same year the Rolling Stones formed, he died of a heart attack in Chicago. But there is not a guitarist here tonight, nor in any bar or club or garage throughout the rock world, who doesn't play and live by the work of Elmore James."

## ROBBIE ROBERTSON ON ELMORE JAMES:

"At the ripe age of sixteen years old, I left my home in Toronto, and I took a train to Helena, Arkansas, home of Sonny Boy Williamson and the Mississippi Delta, and I joined this Southern rock & roll band called Ronnie Hawkins and the Hawks. After I got my first week's paycheck, I went over to Memphis, to this famous record store called Home of the Blues. I blew my whole wad, my whole hundred and thirty-five dollars, on Muddy Waters and Eddie Cochran and Howlin' Wolf and Charlie Rich and Elmore James. And when I got back to Helena, I listened to this Elmore James record, and I heard 'The sky is crying, look at the tears roll down the street,' and I heard, 'I must have done somebody wrong.' And I thought, *Who is this Elmore James, that writes these amazing songs, and gets this sound out of his guitar?* So I practiced twelve hours a day, every day, until my fingers were bleeding, trying to get the same sound as Elmore James got. This went on for weeks and weeks, and then somebody told me that he plays with a slide, with a bottleneck. As I looked at my maimed hand, I made a vow that I would never play bottleneck guitar as long as I lived, but that I would get this sound—if it took twenty years, thirty years, I would get this sound. Well, it's time for me to fess up. It can't be done. This is Elmore's job. The only reason that I'm here helping to induct Elmore James into the Hall of Fame tonight is because Duane Allman, Lowell George, and Jimi Hendrix can't be here to do so."

## KEITH RICHARDS ON LEO FENDER:

"Leo Fender, the armorer of rock & roll—he gave us the weapons. And for you piano players and singers out there that maybe don't know, Leo made guitars. Leo made *the* guitar. The solid-body electric guitar. I think the stroke of genius, really, was that not only did he make the guitar, but he made the amplifier to go with it. You can make the best guitar in the world, but if you don't play it out of the right thing, it don't happen, you know what I mean? I'm not going to bore you with rosewood and maple and adjustable bridges, and all of that stuff, because you don't need to know, and anyway, we wouldn't tell you. When you grow up, and you want to play guitar, and you want to play rock & roll guitar, you have your sights set on one of Leo's jobs. And when you get your hands on one, and you play it for a few years, and you drag it around the country, here and there, you start to get to know Leo, 'cause you've got your hands around his neck.

"Half of you guys out there play this thing, and we all know what we're talking about. But for the uninitiated, Leo Fender virtually defined the solid-body electric guitar from its birth. It's as if the Wright brothers—'Oh, we'll build an airplane, open the hangar, and pull out a Concorde.' Leo Fender gave us the thing to work with. And it's never been bettered, never been equaled, many times it's imitated. That's the one you die for, that's the one you want, and when you've got it, you never let it go. And with this, I'll leave you with the guitar player's prayer: Caress it, don't squeeze it."

## DAVID GRAHAM, BILL GRAHAM'S SON, ON HIS FATHER:

"Bill Graham was one of the great visionaries of our time, giving rock & roll a sense of possibility and positive change, giving the needy a fighting chance, and bringing awareness and consciousness to people of the ills of the world. Bill was a man of relentless mania, but without it, rock & roll, and its relationship with the world, would be much different. From the cultural haven of the Fillmore to the spread of compassion around the globe, no man I know was filled with more love."

## JOHN FOGERTY ON BILL GRAHAM:

"First I've gotta say that I'm kind of nervous. It's rather like inducting Moses into a Hall of Fame somewhere. Bill, wherever you are, I hope I get this right.

"Bill Graham was my friend, and I think about everybody in this room can say this about him. It started almost accidentally in 1966, in San Francisco—it was a thing called the Trips Festival that he put on. It was a mingling of counterculture sight and sound and smell—I think I smelled a little of that tonight here somewhere—kind of the birth of what became the San Francisco sound. With the opening of the Fillmore, Bill provided a continuing stage for this mythical village. I didn't always agree with this psychedelic thing, but it definitely was happening. I first met Bill in 1968, and he and the Fillmore by then were already legendary. Try to picture those times. We realized that the attention of the nation was on San Francisco, and it was a time full of hope, rebellion, idealism. A lot of local artists—the Grateful Dead, Jefferson Airplane, Big Brother with Janis Joplin, Moby Grape, Quicksilver, Tower of Power, It's a Beautiful Day, later Santana, Steve Miller Blues Band, a band called Creedence Clearwater Revival. It was a time of psychedelic posters, acrid smoke, beads, and 'Hey, man, got any spare change?' Bill was the straight guy that kind of wrangled all this, as far as I'm concerned. He was the one that kept the chaos from caving in on itself. He always reminded everybody, the audience comes first, and he truly believed that. Bill made us all better. He certainly made me better. He brought a consciousness to the whole deal that a lot of people didn't have.

"Eventually the San Francisco sound faded. The Fillmores closed, but Bill went on. He kept the magic alive with Winterland. And with so much success, a lot of guys would just sink into self-indulgence and excess. But not Bill. He just got better. He showed us what he was really made of. He began organizing benefit concerts. Bill had a knack for gathering great people around him. The early Fillmore staff has evolved into what is now known as Bill Graham Presents, a top-notch organization that is a production company on par with anybody.

"Bill made you feel that all things were possible. With his guidance, they were. I spent the last few weeks talking to people about Bill, and asking them their reaction and impression. Certain words always come up: passion, integrity, friend, and stubborn as a mule. No, Bill Graham was not perfect. He was exquisitely human. I'm proud to say he was my friend, and he was simply the best man I ever met. If he had asked me, I would have gone through hell in a gasoline suit for the man. There's an old axiom in show business that you should always leave them wanting more. Well, Bill Graham, we wanted more. We wanted a hell of a lot more."

> # "YOU WERE THERE WORKING IN THE STUDIO, BLACK AND WHITE, AS BROTHERS, IN MEMPHIS, IN 1962. YOU WERE WRITING MORE THAN MUSICAL HISTORY."
>
> —STAX RECORDS' JIM STEWART ON BOOKER T. AND THE MG'S

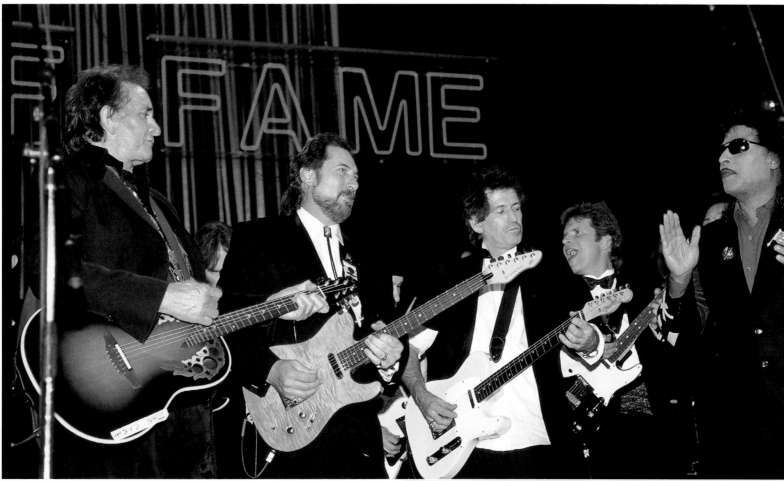

## MUSICAL HIGHLIGHTS

Carlos Santana was on hand to play a beautiful tribute to Bill Graham, a song he said Graham had taught him, called "I Love You Much Too Much." *Rolling Stone*'s Chris Mundy described his contribution to the jam, however, thusly: "Solo Santana quickly turned into muddled madness as the evening's traditional jam finale perfectly demonstrated the highs and lows this ceremony can offer. 'Green Onions,' the opening instrumental tune-up, got the room in a groove, but cluttered sound ruined some of the night's potentially spectacular moments. Then again, it's tough to nitpick about sound quality when Johnny Cash belts out 'Big River,' while Keith Richards shares leads with the Edge." Singing backup throughout were Fogerty, Aaron Neville (who inducted Professor Longhair as an Early Influence), the Isley Brothers, Little Richard, and Sam Moore.

Other collaborative high points included Sam Moore and John Fogerty on "Soul Man," and joining in for one song or another were Stax legends Isaac Hayes and Rufus Thomas. Jimmy Page grabbed a guitar for an over-the-top version of the Isleys' "Shout," and the evening was capped by the guitarists' attack on "Purple Haze," followed by Hayes, Neville, and Little Richard's "When Something Is Wrong With My Baby." For Mundy's money, though, "the night's only truly transcendent moment occurred when Neil Yong took over frontman chores for 'All Along the Watchtower,' a blistering crash of energy." As for Rosanne Cash, there to witness her dad's induction, "I had a psychedelic experience. I just saw my father playing 'Purple Haze.'"

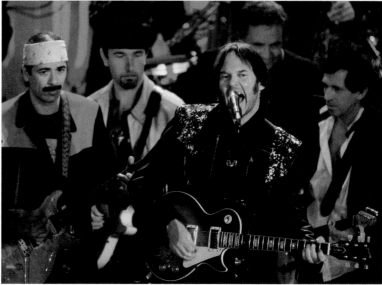

Guitar jam, January 1992. From top: (from left) Johnny Cash, Steve Cropper, Keith Richards, John Fogerty, and Little Richard; (from left) Carlos Santana, the Edge, Neil Young, and Keith Richards.

## INDUCTEES

**PERFORMERS** Ruth Brown ✦ Cream ✦ Creedence Clearwater Revival
The Doors ✦ Etta James ✦ Frankie Lymon and the Teenagers
Van Morrison ✦ Sly and the Family Stone
**EARLY INFLUENCES** Dinah Washington
**NONPERFORMERS** Dick Clark ✦ Milt Gabler

very year since 1987, when it was announced that the Rock and Roll Hall of Fame and Museum would be built in Cleveland, the "ghost building" was a running joke at the induction ceremonies. Finally, at this January 12 gathering, the groundbreaking and building plans were announced, and the governor of Ohio said a few words to bear witness. The anticipation for the building ran a close second, though, to the eagerness for the inductees, particularly Cream, rumored to perform for the first time in two-and-a-half decades.

For the first time, the induction ceremony was held in Los Angeles, minus Paul Shaffer and the World's Most Dangerous Band. This year's music producer was Robbie Robertson, with Don Was holding down duties as music director. Their house band, the Barbed Wire Barracudas, included Was on bass, drummer Jim Keltner, keyboardists Roy Bittan and Benmont Tench, guitarist Mark Goldenberg, and the Memphis Horns. Another new tradition was the enlistment of young artists to play the music of the inductees, with the then-unknown Counting Crows performing Van Morrison's "Caravan" ("Van lite," according to one critic), Boyz II Men taking on Frankie Lymon and the Teenagers, and Eddie Vedder standing in for Jim Morrison alongside the Doors ("Roadhouse Blues," "Break On Through," and "Light My Fire").

*Rolling Stone*'s David Wild and Jeffrey Ressner reported on the musical restructuring: "Robertson and Was replaced the usual after-midnight free-for-all with a musical program emphasizing rehearsed performances that were paced evenly throughout the show. 'Robbie had the great idea,' said Was, 'that instead of a crazy jam session with a twenty-minute version of 'Johnny B. Goode,' we should just let these great bands play." The new setup would stick, and a variation would become the standard, along with a shorter, typically planned-out jam at night's end. There were some disappointments: Creedence didn't reunite, Van Morrison didn't show up, and Sly Stone barely showed up (he belatedly wandered up to the podium as his band mates were singing an a cappella "Thank You (Falettinme Be Mice Elf Agin)."

Fittingly, for the Hollywood crowd of fourteen hundred at the Century Plaza Hotel, an actor was on board for the first time to handle an induction: Billy Crystal gave a funny and moving speech about his uncle, the great record man and producer Milt Gabler.

## "I FIGURED IT WAS ME OR WILLIAM SHATNER."

—EDDIE VEDDER, ON HIS DECISION TO TAKE JIM MORRISON'S PART IN THE DOORS REUNION

# "A LOT HAS BEEN GAINED BY COMING HERE TONIGHT; I'VE BEEN REUNITED WITH TWO PEOPLE I LOVE VERY DEARLY. IT'S VERY MOVING. AND YESTERDAY WE PLAYED TOGETHER FOR THE FIRST TIME IN TWENTY-FIVE YEARS. IT WAS PRETTY AMAZING."

## —ERIC CLAPTON

## BONNIE RAITT ON RUTH BROWN:

"What we get together to do each year, besides party in a very historic way, is to acknowledge and celebrate those artists who have made such a big difference in shaping this strain of trouble we like to call rock & roll. For me in particular, it's those artists who were around during the early days, when the great black traditions of gospel, blues, and jazz were grafted onto that incredibly boring Tin Pan Alley stuff of the day. And in looking over the career of the woman I am so honored to be inducting at long last into the Hall of Fame tonight, you can get a clear one-shot history lesson in just how exhilarating and frustrating it must have been to be a black rhythm & blues star during that time. I'm talking about my friend, the one and only Ruth Brown.

"Ruth, I'd like to talk about your singing for a moment. I like to call it 'sass and ache.' Nobody can sell a song like Ruth Brown: her eyes flashing, her lips curling, that slow and sultry turn of her head and her hips—that's what I like to call sex appeal. I take a look at videos of En Vogue or the Supremes, and I just smile and think, *Thank you, Ruth Brown*. All those torchy ballads and snaky, up-tempo blues, it's sex with class and dignity, not just some cheap and obvious tease. That signature catch in her voice and ache in her heart, that's the stuff that real diva bloodlines are made from. It's not about hairdos and packaging—it's about whether people believe you mean what you're singing about, whether they believe you've lived it, that it's coming from someplace real. And that's what I will always get from Ruth Brown.

"And as for the other lesson we can learn from this extraordinary woman, let's talk about style and perseverance. When all those white artists got hits off of songs that she recorded first; when doors were slammed, and hotels and restaurants weren't open to black performers; when no one knew about proper royalty and publishing participation, union coverage, and the kind of promotional opportunities that would have made it possible for her to cross over into a bigger audience—all this she withstood with steely determination not to let it get her down. She may have been bitter, surely, but defeated, *never*. When musical tastes changed in the sixties, she chose to support her two sons, who are here tonight, doing any job she could to keep their family together and living near good schools. She kept her dignity and priorities intact, until fortune again smiled on her in the eighties, when she began her extraordinary return back to the limelight.

"In the last three years, she's toured all over the world, won a Tony for her performance in Broadway's *Black and Blue*, a Grammy for her *Blues on Broadway* album, she hosts a great new program called *Blues Stage* for National Public Radio every week, and she's expanded her range to acting in many TV, stage, and film roles. It is directly because of her example and her history, her dedication to both the music she loves and the artists who created it, who mostly were treated unjustly by the times they come up in, that the Rhythm & Blues Foundation was formed a few years ago with some others of us who share her belief that history's wrongs can be righted.

"There are mighty lessons to be learned from Ruth Brown—on how to conduct oneself in this often brutal and fickle business, on how not to lose sight of your purpose, your music, your faith, and above all, your sense of humor. That's why she's an inspiration to me and so many others, that's why we honor and thank her tonight on her birthday, for a lifetime of great lessons and unforgettable music."

Previous, page 74: Eddie Vedder and Robby Krieger, January 1993. Opposite: Ruth Brown concert poster, 1954.

### RUTH BROWN:

"There says somewhere, that at some time or the other, 'Art imitates life.' This evening happens to be a moment that brings real good memories to me. I think it was exactly forty-five years ago today, January 12, on my twentieth birthday, that Mr. Ahmet Ertegun, who then was heading up a brand-new record company called Atlantic Records, came to Chester Hospital, where I was a patient, and he brought me a birthday gift, and that gift was a pitch pipe, so I could learn to sing in tune, and a music book, so I could sight-read. Until this day, I don't sight-read, but I think I sing in tune."

### ZZ TOP ON CREAM:

**Frank Beard:** "Tonight, I get to hear Ginger Baker play drums. Starting out in the sixties, there were a hundred drummers in Dallas, and when Ginger Baker and Cream came out, we all set our drums up like Ginger Baker. We all had two bass drums now, and we all had our tom-toms set sideways, and we all put two cymbals on each stand. He was the one drummer that we all wanted to be like. And we all studied his work, and listened to the record, and said, 'How did he do that? How did he make that sound?' So, when we get through introducing Cream, and the gentleman tries to lead me back to my table over there, I'm not going. I'm gonna be hiding over here behind an amplifier, and I'm gonna be watching Ginger Baker play drums."

**Dusty Hill:** "About the same time Frank was listening to Ginger Baker, I was listening to Jack Bruce. I thought I could play the bass at the time, until I heard Jack Bruce play, and I had to rethink that. And the best compliment around then, and now, was to be a musician's band. And every musician loved Cream, and they still do."

**Billy Gibbons:** "There's only one name that rounds out this trio of talented musicians that expressed power. Eric Clapton created a sound that everybody in this room can relate to, and certainly set the stage for our outfit. It's with great pleasure that we announce them bad, bad boys of that good thing—Cream."

### CREAM:

**Jack Bruce:** "I come from Glasgow in Scotland, and it doesn't seem so far away now. I think that must be what rock & roll is about: It brings people together. And if the three of us can be together again, anybody can be together again . . . I'd like to thank Ginger for showing me some mad African rhythms that I can't get over, and Eric for clearing my mind and teaching me the purity of the blues."

### BRUCE SPRINGSTEEN ON CREEDENCE CLEARWATER REVIVAL:

"In 1970, suburban New Jersey was still filled with the kind of sixties spirit *Easy Rider* made us all so fond of. I'm referring to the scene where Dennis Hopper gets blown off his motorcycle by some redneck with a shotgun. A weekend outing at the time was still filled with the drama of possibly getting your ass kicked by a total stranger, who disagreed with your fashion sense. Me and my band worked Route 35 outside of Asbury Park, at a club called the Pandemonium. They had recently lowered the drinking age to eighteen, with the logic that if you were old enough to die, you were old enough to drink. And so it was five fifty-minute sets a night, and rarely a night without a fight. The crowd was eclectic. Rough kids just out of high school,

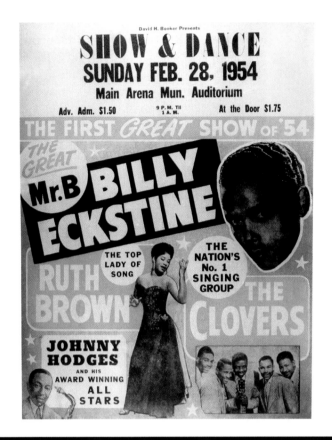

> "[BONNIE RAITT] POSSIBLY HAS ONE OF THE GREATEST UNDERSTANDINGS OF RHYTHM & BLUES AND THE BLUES PER SE THAT I'VE HEARD ANYONE EXHIBIT."
>
> —RUTH BROWN

who hadn't been snatched up by the draft yet, truck drivers heading home, south into the Jersey pines, who weren't gonna make it—not that night at least—and a mixture of college and working girls, women with bouffant hairdos, and a small but steady hippie contingent. Tough crowd to please all at once.

"We played behind a U-shaped bar that was just three feet and spitting distance from many of the patrons, who came to just drink and stare and hassle a band. Into New Jersey came the music of John and Tom Fogerty, Doug Clifford, and Stu Cook—Creedence Clearwater Revival—and for the three minutes and seven seconds of 'Proud Mary,' a very strained brotherhood would actually fill the room. It was simply a great song everybody liked, and it literally saved our asses on many occasions.

"Creedence started out in the long-jamming tradition of other San Francisco bands, realized it wasn't their road, quit cold, and went on to great things. 'Green River,' 'Bad Moon Rising,' 'Down on the Corner,' 'Lodi,' 'Fortunate Son,' 'Who'll Stop the Rain,' 'Born on the Bayou'—it wasn't only great music, it was great dance music,

Clockwise from top: the Doors: (from left) John Densmore, Robby Krieger, Ray Manzarek, and Jim Morrison; Creedence Clearwater Revival: (from left) Stu Cook, Tom Fogerty, John Fogerty, and Doug Clifford; Cream: (from left) Eric Clapton, Ginger Baker, and Jack Bruce.

it was great bar band music. I remember in the late seventies, I'd be in the club watching some band struggle through one of my songs, then just kind of glide effortlessly through a Creedence Clearwater tune. It used to really piss me off. I stand here tonight, still envious of that music's power and its simplicity. And they were hits. Hits filled with beauty, and poetry, and a sense of the darkness of events, and of history. An American tradition shot through with pride, fear, paranoia, and they rocked hard.

"You can't talk about Creedence without talking about John Fogerty. On the fashion front, all of Seattle should bow. John was the father of the flannel shirt. And as a songwriter, only few did as much in three minutes. He was an Old Testament, shaggy-haired prophet. Fatalist. Funny, too. He was severe, he was precise, he said what he had to say and got out of there. He was lyrically spare and beautiful; he created a world of childhood memory and of men and women, back to the wall. A landscape of bayous, Gypsy women, endless rivers, back porches, hound dogs chasing ghosts, devils, bad moon rising, straight out of the blues tradition.

"He turned it into a vision that was all his own, and in Doug, Stu, and Tom, he had the band that could back it up. What makes a great rock band is a funny thing. It's not always the obvious things. You can't ever really know what makes a great band tick. It's not about what the players are exactly like. Tom Fogerty's relentless rhythm guitar, Doug and Stu's great rhythm section, and John's songwriting and singing: All I know is that they played great together.

"Creedence made music for all the waylaid Tom Sawyers and Huck Finns, and for a world that would never again be able to take them up on their most simple and eloquent invitation, which was, 'If you get lost, come on home to Green River.'"

---

## "THERE ARE THINGS KNOWN, AND THERE ARE THINGS UNKNOWN, AND IN BETWEEN ARE THE DOORS."
### —JIM MORRISON

---

## THE DOORS:

**Ray Manzarek:** "We're theoretically the class of 1967, and 1967 was the Summer of Love. Now that the nineties are here, now that a new [Clinton] administration has taken over—from my perspective, now that the fascists are no longer in office, what we're going to do is to try to reinstitute into the nineties the feeling, the spirit of the sixties. Love, love, love—that's what it was all about. Remember getting high, remember taking the psychedelic substances, remember feeling a part of the earth, feeling a part of the planet, feeling your brothers, your sisters, white, black, brown, green, purple, red—we are all brothers and sisters made of the same flesh, made of the same energy. That's what the Doors are all about. That's what the sixties were all about. In the nineties, let's try to bring all the races together. We got together to do poetry and rock & roll—kind of an extension of poetry and jazz, like the Beats in the fifties, Kerouac, and Ginsberg, and McClure, and Ferlinghetti—those are all Jim Morrison's influences. John [Densmore] and Robby [Krieger] and I were into jazz."

## k.d. lang ON ETTA JAMES:

"Etta James is one of the few vocalists, whether it be R&B, blues, country, or rock & roll, who sings truth into every note. For a song cannot be sung until its singer has learned, and has a grip on both its freedom and its cage. Etta James has seen, truly, both sides in her life and in her music. Songs like 'Tell Mama,' 'I'd Rather Go Blind,' 'Something's Got a Hold On Me,' 'At Last,' and so many others, melt together pain, and faith, and vulnerability, and strength, and, of course, the simple love of singing. Her passion allows us to read between the lines and to understand fully the emotion of the song. For she has lived what she sings. That's what makes Etta James great."

## ROBBIE ROBERTSON ON VAN MORRISON:

"Let me tell you what kind of a man we're dealing with here. I've known him since about 1969, after *Astral Weeks* and *Music From Big Pink* came out, and we both felt a musical connection. When I was working on the Band's second album, he dropped by to visit. I was playing around with a guitar idea, and he asked me where I learned to play like that. I said I didn't know, and he got up and left. Not too long after, he moved to Woodstock, New York, where we were living at the time, and one day he came over to my house, and I was in the middle of writing a new song. Well, he had some ideas, and before too long, we finished it up, and that night we went into the studio to record it. We played it down once so everybody could learn it, then we played it again, and put it down on tape, and he got up and left. This was the night he became the Belfast Cowboy.

"A few months later, the Band was doing a tour, and we were going to play Boston, and Van was on the show. I always wanted us to play a show together, so when he went on, I went out into the hall to catch him. It was great to hear those songs live, and he was singing his little Irish soul out. Then, about halfway through, he was in this real emotional part of one of the songs, and he got down on the floor of the stage, and was singing from the floor. When the song was over, he stayed on the floor, and sang the rest of the show laying on the floor.

"A while back, my man Van was doing a concert here in L.A., and I hadn't heard him or seen him in a while, so my wife, Dominique, and I thought we'd go check him out. We arrived at the hall, and one of Van's crew said he wanted me to go to the dressing room before going out and taking my seat. Well, we went back, and he was there all alone, and we talked for a few minutes about nothing in particular. Finally, Van said, 'Why don't you come up and play a song with me tonight?' And I told him, 'Aw, jeez, I'd rather just sit back and enjoy the show.' And he said, 'Come on, we'll do 'Caravan.' You know that one.' I said, 'If I have to come up and play, it's going to be a distraction; that's all I'm going to be thinking about for the whole show, and I won't be able to enjoy it the same way.' He said, 'I'm asking you as a friend to come up and play. I'll tell you what. I'll do the whole show, then you just come up in the encore,' and explained that in the middle of the song, he would break it down real quiet, and that he wanted me to come out and start playing. So before the encore, we went backstage, and they had this guitar all ready, and he repeated the arrangement idea to me again. So he went back out and started doing the song—but he was doing it, like, 190 miles an hour, and I thought, 'You can't play nothing at this tempo.' And it went on, and on, and on, and then he ended it. I thought he forgot, and I was off the hook, but then they started playing some jazz song; then Van steps up to the mic, and with great flare, introduces me.

"Now, if you're gonna do a jazz song, I'm not the one to call. So I walked out on the stage, where I wanted to assassinate him on the spot, and said to him, 'What the hell is this?' And he kind of twirled around and said, *'I don't know.'* Then I remembered back when we first met, and he asked where I learned to play like that, and I said, 'I don't know,' and I thought, well maybe this is a payback.

"So anyway, I was trying to figure out what key they were in, what the chords were, and this god-awful sound was coming out of my guitar, and Van was saying, 'That's it, that's it,' and the guys in his band were yelling, *'You got it, man! You got it!'* And I thought it sounded like Yusef Lateef on acid. But then it started making some kind of strange sense, and pretty soon the audience was yelling and standing up, and it was like being in a nightmare from jazz hell. Then all of a sudden, he grabbed the mic, danced over to me, and sang in my face, 'What a marvelous night for a Moondance . . . ' And then I knew where we were. When the song was over, he whispered to me that he had some plans for us after the show. But this time, I got up and left, and Dominique and I escaped into the night. So that's what kind of man we're dealing with here.

"Van Morrison's body of work is astounding; it speaks for itself. We don't need to name off these songs—we all know how it affects us. And in the tradition of the great Irish poets and the great soul singers, he is the Caruso of rock & roll."

## BILLY CRYSTAL ON MILT GABLER:

"I'm about to introduce an eighty-two-year-old man who's in better shape than Keith Richards. How does he fit into this group? Well, in my opinion, if anyone deserves the word *legend* before his name, it's the great record pioneer Milt Gabler. I might be a little prejudiced because I'm his nephew. In the scope of his career, it's like trying to stuff a cloud into a suitcase. It's impossible. The career started in 1926, when he was just in high school, and working in the Commodore Music Shop, which was a radio store, and it sold novelty items, and it was run by his dad, my grandfather. And Milt said one day, 'We should sell records here,' to which my grandfather, a very astute businessman, turned to him and said, [*hacking*] 'Blluuuurgggh!' So they started reissuing other people's records, and then my uncle during that period of time acquired something which would hold him in great stead: taste. In 1938 he said, 'Let's make our own records.' So he got the legendary jazz guitarist Eddie Condon and Bobby Hackett, a great trumpet player, six other guys, and they made six improvised sides, and Commodore Records was born.

"It's the premier independently owned jazz label of its time. And it made the Commodore Music Shop the place to hang out in New York. Everybody hung out there, including me and my two older brothers. Milt said that jazz taught him many things. And I'm quoting him, he says, 'The most important thing for me, I learned how to listen, and listen hard. The thrill I get from jazz is never knowing where it's going. I can never tell when I'm going to be lifted right out of my seat.'

"It was during his Commodore years that he lifted a lot of people out of their seats. It's when he recorded such artists as Ben Webster, Coleman Hawkins, Lester Young, Benny Goodman . . . and, of course, his greatest achievement, 'Strange Fruit,' with the great Billie Holiday. 'Strange Fruit,' as most of you know, is a lyric that deals with racism, and it's a very ugly, penetrating song, and a lot of producers and labels wouldn't touch it. She only entrusted it to my Uncle Milt.

"In 1941, he left the running of the music store to my dad, and he went over to Decca Records, where the career really blossomed. In thirty-one years, he produced twenty-one records that sold over a million copies each, and another twelve that sold a million each, but were never certified, because there was no RIAA to certify them. The hit records are an amazing cross section of American music. Probably the one that has gotten him into the Rock and Roll Hall of Fame, and probably the badge of rock & roll: Bill Haley and the Comets' 'Rock Around the Clock,' and the sister record, 'Shake, Rattle, and Roll.' Some producers will sit in the booth and just go, 'That was good, let's just do one more.' But then there are other people who crawl into the soul of an artist and pull out stuff that even the artist didn't know was there. And that's what makes them legendary.

"I always loved making my Uncle Milt laugh, because he had seen it all, and he's a tough audience. He, along with my father, filled our house with great stories and great jazz artists. He is an inspiration to me and always has been. He introduced me to all kinds of music and musicians, but most importantly to the thrill of creating. It was this exposure to great artists that made a shy, short little kid want to become an entertainer. He once said to me, 'Kiddo, I've been in the business for over fifty years, and I'm still digging it, I'm still listening. The important thing for me was taste and integrity. The artists had faith in me, and I knocked myself out for them—not that I loved it, but I wouldn't have it any other way.' Ladies and gentlemen, I present to you my mom's big brother, Milt Gabler."

## MUSICAL HIGHLIGHTS

In addition to Cream, the other band that audience members hoped to see reunited, Creedence Clearwater Revival, did not play together. They'd had an acrimonious split, and for years Fogerty refused to play any Creedence songs due to a publishing dispute. As David Wild and Jeff Ressner reported in *Rolling Stone*, Fogerty "chose to deliver a miniset of Creedence classics—'Born on the Bayou,' 'Green River,' and 'Who'll Stop the Rain,'—with all-star help instead [Springsteen, Robertson, and the house band]. [Doug] Clifford and [Stu] Cook, who had found out only that afternoon that they wouldn't be playing, exited the ballroom during the set and expressed anger over the slight. 'Right now I feel pretty hollow,' said a shaken Clifford. 'John refused to play with Stu Cook and myself because he doesn't like us. What can I tell you? Creedence was inducted, not John Fogerty. The love in the grooves will never be taken out by the hate in his heart.'"

Conversely, the Cream reunion lived up to everyone's expectations and set the stage for future reunion shows at the Royal Albert Hall and Madison Square Garden. All their past feuding seemed to be forgotten. The band played a sizzling "Sunshine of Your Love," "Crossroads," and "Born Under a Bad Sign," the latter of which Clapton dedicated to the recently deceased guitarist Albert King. After Cream closed down the joint at 1 A.M., producer Rick Rubin, whose work with Johnny Cash would soon bring the Hall of Famer back into the spotlight, told *Rolling Stone*, "I got to hang out with Phil Spector and hear John Fogerty sing! What could be cooler than that?!"

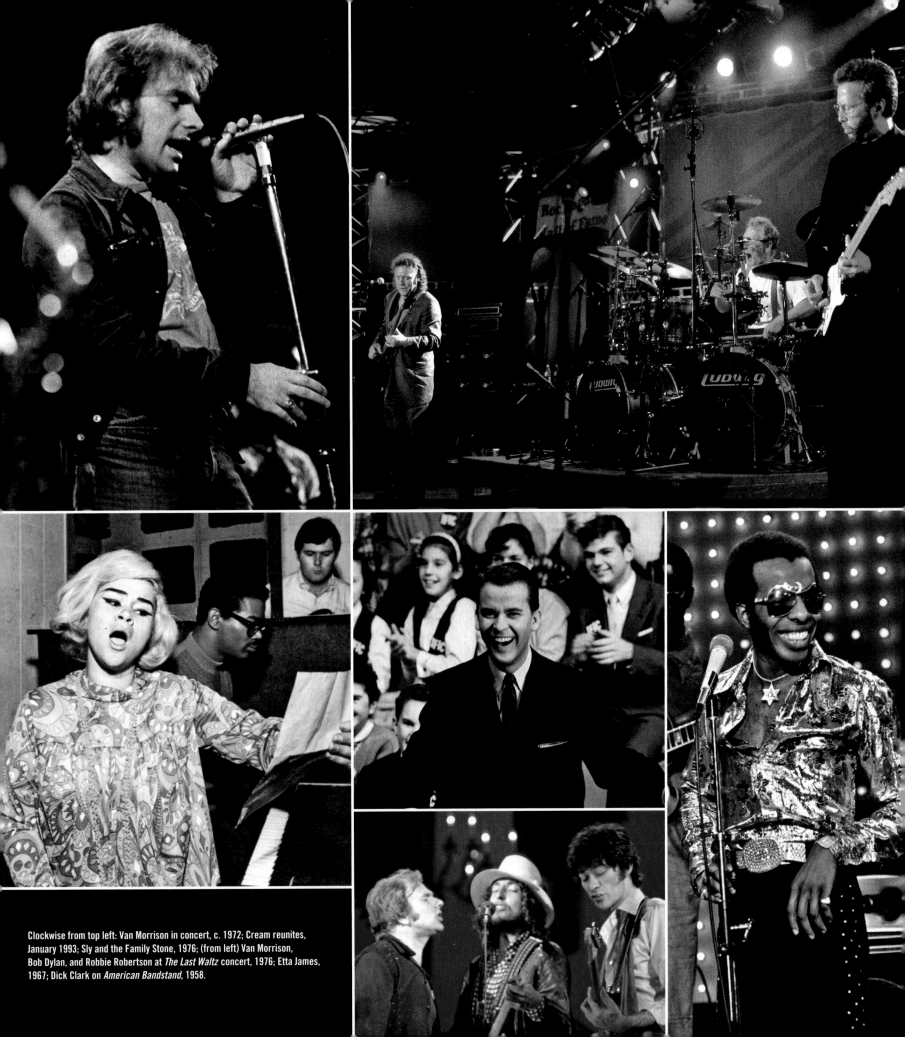

Clockwise from top left: Van Morrison in concert, c. 1972; Cream reunites, January 1993; Sly and the Family Stone, 1976; (from left) Van Morrison, Bob Dylan, and Robbie Robertson at *The Last Waltz* concert, 1976; Etta James, 1967; Dick Clark on *American Bandstand*, 1958.

## INDUCTEES

**PERFORMERS** The Animals ✦ The Band ✦ Duane Eddy
Grateful Dead ✦ Elton John ✦ John Lennon
Bob Marley ✦ Rod Stewart
**EARLY INFLUENCE** Willie Dixon
**NONPERFORMER** Johnny Otis

A natural disaster had a major effect on the January 19 induction ceremony: A massive earthquake had hit the Los Angeles area two days earlier, closing the airports and causing many to cancel their trips to New York, including inductee Rod Stewart. Adding a bit of levity to the situation, to fill in for him, his old band mate Jeff Beck flew in from England with "all this crap written down here on a sick bag." He went on to say, "You can have the schmaltzy speech if you like, or the truth about Rod." He also had a few choice words for his label, Epic Records, saying, "Rod [once] tried to get a contract with Epic, and they turned him down. Just imagine, if he had signed, he would have wound up like me, with no record sales!"

Another artist who didn't make it was Jerry Garcia, for the simple reason that he didn't care for the idea of rock & roll institutions. Unfortunately, he didn't talk to Eric Clapton, who had said the previous year, "I don't believe in institutions. It seemed to me that rock & roll shouldn't be respectable. [But] a friend of mine, Robbie Robertson, pointed out to me that minor and major miracles take place here." To make up for Garcia's absence, the Dead brought along a life-size cardboard cutout of him to prop onstage. Animals vocalist Eric Burdon also didn't show, reportedly honoring a gig in Dusseldorf, Germany, and begging the question—quipped Jancee Dunn in *Rolling Stone*—"Artist of principle or crazy man?" Minus the absent Levon Helm and the late Richard Manuel, the Band played together with Robertson for the first time since *The Last Waltz* and were joined by their presenter and biggest fan, Eric Clapton.

Elton John showed up to collect his Hall of Fame statue, but called his songwriting collaborator Bernie Taupin to the stage and gave it to him, along with a heartfelt embrace. "Without Bernie, there wouldn't have been any Elton John at all," he said. The most moving induction, though, came when Paul McCartney, making his first Hall of Fame appearance, read an emotional "letter" to John Lennon, which had McCartney's wife, Linda, and nearly everyone else weeping. Yoko Ono and McCartney had clearly mended fences, and their congeniality was a nice change from the friction six years earlier when the Beatles were inducted. Usual mainstay Ahmet Ertegun was recovering from surgery and missed the proceedings for the first time.

# "THE [BEATLES] WERE BIGGER THAN... BUDDHA."
## —YOKO ONO

> ## "IT'S BEEN LONG, IT'S BEEN STRANGE, AND IT'S DEFINITELY BEEN A TRIP!"
> ### —PHIL LESH

### DAVE PIRNER OF SOUL ASYLUM ON THE ANIMALS:

"A lot of you probably remember where you were when you first heard 'The House of the Rising Sun.' This reaffirms my suspicion that when the Animals came on the scene in 1964, the year I was born, their sound was not only fresh but riveting. The Animals embraced a rage and darkness that could only be inspired through their devotion to blues music. They can now be recognized as a key link in the evolution from black R&B to punk rock. Upon listening to a live recording of the group, I heard a band possessed by the moment, reveling in the joys of being pissed off. This elusive duality of anger and exuberance is something I often find myself trying to explain. When I find it, I know it's the key element that makes playing in a band so much fun."

### THE ANIMALS:

**Chas Chandler:** "In 1964, we were very lucky to be given the job of going out on tour, with our own spot, with a guy called Chuck Berry, who was doing his very first tour of England. It was just before that tour, actually, that we decided we had to try to find a song that would make Chuck notice us. When we worked out the song 'House of the Rising Sun,' he did notice us. In fact, we spent six weeks on the bus with Chuck, and learnt so much from the man. We actually learned the first rule of rock & roll: Get the money!"

### ERIC CLAPTON ON THE BAND:

"I want to talk about what it was like to be a musician—a serious musician who couldn't be in the Band. That was tough, that was hard. I remember being on tour in about 1966 or 1967 with a band called Cream, and we thought we were the bee's knees. I knew this man in L.A. who had a tape by a band called the Crackers, and he lent it to me, and I took it on the road with me, and it became my drug. When we would get to the end of a gig, Jack and Ginger would go off and do their stuff, and I'd put this tape on. I'd go into another world. It was my kind of release. For someone like me, who had been born in England and worshipped the music from America, it was very tough to find a place to belong in all this—and this band on this tape had it all. They were white, but they seemed to have derived all they could from black music, and they combined it to make a beautiful hybrid. It was serious, and it was grown-up, and it was mature, and it told stories, and it had beautiful harmonies, fantastic singing, beautiful musicianship without any virtuosity. Just economy and beauty. I wanted to be in the Band.

"So I went and told Jack and Ginger that I couldn't go on anymore. There was something else happening and I had to bow out. And I went—Robbie and the boys will never know this—but I went to visit the Band in Woodstock, and I really went there to ask if I could join the band. I didn't have the guts to say it—I didn't have the nerve. I just sort of sat there and watched these guys work.

"I remember Robbie saying, 'We don't jam. We don't jam, so there's no point in sitting here and trying to, you know . . . we just write and work.' I was very impressed, and from that day, I spent the rest of my career—until *The Last Waltz,* anyway—trying to find ways to imitate what they had. It was an impossible dream, really, because from where I came from, and from where they came from, completely different worlds. But it was something to do with a principle that I got from what they did, which was integrity. Integrity and a standard of craft that really didn't bow down to any kind of commerciality, and I really identified with that, and I adored it.

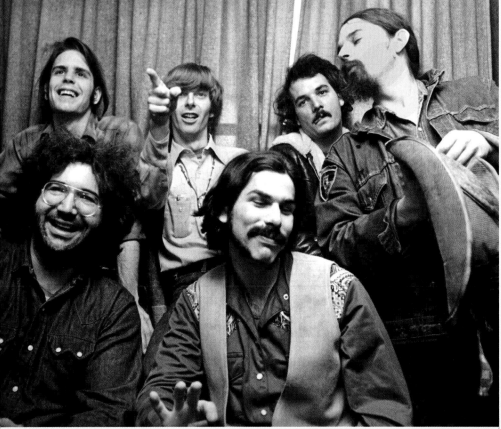

Previous, page 82: Paul McCartney inducts John Lennon, January 1994. Page 84: poster for the Grateful Dead at the Fillmore, 1966. Page 85: the Animals, 1964. This page, clockwise from top left: the Grateful Dead: (front) Jerry Garcia, Mickey Hart, (back, from left) Bob Weir, Phil Lesh, Bill Kreutzmann, and Pigpen; the Dead at their induction with life-size cardboard Jerry; the Band: (from left) Garth Hudson, Rick Danko, Richard Manuel, Levon Helm, and Robbie Robertson; the Band in concert, 1974; Grateful Dead at the Avalon Ballroom, poster by Stanley Mouse and Alton Kelley.

"At the same time, it was very hard; it was very hard to not be part of it, until *The Last Waltz*, and in some respects, I was very relieved with *The Last Waltz*, because it meant that there wasn't a band that I wasn't a part of anymore. I could just go on and be *me*, and it was all right. At the same time, when *The Last Waltz* happened, it was a tragic thing, because as much as they may have reached the end of their journey, there were no more records. I couldn't go to the store and buy a Band album and have my life transformed by listening to it.

"It's been a long journey since then without their guidance, because I always looked up to them as older brothers in the music world. But at the same time, they've always been there in spirit. And I go back and I listen to old records all the time. In fact, most of the time I listen to old blues and old records by people like the Band. It's been a long time since they were really honored. It's a beautiful thing to have a reunion if we can, and get together and rejoice in the gift that we've been given, which is music."

---

# "I'VE HATED TIE-DYE ALL MY LIFE!"
## —BOB WEIR

---

## THE BAND:

**Robbie Robertson:** "First I would like to say how grateful I am for the opportunity to make music and records with Rick Danko, Garth Hudson, Levon Helm, and Richard Manuel. I'm convinced now, as I was then, that nobody in the world could sing and play the songs that I wrote with as much believability and soulfulness as they have. It's an honor to be inducted into the Rock and Roll Hall of Fame, just to be mentioned alongside the recording artists that have been such a tremendous influence upon us. Muddy and Elvis and Chuck and Buddy and Ray, and Mahalia Jackson, who I hope will be acknowledged next year. We should thank Ronnie Hawkins for being so instrumental in us coming together, and for teaching us the code of the road, so to speak. Bob Dylan for not caving in when we were being booed everywhere we played. I'd like to thank Capitol Records for gambling on a band with no name, Mo Ostin for supporting *The Last Waltz*, David Geffen for helping reunite Bob and the Band, and Albert Grossman for his kitchen, and his guidance, and for actually starting the whole Woodstock thing. If it wasn't for Albert, the festival might have been called 'Poughkeepsie.' The 'Poughkeepsie Generation'—it just doesn't quite have the same ring to it. I'd like to thank my friend Martin Scorsese for lending his filmmaking genius to *The Last Waltz*. Of course, all the great artists who performed in the film, and Eric Clapton, for being so gracious to induct us this evening."

## BRUCE HORNSBY ON THE GRATEFUL DEAD:

"A lot's been written about these guys, often discussed in terms of the sort of sociological or cultural phenomenon aspects: the vast undulating, throbbing, tie-dyed masses, and the entire subculture that surrounds and follows the band. But I'd like to deal with the band's music, from the point of view of a fan, someone who was a fan for fifteen or twenty years, who then ended up playing music with them. In 1974, as a nineteen-year-old college student, I went to see the Grateful Dead play in my hometown. At the end of the five-hour show, Bobby Weir walked up to the microphone and said, 'We had so much fun tonight that we're gonna come back tomorrow night, take out all the seats, and play for free.' That was really it for me. From that point on, I was a real fan. My friends and I did come back for the second free night, where they didn't repeat one song from the night before. And still don't, as some know.

"The Dead has always been about more than rock & roll: about artistic curiosity and freedom, and has always been interested in and involved with the musical gamut of the world. From Mickey Hart's world music projects, to Garcia's bluegrass projects, to their Rex Foundation—a charitable organization that, among other things, gives grants to obscure twentieth-century classical composers, as well as such varied musicians from other musical areas—they've always been more than just a rock band. Speaking of world music, picture Mickey Hart, Bill Graham, and Basketball Hall-of-Famer Bill Walton riding around on camels, around the sphinx, in Egypt, when the Dead played there years ago. These guys have truly always gone their own way.

"But in the end, it would always come back to closing the concert night with a Chuck Berry song, or 'Not Fade Away,' or a Dylan song, or 'Turn On Your Lovelight.' Rock & roll has supposedly always been about freedom. To me, the Grateful Dead changed the idea of a rock show from something really rather strict and calculated to something very loose, unstructured, antipop: a less formal and spontaneous approach to a rock show; a rare situation where they play a show, where the music is always up for grabs. Believe me, I know about this. There were many times when I would be onstage with these guys, and I didn't know what the hell was happening. Billy Kreutzmann would have to give me some sort of sign, some sort of hand signal, 'We're going here, Bruce; go there with us.' That's freedom and spontaneity, and it makes for many more special musical moments than would occur if you just played the same rote show every night. How many groups would ask a musician to come off the street, namely me, and let him play all night, every night, with no rehearsal, knowing that I only knew about a quarter of the songs to begin with? That's loose. There's nowhere else I know of, where in front of the aforementioned tie-dyed masses, you can play one song for an hour. Once I started playing with them, I realized that they were on the inside just as I had imagined them on the outside: a bunch of really good people, with some great songs, and a really unique approach. As the bumper stickers have proclaimed for over twenty years, there is really nothing like a Grateful Dead concert.

"The Dead show, to me, is about the best party you can go to—the modern-day three-ring circus, the modern-day tent show, something much more than just a rock show. They are also unique in the sense that, unlike almost anyone ever inducted into the Rock and Roll Hall of Fame, the Dead exist virtually completely outside of the record business. A very nice place to be sometimes. These guys have been together for twenty-eight years—an amazing feat in and of itself. They've been through an awful lot in over a quarter-century of time together, and in that time, have been graced with the talents of several members no longer with us, who should be remembered for the good years spent with the group: Ron "Pigpen" McKernan, Keith Godchaux, and Brent Mydland. And also, let us not forget the current keyboard player, Vince Welnick, and a guy from the early days, Tom Constanten, who are also here tonight. Through it all— the tough times and the mostly great times—they've been the true renaissance band, and frankly, I don't understand why they didn't get into this thing last year. Ladies and gentlemen, here's to the Grateful Dead and another twenty-eight years."

> ## "A LOT OF PEOPLE THOUGHT THAT ROD AND I HAD A LOVE/HATE RELATIONSHIP. THIS IS TRUE, THIS IS TRUE. HE LOVES ME AND I HATE HIM."
> —JEFF BECK

## BONO ON BOB MARLEY:

"I know claiming Bob Marley as Irish might be a little difficult here tonight, but bear with me. Jamaica and Ireland have a lot in common: Naomi Campbell, Chris Blackwell, Guinness, a fondness for little green leaves—the weed. Religion. The philosophy of procrastination—don't put off till tomorrow what you can put off till the day after. Unless, of course, it's freedom. We are both islands, we were both colonies. We share a common yoke—the struggle for identity, the struggle for independence, the vulnerable and uncertain future that's left behind when the jackboot of empire has finally retreated. The roots, the getting up, the standing up, and the hard bit, the staying up. In such a struggle, an often violent struggle, the voice of Bob Marley was a voice of reason.

"So when I heard Bob Marley first, I not only felt it, I felt I understood it. It was 1976 in Dublin, and we were listening to punk rock. It was the Clash that brought them home to us, and that E.C. cover version of 'I Shot the Sheriff.' These were love songs you could admit listening to; songs of hurt, hard but healing; Tuff Gong. Politics without rhetoric, songs of freedom where that word meant something again, new hymns to a dancing god, redemption songs. A sexy revolution, where Jah is Jehovah on the street level—not over his people, but with his people. Not just stylin'—*jammin'*. The Lion of Judah, from Ethiopia, where it all began for the Rastaman, where everything began—well, maybe. . . .

"Mental slavery ends where imagination begins. Here was this new music, rockin' out of the shantytowns, born from calypso, and raised on the chilled-out R&B beamed in from New Orleans. Lolling, loping rhythms, telling it like it was, like it is, like it ever shall be. Skankin', ska, blue beat, rock steady, reggae, dub, and now ragga. And all of this from a man who drove three BMWs. BMW—Bob Marley and the Wailers, that was his excuse.

"Rock & roll loves its juvenilia, its caricatures, its cartoons—the protest singer, the gospel singer, the pop star, the sex god, your more mature messiah-types [*laughs*]. We love the extremes, and we're expected to choose. The mud of the blues or the oxygen of gospel, the hellhound on our trail or the band of angels. Well, Bob Marley didn't choose or walk down the middle. He raced to the edges, embracing all extremes, creating a oneness—his oneness. One Love. He wanted everything at the same time, and *was* everything at the same time: Prophet. Soul rebel. Rastaman. Herbsman. Wildman. A natural mystic man. Ladies' man. Island man. Family man. Rita's man. Soccer man. Showman. Shaman. Human. *Jamaican!*"

## CHUCK BERRY ON WILLIE DIXON:

"When I first met Willie, it was at Chess Records, May 15, 1955. I remember the day so well because I didn't even know you got paid for writing music. And Willie…I had no idea he was so big—in music, that is; well, he was also big in size. But Willie had written five thousand songs for Muddy, and Muddy was my idol. He's the one who told me to go to Chess Records, and play for them, and they'll let you make a record. Willie was on the first twenty records that I ever recorded. And it's that distinguishable upright bass that says *boom-boom-boom-boom,* and only Willie could play it like that. And it made a hit. So he made me what I am, so far as the basics of my music."

## ETTA JAMES ON JOHNNY OTIS:

"Forty years ago, Johnny Otis was the man who discovered me, in San Francisco, when I was fifteen years old. I was in a group called the Peaches. Together, he and I wrote my first hit record, 'Dance With Me Henry.' Johnny Otis was the man who got me started, and I've come here tonight to say thank you, Johnny. You deserve this. You've got a big heart and a beautiful musical mind. Johnny Otis is a brilliant bandleader. He plays all the instruments, he writes, he arranges, and when it comes to R&B and jazz, he's a sure-enough guru. The man is bad. He's a teacher, he's a preacher—believe me, Johnny can preach—he knows how to pray. And my prayer tonight, Johnny, is to thank the Lord for letting us get this far; for letting us live long enough so we can be here honoring you and the wonderful music that you gave the world."

## JANN S. WENNER ON JOHN LENNON:

"Probably there is no single figure more important in the history of rock & roll than John Lennon. He didn't invent it, nor did he embody it in that towering way that Elvis or Chuck did, but he did more than anyone else to move it forward and give it a conscience. As a Beatle, he helped shape the agenda of the sixties, socially, politically, no less than musically. As a solo artist, John made music that disturbed, and soothed, and provoked, and saw community. As a human being, he was an exemplar of honesty. His was not an untroubled life; but he never dishonored his art, he never glossed over his pain, nor did he ever temper a strongly held belief. His impact remains universal, and his impact is undiminished. Many of his post-Beatle compositions—'Give Peace a Chance,' 'Instant Karma,' 'Imagine'—have rightly become international rock & roll anthems. They're born of tough-minded realism, they've got cosmic epiphany, and a hard-won idealism.

"John found love and surrendered to it when he met Yoko Ono. Their relationship endured challenges from within and without, and they became one of the most touching and mythical of twentieth-century romances. They were gallant in doing what were in effect performance-art pieces, records, bed-ins, bag-ins, happenings, billboards that read WAR IS OVER IF YOU WANT IT, as they went to spread their message of peace. In the end, although John was a complicated man, he chose to uncomplicate his art, to figure out his life, and in the process, he merged the two. It broke our hearts the day he died. He touched and enriched my life very deeply—personally, professionally, and spiritually. And for all he did for the world of music and the world we live in, we're all forever in your debt, John Lennon."

## PAUL McCARTNEY ON JOHN LENNON:

"It's a privilege for me to be able to do this tonight, and come here, so I've got some random memories in the form of a letter to John.

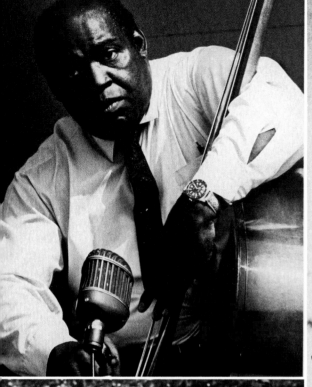

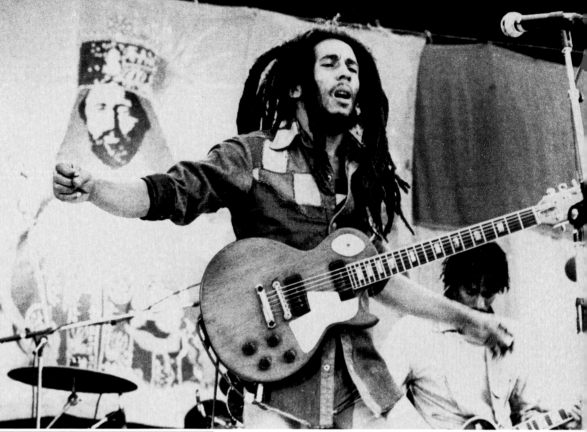

Clockwise from top left: Willie Dixon; Bob Marley; John Lennon and Yoko Ono, London, 1969; Elton John, 1983; Rod Stewart; and a Johnny Otis album.

"Dear John, I remember when we first met in Woolton, at the village fête. It was a beautiful summer day, and I walked in there, and you were on the stage, and you were singing 'Come Go With Me,' by the Del-Vikings. But you didn't know the words, so you made them up. 'Come go with me to the penitentiary'; it's not in the lyrics.

"I remember writing our first songs together. We used to go to my house, my dad's house, and we used to smoke Ty-phoo tea with this pipe my dad kept in a drawer. It didn't do much for us, but it got us on the road. We wanted to be famous. I remember the visits to your mum's house, Julia—she was a very handsome woman, very beautiful woman, she had long red hair, and she played a ukelele. I'd never seen a woman who could do that. I remember having to tell you the guitar chords, 'cause you used to play the ukelele chords.

"And then on your twenty-first birthday, you got one hundred pounds off of one of your rich relatives up in Edinburgh, so we decided we'd go to Spain. We hitchhiked out of Liverpool, and we got as far as Paris. We decided to stop there for a week, and eventually got our hair cut by a fellow called Jurgen. And that ended up being the Beatle haircut. I remember introducing you to George, my schoolmate, and him getting into the group by playing 'Raunchy' on the top deck of the bus. You were impressed. And when we met Ringo, who had been working the whole season at Butlin's Holiday Camp, he was a seasoned professional. But the beard had to go, and it did.

"Later on we got a gig at the Cavern Club in Liverpool, which was officially a blues club. We loved the blues, but we didn't know any blues numbers, so we had to do little announcements like, 'Ladies and gentlemen, this is a great Big Bill Broonzy number called "Wake Up Little Susie." They kept on passing up little notes: 'This is not the blues, this is not the blues. This is pop.' We kept going. And then we ended up touring with a bloke called Larry Ponds, who gave us our first tour. Thank you, Larry. And we all changed our names for that tour. I changed mine to Paul Ramone, George became Carl Harrison, and although people think John didn't really change his name, I seem to recall he was Long John Silver for the duration of that tour. Bang goes another myth.

"We'd be in the van touring later, and we'd have the kind of night where the windscreen would break. We'd be on the motorway going back up to Liverpool. It was freezing. So we'd have to lie on top of each other in the back of the van, creating a Beatles sandwich. We got to know each other. These were the ways we got to know each other. We got to Hamburg, and met the likes of Little Richard, Gene Vincent. . . . I remember Little Richard inviting us back to his hotel. He was looking at Ringo's ring, he said, 'I love that ring,' he said, 'I've got a ring like that. I could give you a ring like that.' So we all went back to the hotel with him, and we never got a ring. We went back with Gene Vincent to his hotel once, and it was all going fine until he reached out in his bedside drawer, and he pulled out a gun. And we said, 'We've got to go, Gene—we've got to go.' And we got out quick.

"And then came the USA, New York City, where we met up with Phil Spector, the Ronettes, the Supremes, our heroes, our heroines. And then later, in L.A., we met up with Elvis Presley. For one great evening, we saw the boy. We saw him on his home territory, and he was the first person I ever saw with a remote control on a TV. He was our hero, man.

"Then later, Ed Sullivan. We wanted to get famous; now we were getting really famous. I mean, imagine meeting Mitzi Gaynor in Miami. And later, after that, recording at Abbey Road. I still remember doing 'Love Me Do,' because John officially had the vocal, 'love me do,' but because he had the harmonica, George Martin, in the middle of the session, suddenly said, 'Will you sing the line, "Love me do?"' It was the crucial line. I said, 'Okay.' And I can still hear it to this day, John [miming harmonica], 'Waaaah, waaaah,' and I go, [voice wavering] 'Love me do-o-o-o.' Nerves, man. I remember doing the vocal to 'Kansas City.' When I couldn't quite get it, 'cause it's hard to do all that stuff, screaming from the top of your head, John came down from the control room, he took me to one side, he said, 'You can do it—you've just got to scream, you have to leave the top of your head. You can do it.' So thank you, thank you for that; I did it.

"I remember writing 'A Day in the Life,' and the little look we gave each other as we wrote the line, 'I'd love to turn you on.' We kind of knew what we were doing, you know—a sneaky little look. Oh, boy. And after that, there was this girl called Yoko. Yoko Ono, who showed up at my house one day, and it was John Cage's birthday, and she said she wanted to get a hold of a manuscript to give to John Cage, of various composers, and she wanted one from me and John. So I said, 'Well, it's okay with me, but you'll have to go and see John.' She did.

"After that, I set up a couple of machines—we used to have these Brunelle recording machines and I set up a couple of them. They stayed up all night, and they recorded Two Virgins on that. Well, you took the cover [photo] yourselves, nothing to do with me.

"Then, after that, there were the phone calls to you, the joy for me of—after all our business shit that we'd gone through—actually getting back together and communicating once again. And the joy as you told me about how you were baking bread now, and how you were playing with your little baby, Sean. That was great for me, because it gave me something to hold on to. So now, years on, here we are—all these people—here we are, assembled to thank you for everything that you mean to all of us. This letter comes with love from your friend, Paul. John Lennon, you made it. Tonight you're in the Rock and Roll Hall of Fame. God bless you, Yoko, and Sean."

## YOKO ONO:

"I'd first like to thank Paul for being here tonight. I think John would have been really pleased. It's really grand, Paul, thank you. Being inducted as a Beatle for John was to be expected. But being inducted for his solo effort would have made John very happy, because it had a very special place in his heart."

## MUSICAL HIGHLIGHTS

The jam session was back, with the ceremony returned to the Waldorf-Astoria's Grand Ballroom and Paul Shaffer and company at the helm. The blues led the way, with the Grateful Dead, Blues Traveler's John Popper, and Chuck Berry rockin' out on Willie Dixon's "Wang Dang Doodle." Whoopi Goldberg joined Bono and Rita Marley and the Wailers on "One Love." John Lennon was toasted by Axl Rose and Bruce Springsteen trading lead vocals on "Come Together," and Eric Clapton rejoined the Band for a show-closing version of "The Weight."

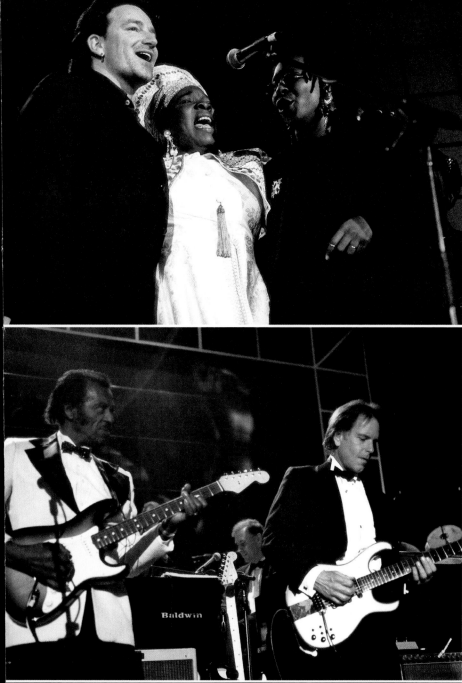

Hall of Fame induction highlights, January 1994. Clockwise from top left: Bono and Rita Marley; Duane Eddy; Eric Clapton and Robbie Robertson; Jeff Beck; Bruce Springsteen and Axl Rose; Chuck Berry and Bob Weir.

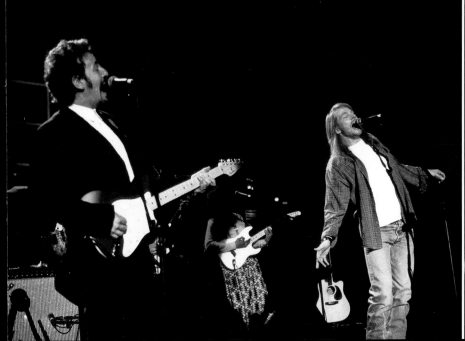

1995

## INDUCTEES

**PERFORMERS** The Allman Brothers Band ✦ Al Green ✦ Janis Joplin
Led Zeppelin ✦ Martha and the Vandellas ✦ Neil Young ✦ Frank Zappa
**EARLY INFLUENCE** The Orioles
**NONPERFORMER** Paul Ackerman

On January 12, a tenth-anniversary party was held at the Waldorf-Astoria. The first class of inductees was chosen in 1985, and now, a decade later, the Rock and Roll Hall of Fame and Museum—a masterpiece designed by I.M. Pei—was only nine months from completion in Cleveland. The gathering was a fond look back and an excited look forward. For the first time, the event was taped for a later broadcast on MTV. But that didn't stop a few raunchy stories and a bit of misbehavior.

*Rolling Stone*'s Jancee Dunn prowled the audience and reported, "Eddie Vedder gleefully spit grapes at photographers all night," just one of her many findings. From the stage, Vedder—whose band was in the midst of an antitrust lawsuit against Ticketmaster—griped about being seated close to a table with Ticketmaster brass: "I predict a food fight by the end of the evening, and I would recommend to the classy people like Lou Reed and Laurie Anderson over there to scoot away or join in. Maybe we should all join in while we've got 'em right here."

Led Zeppelin's appearance onstage elicited the most anticipation—to see if the sometimes squabbling band would make nice or put up their dukes: "There was expectant silence as spurned, bitter bassist John Paul Jones stepped up to the mic," Dunn reported. "He didn't disappoint, winning the evening's award for Best Bon Mot in an Ongoing Family Feud. Jones noted obliquely that he had not been asked to join Page and Plant's current *Unledded* reunion project, but at least they invited him to come to the Hall of Fame ceremony."

There were poignant moments, too, as when Moon Unit Zappa accepted for her father, Frank Zappa, who had died thirteen months earlier of prostate cancer at age fifty-two. Overcome, a weeping Jeff Buckley, who'd just recorded his first album, approached her backstage, frightening her with his emotionalism to the extent that security was nearly called on the then-unknown singer. Also emotional was Melissa Etheridge's inspired induction of and musical tribute to Janis Joplin. But the evening ended on a festive note with an onstage dance party, led by Martha and the Vandellas and B-52's Kate Pierson and Fred Schneider.

## "I'M NEVER GOING TO WASH THIS HAND!"
### —LOU REED AFTER SHAKING HANDS WITH AL GREEN

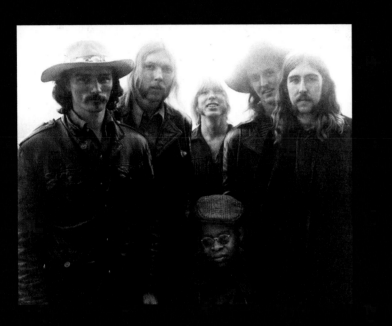

## "WHEN YOU MAKE MUSIC THAT'S HEARTFELT AND REAL, THE PEOPLE WILL RESPOND."
### —WILLIE NELSON, ON THE ALLMAN BROTHERS BAND

JANN S. WENNER:

"When we started ten years ago, we were very seriously worried that anybody would come. But it was like a field of dreams; we built it, and you came. Why has this ceremony, and why has this evening become so special to all of us? I mean, why is this night so different from all the others? The reason it is different is that the people who are involved in the day-to-day running of the Hall of Fame and that nominate and vote on the inductees, or the people in the record business, the musicians themselves, or those of us who write about it and promote it, and live it, are all people who have grown up with music and love music. This evening, then, is about honoring the music and the importance of music in our lives, and honoring the great artists who have created that music—that's been the spirit of this dinner since the first day we started. And it hasn't been easy to walk the line between commerce and art, you know, that sort of delicate place between the bottom line and our hearts. But that's what we've done, and we've tried to keep our special spirit about this dinner intact throughout these years. And that's the spirit that we hope, and we've prayed, and we've tried to make come alive in Cleveland next year, and keep that thing that's so special there.

"Our doubters over the years should know that our biggest financial and civic supporter has been the City of Cleveland and the State of Ohio. They had many legitimate reasons to think that we were really crazy. We did some crazy things. But George Voinovich, who was the mayor of Cleveland when we decided to locate the Hall of Fame there, is now the governor of Ohio. Finally, after all these years, I don't have to stand up here and promise you again that we're gonna build this thing. It's the end of making bullshit promises! This is the year that we're gonna deliver. The museum will open on Labor Day weekend; it opens to the public, the Rock and Roll Hall of Fame, and we are going to throw at that time a grand opening—an event that will bring the kind of love and fun and the spirit that we've known at these dinners all these years to the entire world.

"Before beginning tonight's ceremonies, I would like to honor a man whose friends and whose influence fill this room. And that man is Ahmet Ertegun. For me, working with Ahmet on the Hall of Fame as his partner, and sometimes just as his kind of loving assistant, has been a rare privilege. Ahmet Ertegun cofounded Atlantic Records forty-seven years ago, and he saw it grow from a one-room operation into an international giant. From the earliest days of his company, he not only led his company, but he was a distinguished songwriter and producer as well, and his label, Atlantic Records, has a history of releasing recordings that profoundly affected the course of modern music. It was originally established as an R&B label, as one of the premier R&B labels of the time, but over the years it evolved, and presented the most extraordinary and amazing diversity of artists that we've seen. Ahmet, I want to say that being around you has been one of the greatest joys of my life, and I think that you're a personal and national treasure, and every moment with you—sober or otherwise—has been a great honor. So it's my honor tonight to tell you that the Rock and Roll Hall of Fame main exhibition hall will be named after you, and will be called the Ahmet M. Ertegun Exhibition Hall."

AHMET ERTEGUN:

"I had some words prepared, but they're sort of meaningless at this point, because I never expected anything like this. I really came up here to welcome you to our tenth

Previous, page 92: Al Green, January 1995. Page 94: the Allman Brothers Band: (from left) Dickey Betts, Duane Allman, Jaimoe, Gregg Allman, Butch Trucks, and Berry Oakley. This page, clockwise from top left: Melissa Etheridge; Al Green; Martha and the Vandellas, Led Zeppelin reunion; the Allman Brothers; Frank Zappa, 1966. Following, page 96: Janis Joplin, 1967. Page 99: Robert Plant and Jimmy Page, January 1995. Page 100: Neil Young.

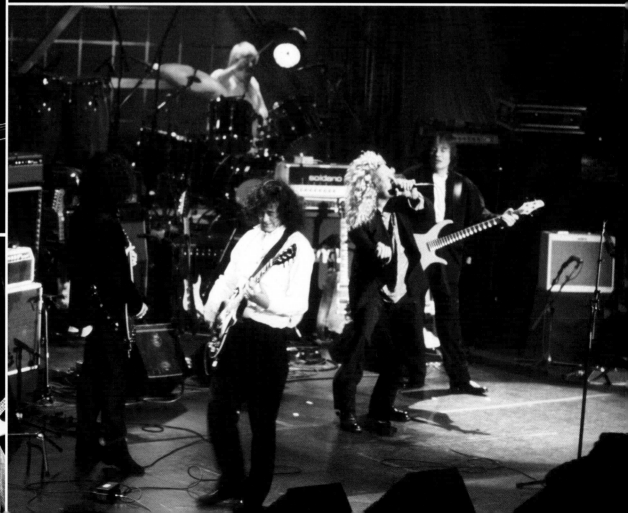

anniversary ceremony. This is a dream which started as a very, very humble effort to recognize the great talent of the people who have created the world's most popular music of all time. Rock & roll music is the music of the world, and it is a music which has been maligned over the years, and the people who have made it were never really recognized as serious and great artists, and we intended to do that. And we intended to do it in a small way. We never dreamed that it would reach these proportions.

"When I was first called and asked if I would do this—be the chairman of this new enterprise—I first called all my peers at the various record companies, and I called some of the outstanding people in the industry outside the record companies, and they were all very supportive. Without them, we wouldn't be here. They're all on our board; every important record company in America is a part of this Hall of Fame."

# "NEXT WEEK IS JANIS'S BIRTHDAY [JANUARY 19], AND THIS AWARD IS A REALLY COOL PRESENT. I JUST REALLY WISH THAT SHE WAS UP HERE INSTEAD OF ME."
## —MICHAEL JOPLIN, JANIS JOPLIN'S BROTHER

### AHMET ERTEGUN ON THE ALLMAN BROTHERS BAND:
"I first met Duane Allman on some of our sessions with Wilson Pickett, Aretha Franklin, and the late, great King Curtis, who became one of Duane's closest friends. In the heyday of the group Cream, when Eric Clapton was in his psychedelic period, dressed in multicolored garb, face painted, bleached hair, almost like a clown, I took Eric to an Aretha session at the Atlantic Studios here in New York. Aretha broke into hysterical laughter when she saw Eric and his weird clothes. I introduced him over laughter to Aretha, and to Duane Allman, who was in the band, and once Eric and Duane began to play together behind Aretha, all the laughter stopped."

### WILLIE NELSON ON THE ALLMAN BROTHERS BAND:
"The Allman Brothers Band defined Southern rock. They had tremendous influence on those who followed in their footsteps, and they could be imitated, but never duplicated. Their music was initially met with slow acceptance outside of the South, so they took it on the road, and they let the public decide what they wanted. I've always believed that if you let the people have the choice, they will always respond to good music. The Allman Brothers Band was and still are one of the most exciting live bands to ever hit the stage. They became road warriors with a vengeance, and left devoted fans wherever they went.

"Unfortunately, the band was beset by tragedy. Duane's death was a great loss, and Berry Oakley's death was another harsh blow. But the band survived and continued to make great music. More than twenty-five years later, the music not only survives, but continues to inspire, influence, and impact the music of today."

### JANN S. WENNER ON JANIS JOPLIN:
"The first time I saw Janis, she was singing in a storefront club in Berkeley, in front of about seventy-five people, and you could see she was raw, she was powerful, and she was incredibly riveting. I heard her perform dozens and dozens of times, in all kinds of small clubs, the Fillmore Ballroom, the Avalon Ballroom, and then in Golden Gate Park, and Monterey Pop. We watched her career take off, and it was great fun, and it was a great privilege to see what happened to Janis, and how it just exploded for her. But then, seeing it come to a premature and, of course, tragic end was really sad and very heartbreaking. She was one of the great voices, one of the great performers of her time, and she was a great symbol, speaking in a way that was so special for the women of that time."

### MELISSA ETHERIDGE ON JANIS JOPLIN:
"Without trying, Janis became an icon. She was the only goddess in a sea of rock gods. Posters of her were sold right next to those of Hendrix, Leary, and other heroes of the time. The posters depicted a wild thing, half nude, hair flying—an image completely different from any other woman in the public eye at that time. Janis once said she became a singer because a friend loaned her his Bessie Smith and Lead Belly records. Janis said of Bessie Smith, 'She showed me the air, and taught me how to fill it.' Before Janis died, she even paid tribute to Bessie by buying a headstone for her unmarked grave.

"Janis *was* the sixties. She was the style, sound, and inspiration for men and women all over the world. She wasn't playing a character; like the rebel in the high school in Port Arthur, she was just being herself. Even when she was a full-fledged rock star, she was ridiculed for her dress and her looks, for being different from others. Yet she never apologized, never backed away from the truth. Instead, she stood fast in her beliefs. To her fans, she was a goddess—she was the passion and power of love and freedom. Men and women both felt it, understood it, and felt understood themselves.

"I remember the first time I heard Janis Joplin. I was ten years old; my parents had just purchased the album *Pearl*. I remember listening to the songs and studying the album cover, as I wondered about this crazy woman in feathers and beads, smiling, lying on that couch.

"In 1967, Janis Joplin was strange and freakish. Today she would be hip and alternative. Because of what she did, I feel like what she did in her life at that time enabled me, when I was a young girl, in 1976, growing up, not to feel so strange about wanting to do the things I wanted to do. She gave me power in my life. We didn't need to be secretaries or housewives: We could be rock stars. I never knew Janis, I never saw her or heard her voice live, I never witnessed the fireball of fury that she unleashed onstage, but I think I understand. When a soul can look on the world, and see and feel the pain and loneliness, and can reach deep down inside, and find a voice to sing of it, a soul can heal.

"I wish the dose of heroin she had injected that night had not been accidentally ten times stronger than what her usual hit was. I wish she was here with us. I wish she was making a comeback now and doing an *MTV Unplugged,* and getting her tribute album together, and standing up for women's rights, standing up for gay rights, standing up for intolerance everywhere, against fur, or Republicans, or whatever—I think she would be doing that, I absolutely do.

"I wish she would have survived; then maybe I could tell her thank you. Thank you for traveling that road, for carrying that ball and chain, for giving a piece of her heart. I wish I could congratulate her personally—tell her she will always be a part of rock & roll history; that she helped create it, lived by it, and died by it. I wish I could say to her now, welcome. Welcome to the Rock and Roll Hall of Fame, a place you so definitely deserve to be."

## AHMET ERTEGUN ON LED ZEPPELIN:

"When Peter Grant, manager, and Steven Weiss, lawyer, came to see us about a new group formed by Jimmy Page, ex-Yardbird, we were very excited about the prospect of this new group, the new Yardbirds. They told us, however, that the group would be called Led Zeppelin. They were Jimmy Page, John Paul Jones, and from the Birmingham area, Robert Plant and John Bonham. From the first time I heard the first cuts of their first album, I knew we had something that was undeniably great. Robert Plant was a revelation, a singer who had his own style of singing great old blues as well as new songs. John Bonham, a drummer without equal. Peter Grant, their manager, was a mountain of a man, and he kept them hidden in a shroud of mystery. They became the most unapproachable band in rock history.

"They toured the world, and they went everywhere, and there were past-midnight dinner parties, groupies, champagne corks popping, and groupies, protection from imaginary devils and foes by Richard Cole, and groupies, TV sets thrown out the window, and groupies, plaster casters, and groupies, wrecked hotel rooms, shoes thrown

---

# "EARLIER, WHEN I WAS INDUCTED WITH THE YARDBIRDS, IT WAS LIKE BEING INDUCED, AND THIS TIME IT'S WITH FORCEPS."
## —JIMMY PAGE

---

out the window, and groupies, and stories that we cannot tell, and groupies—and the great Peter Grant sitting like Buddha, watching it all. Great days I'll never forget, a time in my life I'll treasure.

"The music they made is the music of today. Their influence today on young musicians is greater than ever. It is through their music that many of the young people are discovering the old blues pioneers. It all came to an end with the tragic death of John Bonham. I am proud to have been associated with this extraordinary band, who are more revered today than ever, whose music is timeless, and whose members are like my brothers."

## AEROSMITH ON LED ZEPPELIN:

**Steven Tyler:** "In 1966, my band, Chain Reaction, opened for the Yardbirds at Staples High School, in Westport, Connecticut. We all carried our equipment into the hall together; as I recall, I dragged a couple of Jimmy Page's amps, as well, so I was a roadie for the Yardbirds. Anyway, it was the first time I'd heard them play, and it hit me like a heat

wave. Three years later, in 1969, I saw Led Zeppelin perform at the Boston Tea Party. They ran out of songs after they played their whole first album, so they had to play a bunch of Elvis tunes, because we wouldn't let them get offstage. I just sat cross-legged in the middle section of 'Dazed and Confused,' and it was so fucking heavy that it made me cry. Another time I cried over Led Zeppelin was an hour later, when Jimmy Page emerged from the dressing room with a beautiful girl on his arm. I would have been very impressed, except it was the girl I had been living with up until that moment, and I was getting an incredible visual of all my clothes being thrown out into the alley on Twenty-First Street. But Jimmy was such a motherfucker onstage, I couldn't hold it against him.

"About the same time, this guy called Henry Smith, who was my neighbor in Sunapee, New Hampshire, was my drum roadie. I was a drummer back then, and one day he comes up to me, and he just quits. 'I got a gig with Zeppelin,' he says. I was devastated. Who was going to set up my drums at Murray's Clam Shack in Brattleboro, Vermont? But once I got over the jealousy, I got really excited, 'cause I knew somebody who was going to work with Led Zeppelin. That was the equivalent of going to the moon with Neil Armstrong, in an Apollo capsule full of babes. Eventually, Henry the Horse, as Jimmy and Robert affectionately called him, introduced me to the band. We went over to a sound check at Madison Square Garden. When I got there, the road crew and the union people were all eating, and the band hadn't arrived yet. The stage was empty, and so were the nineteen thousand seats. The silence was deafening. I walked out to the stage; I laid down with my head hanging backwards off the edge. I was overwhelmed. I was having delusions of rock & roll grandeur, imagining that I was roaming the countryside, raping and pillaging, disguised as an ambassador of rock & roll. And that's just one of the things we learned from Led Zeppelin. So here we are, I'm still hanging off the edge of the stage; now we get to induct Led Zeppelin into the Hall of Fame."

**Joe Perry:** "Everything you ever heard about Led Zeppelin was true. They were like Lord Byron: mad, bad, and dangerous to know. They mixed Celtic riffs with the blues, and spiced it up with Indian and Arabic modes. It was pure chemistry: kind of like Howlin' Wolf meets the Loch Ness Monster. No way was it for the faint of heart. Led Zeppelin was the real deal, and it took like Mohammed in the desert. They were even big in Vietnam, where the troops bolted 8-track players onto their personnel carriers, and went into battle broadcasting 'Whole Lotta Love.' What I loved about Led Zeppelin, besides 'Communication Breakdown,' 'The Song Remains the Same,' 'Kashmir,' 'No Quarter,' and 'The Rain Song,' and about a hundred other songs, was that they didn't take themselves all that seriously. They had a no-bullshit mentality, and no compunction about using blues music to catapult their music into Caledonia's damn knickers.

"They were simply the best musicians going. You could put Jimmy Page against any guitar player in the world. Same with Bonzo on the drums, and Zeppelin's unsung hero, John Paul Jones, on bass, keyboards, and orchestrations. His musicianship and classical slant on things gave Zeppelin an added dimension that constantly kept them in a class of their own. And then there was Robert Plant. He came to the first New Yardbirds band rehearsal, straight from his job building roads. He had tar on his hands and tar in his hair, and when he opened his mouth, it was like a fucking air-raid siren going off. Keith Moon told them it would go over like a lead zeppelin. For the next twelve years, they reigned as undisputed champions of rock, set an unattainable standard of music and mystique for those of us who tried to follow them."

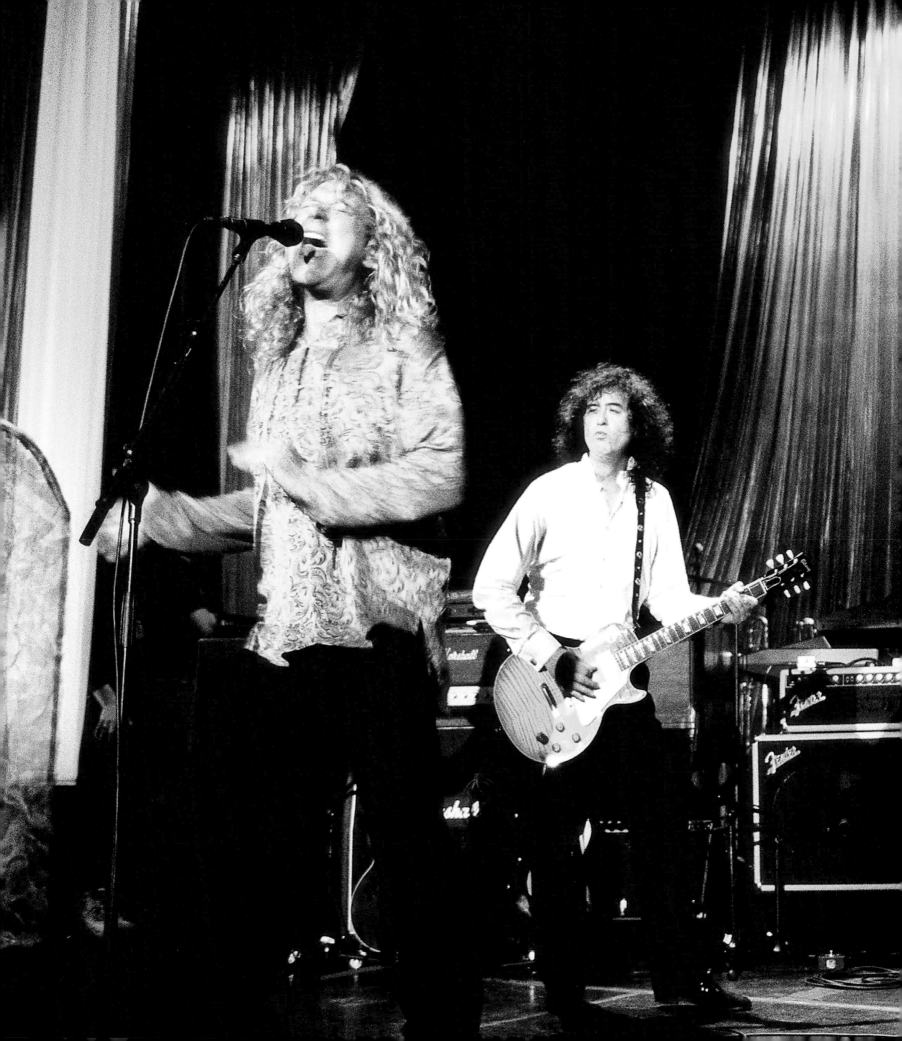

> ## "THINGS HAVE BEEN GOOD FOR ME FOR A LONG TIME, SO IF I LOOK KIND OF SAD, IT'S BULLSHIT, FORGET IT. I'M DOING GOOD. IT'S SOMETHING ABOUT MY SONGS. EVERYBODY THINKS I'M, YOU KNOW, KIND OF DOWNBEAT."
>
> —NEIL YOUNG

### LED ZEPPELIN:

**Robert Plant:** "We looked to America from an early age, and we admired the work of Howlin' Wolf, and the writing of Willie Dixon, and the playing of Muddy Waters, and the singing of the Capris. . . . The whole form of American music made such an impression, whether it was Bonzo listening to [Motown drummer] Bernard Purdy or to Lee Michaels. The whole scene in the late sixties and the early seventies was so amazingly musically varied and articulate. . . . In those times, that music was so amazing, and to be in America at that time, and to be a contributing factor to American music and the American music scene, was a great honor. The inspiration given to us by the American public was phenomenal, and I shall never forget us playing with Janis, and the Doors, and so many amazing artists, and hanging out with the Airplane, and seeing Jonesy and Jack Casady disappearing around the corner to discuss the inner movements of a bass guitar; it was a wonderful time. And all throughout our career, we had a wonderful time."

### THE B-52'S ON MARTHA AND THE VANDELLAS:

**Fred Schneider:** "This is my original record tote, and here is the record that was my downfall and my uplifting, my original copy of 'Dancing in the Street,' which I ruined on a portable Sears record player. I kept it anyway, because this is the record that changed my life. In 1964, I heard this song driving along with my parents. I was totally galvanized, and immediately when I got home, I got my transistor radio and stuck it to my ear until they played it again. As soon as it hit the charts, I drove to the A&P, to the record section, and bought it, and from that point on it was Martha and the Vandellas. Every song they ever released, I was there buying it. I found out that I could get Detroit radio on my kitchen radio. Instead of doing homework, I would just listen at nine o'clock at night to Motown. The incredible voices of Martha and the Vandellas, their songs, and their music inspired me."

**Kate Pierson:** "When I first heard the lines to Martha and the Vandellas' 'Dancing in the Street,' I went crazy. I said, '*They have got it!*' When I heard the honey harmonies of the Vandellas and Martha's mysterious voice, it was my call to party down. It meant freedom, wildness, and unity."

### EDDIE VEDDER ON NEIL YOUNG:

"I was talking to Joel Bernstein, who's Neil's comrade and coworker, and he was cataloging all of Neil's tapes from over the years, for a box set. There were tapes that were 8-tracks, and 16-tracks, and cassettes, like a thousand of them. I asked, 'Were any of them labeled?' And he said, 'Yeah, they were labeled. They were labeled "Wednesday night, Monday morning jammin' B . . . "' After it was all done, Joel ended up cataloging them by songs, like the forty best versions of 'Tonight's the Night,' and the sixty-five best versions of 'Cortez the Killer.' Neil and I were standing in this room, and we were looking at all these, and I thought he was going to take one down, and we were going to play it. He looked around, and he said, 'I gotta get out of here!' I saw a man overwhelmed by his body of work."

### LOU REED ON FRANK ZAPPA:

"It's very rare in life to know someone who affects things, who changes them in a positive way. I've been lucky enough to know some in my life: Andy Warhol, Doc Pomus, people whose vision and integrity was such that it moved the world a bit. People who, through the articulation of their talents and intelligence, were able to leave things better than they found them. Frank Zappa was such a person, and of the many regrets I have in life, not knowing him a lot better is one of them. Whether writing symphonies, satirical broadsides, or casting a caustic glow across the frontier of madness that makes up the American political landscape, whether testifying before Congress to put the PMRC in its rightful, lowly place, or acting as a cultural conduit for President Václav Havel and the Czech government, Frank was a force for reason and honesty in a business deficient in these areas.

"As we reward some with money for the amusement they supply to the cultural mass, I think the induction of Frank Zappa into the Rock and Roll Hall of Fame distinguishes the hall as well as the inductee, as does, I might add, the appointment of the hall's new director, Dennis Barrie, who defended the Robert Mapplethorpe exhibition against attacks by the misanthropic right wing of Cincinnati, while heads of other museums stood silent. This ability to not stand idle—to take a stance and

respond with the steady force of reason and humor—this is not an unimportant talent. And if it were not a talent, all good people would do it, wouldn't they? There are other things beyond the importance of who sold what, or how many records this or that year. Things such as permanence, and again, integrity, which act as inspiration for musicians, and writers, and even political figures, who are in constant need of examples, of how you live your life without selling your soul and talent to the highest-bidding maven of greed and fame.

"There is room in this world for all of us, but I wish there had been a bit more room, and certainly more time, for Frank Zappa. Who in our community will fill his shoes, to rail and articulate the myriad fallacies of Newt Gingrich? Musicians usually cannot speak—that's why they communicate through their instruments. But Frank was one who could, and because music is pure, the musician is pure as well. When Frank spoke, he demonstrated the power of purity."

---

## KATE PIERSON: "ALL RIGHT. FRED, WHAT IS A VANDELLA?" FRED SCHNEIDER: "IT'S A COMBINATION OF VAN DYKE STREET IN DETROIT, AND MARTHA'S FAVORITE SINGER, DELLA REESE."

—THE B-52'S

---

## MUSICAL HIGHLIGHTS

Willie Nelson and Al Green kicked off the "jam," still loose, but planned in advance, with a bluesy "Funny How Time Slips Away." As he promised during his induction, Neil Young got his hard-rockin' Crazy Horse onstage, where they went into garage-band mode, with a ten-minute jam on "Act of Love," followed by a Pearl Jam–backed "Fuckin' Up," "virtually guaranteeing that MTV would have a world of trouble showing a bleepless version of one of the night's genuine highlights (and one that featured some folks under forty)," Jancee Dunn noted in *Rolling Stone*.

The long-awaited Led Zeppelin set featured original members, plus Bonzo's son Jason Bonham on drums and Tyler and Perry, chugging through the Yardbirds' "Train Kept A Rollin'," "For Your Love," "Bring It On Home," "Baby, Please Don't Go," and Muddy Waters's "Long Distance Call." Robert Plant's drummer and Neil Young joined in for a kick-ass "When the Levee Breaks," followed by Buffalo Springfield's "For What It's Worth." The evening ended on a sock-hop high with Paul Shaffer and band back in the saddle to accompany Martha and the Vandellas, assorted B-52's, and others on "Dancing in the Street."

## BLUES COVERS BY THE ALLMAN BROTHERS BAND AND LED ZEPPELIN

✦ ✦ ✦

Two bands who paid allegiance to the blues on either side of the Atlantic, Led Zeppelin and the Allman Brothers Band turned on a new generation to the blues in the sixties and seventies. Here is a taste of those blue covers.

✦ ✦ ✦

### ALLMAN BROTHERS
"TROUBLE NO MORE," Muddy Waters,
*The Allman Brothers Band*
"(I'M YOUR) HOOCHIE COOCHIE MAN," Willie Dixon,
*Idlewild South*
"STATESBORO BLUES," Blind Willie McTell,
*Live at Fillmore East*
"STORMY MONDAY," T-Bone Walker,
*Live at Fillmore East*
"YOU DON'T LOVE ME," Willie Cobbs,
*Live at Fillmore East*
"CAN'T LOSE WHAT YOU NEVER HAD," Muddy Waters,
*Wipe the Windows, Check the Oil, Dollar Gas*

### LED ZEPPELIN
"GALLOWS POLE," Lead Belly,
*Led Zeppelin III*
"I CAN'T QUIT YOU BABY," Willie Dixon,
*Led Zeppelin*
"NOBODY'S FAULT BUT MINE," Blind Willie Johnson,
*Presence*
"TRAVELLING RIVERSIDE BLUES," Robert Johnson,
(as "The Lemon Song") *Led Zeppelin II*
"YOU SHOOK ME," Muddy Waters,
*Led Zeppelin*

## INDUCTEES

**PERFORMERS** David Bowie ✦ Jefferson Airplane ✦ Little Willie John
Gladys Knight and the Pips ✦ Pink Floyd ✦ The Shirelles ✦ The Velvet Underground
**EARLY INFLUENCE** Pete Seeger
**NONPERFORMER** Tom Donahue

There was much to celebrate on January 17 at the Waldorf-Astoria: The long-awaited Rock and Roll Hall of Fame and Museum had opened the previous fall in Cleveland, with a star-studded megaconcert, featuring Bob Dylan, James Brown, Aretha Franklin, Johnny Cash, and more than twenty other legendary inductees performing. Ahmet Ertegun reflected that over the years, at the annual induction ceremonies, "it became almost a joking subject, because it had to be postponed from year to year. At one point, Mick Jagger called up Jann and myself, and asked us to forget about working on our houses in the Hamptons, and try to start to build this bloody museum. Well, the museum was finally built."

Though three new inductees chose not to attend—Roger Waters of Pink Floyd, Grace Slick of Jefferson Airplane, and David Bowie—some unique performances took place throughout the evening. The Velvet Underground played their first U.S. gig in twenty-five years, a bittersweet occurrence for Lou Reed, John Cale, and Maureen Tucker, since the 1995 death from cancer of founding member Sterling Morrison. The surviving Velvets memorialized him by writing and performing "Last Night I Said Good-Bye to My Friend." And Jefferson Airplane, including original members Marty Balin, Paul Kantner, Jorma Kaukonen, Jack Casady, and Spencer Dryden, played together for the first time since 1970 (when Dryden left the band). They got audience members rocking—particularly Patti Smith, who jumped to her feet—with their high-energy version of "Volunteers," "Crown of Creation," and "Embryonic Journey."

For the first time ever, an inductee accepted without saying a word. His battered banjo hanging on his back, Pete Seeger, who was inducted after a long speech by Harry Belafonte and an amusing bit from Arlo Guthrie, just took his statuette and smiled. Madonna accepted for the absent Bowie, and Marianne Faithfull performed a raspy "Rebel Rebel" in his honor. Stevie Wonder made the induction presentation for Little Willie John after performing "Fever" with John's son (performer Keith John, a member of Wonder's band). After Patti Smith gave a poetic induction of the Velvet Underground, she and Lenny Kaye sang a moving "Pale Blue Eyes." Accepting the honor from Smashing Pumpkins' Billy Corgan, Pink Floyd members David Gilmour, Rick Wright, and Nick Mason acknowledged absent band members Roger Waters (who'd had a falling out with the band) and Syd Barrett (who suffered from debilitating mental and physical problems). Then Gilmour and Corgan performed an acoustic version of "Wish You Were Here." Corgan later told *Rolling Stone* that Gilmour had called him that afternoon to invite him to do the song, which they then briefly rehearsed. "I learned it with this weird Chinese fingering," Corgan said. "It was a little loosey-goosey."

In a tribute to Gladys Knight and the Pips, Joan Osborne, backed by Stevie Wonder, sang a powerful version of "Heard It Through the Grapevine." Faithfull, Darlene Love, and Merry Clayton, who'd been performing a musical revue at the Rainbow Room, introduced the Shirelles. The legendary, first-ever girl group performed a medley of their hits after Shirelle Beverly Lee raved, "We deserve this!" followed by the question, "What took you so long [to induct us]?"

## "THIS IS A BEAUTIFUL MAN."
### —MADONNA, ON DAVID BOWIE

> ## "INSPIRATION AND ARTISTIC FREEDOM ARE THE CORNERSTONES OF ROCK & ROLL."
> —JOHN CALE

AHMET ERTEGUN:

"On September 1, we celebrated the long-awaited opening of the Rock and Roll Hall of Fame Museum. It is a triumph of architecture and art, a special structure, which brilliantly reflects the rock & roll spirit of freedom and energy, as well as the rich cultural beauty of this music. Since the fifties when the term *rock & roll* came into common usage, this music had been much maligned by classical, as well as jazz critics all over the world. They didn't get it at first. Some of them still don't get it. As Mark Twain said about Wagner, 'This music is not as bad as it sounds.' Well, there is good and bad in every art form, and tonight we once more celebrate the great artists who have made rock & roll the world's most loved music of all time.

"Tonight also marks the eleventh year that we have gathered to acknowledge the pioneers of rock & roll. In all our well-justified excitement about the opening of the museum, it is very important that we not forget that it is these annual induction ceremonies which have provided the true soul and spirit of this foundation. The importance of these ceremonies cannot be underestimated, for it is on these wonderful evenings that we honor not only artists and their early influences, but music industry innovators as well. I would like now to introduce to you my great friend Jann Wenner, who, more than anyone, is responsible for the success of our organization. He made it happen."

JANN S. WENNER:

"I'd like to read you a letter we received today from the White House signed by the president of the United States:

"'Warm greetings to everyone gathered in New York City for the eleventh annual induction dinner of the Rock and Roll Hall of Fame. I am delighted to join in honoring this year's inductees. . . . Rock & roll is one of our nation's greatest—and most enjoyed—cultural gifts to the world. Rock is simultaneously a celebration of youthful energy and a reflection of humanity's oldest emotions. Lending their vision and talent to rock & roll from its genesis to the present day, this year's distinguished inductees have enriched our culture and moved millions of listeners around the world to dance, sing, and celebrate. I join you in saluting these legends of rock for the immeasurable gifts to our musical heritage. Best wishes for a memorable event, Bill Clinton.'

"I'm happy to report that the museum has been a terrific success. Over two hundred thousand have visited it since we've opened the doors—from music critics to architecture critics, and, of course, the fans and musicians have been enthusiastically positive. Every one of you here has every reason to be proud of what you supported for so long. The building justly and honestly reflects the debt that we owe the music and reminds us it is appropriate to its historical, social, and artistic importance."

DAVID BYRNE ON DAVID BOWIE:

"When David Bowie came along, rock & roll needed a shot in the arm. When I first saw him it was a shock, and yet it was very familiar. It was something that was needed. It was essential. And like all rock & roll, it was tasteless, it was glamorous, it was perverse, it was fun, it was crass, it was sexy, it was confusing. And like all rock & roll, it was freedom, it was pain, it was liberation, it was genocide, it was hope, it was dread, it was a dream, and it was a nightmare. It was about sex

Previous, page 102: David Bowie, 1976. This page: John Cale. Opposite: Lou Reed, John Cale, and Maureen Tucker playing together again in a rare, post-Velvet Underground performance, Paris, 1972.

and drugs, it was about combining literature with rock & roll, with art, with anything you could name. It was about sex as an idea, and sex as a reality, and sex as a liberating force. It was about rebellion, it was about rebellion as a cliché, it was rebellion as an idea. It was about rebellion as a billboard, as an advertisement. It was about the joy of reckless prophecy. It was ironic when rock & roll became self-reverential. It was about joy and terror and confusion in our lives. It was about sexual politics, sexual theater. It was a soundtrack to our lives. . . . He was both a shrink and a priest, a sex object and a prophet of doom. He was the welcome to the brave new world."

## MADONNA ON DAVID BOWIE:

"Excuse me, David Byrne, but it's also *how totally fucking gorgeous* David Bowie is! Before I saw David Bowie live, I was just your normal, dysfunctional, rebellious teenager from the Midwest, and he has truly changed my life. I've always had a sentimental attachment to David Bowie, not just because I grew up with his music, but it's because it was the first rock concert that I ever saw, and it was a major event in my life. I planned for months to go and see it. I was fifteen years old, it was the end of the school year, and leading up to the week of the show, I begged my father and he said, 'I absolutely refuse, over my dead body. You're not going there. That's where horrible people hang out,' so, of course, I had to go.

"My best friend spent the night at my house, and when we thought everyone was asleep, we snuck out of my window, which was no mean feat, as I was wearing my highest platform shoes and a long black silk cape. We couldn't drive, so we hitchhiked into Detroit, and I don't know who was scarier: the drivers that picked us up, or us in our outfits. Anyway, we arrived at Cobo Hall and the place was packed and we fought our way to our seats. The show began. I don't think that I breathed for two hours. It was the most amazing show that I'd ever seen, not just because the music was great, but because it was great theater. Here's this beautiful, androgynous man, just being so perverse—as David Byrne so beautifully put it—so unconventional, defying logic, and basically blowing my mind.

"I came home a changed woman, and my father was not sleeping and he knew exactly where I went, and he grounded me for the rest of the summer. But it was worth every minute that I sat and suffered in my house that summer. So I would just like to thank you, David Bowie—wherever you are—for inspiring me."

## PHIL LESH ON JEFFERSON AIRPLANE:

"No band is the best band in the world every night, or even most nights. Sometimes a group can rise way above themselves and perform beyond their individual capabilities. The Jefferson Airplane, when in flight, would soar far and wide and indeed, were the best in the world on many a night. Jack Casady's throbbing bass, in synch with his dancing eyebrows, the vibration entering your consciousness from the toes, headed straight to the heart, shaking your bones, making your teeth rattle, and Jorma's stinging guitar causing the hair on the back of your neck to sit straight up. Grace and Marty sailing above the pack of madmen behind them. Spencer in a Zorro hat, keeping it steady. Rooted firmly in jazz and the blues, and of course, Paul slashing away at warp-10, all twelve strings vibrating your insides. When they hit the groove, you danced."

## JEFFERSON AIRPLANE:

**Jack Casady:** "I'm going to dedicate this to the memory of my mom and dad. My dad showed me how to build an amplifier, and he'd watch me put the amplifier on the dining room table when I was about fourteen, and my mother—my best friend— came to every single show she possibly could, so this night's for her and dad."

**Jorma Kaukonen:** "I remember in 1952, my dad was stationed in Pakistan. I left to 'How Much Is That Doggy in the Window' and came back in 1956 to Elvis. Rock & roll had happened. It changed my life. And I'd like to say to the great state of Ohio, with God all things are possible."

**Paul Kantner:** "I wonder if there were any people who ever came to the Fillmore to see a *band*, if you know what I mean. We were just one of the louder people on the scene. As Grace said, she liked to be in the band because it was the least crowded place at the party. She sends you her love and wishes and says, 'What are all these old fuckers doing here?'

"I have to give a debt of gratitude to another person who's here tonight who is responsible for much of the way I personally am. A band of Lee Hays, Fred Hellerman, Ronnie Gilbert, and Pete Seeger [the Weavers], who long ago showed us all the way it was supposed to be done. We're still trying to do that today. And let's not forget Alan Freed, I said to myself. They'll never take me alive, I said to myself.

"A little eight-year-old girl in Seattle gave me a poem once that says: 'I am the wind, I am the rain, I am the lightning, and I am the thunder. I am the storm itself. I am the volcanoes who smoke and fire, I am the earth's beating heart, I am the ocean's tide, and I am the billions of people together pushing in one direction, I am the unfolding flowers, I am a new day, I am the change that's coming, nothing can stop me, ready or not, here I come.'"

> ## "THAT'S WHAT WE LOVE SO MUCH ABOUT THIS BAND [JEFFERSON AIRPLANE]. TOGETHER THEY SHARED THE MAGIC, THEY NURTURED IT, THEY PASSED IT ON."
> —MICKEY HART

## STEVIE WONDER ON LITTLE WILLIE JOHN:

"I grew up listening to the music of Little Willie John. I remember sitting on the floor day after day, listening to the different songs they would play on the radio of this great artist. I never imagined that I would not only have the pleasure of becoming an artist myself, but also have the pleasure of being blessed with knowing his son, Kevin John. The Rock and Roll Hall of Fame is such a great thing because so many times in this profession, we forget the talent of music, the goodness, the great things that have happened in life—just as many people, even today, forget

Andy Warhol

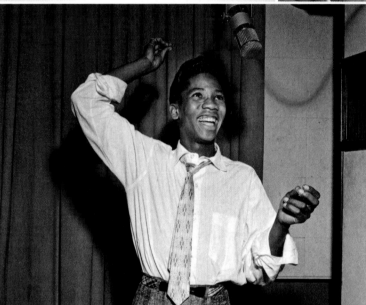

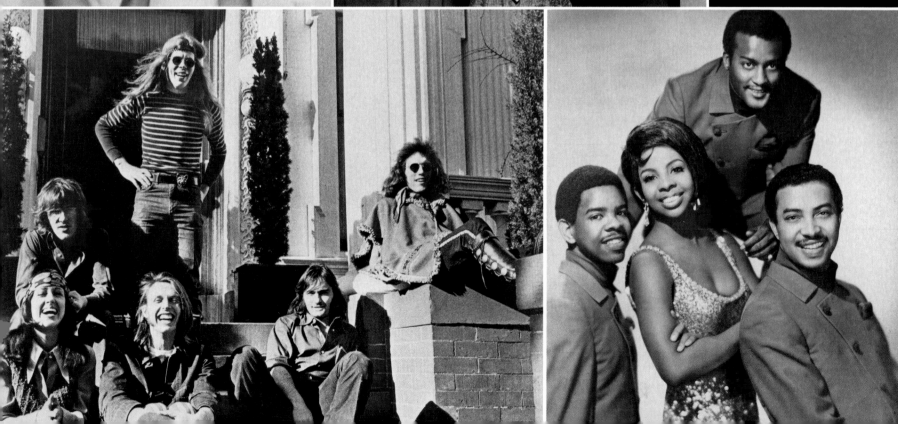

the legacy and life of Martin Luther King. This is a moment that I want you all to remember, as I will always remember it."

## PATTI SMITH ON THE VELVET UNDERGROUND:

"A silver Mylar pillow floats solemnly from the pale hands of Andy Warhol through the Factory window, across the grainy New York skyline, and the sound embodying that unheld work of art was perhaps the work of art itself—the Velvet Underground. They were the stark, elusive balloon that burst upon a deflated scene, injecting that scene with a radiance that connected poetry, the avant-garde, and rock & roll. They were a band of opposites, shooting freely from pole to pole without apology, with dissonant beauty, trampling the flowers of peacemakers. They opened wounds worth opening, with brutal innocence, without apology. Cutting across the grain—gritty, urbanic, and in their search for the kingdom, for laughter, for salvation, they explored the darkest areas of the soul and they reemerged, and they delivered us. All of these things, all of these things can be deemed romantic, but one aspect can be truly romanticized: their work ethic and the body they delivered up, which is being acknowledged this night. They are the Velvet Underground and their work is the clipper ship. They are the Velvet Underground and we salute them, and more than them, their captain, Sterling Morrison, who no doubt, in viewing these proceedings, might have a bit of mythical contempt for us all. But would also feel a secret pride, and may John Cale, Maureen Tucker, and Lou Reed share that pride, and may they be as the heroes of the song 'Waltzing Matilda,' who, when the sun rose and they made believe, *sha-la-la-la-la, sha-la-la-la-la*. Not one regretted a thing."

## MARIAH CAREY ON GLADYS KNIGHT AND THE PIPS:

"When she was four years old, Gladys Knight made her singing debut at the Mt. Mariah Baptist Church in Atlanta, Georgia. But that's not the only reason I feel a special attachment to this extraordinary singer. When I was a little girl and a budding insomniac, I used to sneak out of my room, steal a portable radio from the kitchen, hide under the covers, and sing along with 'Midnight Train to Georgia,' 'Neither One of Us,' and 'Best Thing That Ever Happened to Me.'

"The voice of Gladys Knight pulled me through a lot of lonely times, and I just wanted to thank her for that tonight. Unlike some who came after her, she's not about image or shock value. Gladys is a singer's singer. She's as real as it gets. All she has to do is stand there and sing and she'll blow you away. She doesn't have to follow trends or set them. It's all about that voice, an incredible gift from God. If you happen to hear Gladys sing and you love R&B, she's like a textbook of learning. You hear her delivery and you wish you could communicate with as much honesty and genuine emotion as she does. Even on her very earliest records—the ones I heard years later, like 'Letter Full of Tears'—her voice was so filled with experience and intensity. When she recorded that song she was only seventeen years old, even though she sounded as though she'd already seen and lived through everything."

## HARRY BELAFONTE ON PETE SEEGER:

"Some of us have looked upon art as a curious gift, a troublesome gift, an awesome gift, looking for ways in which to be able to turn this gift into some constructive use.

Many of us were fortunate that in our lifetime Pete Seeger lived. This is the second time in a year that I've had the opportunity to share a platform with Pete Seeger in a ceremony that was honoring him. The first was on the lawn of the White House. President Clinton gave to Pete Seeger the National Medal of Honor for his contributions to America as a great artist and a great citizen. What made that moment so deeply moving and touching was the fact that just a few short decades earlier, this same America, men who sat in powerful places, sought to rob this country of its soul, rob it of its truth, moved about unimpeded, crushing the lives of thousands of men and women—many of whom were artists. Pete Seeger was one of those and he stood strong, he stood tall, and those of us who were also victims of that same cruelty called upon Pete and his strength to find a way to combat this great evil through the use of art and the song.

"One night in Tennessee waiting for the Ku Klux Klan to descend upon us, Pete Seeger took out his banjo, reached into the recesses of a quiet place and brought forth a song called 'We Shall Overcome.' Dr. King was sitting there and though this song was part of his racial heritage, he did not know it when he heard Pete sing it. He said, 'What a great song for the movement.' And that's when 'We Shall Overcome' became the banner for those of us who were in the quest for justice.

"As I've been about the world, in nations where people have sought to find a place in the sun, when they sing 'We Shall Overcome,' I always think of Pete Seeger."

## ARLO GUTHRIE ON PETE SEEGER:

"It's almost fifty years ago now that 'Goodnight Irene' by the Weavers was on the charts and went to Number One, and I can't think of a single event in Pete's life that is probably less important to him, and I think he's still embarrassed by it.

"There are a lot of branches to this rock & roll thing, and somewhere in these branches is all these voices singing so many different things, and the one thing that I don't think we should ever forget—and that Pete has reminded me all of my life—is that when we sing together, nobody can take us down as a country and as a people, and as friends and families all over the world. And I just thank Pete for that."

## BILLY CORGAN ON PINK FLOYD:

"Pink Floyd are the ultimate rock & roll anomaly. They sold massive amounts of records and have always been a popular live band, but they were never a singles-driven band—a lesson forever that needs to be learned in this particular business, because they've always stood for and been about music. Why? Because it is the people who listen to music who drive the business, not the other way around. And they've always been a band who've thought about the fan first. They've always been everything that's great about rock—grandeur, pomposity, nihilism, humor, and, of course, space."

## PINK FLOYD

**Nick Mason:** "The first rule of rock & roll is, if things go well, take the credit. If they don't, blame the record company. The second rule is, if you can't get hold of the record company, blame the manager. So thank you to all of them. I think this [induction] probably means that it's official that we never, ever have to be a support act, ever again."

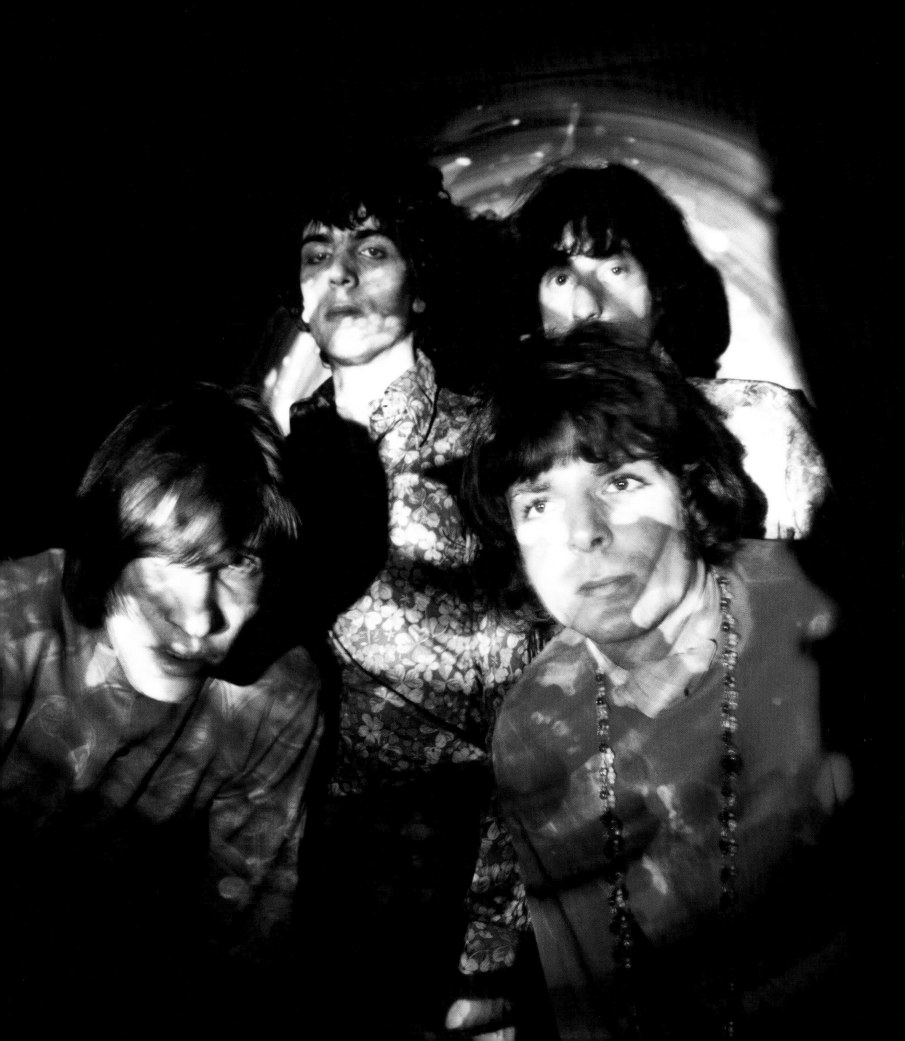

Previous, page 109: Pink Floyd: (clockwise from top left) Roger Waters, Syd Barrett, Nick Mason, and Rick Right, 1967. This page: Hall of Fame induction highlights, January 1996. Clockwise from top left: Pink Floyd's Rick Right (left) and David Gilmour, with Smashing Pumpkins' Billy Corgan (center); (from left) Pete Seeger, Stevie Wonder, Keith John, and Paul Kantner; (from left) Velvet Underground's John Cale, Maureen Tucker, and Lou Reed; Lenny Kaye and Patti Smith toast the Velvet Underground; Stevie Wonder and Keith John; the Shirelles. Opposite: Lou Reed, c. 1972.

> ## "TWO BAND MEMBERS—ROGER AND SID—HAVE STARTED PLAYING DIFFERENT TUNES AND WE'LL TAKE A COUPLE OF THESE [STATUETTES] HOME FOR THEM."
> —DAVID GILMOUR

## MUSICAL HIGHLIGHTS

With musical performances throughout the ceremony, the end of the night jam was limited to a free-for-all of diversity, with Arlo Guthrie, Stevie Wonder, David Gilmour, and Paul Kantner and other members of Jefferson Airplane singing along to "Goodnight Irene." Curiously, Pete Seeger strummed his banjo but didn't sing his Old Weavers hit. On the way out, Peter Gabriel told *Rolling Stone*, "I'm happy that rock & roll is being preserved for posterity. Because pop culture tends to see only the moment and not the history." For those who didn't want the evening to end, Phil Spector threw a late-night after party in his penthouse suite.

## THE DAVID BOWIE–LOU REED– BRIAN ENO–DAVID BYRNE CONNECTION

◆ ◆ ◆

After he quit the Velvet Underground, Lou Reed moved to England in 1971 and crossed paths with Velvets fan David Bowie. There, Bowie produced Reed's first solo album, *Transformer*, released in 1972. It spawned the Top Twenty hit "Walk on the Wild Side," and Reed and Bowie became adherents of a kind of cross-dressing glam look in the early seventies. Brian Eno, whose group Roxy Music also flirted briefly with glam, produced Bowie's trilogy of albums *Low*, *"Heroes*," and *Lodger*, and would also produce three Talking Heads albums (*More Songs About Buildings and Food*, *Fear of Music*, and *Remain in Light*) and later collaborate on an album *(Everything That Happens Will Happen Today)* with David Byrne in 2008.

## INDUCTEES

**PERFORMERS** The Bee Gees ✦ Buffalo Springfield ✦ Crosby, Stills and Nash ✦ The Jackson 5
Joni Mitchell ✦ Parliament-Funkadelic ✦ The (Young) Rascals
**EARLY INFLUENCES** Mahalia Jackson ✦ Bill Monroe **NONPERFORMER** Sydney Nathan

For the first time, the Hall of Fame induction ceremony took place at the home of the Museum, in Cleveland, Ohio. On May 6, at the Renaissance Hotel, the proceedings were filmed for a later, edited broadcast on VH1. For some veterans of the annual event, this documentation put a crimp in the spontaneous style of the proceedings.

The largest band yet inducted—Parliament-Funkadelic, with sixteen of the group's members—crowded onstage (with some deceased band mates being represented by family members). P-Funk's Junie Morrison pointed out, "There are fifty or sixty people in our band!" The group also holds the Hall of Fame record for most colorfully garbed inductees. Flamboyant hats, robes, gowns, and exotic costumes were in festive display as the ensemble kicked off the night with a montage of funk's greatest hits, including "Tear the Roof Off the Sucker (Give Up the Funk)."

The night was a family affair of sorts. Gathered together were all of the Jackson 5, plus their parents, ditto the Bee Gees, along with Mama Gibb and the Gibb brothers' various children. Prince

was accompanied onstage by his wife, Mayte, who clung to his arm while he inducted P-Funk. Inductee Joni Mitchell chose not to come, instead prolonging a reunion with her newly discovered daughter Kilauren Gibb (no relation to the Bee Gees), whom she had given up for adoption in 1965, and Gibb's four-year-old child. Mitchell was inducted by Shawn Colvin, who performed "A Free Man in Paris." Mitchell's former paramour, Graham Nash (a.k.a. "Willy"), accepted for her.

The Father of Bluegrass Bill Monroe died just a few months before his induction. An emotional Ricky Skaggs inducted him, with Emmylou Harris also paying tribute to the music pioneer. One of the night's most comedic moments came when (Young) Rascal presenter Little Steven Van Zandt shook off his black cloak to reveal that, underneath, his attire matched that of the Rascals during their sixties prime: schoolboy knickers and all. Van Zandt's amusing speech was so Jersey-centric that when it was seen by the casting director of a new HBO drama in preproduction called *The Sopranos*, Van Zandt got himself an alternative guise as Silvio Dante.

The Bee Gees, who were inducted by Brian Wilson and Tony! Toni! Toné!'s Raphael Saadia, poured on the disco, with frisky versions of "Stayin' Alive" and "Jive Talkin'." All eyes were on the stage when the reclusive and controversial Michael Jackson bounded up next to Diana Ross before she had a chance to give her induction speech. The other four Jacksons joined them for a kind of family reunion, soon added to by Motown chief Berry Gordy. Ross shushed the J5, telling them, "You guys stand quietly because I want to tell a little story of how we all met, all right?"

Michael's wispy utterances sweetly praised his family and his former label boss, but admonished photographers who snapped away at the "wrong" side of his face: "I don't like that angle!" At one point a young boy appeared onstage next to Michael, who told the audience the child was his godson—and the son of Barry Gibb. (When Jackson called out for Berry [Gordy] to come up, Barry Gibb misunderstood and darted onstage, too.)

All members of Crosby, Stills and Nash and Buffalo Springfield appeared except Neil Young, thwarting a full Springfield reunion. David Crosby, whose life was saved by a liver transplant three years earlier, was filled with gratitude: "For a guy who was supposed to be dead a couple years ago, I'm doing quite well."

> ## "JONI USED THE WORD 'FUCK' LONG BEFORE IT WAS FASHIONABLE."
> —SHAWN COLVIN

> ## "MUSIC IS MAGIC. MUSIC BRIDGES THE GAP BETWEEN HUMAN BEINGS."
> —DAVID CROSBY

### AHMET ERTEGUN ON CROSBY, STILLS AND NASH:

"When the Buffalo Springfield broke up, I kept in very close touch with Stephen Stills. I consider him a very exceptional person and musician, and I was wondering what his next musical step would be. He jammed with Al Kooper, and he began working with his friend David Crosby, who had left the Byrds. You could call it fate, divine intervention, a cosmic coincidence, but what happened that summer day in 1968 was one of the most magical transcendent moments in rock & roll history. David and Stephen were singing together when another friend, Graham Nash of the Hollies, stopped by the house in Laurel Canyon to have a listen. Graham decided to join in, and at that moment an unmistakable sound was born—a blend of voices which is timeless and transporting.

"Sorting out the various contracts was another matter. David Geffen, who was managing the group and just got into the business from being a stockroom clerk at the William Morris Agency, came to see Jerry Wexler and thought that maybe he could get his way with Jerry. He really wanted to put the group on Columbia, where he had some connections because of his being Laura Nyro's agent. He went in to see Jerry Wexler to ask for a release for Stephen Stills, and Jerry threw him out on his behind unceremoniously. David, who was very, very persistent, then came to see me. We hit it off very well and David realized that Stephen Stills was going to stay on Atlantic no matter what happened. And we worked it out so that the group became Atlantic artists.

"It was an incredibly great moment for me because the music was like nothing we had ever heard: three of the most exceptional vocalists, musicians, and composers it has been my pleasure to work with, who have galvanized audiences with their artistic brilliance, as well as with their social conscience. My life was forever changed by these three men, and I would like to personally thank David, Stephen, and Graham for all they have given me and the world since that defining moment nearly thirty years ago."

### JAMES TAYLOR ON CROSBY, STILLS AND NASH:

"I heard about this supergroup before I actually heard the music and I couldn't wait to hear it. I'd been so profoundly influenced and impacted by the Hollies and the Byrds and especially Buffalo Springfield that I couldn't wait to hear what they were going to come up with, and I was amazed, I was blown away. They helped me identify myself as a singer and songwriter and a performer. I've always thought of them as having invented themselves, really, not particularly coming out of any mold but just basically winging it, and I think they helped an entire generation define itself, too. I think of myself as being part of that same batch that they came out of, so this is especially meaningful for me.

"CSN is a working band. They worked night before last and they're probably working tomorrow night, but for our purposes, it's probably best for us to think of them sort of historically and what they meant to us when they first came out of the box. The content of their music was very socially relevant and very in tune with the times, and very helpful to a nation and a generation that were trying to navigate themselves through a very confusing time, things like Woodstock and Kent State. But fundamentally it was about the music, and they took what had been started in those three individual groups that they came from and took it to yet another place. They took it forward.

Previous, page 112: Joni Mitchell, c. 1968. This page: Crosby, Stills and Nash, c. 1970. Opposite: Stephen Stills and Tom Petty, May 1997.

"They were the quintessential vocal group. They were so complex and so sophisticated, and yet so soulful. If I could have been a fly on the wall that night in 1968 when Graham Nash sat down in Laurel Canyon with Stephen and David and they sang together for the first time—it must have been an amazing thing. I'm sure they blew their own minds."

# "WHAT A WONDERFUL, BEAUTIFULLY STRANGE CAST OF CHARACTERS LIFE HAS HANDED ME."
## —STEPHEN STILLS

## CROSBY, STILLS AND NASH:

**Graham Nash:** "I have all my life felt blessed and I thank God for that and I think she's doing a wonderful job. It all starts with every single person sitting here; it starts with your mother and father and how they direct you through life—what they teach you, what you learn from them, what they learn from you. My mother and father were always there for me. When my friends would be slapped upside the head and told to get a real job because music would not last—and this was 1955—my mother and father were there for me. They're both dead now, but not to me. I've stood on many shoulders to be here tonight. Especially the shoulders of my first band, the Hollies. It was a great band and I'll never forget them, ever."

**David Crosby:** "I want to thank the two men standing next to me because they've been brothers to me. They've stuck with me through thick and thin, they've stuck with me when I was a pretty tough person to stick with, they waited, they helped, they cried sometimes, they swore at me sometimes, but they've been my brothers all the way down the line, without whom I could not have made this music."

## AHMET ERTEGUN ON BUFFALO SPRINGFIELD:

"The Buffalo Springfield was not only one of the most important groups in the history of rock & roll, they were one of the most important bands in the history of Atlantic Records and in my personal life. The talent in this one band was prodigious. Boasting no less than three dynamite lead singers, who were also gifted songwriters and incredible guitarists, the only problems came sometimes, I discovered, when they were tuning up, but whenever we got tuned up, the music was unbelievable.

"I remember when I first met them, I was trying to convince them that I was the right person for them to go with, and my company was the right company. I asked them if there was anything I could do for them, and Neil Young looked at me and said, 'Yeah, I'd like you to get me in a good Beverly Hills golf club.'

"The power of the writing and performing talents contained within this band also led to their breakup, after only two years—it was one of the saddest moments of my career, to see this amazing group break up. But their legacy, both musically and culturally, cannot be underestimated. They created barrier-breaking music which drew on country, folk, rock, blues, pop, soul, and bluegrass influences. Not only did the members of this one band go on to form such groups as Crosby, Stills, Nash and Young, Poco, and Loggins and Messina, but they paved the way for the whole country-rock movement. I am honored and proud to have been associated with you, and to have made friendships that have lasted a lifetime."

## TOM PETTY ON BUFFALO SPRINGFIELD:

"Buffalo Springfield was born in 1966. They were blond and brunette, they were fringe and paisley. They were the city and they were the canyons. They were the Sunset Strip and the Whisky-a-Go-Go. They were three main voices and they were poets. They were electric and they were an absolutely new acoustic. They were ominous and they were a country morning. They were Cuban heels and moccasins. They were Gretsch guitars and Fender amps. They were dueling guitar solos—one fluid and bluesy, the other fuzzy and angry. They were beautiful harmonies, they were a psychedelic orchestra. They sang of children's claims to fame, broken arrows, and for what it was worth. They were immeasurably influential. And they went on to make many more groups that would make more silver and gold music throughout the decades to follow. They were most of all Stephen Stills, Richie Furay, Neil Young, Dewey Martin, and Bruce Palmer."

## BUFFALO SPRINGFIELD:

**Bruce Palmer:** "You probably notice that there's one of us missing tonight. Neil. Neil's not here tonight; he wanted to be here; he was waylaid. There was something in the air that can and cannot be. Principle is the fact. I think all of you know what I'm talking about. There's television and all that stuff, and I'm pissing off a lot of people, but overall after that fact, this thing is a wonderful thing after all these years. It's still all new, still all good."

**Stephen Stills:** "When we were young and our hearts beat wildly, we ran amok on the Sunset Strip with electric guitars and words of wisdom—all the wisdom of a twenty-three-year-old completely full of himself. A guy named Ahmet Ertegun walked into a studio and said, 'I like these guys, sign 'em up,' and all the Atlantic family made that happen and it was just glorious beyond belief, and I am flattered and honored to be in this company—the class of 1997, a heck of a group."

## DIANA ROSS ON THE JACKSON 5:

"I'm winging this because I didn't prepare a speech of any kind because this is the way our relationship has always been—it's real and it's on the moment.

"The boys came to Detroit for a showcase for Berry Gordy and I remember them wearing these little green outfits and hats and they did a show at Berry's house and we knew then that it was going to be something special. I got an opportunity to introduce them on *The Ed Sullivan Show*, and the rest is just history. They came to live with me in California for—it seemed like just a few months, but I don't know how long it was. Their parents were moving from Indiana to California. I got to know them very well and I tried to train them. I tried to teach them how to make their beds, and how to wash the dishes and pick up the dishes from the table. Since the

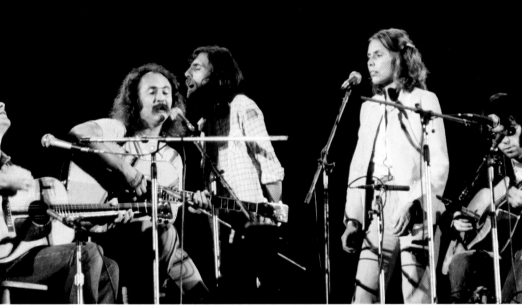

Clockwise from top left: the (Young) Rascals; the Jackson 5's debut album, 1969; P-Funk's Bootsy Collins and George Clinton; Buffalo Springfield; the Bee Gees: (from left) Robin, Barry, and Maurice Gibb; Crosby, Stills, Nash and Young, with Joni Mitchell, 1974. Following, page 118: the Jackson 5 (from left): Michael, Jackie, Joseph (father), Katherine (mother), Marlon, Tito, and Jermaine, 1971.

beginning of their careers, I feel very much as if they are my children. Michael and I bonded very early, and so I feel like I am a parent of these boys and I'm a grandparent of their children."

## BERRY GORDY ON THE JACKSON 5:

"It's been almost thirty years . . . [since] you guys came to audition for me in Detroit, not too far from here. From that first day, your discipline, determination, and incredible talent inspired me. A short time later you moved into my house in California. We worked hard and we played hard. The competition was fierce. The Gordys versus the Jacksons weekly baseball game, do you remember that? These guys were phenomenal.

"The cultural impact that these guys had on society was just incredible. The Jackson 5 not only had hit records and were phenomenal performers, but they were a cultural revolution. For the first time, young black kids had their own heroes and their own image to idolize and emulate. The Jackson 5 gave black kids in the ghetto a license to dream. And many of those same kids went on to realize their own dreams. The Jackson 5 were an all-encompassing group. The ages went from Michael, nine, to Jackie, who was seventeen. They had something for everybody. The girls went crazy. They played sold-out arenas around the world. We had to have such heavy security on the Jackson 5, not to keep the fans from hurting them, but to keep them from loving them to death. Everybody had a Jackson to fall in love with, including my daughter, who married one. If you don't remember where you've been, you won't know where you're going."

## MICHAEL JACKSON:

"Berry Gordy, I love you. Like Diana Ross, you were there and now again, you are here. I'm crazy about you. Four consecutive Number One records, and you delivered them all. I'll never forget it. It was a first in music history, and there's many more singles that went Number One for the Jackson 5. Single after single. Your faith makes it possible for us to be here today. We love you from the bottom of our hearts, sincerely, and I just want you to know that without you, my mother and my father, I don't think we would be here. And, of course, God. And to all the fans—you were there unconditionally. Whenever you call our name I promise we'll be there."

## CHRISSIE HYNDE ON JONI MITCHELL:

"Authenticity is the quality I think best describes Joni Mitchell. The fact that she possesses the most gorgeous voice ever, plays guitar like a man (figuratively speaking, of course), and is a master songwriter, all come second to the authenticity that (like blood through an Ace bandage) seeps through everything she does. Many women in the last twenty years have played Joni Mitchell records during childbirth. I believe it's some kind of phenomenon. Why do they do it? Probably because people appreciate the truth more than ever when going through major life events. We have total faith in this woman. She's never fucked us around or tried to get our attention to serve her own means. In fact, we get the impression that she finds fame more than a bit bothersome and would rather be left alone to go off and paint pictures. Still, millions of us wait for her. We want her authenticity to lend a sense of credence to our lives. She makes us feel better, and if you think about it, who doesn't love Joni Mitchell? Nobody I know."

## PRINCE ON PARLIAMENT-FUNKADELIC:

"I'm here to testify about Parliament-Funkadelic. The great George Clinton is the father of this funk mothership, the soulful supergroup that's included legends like Bootsy Collins, Bernie Worrell, Eddie Hazel, and all the other brilliant musicians and singers that have signed on. They built Parliament-Funkadelic and changed the world. There was something futuristic about Parliament-Funkadelic and that was only fitting since they were creating the future of music. Yet for all the outerspace and alien imagery, Parliament-Funkadelic was earthy and funky and timely."

> ## "LET ME JUST SAY SOMETHING ABOUT GEORGE [CLINTON] SINCE HE'S A GOOD FRIEND OF MINE. ONE TIME HE SENT ME A TAPE THAT SAYS, 'YOU PEE ON IT AND SEND IT BACK TO ME, AND I'LL PEE ON IT, AND THEN WE'LL SEE WHAT WE'VE GOT.'"
> —PRINCE

## AHMET ERTEGUN ON THE (YOUNG) RASCALS:

"When the Beatles first played Shea Stadium, in the summer of 1965, the concert promoter Sid Bernstein flashed a message across the scoreboard. The message read THE RASCALS ARE COMING. At that time, nobody knew what they were talking about. By the end of that year, however, the Rascals were playing at a place called the Barge, on the north shore of Long Island. Sid Bernstein tweaked my cheek, as he was wont to do, and summoned me there.

"I went one evening expecting to hear a band playing just for me. I found that every producer from every other record company was there. They were playing original music and some R&B covers and some Dylan songs. They were surely fated for rock & roll stardom. I was very fortunate to sign them. Bridging the worlds of R&B and rock & roll, dressed up in their Little Lord Fauntleroy suits, the Young Rascals had become a sensation in the New York club scene. The Young Rascals' blue-eyed soul music paved the way for Atlantic's entry into the rock & roll revolution of the sixties. It's also important to note that the first Young Rascals sessions for Atlantic marked the first producing assignment for our label by a young man named Arif Mardin."

## STEVEN VAN ZANDT ON THE (YOUNG) RASCALS:

"Some people may not realize it, but the Rascals were the first rock band in the world. In the fifties, we had vocal groups and solo people. And in the sixties, on the West Coast we had the Beach Boys, but they really were a vocal group and they became a band later. We also had the Byrds, but McGuinn really did that first record by himself and then they became a band later. And okay, there were some guys over

there [across the Atlantic] making some noise, but in the real world, in the center of the universe—New Jersey—the Rascals were the first band, which is why I don't understand why it took so long to get them in the Hall of Fame. Some rumors have gone around that people didn't like their physical accoutrements—you know, their stage garb was a little bizarre. What I'm trying to say is people think they dress funny. Now this is a subject I know something about, and just for the record tonight I want to say that there was absolutely nothing unusual about the way the Rascals dressed. There's nothing strange about that [*as he removes his black cloak, displaying his schoolboy knickers attire*].

"The first time I saw the Rascals was at the Keyport Roller Dome—Keyport, New Jersey. There was no Fillmores, there was no arenas in those days—rock & roll played skating rinks where it belonged. And the way rock is selling, we may be back in skating rinks next year. But they were fantastic in those days. They were wild. Eddie would jump around, he was a wild man, with tambourines and maracas, and Gene was so cool with the guitar up there. He was just fantastic, and Dino, with all due respect to all my drummer friends—and most of my friends are drummers—he was the greatest rock drummer ever. He also gained fame a few years later by being the last individual in the music business to go to the Beatle haircut. And, of course, Felix introducing that amazing B-3. To this day, every roadie in New Jersey has a hernia and back trouble. They hate him. English roadies got to hate Stevie Winwood, but in New Jersey they hated Felix.

"It was the greatest show I've ever seen, and okay, it was also the first show I'd ever seen. But since then I've seen everybody: I saw the Beatles at Shea, I saw the Rolling Stones with Brian Jones, the Who with Keith Moon, Rod Stewart with Jeff Beck, Siegfried and Roy. I've seen everybody since then and that show holds up fantastic. The first time I ever heard the song—I'll never forget, I was with my girlfriend at the time, beautiful girl, oh, you should have seen this girl . . . I'll never forget her, Loretta Gorgonzola, she was so beautiful, she had everything. She had brains [*hand gestures to her other attributes*], she had everything. And we were there and we were starting to communicate and all of a sudden 'I Ain't Gonna Eat Out My Heart Anymore' comes on the radio. I just stopped. She said, 'What's wrong?' It was like she wasn't even there anymore. I don't know how else to describe it—it was the sexiest record I had ever heard in my life. The melody, the chords, Eddie's voice, the texture of Eddie with Felix and David, the guitar solo was even sexy, the organ. The record was sexier than the sex I was having with my girlfriend, let's face it.

"And that was when New Jersey soul was born, right there. People talk about white soul singers, and there's a lot of names that come up, but Eddie and Felix, I'm telling you right now, they're the best. I mean, with all due respect, the Righteous Brothers—we love the Righteous Brothers, they're fantastic—but Eddie and Felix, though, to sound that black you had to be Italian! Ladies and gentlemen, Dino Danelli, Eddie Brigati, Felix Cavaliere, Gene Cornish—it is my honor to welcome to the Rock and Roll Hall of Fame—and it's about time—the Rascals!"

## THE (YOUNG) RASCALS:

**Felix Cavaliere:** "An important date for the Rascals was July 20, 1968, when 'People Gotta Be Free' became a Number One hit in America, but the truly important dates that year were the ones that in fact inspired this song: April 4 when Dr. King was killed, and June 6, when we lost Bobby Kennedy. We wanted our music to be more than pop. We wanted it to reach across races and social barriers and to help all of us understand each other a little better. That's what our music was all about. As timely as those sentiments were in 1968, we believe they're even more vital right now. We seem to be still divided after all these years—rich from poor and black from white. We have one hope, and to accept this award have one request—that all the artists who listen to this speech or program who create tomorrow's music, tomorrow's hit songs, will use the music to reach out and heal and bring us all closer together."

## EMMYLOU HARRIS ON BILL MONROE:

"I know that at the first mention of Bill Monroe, the Father of Bluegrass Music, and the Rock and Roll Hall of Fame might seem like a strange pairing because they are worlds apart. I think one of the things that rock & roll stands for, tries to do, is to bring worlds together. But it also stands for power and passion, for breaking down barriers and for always seeing the truth, and certainly Bill Monroe will always be a native son. Bill Monroe took his music relentlessly and fearlessly into the dark recesses of the soul. He knew instinctively that you have to go through the tunnel in order to get to the light on the other side, and he certainly blazed a trail for all of us to follow. I was really, really honored to know him. I wish that with all of my heart—almost more than anything—that he could have been here tonight, because I don't think I ever met anybody who loved a crowd and loved to perform more than Bill Monroe. And believe me, he could perform and pick all of us young upstarts under the table. Unfortunately that can't happen, but we had him on this earth for a long time. He's left us some wonderful music, a wonderful legacy, and he certainly influenced me a lot."

## MUSICAL HIGHLIGHTS

The night ended with some high-octane musical performances and the traditional jam. The (Young) Rascals kicked it off with their blue-eyed soul, on heartfelt versions of "Good Lovin'" and "People Got to Be Free." James Taylor played a gorgeous acoustic reading of Joni Mitchell's "Woodstock," then Crosby, Stills and Nash harmonized beautifully on "49 Bye-Byes" and "Wooden Ships," punctuated by Stills's scorching lead guitar. Joined by Tom Petty, Emmylou Harris, and James Taylor, CSN delivered a powerful "Teach Your Children." With Stills strapping on his Flying V guitar, and with Petty subbing for Neil Young—and Dewey Martin and a pantomiming Bruce Palmer joining in—the fiery climax was the Springfield nugget "For What It's Worth." "They sang this song at Kent State," Stills yelled out over the mic. "We did another one about that!"

This page: Hall of Fame Induction highlights, January 1997. Clockwise from top: (from left) Stephen Stills, Tom Petty, Graham Nash, Bruce Palmer, and David Crosby; the Bee Gees; Emmylou Harris.

## INDUCTEES

**PERFORMERS** The Eagles ✦ Fleetwood Mac ✦ The Mamas and the Papas
Lloyd Price ✦ Santana ✦ Gene Vincent
**EARLY INFLUENCE** Jelly Roll Morton **NONPERFORMER** Allen Toussaint

With the induction ceremony back at New York's Waldorf-Astoria, January 12 was a night of reunions—some happy, some not quite so. One of the highlights was the appearance of reclusive guitarist Peter Green, the brilliant founding member of Fleetwood Mac. For the opening slot, Green appeared onstage with Santana, playing dueling guitars with Carlos on the Green composition "Black Magic Woman," a Number Four hit for Santana in 1970. During rehearsals, when asked if he wanted to perform with Fleetwood Mac, Green had said, "No—I'd much rather play with Santana."

Having recently embarked on a lengthy reunion tour, members of Fleetwood Mac—the classic seventies version—were apparently a bit frayed, with Lindsey Buckingham reportedly being standoffish. That didn't prevent Buckingham and Stevie Nicks from playing an emotional acoustic version of "Landslide" and "Big Love." After the band's induction, the whole group revisited "Say You Love Me," with Buckingham swapping his guitar for a banjo.

For the first time since 1978, another estranged group, the Mamas and the Papas, performed together on the classic "California Dreamin'," after Denny Doherty exclaimed, "We've been waiting here all day to do this, as most of you have, so without further ado, we'll try to get on with this!" Papa John's daughter Mackenzie Phillips filled in for the late Mama Cass, who was fondly remembered by her band mates.

John Fogerty was on hand to give a spirited induction of rockabilly pioneer Gene Vincent. New Orleans music was a focus of the night, with three innovators from the Big Easy—Lloyd Price, Jelly Roll Morton, and Allen Toussaint—among the inductees.

Another anticipated reunion was that of the Eagles; five members had reunited for a 1994 tour, but all seven former members had never appeared together onstage. The famously combative band came through, but their two-song set arrived in place of the traditional all-star jam at night's end.

> ## "THE HISTORY OF FLEETWOOD MAC LIVES WITHIN THEIR MUSIC, AND THEIR SONGWRITING TELLS OF THEIR JOURNEY."
> —SHERYL CROW

> **"BEING AN ENGLISHMAN, I CAN'T THINK OF ANYTHING BETTER THAN QUOTING A LITTLE BIT OF SHAKESPEARE, AND AS THE MAN SAID, 'IF MUSIC BE THE FOOD OF LOVE, PLAY ON.'"**
> —MICK FLEETWOOD

### JIMMY BUFFET ON THE EAGLES:

"Mark Twain said that creativity is merely undetected plagiarism. *Hello, room full of plagiarists!* I know, 'cause I am one. I confess to stealing a lot of things from the Eagles, from the catering, to the quick out; it was the little things I was privileged to witness backstage that helped me to survive and become a better performer. I've never had the opportunity to thank them for their generous spirit or camaraderie that was extended to me or my band. As for the Eagles, they're going into the Rock and Roll Hall of Fame as one of the signature bands that began in the seventies and is still alive and kicking ass as we head for the millennium. And here I am, still opening for this goddamn band!"

### THE EAGLES:

**Don Henley:** "When a kid first picks up a guitar or a drumstick, it's not really to be famous. It's because that kid wants to fit in somewhere, and he wants to be accepted, and he wants to be understood, even. So I like to think of this award as something that is acknowledging us not for being famous, but for doing the work, and I appreciate the work that all these guys behind me have done. I want to thank [manager] Irving Azoff, without whom we wouldn't be here today . . ."
**Glenn Frey:** "Well, we might still be here, but we wouldn't have made as much money."
**Don Henley:** "Right. As I've said before, he may be Satan, but he's *our* Satan."
**Glenn Frey:** "Obviously, what's going on tonight is a lot bigger than any of the individuals onstage, and a lot has been talked about and speculated about over the last twenty-seven years, about whether or not we got along. We got along fine. We just disagreed a lot. Tell me one worthwhile relationship that has not had peaks and valleys. That's really what we're talking about here, and you cannot play music with people for very long if you don't genuinely like them. I guarantee you that over the nine years that the Eagles were together in the seventies, over the three years that we were together during our reunion, the best of times rank in the ninety-five percentile; the worst of times rank in the very small percentile that obviously everybody but the seven of us have dwelt on for a long, long time. *Get over it!*"

### SHERYL CROW ON FLEETWOOD MAC:

"I was fourteen years old when I first heard 'Rhiannon' on the radio, in Kennett, Missouri, and that was it for me. I knew what I wanted to be and started wearing platforms, shawls, and a Stevie Nicks shag haircut, which I have the perfect hair for. Some twenty years later, I happened to be playing in a dive in Aspen on New Year's Eve, and Mick Fleetwood happened to be in the audience, and he came up to me and said only one thing: 'You remind me of Stevie Nicks.' And I had made it.

"I recently went to see them play, on their reunion tour, at the Meadowlands, and it was really as if they'd never left—as if they'd never been away. In all my vast experience, and my know-it-allness, and my jadedness, I found myself experiencing tears and clapping and singing, and laughing and crying. They were back—and they were as powerful as when I had seen them twenty years ago. And they are—and were—the reason I got into music. They even taught me, a working musician, a valuable lesson: that having relationships with your drummer or your guitar player doesn't signal the end of the band. *Anyway.*

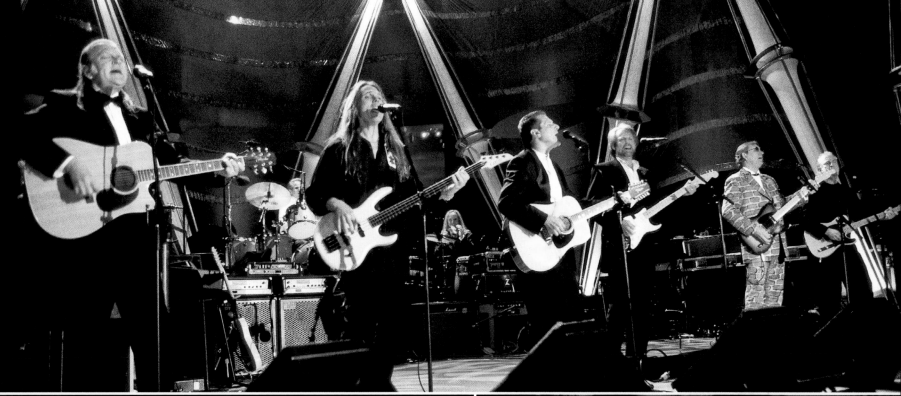

Previous, page 122: Fleetwood Mac's Stevie Nicks, 1978. This page, clockwise from top: the Eagles, January 1998: (from left) Randy Meisner, Timothy B. Schmit, Don Henley, Glenn Frey, Don Felder, Joe Walsh, and Bernie Leadon; Glenn Frey, c. 1974; Joe Walsh, c. 1977; Frey and Walsh, c. 1980.

"Fleetwood Mac's music has spoken to each of us, and they continue to affect each generation. We live in a country that has grown up with Fleetwood Mac at our side. How fortunate we are."

### FLEETWOOD MAC:

**Mick Fleetwood:** "I would like to thank Mr. Peter Green for forming Fleetwood Mac way back in 1967. He left us with a stage that was to continue until today: lunacy, heartbreak, happiness, unhappiness, and, thank God, a sense of healing has come to all of us up here on the stage today. We've had a fantastic journey."

### SHANIA TWAIN ON THE MAMAS AND THE PAPAS:

"Rarely has a group emerged so fully formed on a first single as the Mamas and the Papas. John Phillips, Michelle Phillips, Denny Doherty, and the late Cass Elliot had a great deal of individual experience, much of it as part of the vibrant folk scene of the early sixties, and they were ready for action when their time came. By 1971, when I was six years old, I was wearing out my 8-track tape of their music, which by that time had already become classic. I was mesmerized by the beauty and serenity of their vocal arrangements and their utterly original musical style. They may only have been together for a short while, but they left me with a lifetime of influence and inspiration, and all of us with beautiful, beautiful music."

### OWEN ELLIOT ON THE MAMAS AND THE PAPAS:

"I'm thrilled to be here to represent my mother on this historic occasion. It's hard to believe that it's been almost twenty-four years since the world lost Cass Elliot. Then, as now, rock & roll was suspected of corrupting teenagers and threatening family values, but my mother recognized the positive value of rock & roll, and was one of the first to encourage young people to participate in the political process. I'm grateful for this opportunity to reaffirm my mother's ideals at a time when we celebrate her incredible talent, and the brilliance of the music of the Mamas and Papas."

### TONY RICH ON LLOYD PRICE:

"Lloyd Price is a man who did everything right at a time when what they called 'race records' were not supposed to cross over to the pop charts. Lloyd wrote 'Lawdy Miss Clawdy,' and taught the kids a lesson they never forgot. See, Lloyd never stayed in his place. Just when the public had him pegged as this wild R&B singer, he did 'Personality,' and a whole other thing of a very smooth pop sound. Nobody knew what to expect from this guy; he could do it all. 'Stagger Lee' was a whole new kind of subject matter for the radio. I can't say for sure, but I suspect that 'Stagger Lee' made possible 'Hey Joe' by Jimi Hendrix and 'Down by the River' by Neil Young, and a whole lot of hardcore rap that Mr. Price might not want to take the rap for. It's not your fault, Lloyd! You opened the door; you're not responsible for who followed you through. But you sure do deserve a lot of credit!"

### JOHN POPPER OF BLUES TRAVELER ON SANTANA:

"I'm determined to wing it, because that's what improvisation is all about. I'm a player. I play improvised music. And when you improvise, you really take on a discipline like a samurai—that's the way we always look at it. It requires a facility

## "I HAVE PERSONAL KNOWLEDGE THAT CASS IS SITTING ON TOP OF THAT BIG FULL MOON TONIGHT, LOOKING DOWN ON THESE PROCEEDINGS, WEARING A SIZE SIX THIERRY MUGLER DRESS, AND THANKING YOU ALL VERY, VERY MUCH."

—MICHELLE PHILLIPS

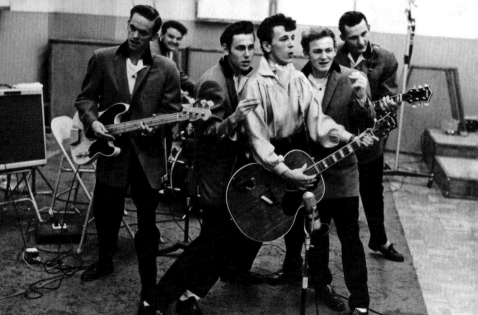

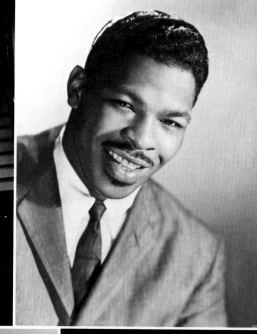

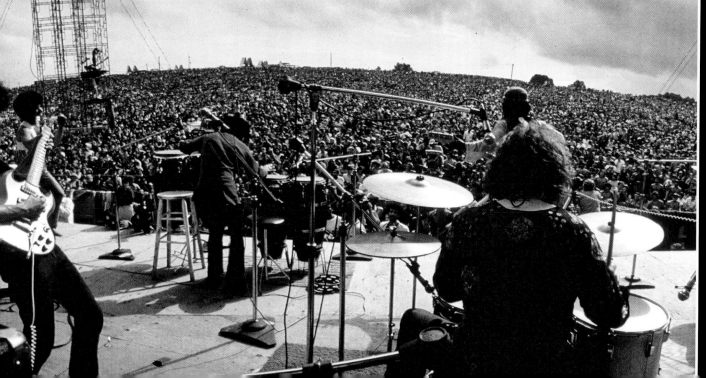

Opposite: the Mamas and the Papas. Clockwise from top left: Fleetwood Mac: (from left) John McVie, Christine McVie, Lindsey Buckingham, Mick Fleetwood, and Stevie Nicks; Gene Vincent (in white shirt) and his Blue Caps; Lloyd Price; Santana at Woodstock, 1969; Carlos Santana; Fleetwood Mac, January 1998.

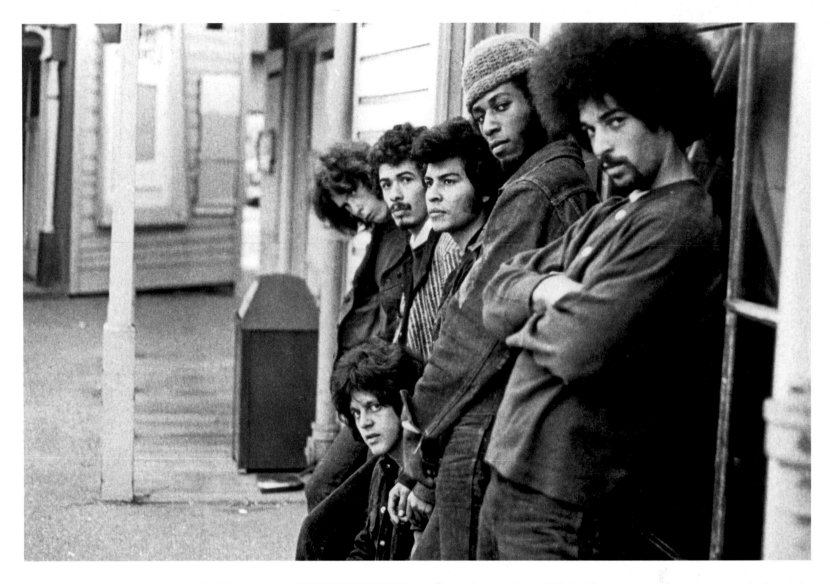

This page: Santana: (from left) Michael Shrieve, Carlos Santana, Gregg Rolie, José Chepito Areas, David Brown, and Mike Carabello, 1969.

## "THERE'S A PREDICTION THAT THE ENTIRE WESTERN HEMISPHERE, FROM CANADA TO CHILE, IS GOING TO START GRAVITATING TOWARD ONE KIND OF MUSIC, AND I THINK IT WAS SANTANA AND HIS BAND THAT REALLY SAW THIS COMING BEFORE ANYBODY."

—JOHN POPPER OF BLUES TRAVELER

with your instrument, much like twirling your samurai sword, and you also have to be very in touch with what you hope is an inner peace. You have to be in touch with and open to things that you're listening to, and you have to be *always* listening, and anticipating the jam as best you can, and improvising that way.

"I want to tell you about the day Miles Davis died. Blues Traveler was at a gig, and so was Santana, and Bill Graham, who was our manager at the time, arranged for Carlos to sit in with us; we did a twenty-three-minute jam of a song of ours. For me and my band mates, it was like our graduation, because we stood toe-to-toe with the champ—the master samurai. When we were younger, there'd been four things we listened to when we'd get stoned: Jimi Hendrix, John Coltrane, P-Funk, and Carlos. You listen to 'Oye Como Va,' you see God. I got to play with God!

"That was the last day I saw Bill alive, actually, and I remember I came offstage, and I said, 'My God, I got to play with Carlos Santana,' and I was freaking out, and he looked really satisfied and said, 'You know, I remember when Carlos got to interact with Muddy Waters, and he was saying the exact same stuff you are.' I felt like I was really part of a tradition. You know, Bill isn't around anymore, and I miss him a lot, but I feel like we're part of a tradition. I'm just very honored to be here tonight, to help us all induct a samurai and a shogun."

## JOHN FOGERTY ON GENE VINCENT:

"[*Singing*] '*We-e-e-ell, be-bop-a-lula, she's my baby . . .*' Whoah. It doesn't get much better than that. I'm not talking about me. I'm talking about 'Be-Bop-a-Lula.' The first time I heard it, I was, of course, riding along in the car, 'cause that's where you hear great rock & roll. I was in my dad's car, and I just stopped, and said, 'Man, that sounds great!' I thought so then, and I think so right now. I do believe that this record is probably one of the greatest records ever made. That voice! Gene Vincent fooled a lot of folks with that record. I've heard the legend that he actually fooled Elvis's mama, and she was real mad that the King hadn't told her he had a new record coming out, called 'Be-Bop-a-Lula.' Anyway, the sound of Cliff Gallup's guitar, and the drummer screaming in the background, that's what we call attitude."

## ROBBIE ROBERTSON ON ALLEN TOUSSAINT:

"Like a lot of us, I have long been an admirer of the music of New Orleans. The freedom of sound came out of there, with an identity so strong that it changed the face of music forever. Going back to the ragtime whorehouse music, and the birth of jazz, the Cajun zydeco French blues. I heard that someone once asked James Brown where funk music came from, and he said, 'From somewhere down in New Orleans.' And I think James ought to know. One of the musical pioneers who took the traditional sound of New Orleans—the Professor Longhair piano, the second-line funky beats, the Mardi Gras Indian musical language, the horn style, and the let-the-good-times-roll melodies—and mixed it all up into a big old pot and made a new musical gumbo; this new recipe was created by Allen Toussaint. Years ago, I did a song with the Band called 'Life Is a Carnival,' and I got in touch with Allen, because besides being a great producer and songwriter, he is also the most badass horn arranger around. We had such a good time that after, I told him that the Band was gonna do a live album, and asked him if he would like to do horn charts for that. And he said yes, and on New Year's Eve, at the old Academy of Music down here, the Band, with the brilliant horn arrangements of Allen Toussaint, recorded the album *Rock of Ages*, and it was one of the musical highlights of my life. And when the show was over, Allen came over to me and said that this had been one of the greatest musical experiences of *his* life, and coming from a master like him, this meant so much to me."

## MUSICAL HIGHLIGHTS

Though the night didn't end with a jam, the onstage collaboration between John Fogerty and Lloyd Price on vocals, Allen Toussaint on organ, and Johnnie Johnson (Chuck Berry's collaborator) on piano resulted in an unforgettable version of Price's 1959 hit "Stagger Lee."

For the evening's finale, past and present Eagles—Don Felder, Glenn Frey, Don Henley, Bernie Leadon, Randy Meisner, Timothy B. Schmit, and Joe Walsh convened to perform the band's very first hit, 1972's "Take It Easy" and the group's signature "Hotel California." *Rolling Stone*'s Matt Hendrickson conjectured, "Wait a minute. No all-star jam? No Bruce? Not this year. Apparently, the logistics—and egos—were too difficult to negotiate."

## ALLEN TOUSSAINT'S MANY TALENTS

The multitalented Allen Toussaint worked with numerous artists throughout his career in various capacities—as arranger, producer, and songwriter. Some of these collaborations include:

◆ ◆ ◆

### ARRANGER
**THE BAND's** *Cahoots*, 1971, and *Rock of Ages*, 1972. Toussaint was also the horn arranger for *The Last Waltz*, 1972.
**LITTLE FEAT's** *Hoy-Hoy!*, 1981.
**PAUL SIMON's** *There Goes Rhymin' Simon*, 1973 (horn arranger)

### PRODUCER
**JOE COCKER's** *Luxury You Can Afford*, 1978 (on which Toussaint also performed), and *Long Voyage Home*, 1995
**ELVIS COSTELLO AND ALLEN TOUSSAINT's** *The River in Reverse*, 2006
**DR. JOHN's** *In the Right Place*, 1973, and *Desitively Bonnaroo*, 1974
**ETTA JAMES's** *Changes*, 1980 (collaboration)
**ALBERT KING's** *New Orleans Heat*, 1978
**PATTI LABELLE's** *You Are My Friend: The Ballads*, 1997; *Gold*, 2005 (producer/arranger); *Nightbirds*, 1974; *Phoenix*, *1975*; *Something Silver*, 1997; *It's Alright With Me/Released*, 2001; and *Love Songs*, 2001 (producer)
**PAUL McCARTNEY**—collaborated on Wings' 1975 *Venus and Mars*
**MORRISSEY's** "Jack the Ripper," 1992.

### SONGWRITER
**GLEN CAMPBELL's** "Southern Nights"
**LEE DORSEY, DEVO, AND THE JUDDS'** "Working in the Coal Mine"
**ERNIE K-DOE's** "Mother-in-Law"
**THE POINTER SISTERS'** "Yes We Can"
**BONNIE RAITT's** "What Is Success"
**OTIS REDDING's** "Pain in My Heart"
**THE ROLLING STONES'** "Fortune Teller"
**TIJUANA BRASS'** "Whipped Cream," which was also *The Dating Game* TV show theme song

## INDUCTEES

**PERFORMERS** Billy Joel ✦ Curtis Mayfield ✦ Paul McCartney ✦ Del Shannon
Dusty Springfield ✦ Bruce Springsteen ✦ The Staple Singers
**EARLY INFLUENCES** Charles Brown ✦ Bob Wills and His Texas Playboys
**NONPERFORMER** George Martin

"It was the most emotionally moving, musically satisfying night the Hall has ever seen," said *Rolling Stone*'s Anthony Bozza of this first-ever Ides of March ceremony, at the Waldorf-Astoria. What a combination: stellar performances, powerful speeches, and the lingering sadness from the recent loss of inductees Charles Brown and Dusty Springfield, plus Linda McCartney's death, and the courage of Curtis Mayfield, who'd planned to attend but whose deteriorating health prevented it at the last minute. Instead of giving a speech, inductee Paul McCartney tearfully spoke of his late wife: "It's brilliant/sad, of course, because, yeah, I would like my baby to share this with me. She wanted this. But it's beautiful, you know, she's beautiful, it's all beautiful, and we're cool. I love rock & roll, I love Cleveland, 'cause Cleveland gave me Linda's mom, she was from Cleveland. And I love New York, 'cause New York gave me Linda. So I want to say to you all, thank you very, very much, and this one's for you, baby."

Ahmet Ertegun called out to his many friends in the room—Jimmy Page, Bette Midler, Eric Clapton, Bonnie Raitt, Peter Wolf, Danny DeVito, Lenny Kravitz, Neil Young, Lloyd Price—there to witness the proceedings. "I think there are more stars here tonight than we've ever had," said Ertegun. "And it's a record audience. I am happy to report that we have recently named Terry Stewart director and CEO of the museum. Under his direction, we look forward to a continuation of the success we have had since our opening."

It was a night of raconteurs—Bruce Springsteen, Bono, Bonnie Raitt, Elton John, Billy Joel, Chris Isaak—giving both funny and moving speeches. The musical performances were superb, including the Staple Singers testifying on "Respect Yourself" and "I'll Take You There" and Eric Clapton and D'Angelo's charged performance of the Impressions' "I've Been Trying." Most spectacular was the end-of-the-night musical marathon, including Bruce Springsteen and the E Street Band reunion—the first in a decade—and the surprise appearance of 1991 inductee Wilson Pickett, duetting with Bruce on his 1965 hit "In the Midnight Hour." The biggest surprise came with the spontaneity at night's end when Paul McCartney joined in on an impassioned "Let It Be."

> "THEY CALL HIM THE BOSS. WELL, THAT'S A BUNCH OF CRAP. . . . MORE THAN A BOSS, HE'S THE OWNER."
> —BONO, ON BRUCE SPRINGSTEEN

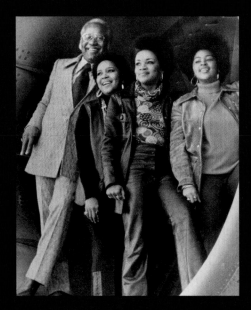

# "THERE'S NOT MANY MEN LIVING TODAY AS WELL BLEST AS POPS."

## —POPS STAPLES

### RAY CHARLES ON BILLY JOEL:

"I must be honest with you—I'm totally out of place. I don't speak too much; I don't know anything about talking. Singing is my business, as you well know. But I'm here to say something to you, sincerely from my heart. My friend, Billy Joel, I want you to know, first of all, I genuinely love and respect this man. He's ultratalented—that's number one. Now, some of you are gonna say, 'Well, wait a minute, now—where do you come off . . . Why do you feel like that, Ray?' Well, I'll give you just a little insight into my brain.

"First of all, if you think about a man who has maybe thirty-seven, thirty-eight huge hits, thirteen of 'em went in the Top Ten, three of 'em were Number One, that gives you what they say, the proof of the pudding is in the eating. Billy Joel said, 'I want to play my music from my experience,' which said to me he wanted to play his music according to the life that he saw around him, what was important to him. Beautiful man. Piano man, they call him. I like that. 'Just the Way You Are,' yeah, okay, man, I hear that. I don't want to bring myself too much into this, but I have to say, to me he wrote one of the most beautiful songs that we sung together, called 'Baby Grand.' I'll leave you with this thought, because he said it himself. He said, 'Yeah, but it's still rock & roll to me.' I like that. You're inducted, brother. *I got ya!*"

### BILLY JOEL:

"I grew up in Levittown, okay? Now . . . not exactly the epicenter of soul in America, you know? And my parents were young people starting out; my dad was an ex-GI, and they got a house for forty bucks down, a quarter-acre, whatever it was, and they thought they were moving to the country; they were getting out of the city. But, we didn't know this at the time, they would not sell Levittown homes to African-American families. We found this out later. So where were we gonna find soul? Where were we gonna find the soul of America? You know where we got it? We got it from the radio. We got it from rock & roll music—that's where we got it from. And I'm not talking about Pat Boone. I'm not talking about Fabian. I'm not talking about Frankie Avalon. I'm talking about Ray Charles, and Little Richard, and Chuck Berry, and Fats Domino, and Wilson Pickett, and James Brown, and Otis Redding, and Little Anthony & the Imperials, and Frankie Lymon and the Teenagers—that's where we got it.

"So I wanna thank those people, 'cause they were the real pioneers. And I know I've been referred to as derivative. Well, I'm damn guilty. *I'm derivative as hell!* Let me just suggest this. Anyone who is derivative like I'm derivative, who should be automatically excluded, would mean that there wouldn't be any white people here."

### SEAN COMBS ON CURTIS MAYFIELD:

"All great music is soul music. No matter what genre of music it is, it has to contain a little bit of soul, and God knows, nobody ever had more soul than my man, Curtis Mayfield. . . . From his early days in Chicago, he brought a sense of religious purity to his music, whether he was creating his songs for the church, or his songs for the streets. Curtis realized there was no difference. Curtis wrote songs connected with singers and saints. . . . Whether they were songs of hope or songs of despair, he wrote about the human experience with amazing grace and remarkable honesty. Growing up, it was hard to imagine some of these creations were actually written by a man. They sounded timeless, God-given, and I believe they were.

Previous, page 130: Bruce Springsteen, March 1999. This page: the Staple Singers. Opposite: Curtis Mayfield.

"When Curtis Mayfield left the Impressions, they were one of the giant vocal soul groups of all time. He headed his own way in 1970, and he bravely showed us amazing new sides of that beautiful soul of his. The realities of American life changed, and Mayfield's music reflected those changes in ways that were very frightening, and gorgeous, and funky as hell. . . . Somehow, as times got tougher, the music got even deeper, which is to say, very deep indeed. Since then, Curtis Mayfield has proven himself to be unstoppable in ways which are simply beyond description. . . . Suffice to say, as much soul as Curtis Mayfield has shown us over the years through his genius as a singer, a songwriter, a producer, and a guitar player, he showed us even more as a man."

### NEIL YOUNG ON PAUL McCARTNEY:

"When I first heard the Beatles back there in the sixties somewhere, the first thing that I noticed was that I might be able to do this kind of thing myself. So the first song I ever sang was a Beatles song—'Money (That's What I Want).' I sang that in the school cafeteria, and it didn't go over good, so we sang, 'It Won't Be Long,' *yeah.* And that was better. But the Beatles meant a lot to me, and Paul's music, particularly his bass playing at that time. A lot of the bands were very impressed with Paul's bass playing. Not only that he plays left-handed, but he really played.

"But as time went by and the Beatles got huge, I joined Springfield, and Stills and I were listening to 'A Day in the Life.' We were listening to the last note of 'Day in the Life,' and listening to Paul's vocals, and John's vocals, and the great things that George [Martin] did to the record. It was just like a marriage of all this talent coming together, creating this wonderful thing that none of us could really fathom at the time. We were just trying to do our thing in the shadow of this great thing that had happened, between the Beatles and the Stones and the Who.

"So I just kept on going, and eventually the Beatles broke up, and about the same time, I broke up myself, and so I started a solo career. That's the same time as Paul came out with his first solo album: the one on Apple Records with 'Maybe I'm Amazed' on it. I loved that record because it was so simple, and there was so much to see and to hear. It was just Paul, and so there was no adornment at all. There was no echo, there was nothing. There was no attempt made to compete with the things that he'd already done. So out he stepped from the shadow of the Beatles, and there he was. And it kind of blew my mind. I said, 'Well, maybe I could do this too, you know? I'm gonna try that.' So I made simple records that didn't have any echo on them for a while.

"To make a long story short, I knew Linda a long time ago, and we were all very happy when Linda and Paul got together, and they had such a wonderful family. I felt close to them over the years. I have a lot of respect for Paul McCartney as a man for holding together a great family through the times of rock & roll, and through all of the success, and through all of the swirling. I have a lot of respect for that.

"The rest of it you all know—he's one of the greatest songwriters perhaps ever. I think he'll be remembered hundreds of years from now for the work that he did, starting with 'Yesterday,' and continuing on to today and tomorrow."

### ART ALEXAKIS OF EVERCLEAR ON DEL SHANNON:

"I actually have to credit Del Shannon as the main influence on my becoming a singer-songwriter. . . . Driving to work and back, I would sing along with the radio, trying to emulate whoever was singing at the time. I remember vividly one time in particular. I was driving home from my crappy job that I hated, depressed about my nonexistent love life, caught up in an L.A. traffic jam at rush hour, when 'Runaway' came on the radio. I remember locking into the pure emotion, hurt and anguish I heard in Del's voice, and I started singing as hard as I could. I'm sure the people in the car next to me thought I was going insane. But you know, I didn't care, because when the song was over, I felt so connected to my own voice, and what was coming out of my heart, that I decided right then and there that I would write and sing my own songs. From that moment on, I've never looked back. I wish Del Shannon was here, so I could tell him what his music and voice meant to me, both then and now."

### ELTON JOHN ON DUSTY SPRINGFIELD:

"When I first heard Dusty's voice, when she recorded a record of 'Islander Dreams' with the Springfields, I fell in love with that voice. Then when I first saw her in God-knows-what year, I fell in love with the way she looked. The beehive hair, the mascara, the pink top, and the purple skirt. *It had no effect on me whatsoever!* When choosing my name, I considered Dusty, but it had already gone, you know.

"After the Springfields, Dusty decided to go solo, and I was a big, big fan. . . . I'd never heard a white woman sing like this before. We'd always heard these kind of cheesy pop records coming out of Britain and America, sung by white women, and then suddenly there was Dusty. This is a voice that is so far untouched. . . . And it's ironic that tonight, we're inducting the Staple Singers into the Hall of Fame. I'm sure Dusty is very happy about that. She was so influenced by American rhythm & blues music, like most of us in the British Isles were, because it was the only real decent music around.

"Dusty had an incredible career. She started off with a song called 'I Only Want to Be With You,' and she blossomed. . . . That voice, which is so sweet and vulnerable and powerful, yet there is something so gentle and melodic about it that moves me today. I just think she's the greatest white singer that ever has been. Apart, of course, from Tiffany! *Oh!*

"Even though we were not close friends, we did spend some time together. There was one occasion in Los Angeles when we wanted to go to a club, and she said, 'I don't think I can go to a club, I don't look right.' So I said, 'No, no.' She said, 'My hair looks terrible.' There's a big Rexall drugstore on La Cienega, and we went to the back of the store, she bought a can of hairspray, by the time we got to the register, it was gone—I swear to God! And then she said, 'Can you fix my hair?' It was like Mount Rushmore, I mean, *please.*

"I love you, Dusty! You're enough to turn a gay boy straight. *But not quite enough.* As you know, she passed away twelve days ago, after a long and really horrible illness, and she was a diva till the end: She would get up and say, 'I'm *not* going to die today,' but in the end she did die, and she left us a legacy of beautiful recordings, fabulous memories. At her funeral the other day—I've never heard of this before—as her coffin came out of the church, she had a standing ovation and a round of applause. Not bad. The fabulous Dusty Springfield."

### BONO ON BRUCE SPRINGSTEEN:

"Bruce is a very unusual rock star, isn't he? I mean, he hasn't done the things most rock stars do. He got rich and famous, but he never embarrassed himself with all that success, did he? No drug busts, no blood changes in Switzerland—even

Terrence Malick. To be so accessible and so private: There's a rubric. But then again, he is an Irish-Italian with a Jewish-sounding name. What more do you want? Add one big African sax player and no one in this room is gonna fuck with you. . . .

"America was staggering when Springsteen appeared. The president had just resigned in disgrace, the U.S. had lost its first war, there was going to be no more oil in the ground, the days of cruising and big cars were supposed to be over. . . . Bruce made you believe that dreams were still out there, but after loss and defeat. They had to be braver, not just bigger. He was singing, 'Now you're scared, and you're thinking that maybe we ain't that young anymore,' because it took guts to be romantic now. Knowing you could lose didn't mean you still didn't take the ride. In fact, it made taking the ride all the more important. Here was a new vision and a new community. More than a community, 'cause every great rock group is kind of like starting a religion. And Bruce surrounded himself with fellow believers.

"E Street wasn't just a great rock group, or a street gang, it was a brotherhood. . . . What do you call a man who makes his best friend his manager, his producer, his confessor? You call him the Boss. And Springsteen didn't just marry a gorgeous redheaded woman from the Jersey Shore; she could sing, she could write, and she could tell the Boss off. And that's Patti right there. . . .

"More than anyone else, Bruce Springsteen owns America's heart."

### BRUCE SPRINGSTEEN:

"I stood on this stage when I inducted Roy Orbison and Creedence Clearwater Revival and Bob Dylan, an artist whose music was a critical part of my own life, and tonight I hope that my music served my audience half as well. If I succeeded, thanks. If I succeeded in doing that, it's been with the help of many, many kindred spirits along the way.

"I'd like to thank my mother, Adele, for that slushy Christmas Eve—a night like the one outside—when we stood outside the music store, and I pointed at that sunburst guitar, and she had that sixty bucks, and I said, 'I need that one.' She got me what I needed, and she protected me, and provided for me a thousand other days and nights. As importantly, she gave me a sense of work as something that was joyous, and that filled you with pride and self-regard, and that committed you to your world. Thanks, mom. This is yours tonight. Take it home as a small return on the investment you made in your son. *Mama!* The Italian side of the family.

"Now, my dad, he passed away this year, but I've got to thank him, because, what would I conceivably have written about without him? I mean, imagine if everything had gone great between us, it would have been a disaster, you know? I would have written just happy songs. I tried to do that in the early nineties, and it didn't work. The public didn't like it. He never said much about my music, except that his favorite songs were the ones about him, and that was enough. Anyway, I put on his work clothes, and I went to work; it was the way that I honored him. My parents' experience forged my own—they shaped my politics, and they alerted me to what is at stake when you're born in the USA. I miss you, dad. . . .

"The next guy—this is Jon Landau, or as I sometimes call him, Jon 'Thank God I'm a Country Boy' Landau. I've seen the future of rock & roll management, and its name is Jon Landau. What I hope to give to my fans with my music—a greater sense of themselves, and greater freedom—he with his talents and his abilities has done that for me. . . .

more remarkable, no golfing. No bad hair period, even in the eighties. No wearing of dresses in videos, though there was those fingerless gloves in the eighties. No embarrassing movie roles, no pet snakes, no monkeys, no exhibitions of his own paintings, no public brawling, or setting himself on fire on the weekends.

"Rock stars are supposed to make soap operas of their lives, aren't they? If they don't kill themselves first. Well, you can't be a big legend and not be dysfunctional. It's not allowed. You should at least have lost your looks. Everyone else has. Do you see them? It's like Madame Tussaud's back there. Then there's Bruce Springsteen. *Handsome!* Handsome mother with those brooding eyes; eyes that could see through America, and a catastrophe of great songs.

"Bruce has played every bar in the USA, and every stadium. Credibility? You couldn't have more, unless you were dead. But Bruce Springsteen, you always knew, was not gonna die stupid. He didn't buy the mythology that screwed so many people. Instead, he created an alternate mythology—one where ordinary lives became extraordinary and heroic. Bruce Springsteen feels familiar to us, but it's not an easy familiarity, is it? Even his band seems to stand taller when he walks in the room. It's complex. He's America's writer and critic. It's like in *Badlands*, he's Martin Sheen and

"Now, last but not least, the men and women—the mighty men and women of the E Street Band. Oh, Lord. Who I have re-dedicated, re-educated, re-animated, resuscitated, and re-invigorated with the power, the magic, the mystery, and the ministry of rock & roll. . . .

"Patti Scialfa—she busted the boy's club, big time. It went like this: 'Okay, fellas—there's gonna be a woman in the band. We need someone to sing all the high parts. How complicated can it get?' Well, a nice paparazzi photo of me in my jockey shorts, on a balcony in Rome, ten of the best years of my life, Evan, Jesse, Sam—three children genealogically linked to the E Street Band—tells the rest of the story. Everybody wants to know how I feel about the band. Hell, I married one of 'em. Thank you, Baby. You hit all the high notes; you're tougher than the rest. . . .

"Now, last but not least, Clarence Clemons. You wanna be like him, but you can't. The night I met Clarence, he got up onstage; a sound came out of his horn that seemed to rattle the glasses behind the bar, and threatened to blow out the back wall. The door literally blew off the club in a storm that night, and I knew I'd found my sax player. But there was something else. Something happened when we stood side by side; some energy, some unspoken story. . . . For fifteen years, Clarence has been a source of myth, and light, and enormous strength for me onstage. Together we told a story of the possibilities of friendship; a story older than the ones that I was writing, and a story that I could never have told without him at my side.

"So, as Stevie Van Zandt says: "Rock & roll, it's a bad, band thing," and that includes you, the audience. Thank you for giving me access and interest into your lives, and I hope that I've been a good companion."

## LAURYN HILL ON THE STAPLE SINGERS:

"Few artists have achieved the longevity and excellence in three genres of music as have the Staple Singers. Over three decades, they have been a force to be reckoned with. In the fifties, they were post-war gospel warriors. In the sixties, they single-handedly invented a genre called soul-folk, which was activist music, and linked them immediately and directly to the Civil Rights Movement. In the seventies they turned to what Mavis Staples described as 'message music'—songs such as 'Respect Yourself,' 'I'll Take You There,' and 'Come Go With Me' were the embodiment of soul: soul-liberating, soul-inspiring, and soul-empowering music. They are a group that has unmistakably proven that speaking of faith and spirituality and God is in accordance with being fly *and* commercially acceptable."

## THE STAPLE SINGERS

**Pops Staples:** "I wanna say to all of y'all out there, young and old: Always hold on to your dream. When I started trying to play, it didn't look like I was going to do anything, but I want to say to you, never say it's too young or too old. I went from twelve to seventy-two years old before I got to make a record, and I went from seventy-two to eighty-four before I made that hit record. Whatever you do, don't give up. Hold on to your dream, don't give up, 'cause you see what I done after all those years."

## BONNIE RAITT ON CHARLES BROWN:

"With his string of hit records in the late forties and fifties, with the Three Blazers

and his own group, Charles Brown led the charge for the West Coast blues explosion that brought a sophistication and elegance to music that had been carpetbagged from Texas and Oklahoma after the war. His piano playing—as far as I'm concerned—is some of the most astounding blend of delicacy and roar that I've ever heard. And while his technical wizardry was so impressive, what always got me the most is the way he let the song take center stage, caressing the melody and leaning on those lyrics, phrasing sometimes behind or just around the beat for just the right emphasis. He was above all the master of the blues ballad.

"When the clubs got too funky for even him, he quit and played for himself. He helped so many young artists starting up, who later never returned the favor, and yet I never saw him buckle under with bitterness. Was he angry? Sure, but Charles didn't worry about that. He said, 'You know, it'll all come around.'

"And for Charles, it did. The best part of it was that in the last ten years, some of it came around in his lifetime. I only wish he could have lasted a couple more months, to be here with us tonight. So let's raise a glass to the great Charles Brown—a man I like to call the Sequoia of the Blues—and really honor him by committing ourselves to getting payback for the artists that put us in this room tonight while they're still alive to enjoy it. No more 'I didn't sign the original contract, it's not my problem.' If you sell their records, give them the money; if they can still sing and play, put 'em on your shows. And Charles, you keep drifting, baby—deep into that black night. You gave us all these blues for Christmas, now you go on and live in that paradise."

## CHRIS ISAAK ON BOB WILLS:

"In 1947 Bob Wills brought Western Swing out to my neck of the woods, when he opened a dance club in Sacramento, California, just sixty minutes away from my hometown, and he also became something of a movie star, but he never really went Hollywood like some people. So as a Stocktonian, I'm claiming bragging rights, because everybody wants to be part of something great. His 78s, his 45s, and his 8-tracks were in my family collection, and my friends', too, and to say that he's a major influence is an understatement. I would have ripped him off more if I had more talent. . . .

"Wills was a fiddle player who surrounded himself with virtuoso sidemen, and Wills's band was a phenomenon unto itself. Bob and his boys had the big beat, and they flaunted it. Drums and country music were mutually exclusive at that time, and when the Texas Playboys played the Grand Ole Opry, Bob was told that the drummer had to play unseen behind a curtain. Bob threw a fit, and the drums were seen and heard on the sacred Ryman stage, and the Playboys' drummer once said of his boss, 'Bob Wills would not allow music to be put in a straitjacket. He did not have to conform with anything but human feeling.'

"In 1939, he called his band together—they'd been having a lot of hits—and he said, 'Guys, we may not have hits forever, and I know that someday we may have to break up this band, but I've got a plan.' And his plan was, he wanted to buy a ranch in New Mexico, and divide it up, put little houses out there, so that after they retired, they could all live close enough to one another, so that they could get together and jam every couple of days. I thought that's very cool. But the way it worked out, Bob never got a chance to retire, 'cause he led the Playboys until 1973, and today he leads them into the Rock and Roll Hall of Fame."

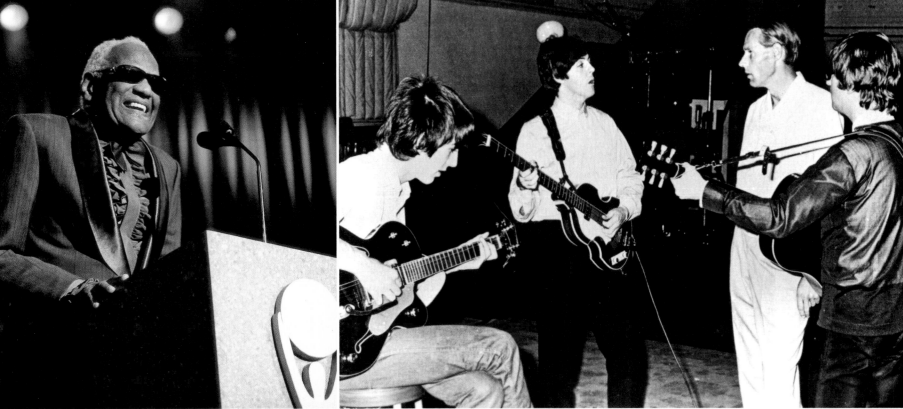

Previous, page 135: Bruce Springsteen. This page, clockwise from top left: Ray Charles inducting Billy Joel; the Beatles with George Martin (second from right); Billy Joel, 1989; (from left) Clarence Clemons, Springsteen, and Little Steven, 2003; an early Shannon album; Paul McCartney, while still a Beatle. Following, page 138: 1999's phenomenal jam: (from left) Billy Joel, Eric Clapton, Paul Shaffer, Paul McCartney, Robbie Robertson, Dion, Will Lee, and Chris Isaak. Page 139: Dusty Springfield, 1970.

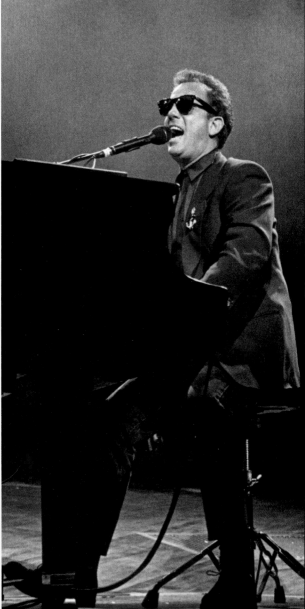

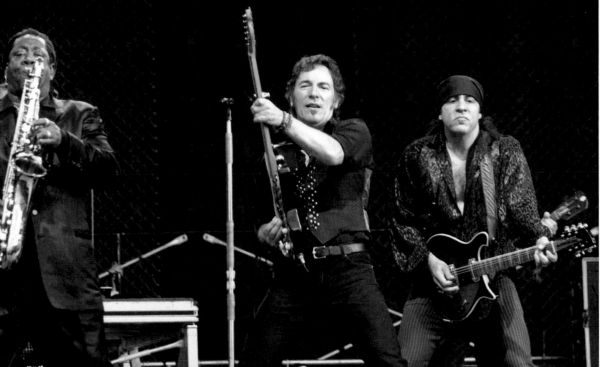

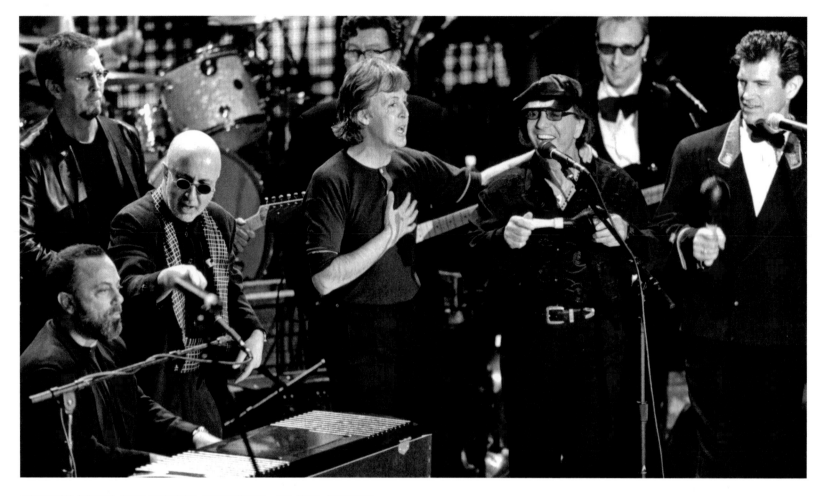

"I wanted to read a quote that I love, which my daddy told a reporter in 1956. He said, 'Rock & roll will be around forever. We didn't call our music rock & roll back when we introduced it as our style in 1928, and we don't call it rock & roll the way we play it now, but it's just basic rhythm—it's gone by a lot of different names in my time. It's the same. When you follow just a drumbeat, like in Africa, or surround it with a lot of instruments, the rhythm is what's important. Rock & roll will be around forever.'"

## JIMMY IOVINE ON GEORGE MARTIN:

"For twenty-five years I've been asked, 'What does a producer do?' My wife asks me, my kids ask me, most of the bands who come into my office ask me. And even some of the bands I've worked with in the studio have asked me. I couldn't tell them what record producers do, but I could always tell them who the great ones were and are. Sam Phillips, Ahmet Ertegun, Chris Blackwell, Quincy Jones; these guys were the visionaries who felt the white heat of great talent and helped stoke the fire, even when nobody else saw the spark. They supported the artists to go beyond the mere hit, to create magic. . . .

 "Still, in order to live up to my responsibilities tonight, I struggled to come up with a slightly more specific description of what a record producer does. And then I had an epiphany. I bought a book about it. I read the book, and guess who had one hell of a definition of the job? Sir George Martin. Here's what he had to say: 'I think one of the basic challenges of the producer is to get into the mind of someone, and find out what they're driving at, what they're trying to achieve, and then help them to achieve it—so consequentially you live with them, and find out their weaknesses, and their strengths, and amplify their strengths.'

 "Had George Martin not followed his own advice, America might not have sat down in front of their television on that winter night in 1964 and been abducted by the British Invasion. What George Martin did with the Beatles would define the role of the modern record producer. First, he established the cardinal law of producing: Don't fuck it up. Second, he was a true pioneer in his innovative and visionary ability to anticipate the coming marriage of music and technology. And third, he was able to grow with these great artists, and make contributions at every phase of their work.

 "We see the impact of popular music nearly everywhere we look, whether it's the clothes we wear, the way we dance, or even occasionally profess our politics. What gives our emotions expression is often a vision emanating from a small, windowless room, where four or five people wrestle with an idea as elusive as putting a collar on a bumblebee. In that semidarkness, a good producer is asked to make a million small decisions, all while looking through the artist's prism. If George Martin and the Beatles hadn't gone though that ring of fire several times, I know I would have been denied what turned out to be the soundtrack of my life.

 "What the Beatles and George Martin achieved in going from something as seductively simple as 'I Want to Hold Your Hand,' to something as revolutionary and complex as *Sgt. Pepper's* inspires all of us to keep raising the bar every day."

## MUSICAL HIGHLIGHTS

After Springsteen's induction, he hollered out, "My wife, my great friends, my great collaborators, my great band, your presence tonight honors me, and I wouldn't be standing here tonight without you, and I can't stand up here now without you. Please join me!" The reunited E Street Band launched into a raucous set, including "Tenth Avenue Freeze-Out," "Backstreets," and "The Promised Land." When the Wicked Pickett took the stage to spar on lead vocals with the Boss, Billy Joel jumped in on keys. What followed was a montage of musical moments: Bonnie Raitt duetted with Joel on Del Shannon's "Runaway," and Clapton and D'Angelo returned for an electrifying "Early in the Morning."

Then came the magical jam. According to *Rolling Stone*, "McCartney hadn't planned to perform at all. During the ceremony, Jann Wenner went over to McCartney's table and asked if he felt like playing, and then suggested Carl Perkins's 'Blue Suede Shoes.' 'Sure, man,' said McCartney. So he and [Robbie] Robertson sauntered onstage" to usher in the jam. McCartney belted the late Perkins's composition, with Clapton and Robertson taking rockabilly solos. Springsteen, Bono, Peter Wolf, Lauryn Hill, Mavis Staples, Melissa Etheridge, and Bette Midler crowded onto the stage, and Billy Joel crooned Ray Charles's "What'd I Say," backed by Chris Isaak, Raitt, and Dion. Bono, Wilson Pickett, and Mavis Staples sang lead on "People Get Ready," the assembled choir handling backup vocals. Bono ad-libbed some lyrics to honor Mayfield: "Curtis is lying in his hospital bed/Another man singing the words he said/Curtis Mayfield's words, they still ring so true/Curtis Mayfield, this is our song for you."

Then, as the stage began to clear, Joel, perched at the piano, began the opening riff of "Let It Be" and crooned the first line. Suddenly McCartney was at the mic, singing his heart out. "Everyone wanted it to be something special," Paul Shaffer told *Rolling Stone*'s Anthony Bozza. "Things happen fast and there are so many great moments. Usually I don't realize it until later." Music advisor Robbie Robertson remembered, "There was a very nice, warm feeling in that room. It was a feeling in the air. It was an opportunity to see musical combinations we may never see again as long as we live. These are people who may not be in the same room at the same time ever again."

## THE MANY FACES OF DUSTY SPRINGFIELD

✦ ✦ ✦

Dusty Springfield began her career in the country-tinged family group the Springfields. After going solo, she first charted as a pop singer—doing Bacharach/David songs and other gems—before reinventing herself as the queen of blue-eyed soul, working with producer Jerry Wexler on *Dusty in Memphis*, released by Atlantic Records. Here is the range of her musical oeuvres, via her various hit singles:

✦ ✦ ✦

### COUNTRY DUSTY (WITH THE SPRINGFIELDS):
**"SILVER THREADS & GOLDEN NEEDLES,"** Number Twenty, 1962
**"DEAR HEARTS & GENTLE PEOPLE,"** 1962

### POP DIVA DUSTY
**"I ONLY WANT TO BE WITH YOU,"** Number Twelve, 1964
**"STAY A WHILE,"** Number Thirty-Eight, 1964
**"WISHIN' AND HOPIN',"** Number Six, 1964
**"I JUST DON'T KNOW WHAT TO DO WITH MYSELF,"** Number Three, U.K., 1964
**"YOU DON'T HAVE TO SAY YOU LOVE ME,"** Number One, U.K. and Number Four, U.S., 1966
**"THE LOOK OF LOVE,"** Number Twenty-Two, 1967

### SOULFUL DUSTY
**"SON OF A PREACHER MAN,"** Number Ten, 1968
**"BREAKFAST IN BED,"** Number Ninety-One, 1969
**"DON'T FORGET ABOUT ME,"** Number Sixty-Four, 1969
**"WILLIE AND LAURA MAE JONES,"** Number Seventy-Eight, 1969
**"A BRAND NEW ME,"** Number Twenty-Four, 1970

### SYNTH-POP DUSTY
**"WHAT HAVE I DONE TO DESERVE THIS?"** (collaboration with the Pet Shop Boys), Number Two, 1987
**"NOTHING HAS BEEN PROVED,"** Number Sixteen, U.K, 1989
**"IN PRIVATE,"** Number Fourteen, U.K., 1989

## INDUCTEES

**PERFORMERS** Eric Clapton ✦ Earth, Wind and Fire ✦ The Lovin' Spoonful
The Moonglows ✦ Bonnie Raitt ✦ James Taylor
**EARLY INFLUENCES** Nat King Cole ✦ Billie Holiday **NONPERFORMER** Clive Davis
**SIDEMEN** Hal Blaine ✦ King Curtis ✦ James Jamerson ✦ Scotty Moore ✦ Earl Palmer

A new century of inductions commenced on March 6, at the Waldorf-Astoria. And new to the Hall of Fame were inductees included in the Sideman category, described by Seymour Stein as, "those musicians who both in the studio and in concert backed up and helped create the magical sound of some of the music that has impacted our lives." The first group of sidemen represented a variety of instruments and talents essential to rock & roll: drummer Hal Blaine, saxophonist King Curtis, bassist James Jamerson, guitarist Scotty Moore, and drummer Earl Palmer. Musicianship was the emphasis among another stellar cast of inductees and presenters.

During their induction, members of Earth, Wind and Fire reunited onstage for the first time in twenty years to perform "Shining Star," following a pause while drummer Freddie White put on his special pair of sneakers. "One of the keys to the groove is that Freddie has a drum shoe," singer Philip Bailey explained. He also said of founder Maurice White, battling Parkinson's disease, "You honor a man with vision and tenacity and courage, one who had a dream and tackled that dream and fought against every obstacle. Now, as he tackles his personal obstacles, I'm sure he'll win." A breathtaking version of honoree Nat King Cole's haunting "Nature Boy" performed by Ray Charles, and an a cappella "Strange Fruit" by Diana Ross, in tribute to Billie Holiday, awed the audience.

In addition to Ross, a diversity of women took the stage over the course of the night—Patti Smith, Melissa Etheridge, Bonnie Raitt, Natalie Cole, and L'il Kim—with the women featured more prominently this year than ever before. Smith inducted Clive Davis, who had originally signed her to Arista Records. Etheridge gave a powerful speech inducting Raitt, who'd been a presence at the ceremonies for years, honoring blues greats. Cole accepted for her father, Nat King Cole, and L'il Kim inducted Earth, Wind and Fire.

When he received his statue, James Taylor echoed a line in his bio video showing him earnestly talking to a reporter at an eighties No Nukes benefit: "I only hope one of these never falls into the hands of someone desperate enough to use it." The laughs subsided as he played a moving "Fire and Rain" and a joyous "Mexico."

## "YOU CAN CALL IT ROCK & ROLL, BLUES, OR R&B—TO ME, IT'S ALL THE SAME."

### —BONNIE RAITT

THE 15TH ANNUAL INDUCTION

> "FOR ME, IT'S ABOUT THE MUSIC. I'M JUST A MESSENGER— I CARRY THE MESSAGE, AND I HOPE TO BE ABLE TO DO THAT AS LONG AS I LIVE. LOVE AND MUSIC IS ALL YOU NEED."
>
> —ERIC CLAPTON

### ROBBIE ROBERTSON ON ERIC CLAPTON:

"I first crossed paths with Eric in 1968 when we were very young, and I was immediately struck by how gracious and supportive and complimentary he was. A while after that, Eric came up to Woodstock, New York, where the Band and I were living at the time, and he said this before, but when he was coming up there—in his mind—he was coming there to join the Band. Now, I was the guitar player in the Band. He's a guitar player. Was he coming there to take my job? Or was he coming there to share my job? I said, 'This is a very unusual compliment,' but it was from the heart.

"I want to send respect out to the man who survived one of the deepest tragedies a father could imagine. I want to send respect out to the man who found the courage to stand up to the demons of addiction. I want to send respect out to the man with a voice that can sing you to tears. I want to send respect out to the only person to be inducted into the Rock and Roll Hall of Fame three times."

### JOHN MELLENCAMP ON THE LOVIN' SPOONFUL:

"[*Sings*] '*In the city, in the summer, in the city.*' In the summer of 1966, I was in eighth grade. I was fourteen years old, discovering my freedom away from my parents. Driving around in cars with older guys, driving from one small town to another, discovering the freedom of what a 305 Scrambler Motorcycle felt like, driving down Interstate 65 to Scottsburg, Indiana, and the song on the radio was 'Summer in the City,' and it played over and over and over again. The song, I assumed, was written about New York City. I'd never been to New York City, but here I was in a town of four thousand people and I related to every word that that guy sang: 'Every night it's a different world, go out and find a girl, c'mon, c'mon let's dance all night, it just might be all right.' I thought '*God!*' Great music, at its best, makes the listener believe that the magic's in the music and the music is about *them*. I hope the guys in the Spoonful are honored and humbled to know that people will be dancing and fucking to their music in the twenty-first century."

### ZAL YANOVSKY OF THE LOVIN' SPOONFUL:

"John, do we have to do the fucking and the dancing at the same time? Because I tried that once . . ."

### PAUL SIMON ON THE MOONGLOWS:

"I was listening to Alan Freed's Moondog show, and the music he was playing was called rhythm & blues. The term *rock & roll* hadn't been coined yet. I knew something magical was happening when I heard the slow bass line of Prentiss Barnes and after a few bars, Harvey Fuqua and Pete Graves joined in with the harmony—a riff that I've stolen on many occasions—and finally Bobby Lester began to sing the lead in his beautiful tenor voice, and I have never forgotten it."

### MELISSA ETHERIDGE ON BONNIE RAITT:

"Bonnie Raitt. Slide, soul, selflessness, passion, compassion, enlightenment, activism, blazing fingers, blazing hair. In the court of rock & roll, she is not the queen. She doesn't

Previous, page 140: Bonnie Raitt. This page: Eric Clapton.

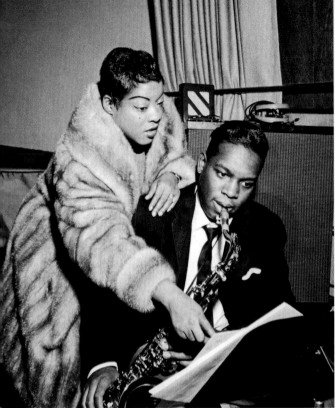

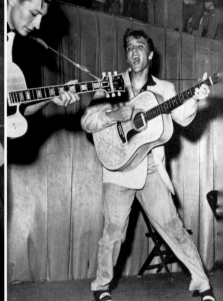

Clockwise from top left: King Curtis and LaVern Baker, 1950; the Lovin' Spoonful, 1967; Janis Joplin and Clive Davis, 1968; Scotty Moore with Elvis Presley, 1955; Earth, Wind and Fire; Nat King Cole, 1960; the Moonglows: (from left) Prentiss Barnes, Harvey Fuqua, Bobby Lester, and Pete Graves.

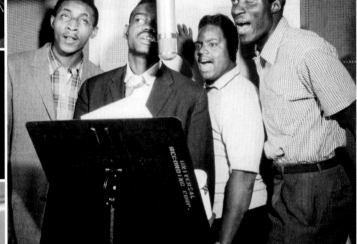

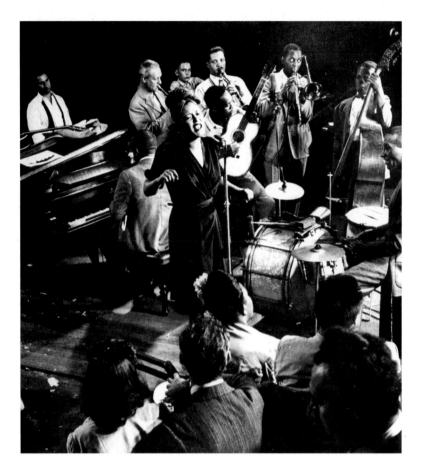

want to be the queen. She is a soldier. She is in the trenches, living it, feeling it. A woman in a man's world, breaking ground. A woman so tough, so uncompromising, so secure that she hasn't felt the need to change her hairstyle for thirty years.

"Over the years I've sat at the Grammys and watched her win award after award, some of them in my category. I've watched her become a superstar and I can tell you that today, she is still the same honest, generous, supportive woman she has always been. The same gutsy, fearless performer. She's won nine Grammy Awards, performed at over two hundred benefits, and she's made sure her friends and mentors, the pioneers of rhythm & blues, will be remembered and valued. Tonight Bonnie Raitt joins some of those friends, both living and dead. Friends who always recognized her for what she is: a musical pioneer in her own right, a force for good, and a force of nature."

## BONNIE RAITT:

"I don't know if any of us ever get up here, having expected to reach this level of respectability when we were first bopping around our rooms as kids to our favorite records. I know I never expected to make a living at it, let alone take a place next to all these legends I've watched walk up these stairs. I'd like to thank you so much for holding me in such high esteem and for that beautiful tribute, Melissa. For being the one to induct me and carrying the torch.

"I'm especially proud to be here tonight because of what it says about what you think is important. I'm proud, partly because I don't just put on an electric guitar, but because I know how to ride it. Let's hope this marks the beginning of lots more women getting out of the kitchen and into the kick-ass fire.

"Nobody gets up here who wasn't obsessed, didn't worry their parents, didn't mess up their relationships, and if they did it right, probably their health as well. It's the thing that still drives me most and it always will. I'm never gonna get enough, so to my friends and fans for sticking with me and everybody out there who brought me here tonight, I really thank you for this great honor."

## PAUL McCARTNEY ON JAMES TAYLOR:

"I'm just going to remember a couple of things from way, way ago in the sixties, when we were starting a new record label called Apple—before it was a computer. And we were looking for talent, so we sent out this message—'Come all ye talented ones unto us'—and a few of them did. My friend Peter Asher one day came to the office and he said, 'I've got this guy from New York.' And for once, it was someone really great. It was this kind of haunting guy who could really play the guitar and really sing beautifully, and right there and then we said, 'Okay, he's on Apple.' I'm just very honored to induct him into the Rhythm & Blues, Rock & Roll, Ballad, Jazz, Slow Fox Trot Awards here tonight. And you know, you've got to do all those categories because we all know you can't really call it one thing. Rock & roll's too slim for what's been going on tonight."

## RAY CHARLES ON NAT KING COLE:

"I used to sleep Nat Cole, I would drink Nat Cole, eat Nat Cole. His voice and his piano were so much in harmony together, and that's what I wanted to do with music when I was growing up. By sounding like Nat Cole, I could work."

> ## "HER VOICE HAD SUCH A GRACE, SUCH A POWER, BOUND UP IN SUCH A SADNESS."
> —DIANA ROSS, ON BILLIE HOLIDAY

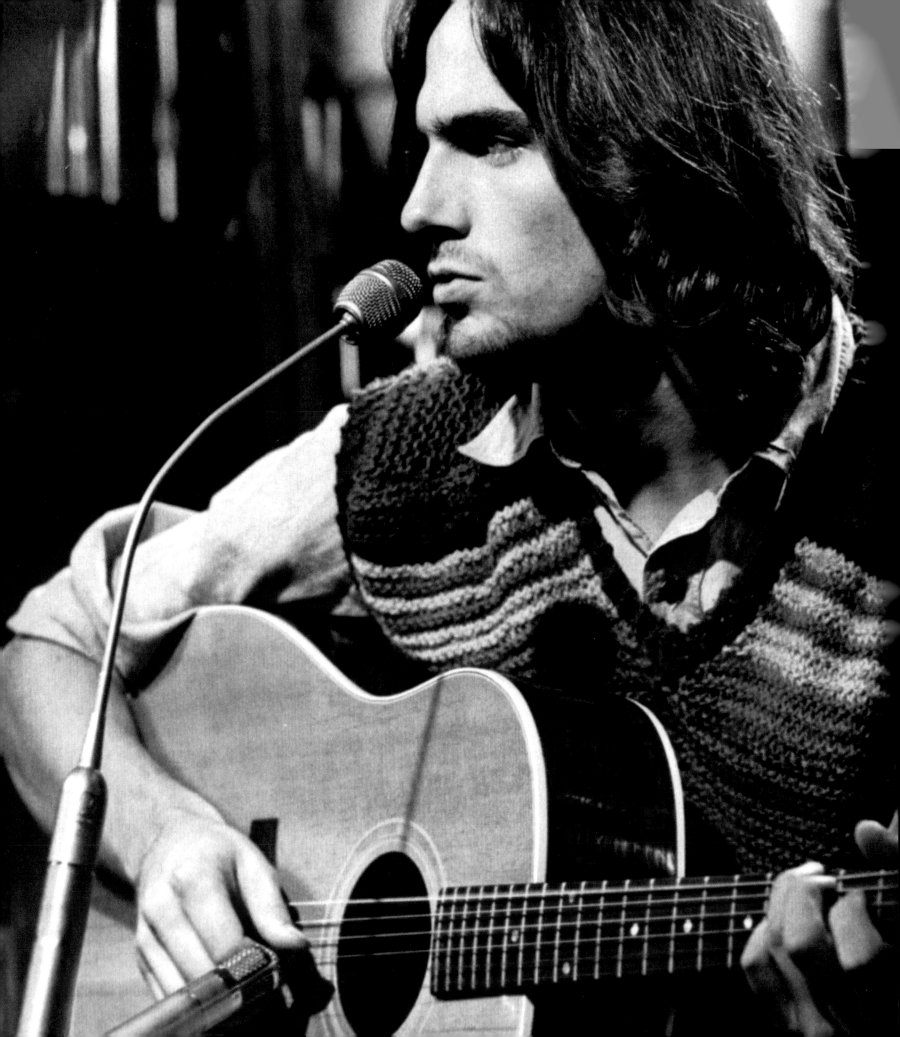

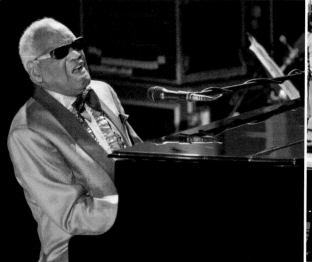

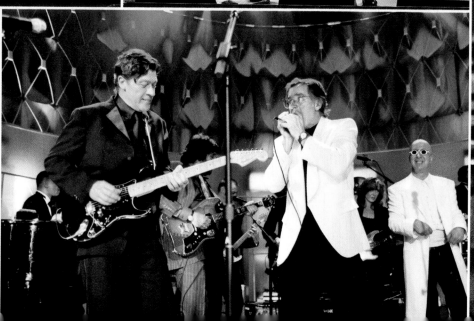

Previous, page 144:
Billie Holiday, 1942. Page
145: James Taylor, 1970.
This page: Hall of Fame
induction highlights,
March 1999. Clockwise
from top left: Patti Smith
Group; (from left) Eric
Clapton, John Sebastian,
and Bonnie Raitt; Diana
Ross; (from left) Robbie
Robertson, Sebastian, and
Paul Shaffer; Ray Charles;
the Moonglows.

## PATTI SMITH ON CLIVE DAVIS:

"In 1975, like myself, Clive Davis was an underdog in the music business. He started Arista Records, and in that same year, drew me from the bowels of New York City's CBGB into a room with a small P.A. and one folding chair to audition. I have always been a performer to reflect the energy of the people, and I was amazed to be confronted with the magnificent energy of one single man. And I was signed to Arista. I could not sing, play an instrument, [and I] barely knew how to use a microphone. I did not comprehend—and I often wondered—what he ever saw in me. He has the energy, the vision, and the passion for the form, and contains within him a natural spring of youth. And so Clive, like the phoenix, you rose from the ashes in 1975, you formed Arista, you are Arista, and none else shall be. You've been shot down, you have risen again, and you are still rising. Clive, your wayward child salutes you and speaks for all in saying, 'Clive Davis, we welcome you as we induct you into the Rock and Roll Hall of Fame.'"

## CLIVE DAVIS:

"I'm overflowing with gratitude to all of the musicians who have filled my life with their music, inflaming a passion that I never knew existed, and providing purpose and meaning every day, every week, every month. I can say without equivocation that this fire can never go out and that this fire *will* never go out."

## MUSICAL HIGHLIGHTS

Some satisfying pairings occurred throughout the night: Bonnie Raitt and Melissa Etheridge traded guitar licks on "Thing Called Love," with Raitt "peeling off slide-guitar solos that extended the heritage of blues and showed exactly why she's a Hall of Fame player," according to *Rolling Stone*. Eric Clapton played a moving acoustic "Tears in Heaven," backed by Paul Shaffer on harmonium, then amped up the wattage with "Further On Down the Road," trading electric leads with Robbie Robertson.

Jam time started with the classic sing-along "Route 66," with Natalie Cole first getting her kicks, followed by Clapton, Raitt, Robertson, and Etheridge taking solo turns. Al Green's "Love and Happiness" was a highlight, with members of Earth, Wind and Fire, including vocalist supreme Philip Bailey, adding gospel-style fervor. The night ended with Clapton taking on "Sweet Home Chicago," and "unleashing his most powerful solo of the night, building suspense through chorus after chorus and ending the proceedings with a masterful barrage of clear, ringing notes," reported *Rolling Stone*'s Anthony Bozza.

Robbie Robertson summed up the night: "In the course of an evening, you take this journey. . . . It's very emotional. It's about people being honest. It's about people being able to express themselves."

## BEHIND CLOSED DOORS

✦ ✦ ✦

The sidemen are often the unsung heroes of some of rock & roll's greatest recordings and performances. Take a look at the work of this first class of Rock and Roll Hall of Fame inductees in the Sideman category:

✦ ✦ ✦

### HAL BLAINE
**PROFILE:** Drummer and member of L.A. session players called the Wrecking Crew
**SIDEMAN TO:** The Ronettes, the Mamas and the Papas, the Beach Boys, and the Fifth Dimension
**NOTABLE SONGS:** The Byrds' recording of "Mr. Tambourine Man," the Crystals' "He's a Rebel," and the Fifth Dimension's "Up, Up and Away"

### KING CURTIS
**PROFILE:** Saxophonist
**SIDEMAN TO:** Buddy Holly, the Coasters, and Aretha Franklin
**NOTABLE SONGS:** The Coasters' "Yakety Yak," Buddy Holly's "Reminiscing," and his own "Soul Twist"

### JAMES JAMERSON
**PROFILE:** Bassist and member of Motown house band, the Funk Brothers
**SIDEMAN TO:** Marvin Gaye, Smokey Robinson and the Miracles, the Supremes, the Four Tops, the Temptations, and Martha and the Vandellas
**NOTABLE SONGS:** The Four Tops' "Bernadette"; Martha and the Vandellas' "Nowhere to Run"; Gladys Knight and the Pips' "I Heard It Through the Grapevine"; The Temptations' "My Girl"; The Supremes' "You Keep Me Hanging On"; and Marvin Gaye's "What's Going On"

### SCOTTY MOORE
**PROFILE:** Elvis Presley's first lead guitarist, 1954–1961
**NOTABLE SONGS:** Elvis Presley's "That's All Right," "Good Rockin' Tonight," "Mystery Train," "I Love You Because," and "You're a Heartbreaker"

### EARL PALMER
**PROFILE:** Drummer on hundreds of sessions in New Orleans and L.A.
**SIDEMAN TO:** Fats Domino, Lloyd Price, Little Richard, Ike and Tina Turner, Frank Sinatra, Randy Newman, and Bonnie Raitt
**NOTABLE SONGS:** Fats Domino's "I'm Walking," Lloyd Price's "Lawdy Miss Clawdy," Little Richard's "Lucille," and the Righteous Brothers' "You've Lost That Lovin' Feelin'"

## INDUCTEES

**PERFORMERS** Aerosmith ✦ Solomon Burke ✦ The Flamingos ✦ Michael Jackson
Queen ✦ Paul Simon ✦ Steely Dan ✦ Ritchie Valens
**NONPERFORMER** Chris Blackwell **SIDEMEN** James Burton ✦ Johnnie Johnson

On March 19, at the Waldorf-Astoria, the class of 2001 proved an eclectic group, including veterans still at the top of their game. Steely Dan had just won several Grammys for their first album in twenty years; Aerosmith continued to get chart-toppers, and Paul Simon had recently hit with *You're the One*. The audience got to meet Freddie Mercury's diminutive mum, who took the stage for her late son, and Foo Fighter Dave Grohl, who inducted Queen with his band mate Taylor Hawkins, then performed with the group, boasting, "I felt like I just slept with Queen. And it was good!" As for roaring through "Tie Your Mother Down" with his idols: "For two-and-a-half minutes onstage, it was like the sweetest orgasm I've ever had in my life."

Bono toasted Chris Blackwell, the founder of Island Records, U2's original label, with his usual provocative wordplay, taunting his fellow artists: "Look at yourselves. Steven Tyler, Michael Jackson, Keith Richards, but more importantly you guys with the wallets—you're the real freaks. I know some of you think you could run Coca-Cola, don't you? Chris Blackwell couldn't. It's not banking, and even if it was, the best of you couldn't run a bank. You could *rob* a bank. You've shown music is an excuse to make money, but for the best, money is an excuse to make music."

Paul Simon beat the Band's Garth Hudson's record of naming the most people (fifty) in his thank-you speech, but while Hudson simply listed them, Simon described them in detail. And the enigmatic Michael Jackson showed up in what looked like a moon boot, telling the audience: "There is not going to be any moon-walking tonight because I hurt my foot." The greatest fashion statement, though, came from humongous soulman Solomon Burke, who reigned onstage donning his signature cape and crown.

> "WE WEREN'T TOO AMBITIOUS. WE JUST WANTED TO BE THE BIGGEST THING THAT EVER WALKED THE PLANET, THE GREATEST ROCK BAND THAT EVER WAS."
>
> —STEVEN TYLER

> **"EVOKING FRED ASTAIRE, SAMMY DAVIS JR., AND JAMES BROWN AT ONCE, HE'D WORK HOURS PERFECTING EVERY KICK, GESTURE, AND MOVEMENT, SO THAT THEY CAME TOGETHER PRECISELY THE WAY THEY WERE INTENDED TO."**
>
> —QUINCY JONES, ON MICHAEL JACKSON

### MARY J. BLIGE ON SOLOMON BURKE:

"There is so much that artists of this generation, such as myself, can learn from those who have come before us. Over the course of his career, Solomon Burke was not only a singer, but also a songwriter. He was not only a performer, but also a showman. Not only an entertainer, but also an entrepreneur. And most importantly, he was a soul singer. His music was always filled with the spirit of God. He continues in this tradition today preaching the word and spreading the gospel through song. No one would ever call me the queen of hip-hop soul had it not been for the kind of rock and soul of Mr. Solomon Burke. It is upon his shoulders that I stand."

### FRANKIE VALLI ON THE FLAMINGOS:

"The fifties represented a time of musical change: the sound of independent record labels was being heard across the country. The magic of the Flamingos began with their ability to experiment, perfecting extraordinary harmonies. That sound, combined with the love of the classics and a touch of dynamic stage presence, is what made them exceptional. Their album *Flamingo Serenade* is without a doubt a masterpiece. From it came 'I Only Have Eyes for You,' which became their signature and created the immortal '*sh-bop, sh-bop.*' Their innovative recordings have made a major contribution to our industry and rightfully deserve to be enshrined in the Rock and Roll Hall of Fame."

### JUSTIN TIMBERLAKE ON MICHAEL JACKSON:

"Michael holds the Guinness Book of World Records for the most charities supported by a pop star, and his devotion to children with cancer and children in orphanages is itself the stuff of legend. He's got the longest span of Number One hits in the U.S. He shares the record for most Grammys won in a single year. He holds the record for an album going to Number One in more countries than any musician in history. He holds the record for the most Number One singles from an album, and he cowrote the biggest-selling single of all time, 'We Are the World.'

"For the past twenty-five years, Michael Jackson has been the man in the mirror. He thrilled us with *Thriller*, the largest-selling album of all time, beat us at our own game with 'Beat It,' he rocked us to our souls with 'Rock With You.' He's bad, he's dangerous, and if he thinks we're going to let him stop because we've had enough, as they so often say in this city, '*Fuggedaboutit.*' There ain't no stopping, there ain't no enough. He's the King of Pop—the one, the only, Michael Jackson."

### DAVE GROHL ON QUEEN:

"From rap tap to space rock, opera to funk, punk rock to arena rock, there were no boundaries to what Queen could do, or would do, for that matter. Together, Roger Taylor, Brian May, John Deacon, and Freddie Mercury created some of the most diverse music in the history of rock & roll. Stylistically, Queen changed more often than most of you people have changed management. With albums such as *A Night at the Opera, Sheer Heart Attack, A Day at the Races, The Game,* and, of course, *Hot Space*, Queen opened up the ears of millions."

Previous, page 148: Aerosmith, 2004. Opposite: Michael Jackson, 1990.

## TAYLOR HAWKINS ON QUEEN:

"As a live band, Queen kicked everybody's ass. Queen was my first concert, and every concert since has been a bit of a letdown. They were raw, yet tight, huge, yet intimate. Their legendary performance in Live Aid 1985 with no lights, no sound check, no frills, no more than twenty minutes on the stage, showed the world how to turn a huge stadium into a tiny, sweaty club, while proving to every other band that day who really owned the stage."

## MARC ANTHONY ON PAUL SIMON:

"Wherever you grew up, unless it was under a rock, you were touched by the songs of Paul Simon. Growing up in my neighborhood in the projects, you walked down the street and out one window was Paul Simon, and out the other window was the Fania All-Stars and Ruben Blades, and it sort of made sense. Later, Paul's music got more and more rhythmic, but coming from my schoolyard, that was how I always heard him. . . . I'll call him my mentor, I'll call him my hero, I'll call him my friend. He's shorter than I am, but he's definitely a giant in the industry."

---

# "TO ME, PAUL [SIMON] IS BRILLIANT, WITTY, AND WISE. HERE IS A PERSON DRIVEN FOREMOST BY ART, AND I DON'T MEAN GARFUNKEL."

### —MARC ANTHONY

---

## PAUL SIMON:

"I'd like to begin by thanking the Crows, whose song 'Gee' was the first record I really liked when I heard it on the radio. After that, I started to listen to Alan Freed's Moondog show, and I loved the Penguins, the Moonglows, the Paragons, Johnny Ace—the song 'Pledging My Love' was the first record I ever bought. . . . I'd like to thank Ray Charles, Ruth Brown, Dinah Washington. I was always a great fan of Fats Domino and all of the Louisiana musicians who knew how to put the 'roll' into the rock & roll. I thank Sam Phillips for Sun Records, for rockabilly's Carl Perkins, Jerry Lee Lewis, Johnny Cash, and Elvis Presley, whose recording of 'Mystery Train' remains my all-time favorite. I spent a career trying to get that sound.

"I want to express my gratitude to the New York groups that we imitated on the steps on summer nights when we really did stand under streetlights and sing doo-wop. So here's to Frankie Lymon from Washington Heights, the Cleftones from Queens, and Dion and the Belmonts from the Bronx. . . .

"In the early sixties I hung around the folk scene at Bleecker and MacDougal. I thank the owners of Gerde's Folk City. I was influenced by Dave Van Ronk, Tom Paxton, Phil Ochs, and Bob Dylan, whose producer Tom Wilson signed us to Columbia Records. . . .

"The happiest times of my youth were spent in England. I played with several of the great players of the English folk scene . . . Martin Carthy, who taught me

'Scarborough Fair,' Davy Graham who wrote 'Angie,' Bert Jansch, John Renbourn. . . . I started singing in pubs for three pounds a night, although as my brother once asked me, 'Three pounds of what?' And just before I returned to the U.S., my price had shot up to twenty-five pounds a night, and I thought I was just about worth that.

"'The Sound of Silence' became a Number One record after Tom Wilson overdubbed electric guitars and drums on the original acoustic version. He changed my life with that one move. My appreciation to Roy Halle, who engineered every Simon and Garfunkel record from our audition tape to *Bridge Over Troubled Water*. I'd like to thank the Reverend Claude Jeter, whose group the Swan Silvertones inspired 'Bridge Over Troubled Water.' I thank Art Garfunkel for sharing the amazing days of our early success. The sound of his voice with mine was how I imagined the songs I wrote. I regret the ending of our friendship but I hope one day before we die, we'll make peace with each other. No rush. Just kidding. It's New York!

"I want to thank a man named Leslie Kong, who took me to Kingston, Jamaica, to record 'Mother and Child Reunion' . . . the spliffs were as big as a baseball bat, cows and goats grazed outside the studio door. The band that backed me on that record was Toots and the Maytals. I am grateful to the Muscle Shoals rhythm section for their work on 'Kodachrome' and 'Loves Me Like a Rock.' I thank the Dixie Hummingbirds, the Oak Ridge Boys, and all the gospel groups I've worked with . . . I thank Phil Ramone, who was at my side for much of that work, and who introduced me to Richard Tee and Steve Gadd, who are like brothers to me. . . .

"My gratitude and love to Lorne Michaels, a friend who let me dress up like a turkey after singing 'Still Crazy After All These Years' on *Saturday Night Live*. I want to mention Quincy Jones, who wrote the beautiful arrangement for 'Something So Right,' and years later introduced me to Milton Nascimento, who took me to Brazil for my work on *The Rhythm of the Saints*. I am indebted to Eddie Palmieri and Tito Puente for their guidance and support when I began to write a Latin musical for Broadway. I thank Oscar Hernandez, Ruben Blades, Edruta Nazario, and Marc Anthony, who shared the exhilaration and disappointments of *The Capeman*. . . .

"I thank my father—six years gone now—who was a musician and a bandleader. He was my greatest teacher. He taught me to love and respect musicians. He made me a bandleader. He gave me my first guitar and showed me the changes to all those old doo-wop songs. I thank God for the gifts I was given and for letting me live the dream I dreamed when I was twelve years old and first heard the mystical, mind-expanding magic of rock & roll."

## MOBY ON STEELY DAN:

"A few weeks ago when I got the phone call asking me to induct Steely Dan into the Rock and Roll Hall of Fame, I immediately asked myself a few questions. The first of these questions was, 'Why are they asking me?' because as far as I know, Steely Dan seems to hate everybody. So I was flattered, but very suspicious. I wondered to myself, 'Either they like me, or for some reason they really hate me and this is some sort of monstrous practical joke.'

"Because the truth is, we are talking about two men who named their band after a dildo in a William S. Burroughs book. So after I got over my suspicions that this was a practical joke—although, to be honest with you, I haven't quite gotten over my suspicions, and I do have a fear that there's a carload of giant rubber chickens

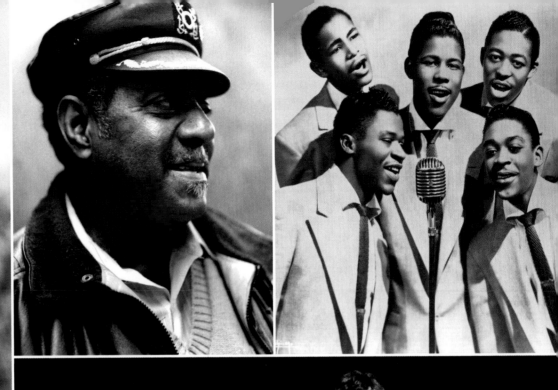

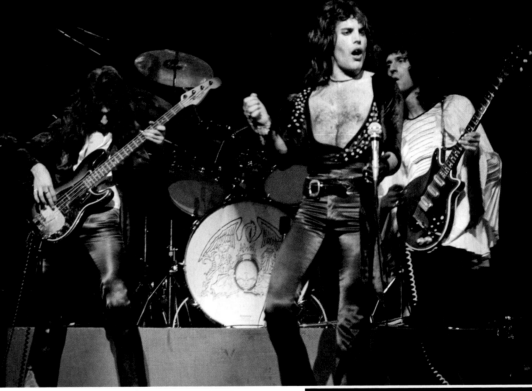

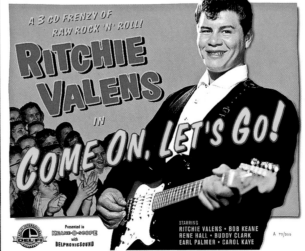

Previous, page 153: Paul Simon at an early recording session. This page, clockwise from top left: Michael Jackson, c. 1971; Johnnie Johnson, 1991; the Flamingos; Queen; Ritchie Valens movie poster; Steely Dan (from left): Walter Becker and Donald Fagan.

waiting offstage—but assuming this isn't a practical joke on their part, I have to say that I'm completely thrilled to be here as the official Rock and Roll Hall of Fame inductor for Steely Dan, although I'm not quite sure what an inductor is, but I'm proud to have Steely Dan as my inductees.

"One of the things that inducting Steely Dan into the Rock and Roll Hall of Fame demonstrates to me is the inclusive nature of rock culture, because although Steely Dan do have a very visceral quality to their music, I would hardly consider them a kick-ass, balls to the wall, brainless rock band. Not that there's anything wrong with kick-ass, balls-to-the-wall, brainless rock music, but—and I do feel like a bad cliché saying this—the musical tradition that Steely Dan represents is certainly one that's more cerebral and intellectual. And beautiful as well. For one of the things that's always struck me about Steely Dan is that although they seem to approach popular culture with a certain sense of irony and distaste, they also clearly have a love for beauty and beautiful music. I mean, they cite John Coltrane as one of their influences, and *A Love Supreme* is probably one of the most beautiful and sublime recordings of the twentieth century.

"So I found myself in the strange position of trying to find out biographical information about Steely Dan. And when I did, I encountered nothing but really bizarre apocryphal stories. According to what I found on the Internet, Walter and Donald were members of the Bader Meinhoff terrorist organization in Germany. They were the inventors of the indoor swimming pool. They have spent time training circus elephants and they are super-rich moguls who aren't ashamed of corrupt retirement homes in Brazil.

"The only seemingly reliable piece of biographical information that I was able to uncover is that they both went to Bard in 1967, which explains a lot to me. And if you know anything about Bard, I'm sure the fact that they went there explains a lot to you, too. So last night I was talking to my friend Damien about my inducting Steely Dan into the Rock and Roll Hall of Fame and we were reminiscing about growing up with Steely Dan in the seventies, and the one memory that we both have in common was hearing the song 'FM' on the radio and being scandalized that they could actually say 'fucked-up music.' In fact, it wasn't until we were both well past puberty that we realized that they were, in fact, saying 'funked-up music,' but the sense of strange subversion still remains. And in a weird way, I always found that song 'FM' to be extremely subversive. The line 'no static at all' still kind of makes the hair on the back of my neck stand up and conjures up this image of a deftless and airless life in Los Angeles that's equally horrifying and seductive. I don't know if that was their intention, but it's very effective.

"Steely Dan are weird—in a wonderful and slightly unsettling sense—because they didn't choose to play obscure jazz in the East Village, but rather chose to make beautiful records that sold millions of copies and became radio staples throughout the world. But they've always seemed different somehow. On the one hand, their music is warm and beautiful, and on the other hand, their music is quite foreign. And that's what makes them so wonderful and so unsettling. Because every time you listen to a Steely Dan record, you find yourself seduced by the warmth and the beauty of the music, and then you become wonderfully unsettled by the intelligence and their other-worldliness. From a William S. Burroughs book, Steely Dan."

## STEELY DAN:

**Donald Fagan:** "I'd like to thank all the musicians who have ever played for us, which is a really long list, including our original group we formed in 1972, especially since they stuck it out with us for a couple of years when we gave them all kinds of weird chords to play and things like that."

**Walter Becker:** "Well, actually we've already gotten to say, through our Web site and other places, pretty much everything we wanted to say about the Hall of Fame, so we thought we'd throw the floor open to questions—if anyone has any questions. Nobody, huh? Okay. I have a question, who was the original drummer in the Mothers of Invention?

[A voice calls out]: "Jimmy Carl Black."

**Walter Becker:** "Very good."

**Donald Fagan:** "This is the Rock and Roll Hall of Fame, so some of you must know some of this information."

**Walter Becker:** "We're persuaded—it's a great honor to be here tonight. Thank you."

## BONO ON CHRIS BLACKWELL:

"On a good night, misfits, malcontents, second-story men, visionaries, pirates—on a bad night, it's just the music business. On a good night like tonight, it's like a kind of outpatient facility.

"The first time I saw Chris Blackwell I was eighteen years old. U2 was playing in a pub in south London. It was the height of punk rock. He was wearing these flip-flops. Now there's something about Chris Blackwell. Some of you, when you see how the trick is done, you lose interest. Some of you, when you see the wires, you get interested. These people are called magicians. Chris Blackwell is a magician, and music is much more than magic. It's much more than numbers. When you hear Bob Marley sing—it's not even Bob—it's like the voice is singing him. It's a religious experience, yes, and there's life in those songs. Now to people tuning into VH1 who are still asking questions, 'Who is Chris Blackwell?' Well, let me tell you: 'Gimme Some Lovin',' 'Wild World,' 'The Harder They Come' . . . He's a magic man."

## KEITH RICHARDS ON JAMES BURTON AND JOHNNIE JOHNSON:

"I've got to talk about sidemen. I guess they chose me because I am one. But after all, the guy I work with, he's got more side on him than most put together. Really, you're sitting there watching this bum with a hairdo, and you're trying to make sure that he doesn't make an ass out of himself. And that's the gig, you know what I mean? And if you're not mentioned, that means you've done your gig really well, and if you are, you've usually screwed it up.

"But it is today my pleasure—and honor—to introduce you to two of the most incredible sidemen of all time. Let me put it this way: I never bought a Ricky Nelson record, I bought a James Burton record. And as far as Johnnie Johnson goes, well, he goes beyond the beyond. We all know who he works with [Chuck Berry] and he probably had as hard a time as I do with mine!

"But it's only rock & roll. You've got to laugh. A sideman needs humor, he needs incredible patience, and usually more money than he ever gets. But the pleasure of being a sideman is that you get to work with the guys you want to work with. And it's putting the team and the unit together, so that the guy out front can do anything

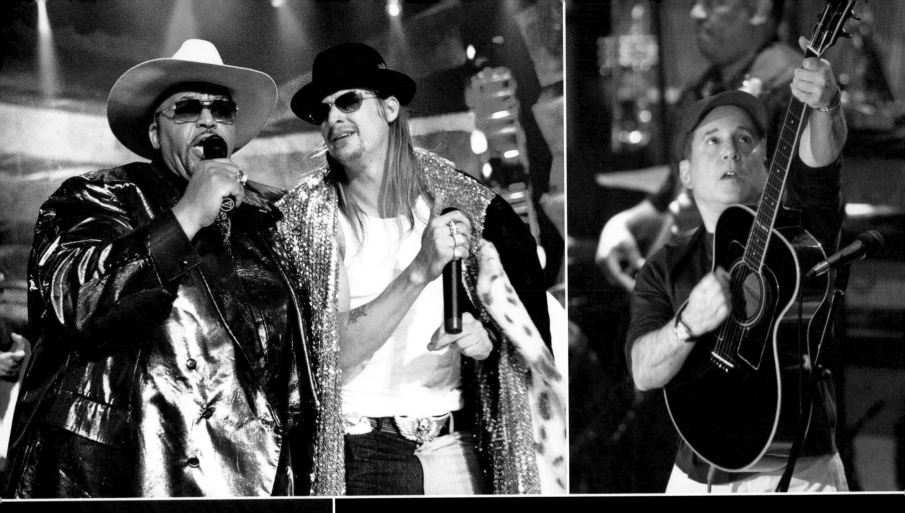

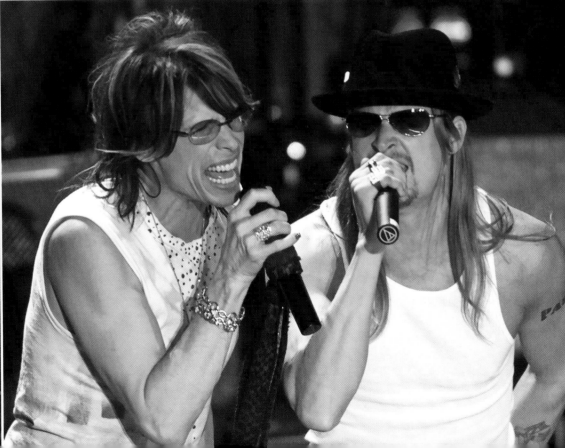

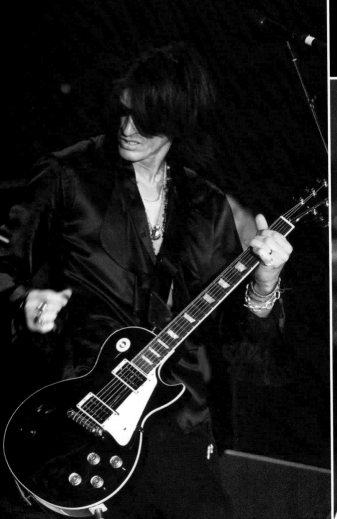

This page: Hall of Fame induction highlights, March 2001. Clockwise from top left: Solomon Burke and Kid Rock; Paul Simon; Steven Tyler and Kid Rock; Joe Perry. Opposite: Bono flanked by Mary J. Blige and Melissa Etheridge.

he wants to do and feel safe and comfortable, and he knows that you'll catch him if he falls over. One of the best jammers in the world and one of the best guitarists—Fender had no idea what he was making for the man that really knows how to play the Telecaster—and whoever invented the piano, eat your heart out. It's my pleasure to bring on James Burton and Mr. Johnnie Johnson."

## JOHNNIE JOHNSON:

"It was about fifty years ago since me and Chuck Berry got together and started making music—"Maybellene" and "Wee Wee Hours," out in 1955. Alan Freed was the first person to call this music rock & roll. Before that, we didn't have no name for what we were doing. We were just making up music for the words Chuck had wrote. The kids seemed to be eating it up—eating it up and took it with them. There's one of these kids now, Keith Richards. Now after a song called 'Amazing Grace,' some of the words go like this: 'I once was lost, but now I'm found.' I feel like those words were meant for me because in 1986 when Keith Richards found me, I was driving a bus for senior citizens in St. Louis. But because of people like Keith Richards and a whole bunch of other folks, I'm standing here in front of you tonight. I'm living proof for young people that you should never give up your hopes and never give up your dreams, because after each song, there's life. This is my proudest moment of my life."

## MUSICAL HIGHLIGHTS

A highlight of the music were the Latin sounds, heard for the first time at an induction. In honor of Ritchie Valens, Ricky Martin performed an invigorating set of "La Bamba," "Come On Let's Go," and "Donna." Paul Simon demonstrated his love of Latin music by duetting with Marc Anthony and Jann S. Wenner on "Me and Julio Down by the Schoolyard." Steely Dan, who'd performed earlier prior to their induction, returned at night's end with their early hit "Do It Again."

Chris Blackwell was fêted with a version of Bob Marley's "Could You Be Loved" by Melissa Etheridge on guitar and Bono and Mary J. Blige on vocals, which segued into "Get Up, Stand Up." The jam continued with a guitar extravaganza, courtesy of Robbie Robertson, James Burton, Keith Richards, Brian May, and Aerosmith's Brad Whitford and Joe Perry. As *Rolling Stone*'s Anthony Bozza put it, "If you've ever imagined a rock & roll wet dream, what came next was likely a part of it. In an extended blues free-for-all, [Paul] Shaffer cued guitar solos by Richards, Burton, Robertson, May, Perry, and Whitford. Johnnie Johnson hammered away on keyboards, and Mario Ramirez dropped to his knees, blowing away the audience with a harp solo. As the clock struck one, Kid Rock emerged, wrapped in Solomon Burke's massive cape, which he handed back to the soulman, before the duo led the band through Burke's 'Everybody Needs Somebody to Love.'"

## INDUCTEES

**PERFORMERS** Isaac Hayes ✦ Brenda Lee ✦ Tom Petty and the Heartbreakers
Gene Pitney ✦ The Ramones ✦ Talking Heads
**NONPERFORMER** Jim Stewart **SIDEMAN** Chet Atkins

The induction was held on March 18 at the Waldorf-Astoria's Grand Ballroom, though, before inducting the Talking Heads, Red Hot Chili Pepper Anthony Kiedis quipped, "They told me this function was gonna be at CBGB this year!" In fact, CBGB owner Hilly Kristal was in the audience and was called to the podium by Talking Heads to stand with them onstage, during this first induction of punk-era bands. The band—David Byrne, Tina Weymouth, Chris Frantz, and Jerry Harrison—then played together for the first time in nearly two decades.

Eddie Vedder, sporting a Mohawk, took his time inducting the Ramones, and noting the restless audience, saying at the end, "After this, I'm sure the evening will move quickly. It's the Ramones and it's punk rock and I'm just about finished and I hope you're okay with that. Apparently you're not. Fuck you. Take it easy, Eddie." Ironically, both Dee Dee and Johnny Ramone were most excited about meeting their fellow inductees of the old-school variety, Brenda Lee and Gene Pitney. Because of the 2001 death from cancer of Joey Ramone, the band did not wish to perform, but Green Day did their damnedest with loud-fast versions of "Rockaway Beach," "Blitzkrieg Bop," and "Teenage Lobotomy."

For the first time, high-school teachers were thanked from the podium—courtesy of inductee Isaac Hayes, who offered gratitude to some of his by name. Anthony Kiedis also gave props to school librarians, but in a lascivious way. Young artists Jewel and Alicia Keys gave heartfelt speeches about Brenda Lee and Isaac Hayes, respectively, while Jacob Dylan recalled being in awe of Tom Petty as a youngster. A special tribute to Stax Records, whose cofounder Jim Stewart was inducted, brought sweet soul music to the fore. Former Stax writer and session player Isaac Hayes was joined onstage by Stax guitarist Steve Cropper and Sam Moore of Sam and Dave.

> "THE MUSIC OF ISAAC HAYES TOLD US WE COULD WIN—NOT BY STOOPING DOWN TO A LOWER LEVEL, BUT BY RISING UP OUR OWN HIGHER STANDARDS."
> —ALICIA KEYS

## "I ALWAYS THOUGHT THAT IF I HADN'T MADE IT IN THIS BAND, I WAS GOING TO TRY TO AUDITION FOR THE RAMONES."
### —MIKE CAMPBELL

### ALICIA KEYS ON ISAAC HAYES:

"I am here tonight to pay tribute to Mr. Isaac Hayes: as a singer, a songwriter, a musician, a producer, an arranger, and most of all as an example. For thirty-five years, he's advanced the forms he's worked in, while carrying himself with dignity and grace. A lot of artists are prima donnas; they shout to get their way, but not Mr. Hayes. He's always cool. Can you feel me on that? He's always in control, and so in a business full of screamers, he is a man who knows how to command attention with a whisper.

"You know the Hall of Fame is home to not only some of the greatest musicians, it's also home to some great nicknames. The Fab Four, the King of Pop, the Queen of Soul, the Hardest Working Man in Show-Biz, the Greatest Rock & Roll Band in the World; these are some hard titles to live up to. But I always thought that Mr. Hayes had the best superlative of all; you know what they call him, don't you? They call him 'Black Moses.' *Yeah!* And you know why? Because way back in the sixties when things were real hard for black people in America, Isaac Hayes was the man with the magic. He was the man who just made you believe that he had seen the Promised Land.

"He taught us so much. He showed us how music could be funky and sophisticated, symphonic and soulful; at the same time he could show us the grownup beauty in a bubblegum hit like 'Never Can Say Goodbye.' He could make us understand that to say 'I'm a Soul Man' was not just a musical bolt, it was a declaration of independence. Isaac Hayes, you set the standard for everyone that came after you."

### ISAAC HAYES:

"To the rap and hip-hop community, it's not all about bling-bling and all the gold and Cristal. The music creates a heart flow, that's what it's all about. Run the business, own something, and don't slip into the trap, and don't forget about your 'hood. Remember you're disposable, so take advantage of it while you can, okay? I want to say to the kids in the 'hood—you've got to give them education, you've got to give them literacy, put something back from whence you came."

### JEWEL ON BRENDA LEE:

"When I was asked to induct Brenda Lee into the Rock and Roll Hall of Fame, I figured I'd better do a little homework. I thought I knew about Brenda Lee, but when I realized all I didn't know, it was very humbling. For instance, when I was six years old, I was singing with my parents in Eskimo villages in Alaska, and when Brenda was six, she was already singing on Atlanta radio stations. When I was eleven, I had graduated to playing bars and restaurants with my dad's bands, and when Brenda was eleven she'd already graduated to a major record label deal—all of which goes a long way to explain why Brenda was always mature beyond her years, and why she never, ever sang like a little girl. Even when she made her first record, she already had that killer rockabilly growl in her voice.

"I knew Brenda was a great pop singer, but I didn't know that she had more than fifty singles that hit the *Billboard* Hot 100, and of course I knew she was a country star, but I didn't know that she also had a string of R&B chart smashes, as well. But I think the coolest thing I learned was that Brenda fronted the first rock & roll band to come out of Nashville, and that was when she was only thirteen.

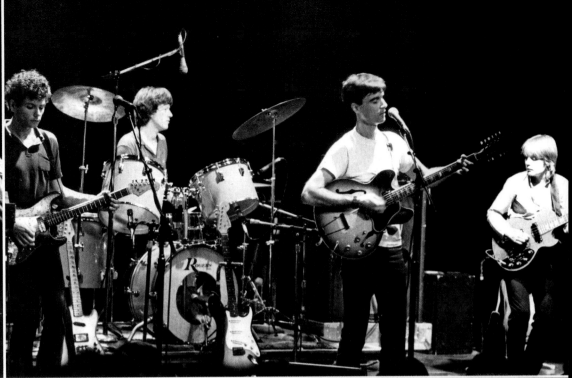

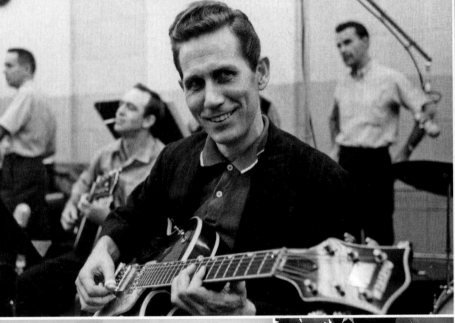

Previous, page 158: Isaac Hayes, March 2002. Opposite: Tom Petty and the Heartbreakers: (from left) Howie Epstein, Stan Lynch, Petty, Benmont Tench, and Mike Campbell. Clockwise from top left: Isaac Hayes; Talking Heads: (from left) Jerry Harrison, Chris Frantz, David Byrne, and Tina Weymouth; Brenda Lee, c. 1956; letter from Johnny Ramone to the Hall of Fame; early Gene Pitney Album; Chet Atkins.

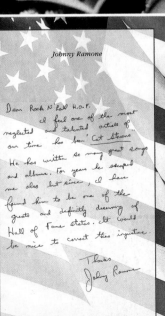

"There are artists who sing songs and artists who own the songs they sing. Brenda owns her songs. She pours real-life experience into every note, every phrase, every lyric. She brings passion and soul to everything she does, and she's been doing it for fifty years. I called Harold Bradley, who played guitar on many of Brenda's records, and whose brother, Owen Bradley, produced a lot of her records. I asked him how Owen recorded those sessions, and Harold said that everyone played together in one room, and Brenda sang the song straight through with the band. And I can't impress on people enough today how hard that is—no computers, no pitch perfectors. It was all one take, and every single song is an incredible take. No matter what style of music, she's great with that incredible voice.

"She's always come back to her first love—rock & roll. The Beatles opened for Brenda in Hamburg, Germany, and John Lennon sure got it right when he said that she has the greatest rock & roll voice of them all. Brenda is the real deal. She's an icon for singers, for young girls, and grown women. She's about reality and conviction and courage and heart."

## BRENDA LEE:

"I have been blessed to sing and be on stages most of my life, and this is certainly a stage that I have wanted to be on. Here I find myself tonight and I feel like Cinderella at the ball. It's a long way from the Georgia cottonfields to the Waldorf-Astoria. I can tell you that I owe it to Owen Bradley, the great musicians that I've worked with, and the great songwriters who have seen fit to share their creativity with me through the years. And most of all, I owe it to rock & roll."

## JAKOB DYLAN ON TOM PETTY AND THE HEARTBREAKERS:

"The first time that I spent any time with Tom Petty and the Heartbreakers was in 1986, and that was not the first tour that I had been on, but it was certainly the most excited I'd been. I was already a huge fan and I definitely planned on watching every moment from the side of the stage, which I did. He had his two daughters there and I remember sitting with them and thinking, 'That's got to be so weird—Jesus, your dad is Tom Petty! I can only imagine—that's got to be so cool.' That summer had a huge effect on me.

"Before Tom came along, a lot of singer-songwriters were stuck with the label 'a new Dylan,' and it ruined a lot of people. And the only way to overcome it was to show you had a vision that was unlike anyone else's. Most of them didn't. But Tom's vision was so strong that by the time I came along, I was called 'the new Petty,' when actually I was maybe the only one who deserved the burden of 'the new Dylan.' When I was putting my group together, I set it up just like the Heartbreakers: two guitars, bass, drums, and a keyboard. A lot of people might call that a retro lineup of classic rock, but I never saw it that way. To me, that was where rock & roll started and that's where it always gets back to. There's plenty of room for whatever else you want to throw in, but you will never need anything more than those instruments.

"Tom Petty and the Heartbreakers made it clear that while rock & roll will have its trends and fads, it's really about the opposite. It's about being timeless. Tom Petty and the Heartbreakers made their first record in 1976, one of those times when they said that rock & roll was dead. I suppose if you listen to the radio or watch the music channels right now, you might agree, but you will also know that if Tom and the Heartbreakers are on a stage somewhere or in the studio, then you can be well-assured that rock & roll is doing fine.

"They truly are one of the great American rock groups. They picked up the torch and they held it proudly for a long time, and when they're done they will pass the music along stronger for having been there, and that's the most that anyone can hope to do. Tom has written songs we will never forget—from 'American Girl' to 'Refugee' to 'Free Falling.' What is rare with Petty is that after twenty-five years, his next song may be his best one yet. All the songs are bursting with his unique spirit. One of my favorite lines—one of the most inspiring lines—is 'think of me what you will, I've got a little space to fill,' which is incredibly humbling coming from a guy making records for twenty-five years. That's exactly what a lot of us are trying to do. The great rock & roll band comes onstage and says what it has to say, and it's gone. What matters most is how they fill the time that they've got. Tom Petty and the Heartbreaker' songs that will last forever."

## TOM PETTY:

"The music overcame me at a very early age and has consumed my life and I love everything about it—all the people I've met and the great times I've had. I'm very proud that we're being inducted as a group—as Tom Petty and the Heartbreakers—'cause they're the best fucking band in America. They are my family. We all have grown into manhood together in the back of cars and planes and dressing rooms. Mike Campbell, the whiz on the guitar, great songwriter. My friend all my life, Benmont Tench, who I met at eleven years old, plays on everybody's records—I can't keep up with him, but he's just wonderful. Howie Epstein, on the high harmonies and the bass guitar. Stan Lynch—the very spirit of the band for twenty years on the drums back here, as well as Ron Blair on the bass. I thank you all so much.

"This is wonderful music that we're all involved in, this rock & roll—emphasis on the *roll*. At its best, it really is true magic, and it's liberated so many people in this world. I look around the room and I see so many faces of people I know who have spent all their time and endeavors behind this music, and I want you to know I love you for it."

## DARLENE LOVE ON GENE PITNEY:

"Gene Pitney was one of rock & roll's first teen idols. Don't just take my word for it, ask Marianne Faithfull, or any other female artist on tour with Gene. Gene had far more than just solid good looks; he possessed a strong, unique, and highly identifiable voice that set him apart and made him one of the greatest vocalists in rock & roll.

"A talented musician, Gene was invited by the Rolling Stones to play on their first U.K. album. The Stones and Gene met while on tour in England, which is also how the Crystals first met Gene. At one of these gigs, Gene played a song he had recently composed, 'He's a Rebel,' and we recorded the song and it became the Crystals' first Number One hit. It must have been somewhat bittersweet for Gene, though, because while 'He's a Rebel' sat at Number One, Gene's own record, 'Only Love Can Break a Heart,' languished behind at Number Two. Sorry, Gene! A prolific songwriter, Gene not only wrote many of the hits, but also gave Ricky Nelson one of his biggest smashes, 'Hello Mary Lou.'

"Gene's dynamic vocal delivery made him a natural for movie soundtracks in an era when Hollywood was reaching out to new artists. Hit songs for the silver

screen include 'Town Without Pity' and '(The Man Who Shot) Liberty Valance.' Gene must also be recognized for his pioneering country music crossover efforts and his duets with Melba Montgomery and the legendary George Jones. From his early hit '(Wanna) Love My Life Away' and 'Every Breath I Take,' to the classic 'Twenty-Four Hours From Tulsa,' right up to his 1989 Number One U.K. smash 'Something's Gotten a Hold of My Heart,' a duet with Marc Almond, Gene remains active in the business. This is especially true on the live circuit, with U.S. gigs and annual tours in the U.K., Australia, and Italy. It is with great pride and considerable honor that I induct my friend of more than forty years, Gene Pitney, a man with a vast list of accomplishments and a life dedicated to music."

## EDDIE VEDDER ON THE RAMONES:

"I do have a Mohawk, and no I didn't get it to pose up here as a punk rocker for this exalted occasion. Actually, it stemmed from my frustration of world events and bombings and I took it out on my own hair. Sometimes you feel powerless and you do silly things. But two days after it was done, I walked in a shop to buy Christmas gifts, and I was accused of shoplifting. So even though the Ramones tonight are being inducted into the Rock and Roll Hall of Fame, it doesn't mean that looking like a punk rocker has become respectable. The Ramones didn't need Mohawks to be punk. They're visually aggressive; they were working-class construction worker delinquents from Forest Hills, Queens, who were armed with two-minute songs that they rattled off like machine gun fire. It was enough to change the earth's revolution.

"The first time I saw the Ramones, I was pretty young. Before the show even started, I was trying to get closer and closer to the stage. The crowd was intense—outcasts one and all. They were ready to get out all their aggression in the next hour and fifteen minutes. As I was getting closer, I saw something really strange about the microphone stand in the middle, in that it was about ten feet high. I saw a roadie put the set list down and he was half the size of the microphone stand. I thought, 'Who the fuck is going to sing at that microphone stand?' Looking at the amount of amps they had symmetrically placed on either side, and knowing that there was a huge amount of volume that was going to come out of that—it was very unsettling. . . . The Ramones come out, and 'one-two-three-four' into the first song, and all hell broke loose—complete chaos. . . . It was terribly frightening and totally blissful at the same time. I think of the amount of intensity in that show in that one night and of how many times that happened. The Ramones played 2,269 shows.

"The musical landscape of 1976: Disco had taken over the clubs and the airwaves along with the indulgent guitar solos. The Ramones made a record in 1977, with a black-and-white photo of four guys in leather jackets, all with the same last name, standing against a brick wall, and this became a beacon for anyone who ever wanted to be in a band who was disenfranchised by the dynasty of giant rock bands. The Ramones obliterated the mystique of what it was to play in a band. You didn't have to know scales; with the knowledge of two barre chords, you could play along with their record—that's what people did. They sat in front of their parents' hi-fi's and played along with *Road to Ruin* or *It's Alive*, and within weeks they were starting bands with other kids in town who were doing the same thing. All of a sudden you could be onstage getting it out, saying what you feel, singing about sniffing glue—and not be a virtuoso. Not be genetically gifted with Elvis's cheekbones, either. You could look like an outcast and still be cool. . . .

"After the initial surge of the late seventies, commercially the Ramones were never embraced. Bands around them were, but never them. Virtually ignored by radio, eighties MTV, and even other artists, they never stopped and regardless have a following worldwide that's as devoted as ever. I went with them once to South America—fifty thousand people arrived for tickets, screaming fans outside. It was the reaction I always thought they deserved.

"When punk finally broke in 1991, the Ramones still weren't brought along for the ride, even though bands like Green Day wouldn't have existed without them. Punk bands now with their first or second record sell ten times the amount the Ramones did throughout their career with twenty-something records.

"That's why I go over to Johnny Ramone's house and do yard work three times a week, just to absolve some of the guilt. A bunch of people do it: Bono and Edge do the windows; Kirk Hammett from Metallica, he dusts and housecleans, makes French toast. That's a true story. Even Kurt Cobain wanted to be as good as the Ramones. The list is endless.

"They never had a Top Ten hit. It doesn't alter the fact that they were one of the most important bands in rock & roll. They accomplished a lot, for a punk band, when most of the others, like the Sex Pistols, were all crash and burn. They existed for twenty-two years with the same level of intensity, and they may not have gotten along the whole time, but that was touring for twenty-two years in a van, for fuck's sake, so you have to understand. . . .

"Even after Dee Dee left the band—he was such a huge part of the band that he still wrote songs for them, which I think speaks to the intense brotherhood they had. I have to mention after Dee Dee left, there was some intense Converse shoes to fill and the guy who did it: his name is C.J., and for whatever reason, the Rock and Roll Hall of Fame chose not to include him with those being inducted. I wouldn't understand, but he played eight-hundred-something shows, he participated in three or four records, wrote a lot of songs, and was accepted by the hard-core Ramones fans. The Ramones were able to play for another generation because of C.J. C.J.'s been working twelve-hour days cleaning pollution out of the air ducts down around the World Trade Center.

"The Ramones' manager, Gary Kurfirst, talked to me and said that there was a night back in December 2000 when he got a phone call from Joey Ramone. Joey had an accident in front of his apartment and slipped and fell on some ice. He was just laying there for a bit; he ended up breaking his hip, and people were just walking by on either side of him. He was pretty upset by it, and later he called Gary and said, 'The worst part about it was when I was down, no one would help me.' Maybe they didn't know it was Joey Ramone; he was tangled in black hair and they thought he's a bum. I'm only mentioning it because it's kind of analogous to the Ramones' career, in a way. Joey died on Easter of 2001, less than a year ago, and I'm sure he would have loved to be here tonight. That's why tonight is really important and special. There's a number of bands and people who will never get to be up here and be brought up in front of all you people and applauded. Something very unusual is happening here tonight—that this industry is paying so much respect to the Ramones. So with the power invested in me, I'd like to induct Joey, Johnny, Dee Dee, Tommy, Marky, C.J.—the Ramones."

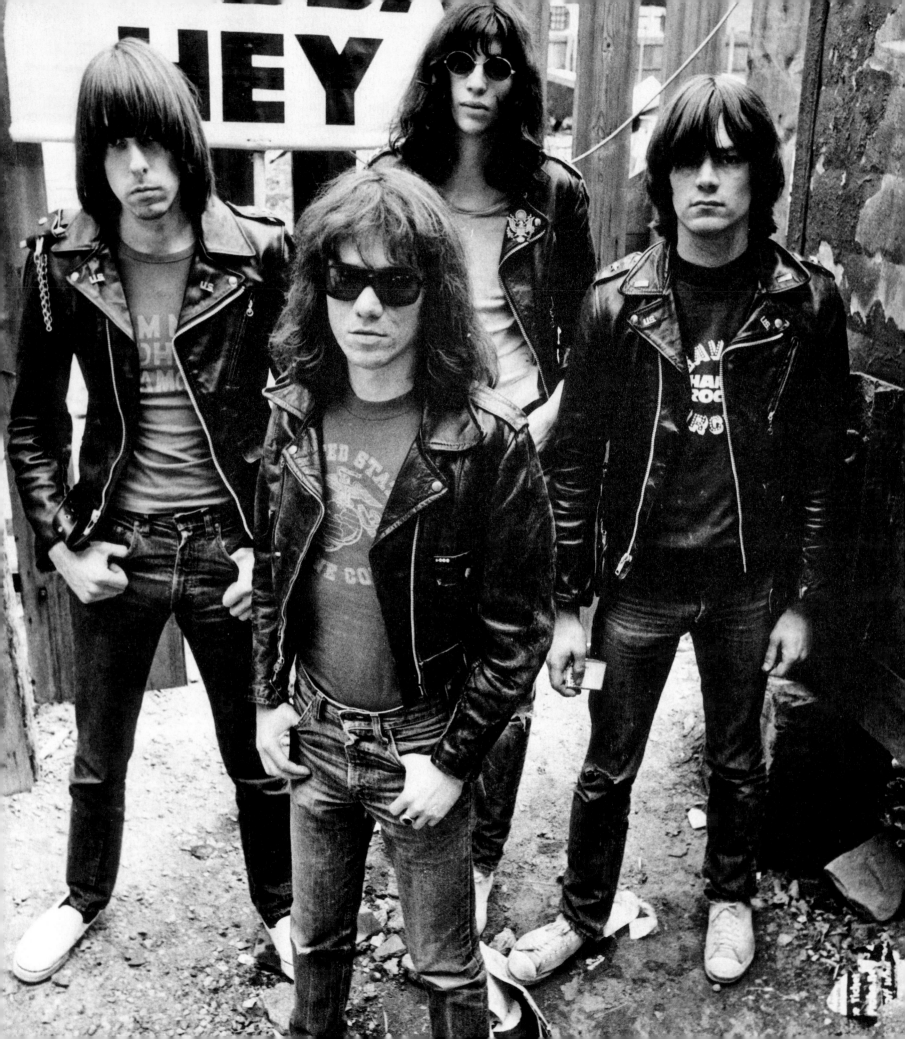

> ## "IF IT WEREN'T FOR JOHNNY RAMONE, I WOULD HAVE COME HERE NOT KNOWING WHO BRENDA LEE WAS."
> ### —EDDIE VEDDER

## THE RAMONES:

**Tommy Ramone:** "I feel very privileged and fortunate to have been involved with the incredible talent and intelligence of the Ramones. Believe it or not, we really loved each other, even when we weren't acting civil to each other. We were truly brothers. The honor of our induction to the Hall of Fame means a lot to us, but it really meant everything to Joey."

**Dee Dee Ramone:** "I'd like to congratulate myself and thank myself and give myself a big pat on the back. Thank you, Dee Dee, you're very wonderful, I love you!"

> ## "EDDIE VEDDER, WHEREVER YOU ARE, YOU ARE A GENIUS. THE RAMONES SONGS MAY BE TWO MINUTES LONG, BUT THAT SPEECH WAS NOT. IT WAS ACTUALLY A VERY SHORT SPEECH, JUST SPOKEN VERY SLOWLY!"
> ### —ANTHONY KIEDIS

## ANTHONY KIEDIS ON TALKING HEADS:

"I remember the exact place I was, the exact moment it happened, that I heard the Talking Heads for the first time. That's an indication of what a beautiful influence they would have on my life. I was in the living room of Dondi Bastone's house, I was fifteen, and it was 1977. The song he put on was 'Psycho Killer' and I absolutely freaked out. I made him play that song over and over and over again, 'cause it was like nothing else I had ever heard and it made me feel like nothing else I'd ever felt. Some very strange things happened to me when I heard the Talking Heads. For one thing, I felt smart. I'd felt a lot of things from music before, but I'd never felt particularly smart, and I liked that. The Talking Heads also made me want to dance like a maniac, which I love, because that also changed my life. There is nothing more meaningful to me than music and dancing. It's as important to me as my mother

and my best friends. Another thing that happened to me when I started listening to the Talking Heads was I wanted to have sex with a lot of librarians, and other music hadn't made me feel like that either.

"They also completely expanded upon the definition of what it was to be a cool rock & roll band. There were all kinds of different cool, but this was a new one. A smart cool, with an incredibly beautiful girl in the band, a beautiful concept to me at the time. There had been girls singing in the back, but this girl was actually *in* the band. They rocked the fuck out of the four piece, then they made a very graceful transition to their orchestral funk.

"They taught me a lot. I didn't realize it at the time, but I was learning from them, and it was making me want to develop my character. They taught me that music could be inspired by visual art. I have to thank Brian Eno, as well, along with a few other people that were involved with Talking Heads, like Bernie Worrell and Adrian Belew, and Robert Fripp. These people were all guiding me into what I would later want to do with my life.

"The most important thing that I can possibly express besides my incredible gratitude to the Talking Heads for existing is that I just want them to know what an infinitely beautiful impact they have had on this world. I know they haven't been together for a while; they haven't played for eighteen years, and time moves on and you become occupied with what you're creating in the present. I really want them to know that they left this world a better place; as a band, they did things as beautiful and meaningful as any Nobel scientist or a saint or any form of god we believe in."

## TALKING HEADS:

**Tina Weymouth:** "We want to start where we began by thanking Hilly Kristal. Hilly is responsible that we're here, that the Ramones are here, that Blondie is here. He kept us alive. He fed us and he supported us in every way possible. He told us we needed to expand our sound, get a little more interesting, and he taught us a lot about ethics—about how to treat people.

"In chronological order, the next person would be Seymour Stein. Seymour Stein was like our other godfather. He found us for Sire and we wouldn't come. We just said, 'Sorry, we can't do that, we're not ready.' He was willing to wait, he stuck his neck out for us, and he left it out there, and he was fighting in our corner every inch of the way, even when there were accountants and lawyers telling him, 'This isn't happening.'

"It's very important if we're going to save our business, we've got to remember to have the checks and balances we've learned from Enron, from our federal government. We have to have the accountants and the lawyers *outside* the house.

"We have to thank our parents and our children for the sacrifices they made, and for telling us to hang in there when the going got tough—for telling us that we had an obligation as artists to survive, that even when we weren't popular, we had an obligation to keep making art for the future. It might not be timely now, but one day it will be there even when we're gone.

"I have to confess that I'm a bit of a hypocrite because I'm really a large black man, and, therefore, I have to thank God for all our blessings. We have to thank our fans, because without them we'd be nowhere, and we have to ask them to please buy our music. Sure, you can listen to it all you want on bootlegs, but please help us keep

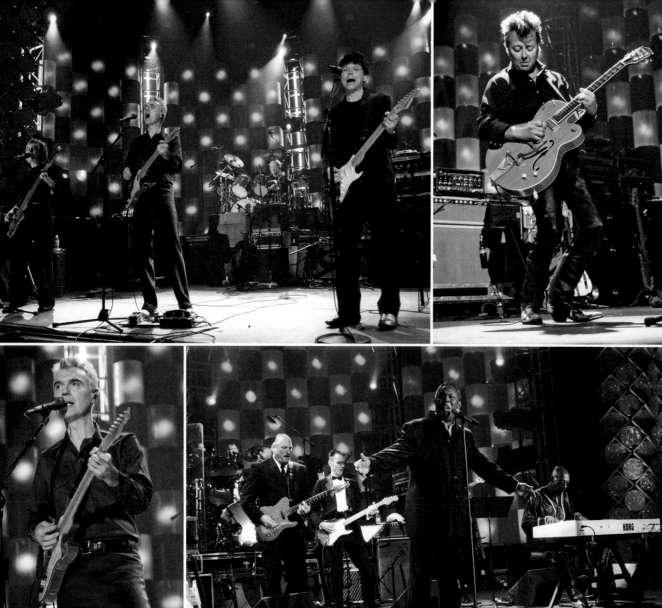

Previous, page 164: the Ramones: (from left) Johnny, Tommy, Joey, and Dee Dee. This page: Hall of Fame induction highlights, March 2002. Clockwise from top left: Talking Heads; Brian Setzer; Green Day's Billie Joe Armstrong; Mike Campbell and Tom Petty; Jewel and Rob Thomas; David Byrne; Steve Cropper, Sam Moore, and Isaac Hayes.

it going. We don't make money from selling records or from touring. We just make money from publishing. That's how we've survived.

"We have to thank all the artists who were there for us in our corner, starting with the Ramones. Talking Heads was my first band, and the first band we ever played with was the Ramones. Can you imagine? Blondie, Patti Smith, Television. We thought we were rivals, but we knew we weren't really. It was just mainstream envy."

**David Byrne:** "When we started out, there really weren't clubs where bands could play their own material, and poor Hilly [Kristal] wanted to have a kind of bluegrass bar on the Bowery. The road took another turn and we're thanking him that he went that direction and didn't mind. He said, 'We're going to let anybody who comes in here who has something to say, some original music, we're going to let you play.' Bands came out of the woodwork. They were coming from out of state, from all the neighborhoods of New York. Nobody knew they were there! They came out because there was somewhere to play. Anyway, the fact that these clubs opened up here and in other places brought the music into existence in many ways."

**Chris Frantz:** "I'd like to thank the Rock and Roll Hall of Fame for giving this band a happy ending, and I'd also like to thank the music fans of New York City in particular."

## STEVE CROPPER ON JIM STEWART:

"Jim Stewart became a self-taught country fiddler listening to the Grand Ole Opry. He soon wound up on radio as a regular, playing with Don Pell's Canyon Cowboys. After a two-year stint in the Army, Jim got a job in the house band at the Eagle's Nest on Lamar Avenue in Memphis, where Elvis Presley occasionally performed. This is where Jim really got interested in the record business, watching Elvis become a giant, and his ever-growing respect for a guy named Sam Phillips. While trying to hold down a day job at First National Bank, run a studio on the afternoon and weekends, and listening to WBIA and LNOK, he found a great love for rhythm & blues music. After hearing a demo tape of a top BIA jock—Rufus Thomas and his daughter Carla—Jim knew he had a star and agreed to record them. After their duo success on a song called 'Cause I Love You,' Jim decided to cut a song on sixteen-year-old Carla, a song which Jim relentlessly believed in and promoted until it became a chart hit—'Gee Whiz.' By now, Jim Stewart's dream was well on its way with a small house band, and with the distribution arm of Atlantic Records, he helped create the hits.

"The guys and I spent many hours looking through the glass watching Jim frown at us, waiting to see what we were going to come up with next. He had a way of pulling the best out of everyone. Time after time we hear about artists and lawsuits from artists, who, in the past have had songs stolen or were cheated out of monies due them. I'm here tonight to tell you—as a witness—that Jim Stewart, with his banking and accounting abilities, stayed up hour after hour himself, making sure that every artist on Stax got every penny that was due them. My friends from Stax would agree that Jim Stewart is the most honest and caring man they have ever met in this industry, and every artist at Stax and everyone who ever worked at Stax owes Jim Stewart a debt of gratitude."

## MARTY STUART ON CHET ATKINS:

"Chet Atkins began his career in country music and went on to transcend musical boundaries; for more than fifty years Chet's music has influenced country, rock, pop, and jazz musicians like Scotty Moore, Carl Perkins, James Burton, Jerry Reed, Duane Eddy, Brian Setzer, and George Harrison. Chet drew from the folk music of the east Tennessee hills where he was born in 1924. Early on he worked as a fiddle player, but his first love was the guitar. After hearing thumb-picker Merle Travis on the radio, Chet began to perfect his own thumb-picking style, and he worked many radio shows in many cities during the forties. He broadened his musical horizons and eagerly learned from multiple genres. After he settled in Nashville in 1950, Chet began to organize recording sessions for record producer Steve Sholes, who signed Elvis to RCA in 1955. In January 1956, Chet and Scotty played guitar on Elvis Presley's first Nashville sessions, which yielded 'Heartbreak Hotel.' Pretty good way to start out.

"In 1957, Chet built RCA its own studio in Nashville and Sholes elected Chet to be the label's Nashville producer. He produced Janis Martin, the rockabilly find, and RCA also rented the studio to other labels and Chet played guitar on many of the Everly Brothers' hits. He also played on recordings by Carl Perkins, Roy Orbison, and a host of others. Not only was he a guitar player, he was a designer. He designed the 6120 Gretsch like you see Brian [Setzer] playing, and it became known as the standard rockabilly guitar. When the Beatles first came to America in 1964, George Harrison was playing a Gretsch Country Gentleman model named after one of Chet's hit songs. . . .

"Chet Atkins passed away last year, and he left us an enduring legacy that listeners will always be able to enjoy and guys like Brian and me can always strive for. I know I speak for millions when I say I feel blessed that his time on earth overlapped with mine."

## MUSICAL HIGHLIGHTS

Gene Pitney's soaring vocals filled the room, backed by Paul Shaffer's full-on orchestra, on the majestic "Town Without Pity," which the singer pointed out was "one of the most important songs of my career for a motion picture." For a different kind of soul, Isaac Hayes took over the keyboards alongside Steve Cropper on guitar, and Sam Moore (of Sam and Dave) sang the exquisite "When Something Is Wrong With My Baby" to honor Stax's Jim Stewart. Continuing the theme, Talking Heads played a tight "Psycho Killer"—sounding as if they'd never left CBGB's beer-soaked stage.

Rocking the house, all members of Tom Petty and the Heartbreakers, including original bassist Ron Blair and drummer Stan Lynch, played on either the early classic "American Girl" or the more recent "Mary Jane's Last Dance." (After the tragic overdose death of bassist Howie Epstein not long after their induction, Blair would rejoin the band.) Talking Heads reprised their version of Al Green's "Take Me to the River," kicking off the all-star jam that included the powerhouse vocals of Darlene Love, as well as the chops of Hayes and Cropper. The show ended with a rather anticlimactic but sweet "Here Comes the Sun," a duet between Rob Thomas and Jewel.

## INDUCTEES

**PERFORMERS** AC/DC ✦ The Clash ✦ Elvis Costello and the Attractions
The Police ✦ The Righteous Brothers
**LIFETIME ACHIEVEMENT AWARD IN THE NONPERFORMER CATEGORY** Mo Ostin
**SIDEMEN** Benny Benjamin ✦ Floyd Cramer ✦ Steve Douglas

The British took over the March 10 induction ceremony, with the Clash, the Police, and Elvis Costello and the Attractions all in attendance. AC/DC traveled from Down Under and the Righteous Brothers and record exec Mo Ostin came from California.

Tragically, the sudden death of Joe Strummer in December 2002 put an end to the hope of a Clash reunion. The Police were a different story, though. In exchange for a reunion that night, the trio arranged to go on last, and refused to participate in a jam with their co-inductees, who wanted to play the Clash's version of the Bobby Fuller Four nugget "I Fought the Law." Thus, no Clash musical tribute at all.

Jann S. Wenner began the program by announcing the establishment of a new Hall of Fame Library and Archive that would become the "comprehensive repository of the records and documents of the history of rock & roll": "I'm pleased to report that we've now raised five million dollars for that from our induction dinners. I thank everyone who's eaten our expensive lamb chops for their support."

Many of those who took the podium used it to protest against the bombing of Baghdad and George W. Bush's declaration of war. The opening song by soulful duo the Righteous Brothers, "You've Lost That Lovin' Feelin'," fit the mood perfectly. (Sadly, Righteous Brother Bobby Hatfield passed away a few months after their performance.) Though Ohio's governor had appeared at previous induction dinners, on this evening New York's mayor Michael Bloomberg, did the honors for the first time. He cited all the reasons New York City is the music capital of the world, saying, "There have been more than 350 songs about New York City, and I'm not going to sing each, or as a matter of fact, any of them for you. We're going to continue to make this a city where people can enjoy rock and all other types of music. As mayor, I want to thank all of you for coming, and to remind you, rock & roll is here to stay. It—and New York City—will never die."

> "SO IF THERE'S ANY OF YOU WHO AREN'T PAST IT YET, AND IF YOU CAN DO ANYTHING, WHY DON'T YOU GET UP AND DO IT, INSTEAD OF, LIKE, LYING AROUND?"
>
> —JOE STRUMMER

> ## "AC/DC IS THE ULTIMATE MIDDLE FINGER AIMED AT THE ESTABLISHMENT."
> —STEVEN TYLER

### AHMET ERTEGUN:

"It's been a subject of much conjecture, from people who've asked ever since we started, who wanted to know why certain people were inducted, and others weren't. I've been accused by various third-rate group singers and some musicians I've never heard of of keeping them out of the Hall of Fame. Let me point out tonight, once and for all, so everybody knows about this, that there's nobody on the Rock and Roll Hall of Fame Foundation executive committee, or anybody connected with the Rock and Roll Hall of Fame, who can get anybody in. It's done by a voting procedure, which we established immediately upon the formation of our foundation, and nobody becomes eligible until twenty-five years after they've started their career. The candidates chosen by a nominating committee then have their name sent as qualifiers to a much larger voting group of several hundred experts, whose votes finally determine the inductees. We have stressed that artistic quality be the measure, rather than commercial success. It's our fervent hope—we know that everybody has their favorites who are not in—that all those who deserve to be in the Hall of Fame will eventually find their place. We take great joy in recognizing the illustrious people who have been inducted so far; not only the giants of rock & roll, but those important sidemen, the nonperformers, and early influences who were the seeds of this music. American music legends from country, blues, and jazz are all names who still inspire rock & roll musicians today. The fact that their legacy survives and is celebrated in our beautiful museum in Cleveland is a source of great pride to all of us at the Hall of Fame."

### STEVEN TYLER ON AC/DC:

"Thank God for the power chord! That thunder from down under that grabs you in the lower-40 and gives you the second most satisfying surge that can run through your body. There is no greater purveyor of that power chord than AC/DC. The sparks that flew off the heavy metal of *Back in Black,* and the primal stink behind "You Shook Me All Night Long" lit a fire in the belly of every kid that grew up born to break the rules. And they're still out there touring; the fire rages on.

"On the journey from the pubs of Australia to the stadiums of the world, AC/DC became the Litmus test of what rock does. Does it make you clench your fist when you sing along? Does it scare your parents to hell and piss off the neighbors? Does it make you dance so close to the fire that you burn your feet and still don't give a rat's ass? Does it make you want to stand up and scream for something that you're not even sure of yet? Does it make you want to boil your sneakers and make soup out of your girlfriend's panties? If it doesn't, then it ain't AC/DC. These guys have dedicated themselves to the majesty of the power chord, ignoring the spoon-fed, 'don't bore us, get to the chorus' fickle taste of pop music.

"But just as they reached their creative pinnacle, they experienced the worst kind of tragedy imaginable: the death of the great singer Bon Scott. Rather than collapse, they rose like a sweat-soaked phoenix from the ashes, with their nerves of steel, hand in a velvet glove, sledgehammer to the back of the head vocals of Brian Johnson. Then came *Back in Black,* which sold a crushing nineteen million. That's thirteen million more than the previous release, with more than a little help from brilliant Mutt Lange, who continues to blow minds and speakers all over the world. The monster meet-me-in-the-backseat backbeat, the shredding vocals, that 100,000

Previous, page 168: Mick Jones and Joe Strummer of the Clash, 1979. Opposite: AC/DC: (from left) Mark Evans and Angus Young. Following, page 172: Paul Simonon, Strummer, Jones, 1980. Page 174: Elvis Costello and the Attractions, c. 1979.

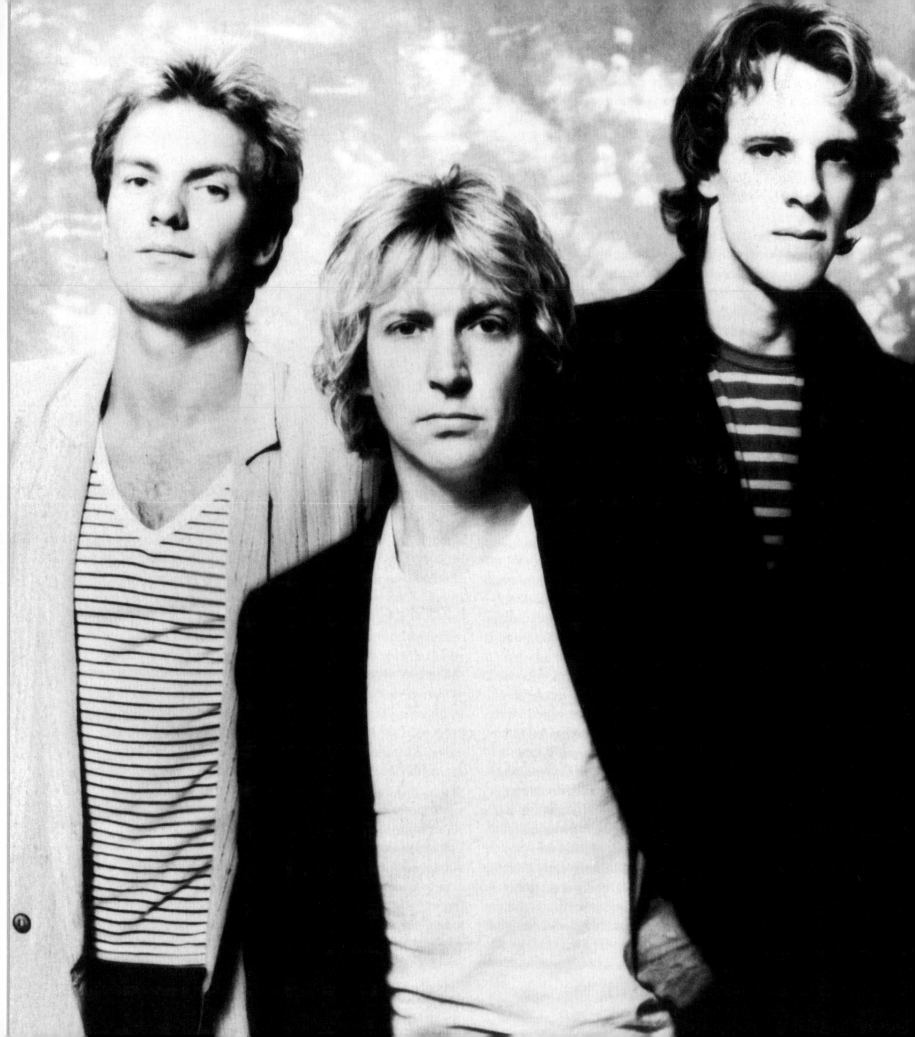

looking at me! He's totally grumpy, he didn't want to sign my poster, but he didn't blow me out too bad. That was the last and only autograph I ever got. This was one of the most memorable concerts of my life. It was crazy to see fifty thousand people singing all these songs word for word, and it was a life-changing performance for me.

"The Police were so unique. . . . In addition to being hugely popular, they were totally a musician's band. Andy Summers's guitar style created such a wall of sound, which is really amazing, because these guys were only a three-piece. Stewart, he was a drummer's drummer. Then, of course, Sting. Let's start with, how sexy is it to have a bass player be the lead singer as well? And his lyrics are just purely poetic. He simplifies all his experiences so the whole world can relate. His vocal style is so completely recognizable; as soon as you hear it, you just know it's him.

"The Police achieved something with me and many others that I believe is one of the most difficult and fulfilling accomplishments. They created music that inspired me to be in a band. They motivated me and many others to create and grab hold of our destiny. I'm sure that they will continue to be a creative point of reference for years to come."

> # "[THE POLICE] WERE A MIX OF ROCK, NEW WAVE, PUNK, REGGAE, JAZZ, POP. THEY WERE LIKE THIS FRUIT SALAD OF SOUND, ALL COMING TOGETHER."
> —GWEN STEFANI

## THE POLICE:

**Andy Summers:** "I'd like to make it very clear that there's absolutely no ego in our band whatsoever. We came here against the record company wishes, in deep snow and deep shit, and somehow we made it out of there. But we have to thank this country for giving us the start, and I'd like to actually point out, there's a gentleman [DJ] here by the name of Oedipus, who played 'Roxanne,' and without him, we might never have gotten started, and I think we're all very fortunate to have met each other, because we brought something very special out of one another that might not have happened in another combination. And God, of course, who's there with every single rock band, at every award ceremony."

**Sting:** "So they asked me, 'What do you think we should play at the Rock and Roll Hall of Fame?' and I said, 'That's very easy, we'll do our first hit and our last hit, and that's 'Roxanne' and 'Every Breath You Take.' And then I got a call from Stewart, and he said we're not doing those numbers 'cause there's not enough drumming in them. What bullshit. So we're doing them anyway."

## BILLY JOEL ON THE RIGHTEOUS BROTHERS:

"The year was 1965. My friends and I were about sixteen years old when 'You've Lost That Lovin' Feelin'' started to get airplay here in the New York area. Bill Medley's bass register lead grabbed us immediately, and Bobby Hatfield's tenor responses were the perfect feel. The chorus came in, crashing, throbbing, with that huge Phil Spector wall of sound. Then came the breakdown: 'Baby, baby, I'll get down on my knees for you.' We all looked at each other, and we said, 'Is he singing about what I think he's singing about?' It was a triumphant moment for guys that age everywhere—and I hope for women, too.

"The recording lasted something like four minutes, which in that era was like sitting through *Tristan and Isolde*. It was an opera of recordings—'I can't believe this fricking thing is still going . . .' It was great. It kicked off the potential to have something longer than two-and-a-half minutes, or whatever the law was back then. I ran out and bought their album, which was my whole life's savings at that particular time. I was hooked.

"The record that followed was the brilliant *Soul and Inspiration*. I can't think of any two singers that formed that kind of music with that much power. . . . I even wrote a song back in 1978, for an album called *52nd Street*, based on the Righteous Brothers style, called 'Until the Night.' I attempted to vocalize like both Bill Medley and Bobby Hatfield. I failed. But I had a lot of fun doing it, and I also learned to stretch my vocal reach to higher and lower ranges, and it also brought me closer to an epiphany, and that was this: Sometimes—just sometimes—people with blue eyes transcend the limitations of what their color and their culture is supposed to be. Sometimes white people can actually be soulful."

## LORNE MICHAELS AND PAUL SIMON ON MO OSTIN:

**Lorne Michaels:** "I've been coming to the Waldorf, to the Rock and Roll Hall of Fame induction ceremony since the beginning. Over the years, we've all gotten a little older, except for Mo. He looks exactly the same—very elegant and very cool. For almost fifty years, from Frank Sinatra, to Jimi Hendrix, to the Sex Pistols, to Madonna, Mo has worked with the greatest artists. Demanding artists, sometimes volatile artists, and Mo has dealt with them all with strength, and patience, and kindness, and a belief in the integrity of the work. For a man who's been at the center of things in show business for so long, he has never been comfortable standing in the spotlight. For him, before everything else, there was the music, and whoever it was that was making the music. Off to the side was Mo, modest, self-effacing, almost shy."

**Paul Simon:** "That was his public image. I remember the night that Mo signed me to

Previous, page 176: the Police: (from left) Sting, Andy Summers, and Stewart Copeland, 1985. Page 177: Mo Ostin. This page: Hall of Fame induction highlights, March 2003. Clockwise from top left: the Righteous Brothers; Steven Tyler and Gwen Stefani; AC/DC's Brian Johnson and Angus Young; the Police; Elvis Costello.

a contract with Warner Bros. Records. We were standing in the basement of Studio 54. Mo 'the Blow,' as he was known then, was a buff little guy in a powder blue suit. He said to me, 'Paul, let's sign these papers, and get upstairs, and check out the artistic integrity at the bar.'"

**Michaels:** "That really happened?"

**Simon:** [*Laughing.*] "What a great straight man. No, I have no idea what happened in the seventies. I can't remember anything."

**Michaels:** "He was very, very involved in the making of *Graceland.*"

**Simon:** "He was very involved in the making of *Graceland.* There's no question about that. I mean, first of all, he spoke Zulu fluently. There were times when I—one time in particular—I came to him, and I said, 'Mo, I am . . . I can't figure out this song. I've got the rhythm of it—it's *da-da-da-da-da-da*, but I can't get the words.' And he said, 'Okay, okay, okay—I just got off the Warners jet from Aspen, I haven't changed out of my clothes yet. Let me go to lunch and think about it.' So I waited in his office, and in a mere three hours that he took for lunch, he came back and he brought me this. It's a napkin from Spago. It says, 'If you'd be my bodyguard, I'd let David Geffen go. You can call me, Evelyn, and Evelyn, when you call me, you can call me Mo.'"

**Michaels:** "He just gave you that?"

**Simon:** "Gave it to me. Wanted absolutely nothing but thank-you, and three-quarters of the publishing."

**Michaels:** "He really supported his artists."

**Simon:** "It was tremendous. Anybody who was on Warner Bros. during the Mo years knew it to be an exalted time. I mean, with the possible exception of Prince, who was enslaved during that period."

## NEIL YOUNG ON MO OSTIN:

"I turned off my teleprompter; I have no idea what to do. But one thing is on my mind before I get to Mo. War sucks a big . . . it just sucks! We're having a good time tonight, but we're gonna kill a lot of people next week. So let's not forget about that. I don't want to ruin this, but it's too real to not mention. And music used to be about this, and it still is about this. It's a human thing, and these are human beings over there. We're making a huge mistake. I feel like I'm in a giant, gas-guzzling SUV, and the driver's drunk as a fucking skunk. He's drunk on power.

"Let's get to Mo, 'cause I love Mo, and you talk about a phrase that means something different today than it used to mean; it's called 'behind the music.' That phrase now connotates [sic] soap operas to me. But this man, Mo Ostin, was behind the music. He was behind making it happen, he was behind letting it happen, however it was going to happen, and he was behind keeping it happening, and that's why Warner Bros. and Reprise were the greatest labels ever, as far as I'm concerned. I don't want to put down any other people; you're all great, too. Everybody's great. Mo's just a little better, 'cept for Ahmet, of course. They're right up there together. Mo brought something to my life that made a big difference, and it was creative freedom. When we signed with Reprise, we asked Mo, 'Can we do what we wanna do? Can we just make these records and produce them ourselves, and not call you, and not call the record company, and not tell anybody what we're doing? Just let us do what we do on our own timetable?' And he let us do it. . . .

"So, Mo Ostin, thank you very much, and it's my pleasure, along with Paul, and Lorne, and—sorry about that thing with the war; I just had to put that in there;

screwed it up—Mo, I love you, thank you very much for everything. You and Evelyn have been wonderful to me over the years."

## MO OSTIN:

"First, I think I should confess. Whatever I did to achieve this honor, those things were not my ideas. What I did was based on four things I learned from four individuals in my life, so instead of reciting a long list of well-deserved thank-yous tonight, let me simply mention the four crucial lessons I've learned.

"Lesson one: Right out of UCLA, I got hired by Norman Granz to work at his jazz label, Verve. From Granz, I learned my first lesson on how to run a label. Granz taught me that a record executive should not mess with the artist's music. From him, I learned that artists are so much smarter about music—and many other things— than most executives, and it's best just to get out of their way.

"Lesson two: After Granz came Frank. When I first met him, Frank Sinatra was not happy with his record company. Frank had tried to buy Verve from Granz. No deal. Frank then told me he wanted to start his own label, one called Reprise. He asked me to run it. Hard to argue with that. What Frank taught me is that record labels should be about artists, more than anyone or anything else. That it's the music and not the bottom line that should get our highest priority. That Wall Street should not define our values, and that instant gratification and dollar squeezing are not how to run a company. This is a business of creativity, and risk-taking, and passion, and in the struggle between art and commerce, the artist must prevail. That remains— particularly these days—a battle worth fighting.

"Lesson three: When Reprise got big, it was Steve Ross of WCI who owned us. Steve blessed our label and stood by our management style. He always said the most important aspect of a company is not on the balance sheet, it's the people who work there. He encouraged executives to take risks, and protected them against corporate interference. I tried to do the same. . . .

"Four: Because of her, I've had a good life and loving family. . . . All begun because I learned one more great rule. I learned this rule over fifty years ago. It is: The most important thing any of you can ever do, and get a lifetime achievement award, is marry Evelyn. I love you, sweetheart, and all of you guys. And to all the talented artists and executives that contributed so much, I'd love to hug every one of them for making me look so good. And to all of you out there, you're tied for number five."

## MUSICAL HIGHLIGHTS

Rock from Down Under kicked the energy into high gear: AC/DC strutted their stuff on "Highway to Hell," with Steven Tyler joining them to belt out on "You Shook Me All Night Long." Elvis Costello performed with the Imposters—Steve Nieve and Pete Thomas—delivering a very impassioned "(What's So Funny 'Bout) Peace, Love, and Understanding" that held a particular resonance on that particular night. The Police closed the show, as Sting promised, by performing "Roxanne" and "Message in a Bottle." Later, Elvis Costello snarked that the trio's set "was like a black comedy of rock & roll—band members trying to blow each other offstage for reasons of ego." But that didn't prevent über-fans Gwen Stefani and John Mayer from joining the Police onstage to add backup vocals to "Every Breath You Take"—a truly arresting moment.

## INDUCTEES

**PERFORMERS** Jackson Browne ✦ The Dells ✦ George Harrison ✦ Prince ✦ Bob Seger ✦ Traffic ✦ ZZ Top
**LIFETIME ACHIEVEMENT AWARD IN THE NONPERFORMER CATEGORY** Jann S. Wenner

The music and speeches at this Ides of March fête were superb, with Prince's nine-piece revue kicking it off with an incendiary set: "Let's Go Crazy," "Sign O' the Times," and "Kiss." Other high points were stellar speeches, including Bruce Springsteen's induction of Jackson Browne and Mick Jagger's of Jann S. Wenner, both spiked with humor and insight.

Three young artists influenced by Prince testified about his influence on their own work. OutKast's André 3000 (André Benjamin) and Big Boi (Antwan Patton) recalled how they first discovered Prince's music during their childhood. Alicia Keys added her thoughts in an eloquent speech praising the artist who can "only be identified by a symbol."

As for reunions, Dave Mason would not perform with Traffic band mates Jim Capaldi and Steve Winwood when the group performed "Dear Mister Fantasy," but he did return to the stage to join them on the finale of "Feelin' Alright?" The Silver Bullet Band reconvened with Bob Seger for the first time in eight years, following an enthusiastic presentation from Kid Rock.

Filmmaker Robert Townsend inducted the fifty-one-year-old vocal group the Dells, who had inspired Townsend's movie *The Five Heartbeats*. And there were crunchy blues and humorous remarks surrounding ZZ Top's induction by Keith Richards.

The posthumous induction of George Harrison by his Traveling Wilbury pals Jeff Lynne and Tom Petty, naturally, weighed heavy, but the counterpoint was an uplifting musical tribute, punctuated by a powerful guitar solo by none other than Prince. Harrison's widow, Olivia, and son, Dhani—who looks strikingly like his father—were there to accept the award. Dhani told an amusing story about accidentally breaking the statuette his father received from the Rock and Roll Hall of Fame when he was inducted as a Beatle in 1988. Olivia quoted lines from George's favorite poet, while the hushed room mourned the loss of "the quiet Beatle," as he had referred to himself on the same stage sixteen years earlier.

"WHEN I FIRST SAW THEM, I THOUGHT, 'I HOPE THESE GUYS ARE NOT ON THE RUN. THIS DISGUISE IS NOT GOING TO WORK.'"

—KEITH RICHARDS, ON ZZ TOP

> **"THERE WAS NO ALBUM THAT CAPTURED THE FALL FOR ME OF THE LONG AFTERBURN OF THE SIXTIES—ITS HEARTBREAK, ITS DISAPPOINTMENTS, ITS SPENT POSSIBILITIES— BETTER THAN JACKSON'S MASTERPIECE *LATE FOR THE SKY*."**
>
> **—BRUCE SPRINGSTEEN**

## BRUCE SPRINGSTEEN ON JACKSON BROWNE:

"I first met Jackson Browne in the early seventies. It was at the Bitter End; I was brought down there by David Blue, a folksinger, after a set I did at Max's Kansas City. On David Blue's word, Jackson was kind enough to let somebody he just met get up onstage and play a song during his set. I watched Jackson play that night; he was accompanied by the great sideman David Lindley, and I recollect them playing songs from Jackson's first album: 'Doctor My Eyes,' 'Rock Me on the Water,' 'Jamaica Say You Will,' 'Song for Adam.' They're great songs, directly written and sung in that pure emotional tone that I have always loved of Jackson's. As I listened that night, I knew that this guy was simply one of the best. Each song was like a diamond. My first thought was, 'Damn, he's good!' My second thought was, 'I might need less words.' The emotions of all the music was right out there on his sleeve, and I've remained a major, major fan since then. I remember watching that night, he was kind of quintessentially California, right down to the surfer haircut, a good-looking guy, great songwriter, and we became pretty friendly.

"Over the next few years, Jackson was gracious enough to let me open up at several of his gigs. Now, being a little competitive, the first thing I noticed was Jackson didn't have much of a show. He just stood there in the baggy jeans and the T-shirt, singing his serious songs. That was it! Being a little competitive, I also noticed that Jackson drew an enormous amount of good-looking women. *Great-looking women*, who stood there staring at the stage, entranced. His hair was perfect, and that was something I aspired to, myself. Both the hair and the women. Tonight, this is an un-looked-at part of Jackson's work that I'd like to focus on for the moment. The great songwriting, all right, I could deal with that. I don't need to stand here tonight and dwell on the obvious. But the gals that came to the show! See, what most people don't realize—and to me this was a big part of Jackson's rock & roll credentials—was that Jackson Browne was a bona fide rock & roll sex star! And my wife says he still is. She tries to hide it, but not too much.

"Now, being a little competitive, I also noticed that while the E Street Band and I were sweating our asses off for hours, just to put some fannies in the seats, that obviously due to what must have been some strong homoerotic undercurrent in our music, we were drawing rooms filled with men, and not that great-looking men, either! Now, meanwhile, Jackson is drawing more women than an Indigo Girls show! It's true that Jackson wrote some of the most beautiful breaking-up music, break-your-heart music, of all, and I think that what drew women to Jackson, besides the obvious, was that they finally felt they were listening to a guy who knew as much about love as they did. And what drew men to Jackson—besides the obvious, I guess—was that when they listened to him, they realized that they knew more about love than they thought they did.

"*Late for the Sky* is a beautiful body of work, it's essential in making sense of the times. . . . There was no more searching, yearning, loving music made for and about America at the time. In this, and so much of Jackson's writing, the slow meticulous crafting of the songs, the thoughtfulness—Jackson was one of the first songwriters I'd met that demonstrated the value of thinking hard about what you were saying, your subject.

Previous, page 180: ZZ Top: (from left) Dusty Hill and Billy Gibbons.

"While writing 'The Pretender,' produced by unheralded genius Jon Landau, Jackson would play me a verse. I would come back a month later and he would play me two more lines. The song would show up two albums later somewhere. He took his time; it was the condensed emotional power in each line of his great songs that was a result of that willingness to work and think hard, the meticulousness of craft that was always matched and balanced by deepness of soul. 'The Pretender,' 'These Days,' 'For Everyman,' 'I'm Alive,' 'Fountain of Sorrow,' 'Running on Empty,' 'For a Dancer,' 'Before the Deluge': I know the Eagles got in first, but let's face it—and I think Don Henley would agree with me—these are the songs they wish they'd written! I wish I'd written them myself, along with 'Like a Rolling Stone' and 'Satisfaction.' But Jackson's influence and his voice has always been his own.

"He's one of the few true activist musicians I've ever known; he followed his muse wherever it took him and he paid whatever the cost. He has long put his mouth, his money, and his body where his politics are. 'Lives in the Balance' sounds more urgent today than it ever did. The Beach Boys and Brian Wilson, they gave us California as paradise, and Jackson Browne gave us paradise lost. I always imagined what if Brian Wilson married that nice girl and moved into the Valley and had two sons? One of them would have looked and sounded just like Jackson Browne. Cain, of course, would have been Jackson's brother-in-arms, Warren Zevon. We love you, Warren. But Jackson to me was always the tempered voice of Abel, toiling in the vineyards, here to bear the earthly burden confronting the impossibility of love. Here to do his father's work.

"Jackson's work was really California pop gospel. Listen to the chord changes of 'Rock Me on the Water' and 'Before the Deluge'—gospel through and through. I always thought that in our fall from Eden, the way we regain our divinity and our sacredness, and our general good standing, is by reconstructing love and creating love out of the broken pieces that we've been given. That's all we have of human promise, that's the way we prove ourselves in the eyes of God and facilitate our own redemption. Now, to me, Jackson Browne's work was always the sound of that reconstruction. As he writes in 'The Pretender,' 'We'll put our dark glasses on, and we'll make love until our strength is gone and when the morning light comes shining in, we'll get up and do it again, amen.'"

### JACKSON BROWNE:

"I'd like to thank my mother and my father who brought me up in a house filled with music and books. And my brother who taught me to play piano and allowed me to appropriate his piano style. I was sort of a folk purist, and my brother kept learning these great rock & roll songs he got off the radio, but he wound up playing them at home on the piano by himself, and I learned to do that from him. I feel fortunate to have grown up in the bosom of a bunch of friends and musicians, people who all wrote and who all learned each other's songs. . . .

"I'd like to thank Billy and Judy James, who took me to live in their house in Laurel Canyon where so much was going on and really introduced me to so many record producers and engineers and musicians, and Jac Holzman. They got him to sign me to a publishing contract. . . . He founded Elektra Records on the back of his motorcycle. He literally used to take the records on the back of his Vespa to the various record stores in New York, and was a mentor to so many folk musicians. At the same time he was doing that, he only needed one hit from the Doors to pay for the hundred other records that he would make of people who were nuanced and unusual and one-of-a-kind but who were not necessarily going to make the top of the charts. I'd like to thank him for instilling that ethic in me.

"I'd like to thank all the writers who wrote about my music and helped popularize what I was doing, helped communicate the nuances of my music. I'd like to thank all the DJ's and radio people, the self-empowered people who played what they wanted to play, and played me. I'd like to say how fortunate I feel to have played with the musicians I've played with, and if I give myself any credit at all, it's that I got them to play what they wanted to play. In the beginning you made records and they would expect you to make three [songs] in a three-hour session, and we changed all that because we spent years making a song. . . .

"I'd like to say what an honor it is to be inducted in the company of these people that have made such a difference in my life and who are the embodiment of the values that I've tried to bring to my music. . . . I want to thank you for allowing me to put my personal politics inside the songs and for listening to them and hearing them. Music is a very empowering thing and I'm happy to have had a lifetime doing it."

> **"I THINK PEOPLE WHO CAN TRULY LIVE A LIFE IN MUSIC ARE TELLING THE WORLD, 'YOU CAN HAVE MY LOVE, YOU CAN HAVE MY SMILES. FORGET THE BAD PARTS; YOU DON'T NEED THEM. JUST TAKE THE MUSIC, THE GOODNESS, BECAUSE IT'S THE VERY BEST, AND IT'S THE PART I GIVE."**
> —GEORGE HARRISON

### ROBERT TOWNSEND ON THE DELLS:

"The Dells were my inspiration for my film *The Five Heartbeats*. When I was a kid I grew up in Chicago listening to their songs. I always wondered if they had love in their real lives and it made me write the movie. They were my technical advisors; stuff that you see in that movie came directly from their lives."

### TOM PETTY ON GEORGE HARRISON:

"Some years ago George asked me to speak and present him with the *Billboard* Lifetime Achievement Award, and he began his acceptance speech by saying, 'I'm sure being in the Beatles has not been a hindrance to my solo career.' As he stood, onstage and off, between Lennon and McCartney is a really tough spot for an aspiring songwriter. Yet learning his craft, he turned into an excellent writer, coming up with classics like 'Something,' 'Here Comes the Sun,' and many more. He became so prolific

that he began to stockpile large amounts of unreleased songs, and this had become the basis for his first album, *All Things Must Pass*, which is the first Number One album by an ex-Beatle. Many more hits would come. He often said he wasn't pursuing a solo career at all. He never hired a manager or had an agent. He just loved playing music with his friends and he loved guitars and he loved rock & roll, and he loved Carl Perkins and he loved Little Richard, and he loved Dhani and Olivia. He loved to stay up all night long and play the ukulele till dawn. Throughout the eighties, he hit Number One again with his *Cloud Nine* LP, and then he formed what he called his 'other band,' the Traveling Wilburys. That was with Jeff Lynne and myself and some other guys."

---

## "KNOWING GEORGE [HARRISON] AS WELL AS I DID, HE'S PROBABLY WATCHING TONIGHT AND SAYING, 'GET ON WITH IT!'"

—JEFF LYNNE

---

### OLIVIA HARRISON ON HER HUSBAND, GEORGE HARRISON:

"There was a quote by an Indian poet that George read to me one day. He said, 'Blessed he whose fame does not outshine his truth.' Here we are in the Hall of Fame. The inductees are not chosen because of their fame, but because they express their truth through their music. George said that he tried to write songs that would still mean something years from now, and I think it's safe to say that in spite of his immense fame, his truth will never be outshined or forgotten."

### ALICIA KEYS ON PRINCE:

"There are many kings: King Henry VIII, King Solomon, King Tut, King James, King Kong, the Three Kings, but there is only one Prince. Only one man who has defied description, defied the obvious and all the rules of the game—a mysterious figure, who…can only be identified by a symbol. Whose music is like an internal rollercoaster that takes each individual on their own separate legendary ride, and still takes listen after listen to discover and uncover even half of the story behind the intriguing and unapologetically addicting beat of music. There is only one man who is so loud he makes you soft, so strong he makes you weak, so honest you feel kind of bashful, so bold he defies you to be subtle, and so superbad he makes you feel so supergood. He's the only man that I've ever seen that lights the stage on fire, leaving you to burn within it in a frenzy of movement, lights, electric guitars, slide piano, dancing, voices, splits, and songs. Songs so powerful that you are forever changed. Songs that make you laugh and cry, think and dance, songs as stories of the untold passion dying to be heard.

"Because of him, I've never wanted to be like anyone else but myself. Because of his music, my music has wings to be different. He's an inspiration we'll return to till the end of time. So yes, throughout history there have been many, many kings, both real and mythological. They have borne sons, but none of them can touch the rays of this man who stands alone."

### PRINCE:

"When I first started out in the music industry, I was most concerned with freedom. Freedom to produce, freedom to play all the instruments on my records, freedom to say anything I wanted to. After much negotiation, Warner Bros. Records granted me that freedom and I thank them for that. Without any real spiritual mentors other than those whose records I admired—Larry Graham being one of them—I embarked on a journey more fascinating than I could ever have imagined. But a word to the wise: Without real spiritual mentoring, too much freedom can lead to the soul's decay. And a word to the young artists: A real friend or mentor is not on your payroll. A real friend and mentor cares for your soul as much as they do their own. This world and its wicked system will become harder and harder to deal with without a real friend or mentor. And I wish all of you the best on this fascinating journey. It ain't over yet. Peace."

### KID ROCK ON BOB SEGER:

"Until tonight, the most underrated singer-songwriter and live performer of our time has been Bob Seger. He was 'The Beautiful Loser' who has sold fifty million records. Bob Seger has paid more dues than all the artists in the current *Billboard* Top 40 combined. He played two hundred and some odd nights a year for over a decade before enjoying commercial success outside his hometown. He worked on the Ford assembly line; he was a product of very humble beginnings and a broken home. Now, you can't talk about Bob Seger and not mention the Midwest—the great state of Michigan or Detroit Rock City. Anyone who lives there will testify, around those parts, Bob Seger is God. You can't talk about Bob Seger and not mention the Silver Bullet Band, you can't talk about Bob Seger without the same two words coming up time and time again—Punch Andrews. As Bob's manager, producer, and friend for forty years, Punch has always tried to avoid the spotlight, but isn't it ironic that the stories about Punch at times have also been as legendary as the music?

"Being from Michigan, Bob lived north of Detroit, and he's still living there today. Bob Seger's music not only influenced me, it taught me to be proud of where you come from—and I am. He set the bar for all singers and songwriters from the Midwest. Bob Seger is the voice of the workingman and the living proof of the American dream.

"Through my travels, I've heard Seger's songs blasted from the clubs on the Sunset Strip and I've heard it down on Broadway at the honky-tonks in Nashville, Tennessee. A few of my hip-hop friends have even brought it up to me time and time again about how great he is. His music has always done the talking, and in a day and age where we have gotten so far from that, let the example that Bob Seger has set remind us—especially the radio stations, video channels, record companies, and artists—that nothing is bigger than the music, nothing.

"Might I add what an incredible family man this guy is. If anybody should set the bar or set the standard of how to be in rock & roll, and how to go through it with dignity, how to not lose all your money, how not to blow everything, how to make great songs and still hold onto all that, it's Bob Seger. For that, he's a role model and a hero to me.

"His music and his fans have always been the other great voice of Bob Seger. He has toured and entertained millions of music lovers around the world for some thirty-odd years, backed always by the sweet, heavy, soulful sounds of the Silver Bullet Band. So now we turn another page in the life and times of Bob Seger, and in his own words it has never rang more true than tonight: 'Rock & roll never forgets.'"

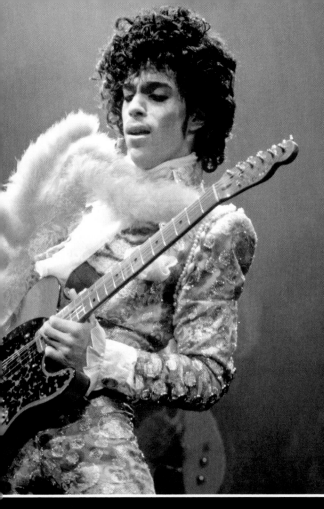

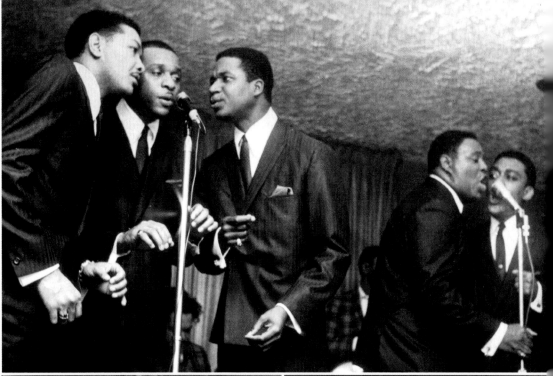

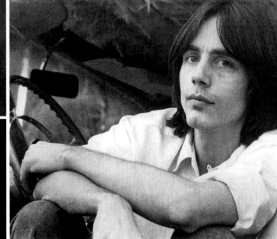

Clockwise from top left: Prince, 1985; the Dells; early ZZ Top promotional poster; Traffic: (from left) Jim Capaldi, Steve Winwood, Dave Mason, and Chris Wood, c. 1968; Bob Seeger; George Harrison, 1968; Jackson Browne, 1978.

## DAVE MATTHEWS ON TRAFFIC:

"When I was a little kid, my brother turned me on to lots of good stuff: Dylan and the Beatles and Traffic. Traffic affected me in a great way when I was small, especially their first two albums. I loved singing along with them and I thought I was a member of their fantasy. But there's a story that I have that is really the reason that I accepted the honor of coming here and inducting Traffic into the Rock and Roll Hall of Fame. I was probably somewhere between nineteen and twenty-two and I was at a film festival in Grahamstown, South Africa, at the university there, and I'd been drinking, and smoke had been involved. There were other things that you could swallow that were involved, too, so needless to say, I wasn't in great condition. I was on a couch in a house and I began to be afraid, terribly afraid, desperately afraid. I was actually en route to hell at that point; I was quite convinced that the end was near. And then, like a friend in a crowded room of scary strangers, I heard [*sings*] 'Dear Mr. Fantasy, play me a tune, something that will make us all happy.' And I thought, 'Wow! Everything's going to be okay!' I honestly believe they're one of the greatest rock & roll bands of all time."

---

> ## "WHO'D HAVE THOUGHT WE'D STILL BE MAKING MUSIC AT THIS AGE? OF COURSE, ROCK & ROLL IS NOT AN AGE; IT'S AN ATTITUDE."
> —DAVE MASON

---

## TRAFFIC

**Jim Capaldi:** "America adopted us a long time ago and what can I say? These two guys [Stevie Winwood and Dave Mason]—I'll never forget meeting them, it's ingrained in my memory. I was blind drunk and I fell headlong into the gutter and there they were looking up at me. When you're eighteen years of age on a street corner near where we all came from, and you say to your mates, 'I've got a great name for a band—Traffic,' and then it comes to fruition, and having been through what I've been through, and standing here today on the stage, it just goes to show how dangerous some ideas can be. Chris [Wood] was a magic man in Traffic. He was the one who came up with *John Barleycorn Must Die*. We sadly miss Chris. Traffic forever."

## KEITH RICHARDS ON ZZ TOP:

"In Texas the heart of the matter is rock & roll and the blues. We have to talk about the blues here because we cannot leave it out, right? Without it, we're nowhere. What I want to say about the guys I'm going to bring on is that they're a solid band. This is the heartbeat of the whole country, of rock & roll. These cats know their blues and they know how to dress it up.

## AHMET ERTEGUN ON JANN S. WENNER:

"I've known Jann Wenner for many long, wonderful years. Those very early days when he and Jane Wenner printed the first copies of *Rolling Stone* on newsprint. Jann's mentor in those days was my old friend, the great jazz critic Ralph Gleason, who was the first one of his ilk to take serious interest in the newly emerging form of music known as rock & roll. Very early in the game, Jann realized the importance of the oncoming surge of rock music. He recognized it, not only simply as an outgrowth of the blues, but also as a harbinger of a new set of mores and a new philosophy of life. More than anyone else, he first identified the power of rock as a politically and socially evocative form of music that would change our world. His statements, and those of the writers in his magazine, espoused a revolution of not only musical but cultural importance. He played a pivotal role in the explosive San Francisco scene of the sixties, but more importantly, he embodies what we call 'fearless journalism'—then and now."

## MICK JAGGER ON JANN S. WENNER:

"I like to think that Jann has entered the Rock and Roll Hall of Fame because he represents people that love music, and Jann himself is a passionate fan of music. When we first came to America, things were very different. There was a magazine called *16*, and they would ask you really deep questions like 'Do you like blondes or brunettes?' 'Do you like Italian food or Chinese food?' 'What kind of socks do you like?' And also, Keith, do you remember, you used to get posed with sheepdogs at airports? For them, this was the kind of news to do.

"This innocent triviality was swept away when in 1967 *Rolling Stone* magazine was launched in San Francisco, and it was Jann's main thing to put the current music scene into the limelight. The magazine was started, as Ahmet said, with Jane Wenner who was there at the beginning. The magazine quickly expanded its range into politics, which was the real hot potato at the time, and into movies, kidnappings, and drugs. Strange to say, this was all new stuff to American music journalism. People took jazz at that time very seriously. Sometimes too seriously. But rock performers were treated as third-class fly-by-night citizens, having a hard time to form one brain between them. *Rolling Stone* changed all that, by revealing indeed two brains existed, and they did that by inventing the very long interview. While *16* magazine would do five minutes on your hair or wardrobe, now you had to spend hours describing your views on everything from Vietnam to the Beatles, as well as, of course, your sexual preferences. Now, intrepid *Rolling Stone* reporters would hang out with you on tour—having to be supplied with drink, drugs, and even food—to produce the interviews that Jann demanded.

"There's one time a few years ago that Jann decided that he was going to do a very long interview with me, and he decided that he was going to come visit us on a tour to do this, in small places where there wouldn't be any interference. And after a couple of interviews—and he's really getting into this—he said, 'I feel like a cub reporter again.' I said, 'Yeah, Jann, you're a cub reporter with a Gulf Stream G-4 waiting at the airport.'

"Anyway, all of this caught on, and Jann was always there, driving it with his mix of enthusiasm for the grand design and all the details. The magazine then came to define rock journalism. Jann had then a second great idea, which also defined the magazine, which was to have covers with rock icons portrayed by some brilliant photographers,

such as Annie Leibovitz, Dick Avedon, and Herb Ritts, to name some of them. Also some great illustrators like Ralph Steadman. Jann had a third idea, which was to put very young virginal girls with very little on, on the cover. All these things helped make *Rolling Stone* the cover that the artists and the public would just die for.

"The thing about Jann is that he is a great editor, always going to the heart of the story, and he remains young and being interested in the 'now' as much as the 'then.' He has a passion for music, politics, and movies. Among Jann's groundbreaking ideas is that he was one of the first music critics and editors who really understood how we, as artists, felt, and he could sympathize with our yearnings. It was this understanding that placed the magazine in the forefront of rock criticism. Jann almost single-handedly pioneered the idea of popular music and rock & roll in particular as a vibrant art form, not just a collection of flash in the pans. It was Jann and his staff that elevated our music to a place where it enjoys the status of other musical forms. Even now, *Rolling Stone* remains a beacon of light. . . . To have kept the magazine up to its incredibly high standards for thirty-six years without even batting an eyelash is no mean feat, and Jann Wenner has made an invaluable contribution to the appreciation of our music."

## JANN S. WENNER:

"I started *Rolling Stone* in 1967 when I was twenty-one, a hopped-up rock & roll fanatic in San Francisco. . . . The Beatles [had] changed my world. After *A Hard Day's Night,* nothing was ever the same. To have that much fun and to feel so free—well, the doors of perception had opened for me, and I now understood where I wanted to be going. In college I met Ralph Gleason, who took me under his wing. But the academic life couldn't really compete with the discovery of pot and psychedelics. I was going to the Bill Graham Family Dog dance concerts every weekend and, for two dollars' admission, seeing the Airplane, the Dead, Otis Redding, Butterfield, Janis, Muddy Waters, and Wilson Pickett. Every month a new record would come out: *Bringing It All Back Home*, or *Rubber Soul*, or the first Byrds album, or *Out of Our Heads*, and then *Highway 61*. Those were the major events in my life—and that was the end of college for me.

"I would have loved to have been a guitarist, and I was in a band—for the record, it was called the Helping Handout—but I felt more at ease writing journalism; I was not certain as to why but I just seemed to be comfortable there. In high school I started a student newspaper called *The Sardine*, whose motto was "all the news that fits," and the most popular feature in it was a column I wrote called 'Random Notes.'

"My thank-you's begin with Jane Wenner. Jane helped me start *Rolling Stone* and she kept me from getting too crazy, and she had just exactly the right judgment at the most important times. My cofounder was Ralph Gleason and he was the gray-haired wise man, and Ralph was once quoted as saying 'the proof of how good an idea at *Rolling Stone* is, is if it survives Jann's business management of it.' My earliest supporters in the record business were Jac Holzman, Clive Davis, and Gil Friesen. They all saw what was going on at *Rolling Stone* more clearly than I did. They saw how important *Rolling Stone* could be. The three of them each stepped up to the plate with a loan in the early days when it looked like we might be going out of business. Then, Gil distributed *Rolling Stone* to record stores, through A&M Records, and he decided he would be a guiding hand and a friend for life, and he's still that.

"Jon Landau reviewed records in Issue No. 1, and he was then, as now, one of the most knowledgeable, wise, smart, and articulate guys in rock & roll, and he was a soul mate, and I have files of single-spaced letters and long-distance phone bills to prove all that. And Jon and Ralph set the bar for the critics and the editors that came up through *Rolling Stone*—like Jon Pareles, Ben Fong-Torres, Jim Henke, Kurt Loder, Joe Levy, Greil Marcus, David Fricke, Anthony DeCurtis, Lenny Kaye, Jonathan Cott, Dave Marsh, Tim White, to name a few. We thrive on talent and taking risks. For years *Rolling Stone* was defined by Hunter Thompson and his gonzo ethics, his masterful writing, his taste for intoxicants. He was my Keith Richards. Tom Wolfe was a star before I came along, and we've been his literary home for thirty years now and he wrote both *The Right Stuff* and *Bonfire of the Vanities* for *Rolling Stone*. Cameron Crowe was the only person who was younger than me when he started working there. And it is true, we did have to get both his mother's and his father's permission to send him out on the road with Led Zeppelin. He had not graduated from high school yet. He was a kid who could write and report better than most of all the big guys, and *Almost Famous* is what it was like, and it's one of the greatest love letters to rock & roll ever written. He made us all really proud. . . .

"Early on, *Rolling Stone* became an outlet for John Lennon and Yoko Ono when they began their Peace Crusade. They gave us the *Two Virgins* photos for the cover of our first anniversary issue, numerous interviews, including 'Lennon Remembers,' and they conferred upon us the benefits of their fame and their legitimacy. It was a tragedy that staggered us all when John died. Yoko's support, though, continued over the years. I'm the godfather to her son, and she's the godmother of one of mine, and war is over if you want it.

"The first musician ever to visit *Rolling Stone* when we were in a loft over a printing plant in 1968 was Stevie Winwood. I remember Pete Townshend, a frequent visitor to San Francisco then, and he became a good friend in those years. I am really glad to share the stage also with my comrade-in-arms Jackson Browne. Music was the voice of the Baby Boom, the biggest, the best educated, the most affluent generation in human history. As the world around us became increasingly dangerous and we went out on our own, with no direction home, rock & roll music got a real sense of urgency. Bob Dylan is the voice of my America—to be alive during his lifetime when he has held the stage and made us all special, I've tried to be his greatest champion. Last summer Bob came down to my house for a visit, and he ended up playing guitar with my youngest son, showing him the ins and outs of how to play 'Hurricane' and trying to turn him on to Charlie Christian. There just couldn't have been a better reward than that moment.

"Bob's vision of America was woven into the mighty fabric by the artists to whom *Rolling Stone* gave support and faith for many, many years: Don Henley, John Mellencamp, Robbie Robertson, Paul Simon and Artie Garfunkel, Bono, Pete Wolf, Jackson Browne, and Bruce Springsteen. Most of them are here tonight. Their work is what the magazine stands for, and they're the people with whom I became friends and became an adult.

"To the two most elegant men in the room: Ahmet Ertegun and Mick Jagger. Thank you for bringing me into the Rock and Roll Hall of Fame. I am honored by both of you. Ahmet, you are a national treasure and you and Mica have been family to me and mine, and one of the greatest privileges of my life is to serve under you and see your vision of the

This page: Hall of Fame induction highlights. Clockwise from top left: (from left) Kid Rock, Jackson Browne, Billy Gibbons, Tom Petty, and Keith Richards; Beatles' sons: (from left) Dhani Harrison and Sean Lennon; Steve Winwood; (from left) Jeff Lynne, Dhani Harrison, and Tom Petty; Jackson Browne; the Dells. Opposite, far right: letter from Mick Jagger to Jann S. Wenner; near right: Jann S. Wenner, Mick Jagger, and Ahmet Ertegun, March 2004.

Rock and Roll Hall of Fame. You've done so much for me. To Mick Jagger, how cool it is to be inducted by you! First, I want to thank you, Mick, in lending Bob Dylan the name. I worshipped the Rolling Stones. You and Keith still have the world's greatest rock & roll band. I always set my compass to you, Mick, for sensibility and taste and how to guide *Rolling Stone* by how you conducted yourself as an artist and a driving force and how you held it all together with such intelligence and integrity. I have been in awe of you and I still am, and it's been a pleasure to be your friend for all these years.

"I wanted to tell the world about rock & roll and I wanted to tell the stories of musicians, and I wanted to have a place for them to speak to other musicians and the audience. I've tried to stand for quality and integrity and reflect the values of music, and I wanted to be the voice for the artists. I believe so deeply in music, all kinds of music, and I believe it can soothe and it can heal, and it can uplift, and it can shake the walls of the city itself. Rock & roll has been giving us the truth about America, and we have the responsibility of doing something about it and having our voices heard, and deciding where this country is going, more than ever. *Rolling Stone* was founded on that idea, it still believes it, and it will do so for as long as I live."

## MUSICAL HIGHLIGHTS

There were tantalizing musical moments throughout the induction program, leading up to the end-of-the-night finale. Jackson Browne played an impassioned "Running on Empty" as well as the song Springsteen singled out as a masterpiece, "The Pretender." After their induction by Robert Townsend, the Dells sounded like spring chickens on "Oh What a Night." ZZ Top chugged their Deep Ellum blues with "La Grange" and "Tush," after Bob Seger and the Silver Bullet Band fired up "Old Time Rock & Roll."

But the jaw-dropper of the night was Prince's phenomenal guitar solo on "While My Guitar Gently Weeps"—after he sashayed out in a red fedora with matching jacket to join Tom Petty, George Harrison's son Dhani, and Jeff Lynne, who'd just played a moving "Handle Me With Care." The all-star jam followed with Kid Rock, Steve Winwood, Jackson Browne, Tom Petty, Keith Richards, Dave Mason, Jim Capaldi, and the Dells doing a singalong on "Sweet Little Rock & Roller," and climaxing in a soulful "Feelin' Alright?"

June 16, 1981

Jann S. Wenner
Editor & Publisher
ROLLING STONE MAGAZINE
745 Fifth Avenue
New York, New York 10151

Dear Jann:

In return for my consent to allow you to register the name "Rolling Stone" what do you offer as far as cover stories, special small ad rates and summer clothes coverage?

Best regards.

Sincerely,

Mick Jagger

MJ:km

Rolling Stones Records, 75 Rockefeller Plaza, N.Y., N.Y. 10019 (212) 484-6411

"AT SOME POINT MOST OF THE ARTISTS IN THIS ROOM HAVE HAD GREAT REVIEWS IN *ROLLING STONE* MAGAZINE FOR THEIR RECORDS AND MAY HAVE SOMETIMES HAD BAD REVIEWS IN *ROLLING STONE*. IF YOU HAD A BAD REVIEW, THAT CAN REALLY AFFECT YOUR SALES. BUT IF YOU GET A SCANDALOUS STORY IN *US* MAGAZINE, THAT COULD RUIN YOUR LIFE!"

—MICK JAGGER

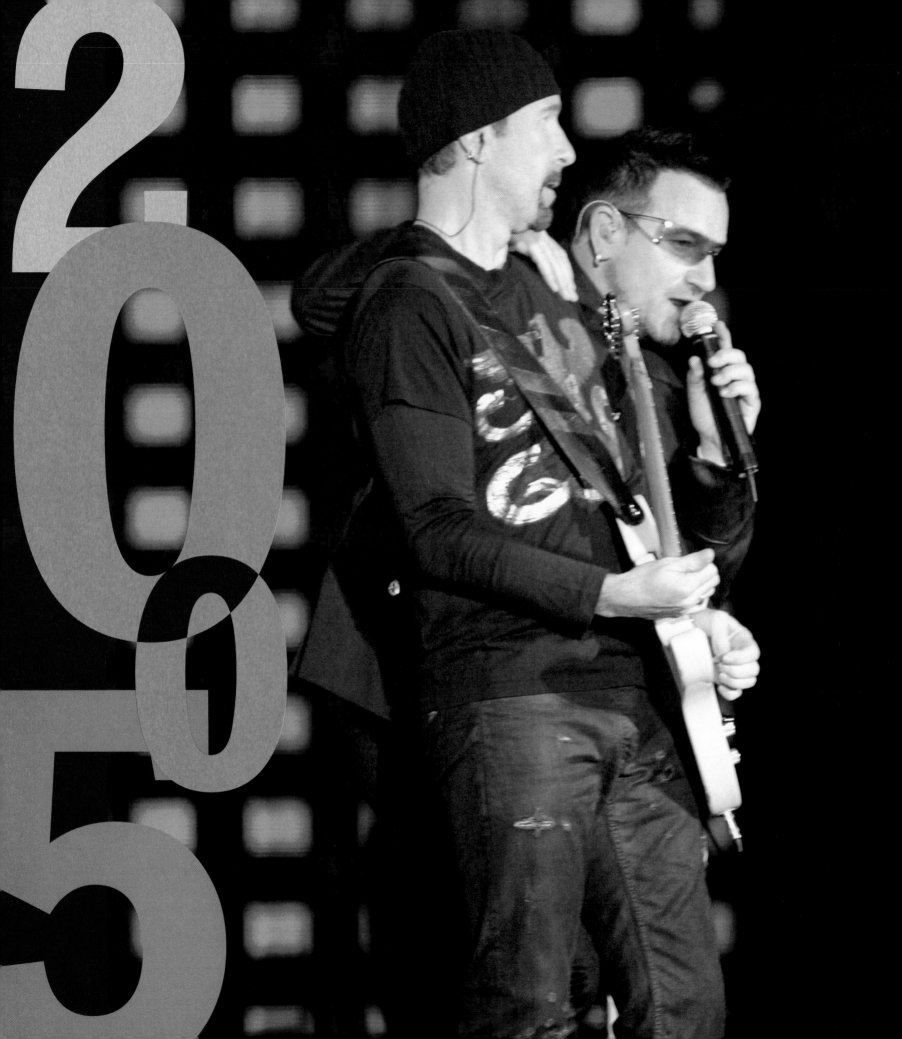

## INDUCTEES

**PERFORMERS** Buddy Guy ✦ The O'Jays ✦ The Pretenders ✦ Percy Sledge ✦ U2
**LIFETIME ACHIEVEMENT AWARD IN THE NONPERFORMER CATEGORY**
Frank Barsalona ✦ Seymour Stein

Celebrating the twentieth anniversary of the Rock and Roll Hall of Fame and the fiftieth birthday of rock & roll transformed this March 14 induction ceremony into an extra-special occasion. As Jann S. Wenner pointed out in his opening remarks, "In 1954 came the first record by Elvis Presley, followed by Chuck Berry's, Bo Diddley's, and Little Richard's first releases in 1955, the same year that Bill Haley's 'Rock Around the Clock' hit Number One. Jerry Lee Lewis released his first national record in 1956."

The night started with none other than Silvio Dante (a.k.a. Little Steven Van Zandt) taking the stage with members of his "family"—Tony Soprano (James Gandolfini) and Bobby "Bacala" Baccalieri (Steve R. Schirripa), from the hit HBO show *The Sopranos*. With a hysterical in-character performance, he inducted the pioneering booking agent Frank Barsalona. Van Zandt's other "boss," Bruce Springsteen, gave his own "payback"—an eloquent induction of U2.

Neil Young spoke about the importance of keeping a band together and commended Chrissie Hynde for not going solo. Pretenders drummer Martin Chambers thanked Hynde for "making my life really interesting." And Rod Stewart, in a very brief speech, humorously misspoke when he said that he was "humbled and honored to have the great pleasure to induct the amazing Percy Sledge into the Rock and Roll Hall of Flame—flame! What the fuck am I talking about?"

Blues guitar maestros B.B. King and Eric Clapton together inducted Buddy Guy, and Justin Timberlake did the honors for the O'Jays. As part of the golden anniversary celebration, Bo Diddley and Jerry Lee Lewis showed they were still rockin' and rollin'. Those whippersnappers U2 and the Pretenders gave it their all as well, shaking the Waldorf's rafters with some of their finest sounds. (Before U2 hit the stage, Bono warned, "We've got about thirty-five songs to play—we won't be long!")

> **"GOD MAKES MUSIC OUT OF HIS MISTAKES. I KNOW, I'M ONE OF THEM."**
> —BONO

> ## "THE REASON WE'RE ALL HERE TONIGHT IS THAT, DESPITE ALL OF THE CLICHÉS, ROCK & ROLL, WHEN IT IS GREAT, IS AMAZING. IT CHANGES YOUR LIFE; IT CHANGED OUR LIFE."
> —THE EDGE

### JANN S. WENNER:

"We're celebrating the tenth anniversary this year of the opening of the Hall of Fame in Cleveland. Some five million visitors so far, and now it's become an even deeper and richer collection of the treasures we collectively share. So on the occasion of this twentieth anniversary, it's an honor that's very personal to me, to dedicate tonight's dinner, on behalf of the Board of Directors of the Rock and Roll Hall of Fame, to Ahmet Ertegun."

### B.B. KING AND ERIC CLAPTON ON BUDDY GUY:

**B.B. King:** "They usually reserve the place for the oldest and the ugliest to speak first."

**Eric Clapton:** "Go ahead."

**King:** "Buddy Guy's been a friend for a long, long time. He's been an inspiration for many, many, many people including myself. I never was as handsome as he is. And I think Lucille liked him better. When I first met Buddy Guy, he was with what I call the Godfather of the Blues, the great Muddy Waters. But I'll say this, and then I'll move over for the handsome one. When it comes to being a great person, Buddy Guy is that. When it comes to being a great guitarist, Buddy Guy is that. The number one rock & roll guitarist today is my friend right behind me, the handsome one, and he plays blues better than me and most of the others, but I think that Buddy Guy is a very close second to him."

**Clapton:** "My first experience of Buddy Guy was when I bought a record called *Folk Festival of the Blues,* a live album recorded in Chicago in the sixties, and in the company of such great artists as Otis Spann, Muddy Waters, Howlin' Wolf, and Sonny Boy Williamson, Buddy did far more than just hold his own. With the greatest respect to all those fabulous masters, in my humble opinion, he stole the show. Coming from the back of a field like a show horse, he shone through that genius ensemble, taking no prisoners, and letting everyone know that he was the new, dangerous kid on the block. It is still one of the great debut albums by any artist in any genre, and it started me on a relentless mission to find out just who this man was, and what else he had done.

"I gradually discovered a wealth of recordings, mostly on Chess Records, and mostly singles like 'Stone Crazy,' 'My Time After a While,' and 'First Time I Met the Blues'—serious blues anthems with incredible productions, which would often feature various members of the Chess house band—great players like Little Walter and Willie Dixon. Aside from his own recordings, which became musical milestones for me, I also found him on countless other artists' records—people like Otis Rush, Muddy Waters, and Little Walter, and no matter how great the song or the performance, my ear would always find him out. He stood out in the mix, simply by virtue of the originality and vitality of his playing. And beside the music, another point for me at that time is that he was a younger blues musician, in a field totally dominated by much older guys, and on that level alone, I could identify with him completely, as well as [admire] his skills. There he was, standing alone beside the masters of his craft, holding his own and confidently pushing the blues into the twentieth century.

"Buddy personified all that a bluesman needed to be. His technique was and is unique; fueled by the Delta and the more recent contributions of Robert Lockwood and Muddy Waters, he combined these ingredients with the sophisticated phrasings of T-Bone Walker and B.B. King, and blasted them all into his own personal vision of what the blues ought to be saying right now.

"I remember in 1965, when he first came to England and played at the Marquee club, and I was finally able to see him in person. In the flesh, he was earth-shattering. His style

on every level was fantastic, doing all the things we would later come to associate with Jimi Hendrix, playing with his teeth, his feet, and behind his head—he brought the house crashing down. But beyond all that, it was his actual playing that got to me. With only a drummer and a bass player behind him, he gave a thundering performance, delivering the blues with finesse and passion in a way I'd never heard before, and incidentally started me thinking that a trio was a pretty good lineup for a band. All in all, everything about that night was deeply profound for me. The blues was clearly alive and well, and it looked good too, for as well as being the real thing musically, Buddy was a star. His suit, his hair, his moves, his sunburst Strat, everything was sharp and perfect. He was for me what Elvis probably was for most people. My course was set, and he was my pilot.

"Since those early days, Buddy has become the hardcore reality of what the blues is supposed to sound and look like—not, I think, by any calculated need on his part to be accepted—simply because that's the way it is, and that's the way he is. Buddy has been solid and a hub of the blues for more than fifty years, touring, recording, and spreading the word, and somewhere in that journey we became friends.

"Whenever I was in Chicago, I would drop by the club and play, or just hang out and shoot the breeze. Over the years we've played many, many times together, but it seems like I always forget how powerful and soulful his thing is, until he cranks it up once again, and then it all comes back to me, and I go straight back to the Marquee club, my jaw drops, and I become a helpless, ecstatic teenager all over again. For that, and for keeping it true, I thank you, Buddy Guy."

## JUSTIN TIMBERLAKE ON THE O'JAYS:

"The O'Jays' story begins back in the fifties, not in Philadelphia, but closer to the home of the Rock and Roll Hall of Fame, in Canton, Ohio. The great Eddie Levert and Walter Williams had been pals since they were six years old. These two pals blended their amazing voices on everything from gospel to doo-wop. Eventually, they met up with other singers, like the late, great William Powell, Bobby Massey, and Bill Isles. Now early on, this young vocal group was known as the Triumphs, but truthfully, their triumph took awhile to come. Eventually, they renamed themselves after Eddie O'Jay, a Cleveland DJ who was one of the first to believe in them, and so the O'Jays were born. The O'Jays would record for a few different labels in the sixties, but their love train really got rolling in 1968, when they were playing the most hallowed hall in soul history—a little place down the street called Harlem's Apollo Theatre. Two young, gifted songwriters and producers by the name of Kenny Gamble and Leon Huff just happened to be in the crowd that night. That was the beginning of a beautiful partnership that would produce some of the most exciting and enduring soul music ever made.

"The O'Jays racked up nearly thirty hits during the seventies alone. But the O'Jays' real triumph was measured not only in platinum and gold, but in the way the music made you think, made you feel, and even made you make love, all at the same time. Working with Gamble and Huff, and an outstanding group of associates, the O'Jays made stunning music that mattered. And even when they lost their friend William Powell in 1978, Eddie and Walter were joined by Sammy Strain, and kept the music and the message alive."

## NEIL YOUNG ON THE PRETENDERS:

"I'm very honored and very happy to be here, to talk about the Pretenders, who had a great influence on myself and my band, Crazy Horse. . . . This is one of the greatest rock & roll bands that ever lived. They went through all the heartache that rock & roll is built on. They lost two key members, and they never gave up, they kept going, nothing would stop them. Chrissie, she's a rock & roll woman—she's got it in her heart. She's gonna be rocking till she drops. I love her. And Martin—a great drummer that's always been there with her. Those of you who are in bands, who front bands, know what it's like to have a great drummer who's always with you, and what a great feeling that is, to have these people with you. Sometimes with these bands, we make so much out of the lead singer. In our business, we try to destroy some bands by pulling these people out, and making them something they aren't. They're really part of a rock & roll band, and I'm sure that Chrissie had a lot of people trying to make her take a step someplace else, but she never did, 'cause she's a true rocker. Playing with a great rock & roll band, she just can't get enough, and you can tell every time she walks on the stage."

## THE PRETENDERS:

**Chrissie Hynde:** "I know the Pretenders have looked like a tribute band for the last twenty years, and actually, they are a tribute band, and we're paying tribute tonight to [the late] James Honeyman-Scott and Pete Farndon, without whom we wouldn't be here. On the other hand, without us, they might have been here, but that's the way it works in rock & roll. All I really have to say about it is: two notes, *boom-boom, boom-boom*, never change, never change it. Just keep moving, but never change."

**Martin Chambers:** "Twenty-five years ago tonight, we were playing our first show in America, on the first U.S. tour, in a place called Syracuse, in the State of New York. It's called Uncle Sam's, in case you were there. We tore up the country a couple of times that year, and a couple of weeks after that, Jimmy [Honeyman-Scott] and I were in front of the converted Greyhound bus, middle of the night, exotic booze, and he looked out the window, and he said, 'We're crossing the Mississippi! Is Hank Williams on the radio?' And I went, 'Yeah, and we're from Hereford.' It was a great moment for Jim and Pete, from a little market town in England, on the Welsh border—like it is tonight."

## PERCY SLEDGE:

"Unbelievable. A little guy, born in a little town called Leighton, Alabama, way back in the year 1940. Ten years old, singing my songs in the fields, picking and chopping cotton. And my bossman told me one day, he said, 'Perce, that voice that you're using now, coming out of your throat, the whole world is gonna hear one day.' I had never in my life thought that I could go so far from that sentence coming from Mr. Beale McConnelly in Leighton, Alabama. God knows that I sung my songs so deeply from my heart, from all the love that I could give to you, and now look at me today. . . .

"I want to thank Jerry Wexler. He is the ears. He's one of the greatest men I've ever met in my life, in the history of the world, entertainment, and people. He had so much love to give to everybody, so much confidence. He could make you feel like you could reach the sky to heaven, as far as you could go; a man can can do so many great things in life, but without a great woman, he ain't getting nowhere. My lovely wife Rosa is my life, my heart, my stone, my backbone, my brain, and I ain't gonna say nothing else. But I want to say thanks to the Hall of Fame for thinking about old Perce, and not forgetting about me."

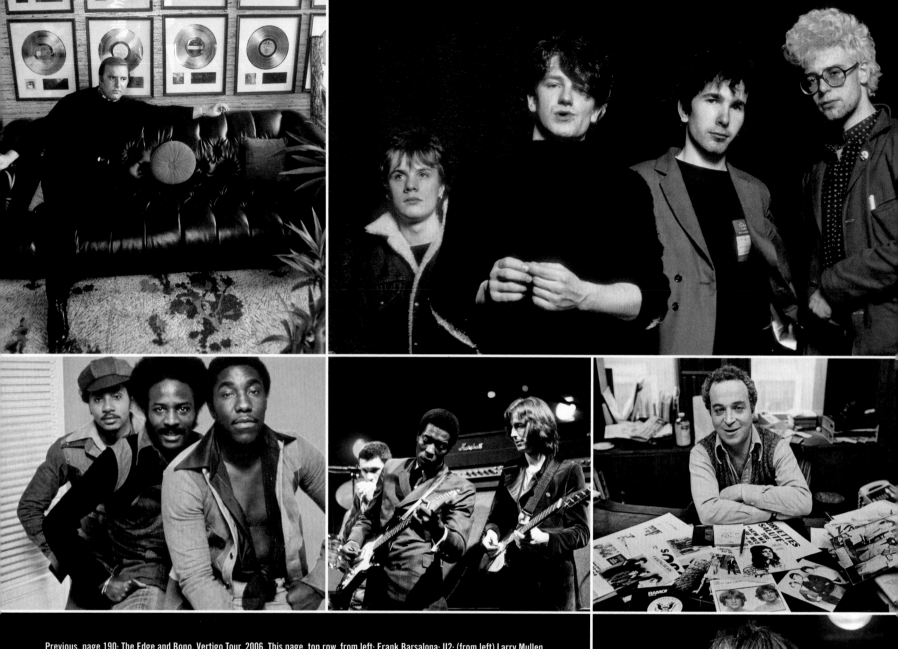

Previous, page 190: The Edge and Bono, Vertigo Tour, 2006. This page, top row, from left: Frank Barsalona; U2: (from left) Larry Mullen, Bono, the Edge, and Adam Clayton. Center row, from left: the O'Jays, 1974; Buddy Guy and Eric Clapton, 1969; Seymour Stein, c. 1977. Bottom row, from left: Percy Sledge; the Pretenders' debut album, 1980; Chrissie Hynde, 2009. Opposite: the O'Jays. Following, page 197, top: U2: (from left) the Edge, Bono, Larry Mullen, and Adam Clayton; bottom: U2 at the Super Bowl, 2002.

## BRUCE SPRINGSTEEN ON U2:

"*Uno. Dos. Tres. Quatorze*. That translates as one, two, three, fourteen. That is the correct math for a rock & roll band. For in art, and love, and rock & roll, the whole had better equal much more than the sum of its parts, or else you're just rubbing two sticks together in search of a fire. A great rock band searches for the same kind of combustible force that fueled the expansion of the universe after the big bang. You want the earth to shake and spit fire, you want the sky to split apart, and for God to pour out. It's embarrassing to want so much and expect so much from music, except sometimes it happens. The Sun sessions, *Highway 61, Sgt. Pepper's*, the Band, Robert Johnson, *Exile on Main Street, Born to Run*, oops, I meant to leave that one out. The Sex Pistols, Aretha Franklin, the Clash, James Brown, and Public Enemy—*It Takes a Nation of Millions to Hold Us Back*. This was music meant to take on not only the powers that be, but on a good day, the universe and God himself, if he was listening. It demands accountability, and U2 belongs on this list.

"It was the early eighties. I went with Pete Townshend—always one to catch the first whiff of those about to unseat us—to a club in London. There they were: a young Bono, single-handedly pioneering the Irish mullet. The Edge—what kind of name was that? Adam and Larry. I was listening to the last band of whom I would be able to name all of its members. They had an exciting show and a big, beautiful sound. They lifted the roof. We met afterward, and they were nice young men, and they were Irish. *Irish!*

"And this would play an enormous part in their success in the States, for while the English occasionally have their refined sensibilities to overcome, we Irish and Italians have no such problem. We come through the door fists and hearts first. U2, with the dark, chiming sound of heaven at their command, which of course is the sound of unrequited love and longing, their greatest theme, the search for God intact—this was a band that wanted to lay claim to not only this world, but they had their eyes on the next one too. Now, they're a real band: Each member plays a vital part, and I believe they actually practice some form of democracy. Toxic poison in a band setting. . . .

"Yet, they survive. They have harnessed the time bomb that exists at the heart of every rock band and usually explodes, as we've seen regularly from this stage. But they seem to have innately understood the primary rule of rock band job security: 'Hey, asshole, the other guy is more important than you think he is.' They are both a step forward, and direct descendents of the great bands who believed rock music could shake things up in the world, who dared to have faith in their audience, and who believed if they played their best, it would bring out the best in you. They believed in pop stardom and the Big Time. Now, this requires foolishness and a calculating mind. It also requires a deeply held faith in the work you're doing, and in its powers to transform. U2 hungered for it all and built a sound, and they wrote the songs that demanded it. They're the keepers of some of the most beautiful sonic architecture in rock & roll.

"The Edge, the Edge, the Edge, the Edge. He is a rare and true guitar original, and one of the subtlest guitar heroes of all time. He's dedicated to ensemble playing, and he subsumes his guitar ego in the group. But do not be fooled. Think Jimi Hendrix, Chuck Berry, Neil Young, Pete Townshend—guitarists who defined the sound of their band and their times. If you play like them, you sound like them. If you are playing those rhythmic two-note sustained fourths, drenched in echo, you are going to sound like the Edge, my son. Go back to the drawing board, and chances are, you won't have much luck. There are only a handful of guitar stylists who can create a world with their instrument, and he's

## "THE INFLUENCE OF THE O'JAYS CAN BE HEARD NOT ONLY IN THE MUSIC OF THE NEXT GENERATION, BUT IT CAN ALSO BE HEARD ANYTIME THAT A GROUP OF GUYS, BLACK, WHITE, YOUNG, OR OLD BLEND THEIR VOICES TOGETHER INTO SOMETHING MUCH BIGGER THAN THEMSELVES."
### —JUSTIN TIMBERLAKE

one of them. The Edge's guitar playing creates enormous space and vast landscapes. It is thrilling—a heartbreaking sound that hangs over you like the unsettled sky. In the turf it stakes out, it is inherently spiritual. It is grace, and it is a gift.

"All of this has to be held down by something. The deep sureness of Adam Clayton's bass and the elegance of Larry Mullen's drumming hold the band down while propelling it forward. It's in U2's great rhythm section that the band finds its sexuality and its dangerousness. Listen to 'Desire,' 'Mysterious Ways,' the pulse of 'With or Without You.' Together, Larry and Adam create the element that suggests the ecstatic possibilities of that other kingdom—the one below the earth and below the belt, that no great rock band can lay claim to the title without.

"Adam always strikes me as the professorial one, the sophisticated member. He creates not only the musical but the physical stability on his side of the stage. The tone and depth of his bass playing has allowed the band to move from rock to dance music and beyond. One of the first things I noticed about U2 was that underneath

the guitar and the bass, they have these very modern rhythms going on, and rather than a straight two and four, Larry often plays with a lot of syncopation, and that connects the band to a lot of modern dance textures. The drums often sounded high and tight, and he was swinging down there, and this gave the band a unique profile, and allowed their rock textures to soar above on a bed of his rhythms.

"Larry, of course, besides being an incredible drummer, bears the burden of being the band's requisite 'good-looking' member. Something we somehow overlooked in the E Street Band. We have to settle for 'charismatic.' The girls love on Larry Mullen. I have a female assistant that would like to sit on Larry's drum stool. A male one, too. We all have our crosses to bear.

"Bono—where do I begin? Jeans designer, soon-to-be World Bank operator, just plain operator, seller of the Brooklyn Bridge—oh no, he played *under* the Brooklyn Bridge, *right*. Soon to be mastermind of the Bono Burger franchise, where more than one billion stories will be told by a crazy Irishman. I realize it's a dirty job, and somebody has to do it, but don't quit your day job yet, my friend. You're pretty good at it, and a sound this big needs somebody to ride herd over it. And ride herd over it, he does.

"He has a voice bighearted and open, thoroughly decent, no matter how hard he tries, and he's a great frontman—against the odds. He is not your mom's standard skinny, ex-junkie archetype. He has the physique of a rugby player—well, an ex-rugby player. Shaman, shyster, one of the greatest and most endearingly naked messianic complexes in rock & roll. God bless you, man! It takes one to know one, of course. You see, every good Irish and Italian-Irish frontman knows that before James Brown, there was Jesus. So hold the McDonald arches on the stage set, boys. We are not ironists. We are creations of the heart, and of the earth, and of the stations of the cross. There's no getting out of it.

"He is gifted with an operatic voice and a beautiful falsetto, rare among strong rock singers. But most important, his is a voice shot through with self-doubt—that's what makes that big sound work. It is this element of Bono's talent, along with his beautiful lyric writing, that gives the often celestial music of U2 its fragility and its realness. It is the questioning, the constant questioning in Bono's voice, where the band stakes its claim to its humanity, and declares its commonality with us.

"Bono's voice often sounds like it's shouting not overtop the band, but from deep within it: 'Here we are, Lord, this mess, in your image.' He delivers all of this with great drama, and an occasional smirk that says, 'Kiss me, I'm Irish.' He's one of the great frontmen of the past twenty years. He's also one of the few musicians who's brought his personal faith and the ideals of his band into the real world, in a way that remains true to rock's earliest implications of freedom, and connection, and the possibility of something better. Now, the band's beautiful songwriting—'Pride (In the Name of Love),' 'Sunday Bloody Sunday,' 'I Still Haven't Found What I'm Looking For,' 'One,' 'Where the Streets Have No Name,' 'Beautiful Day'—reminds us of the stakes that the band always plays for. It's an incredible songbook. In their music, you hear the spirituality as home and as quest. How do you find God unless he's in your heart, in your desire, in your feet?

"I believe this is a big part of what has kept the band together all these years. You see, bands get formed by accident, but they don't survive by accident. It takes will, intent, a sense of shared purpose, and a tolerance for your friends' fallibilities, and they of yours. And that only evens the odds. U2's not only evened the odds, but they've beaten them, by continuing to do their finest work, and remaining at the top of their game and the charts

for twenty-five years. I feel a great affinity for these guys as people as well as musicians.

"Well, there I was, sitting on my couch, in my pajamas, with my eldest son. He was watching TV. I was doing one of my favorite things. I was tallying up all the money I passed up in endorsements over the years, and thinking of all the fun I could have had with it. Suddenly, I hear, '*Uno, dos, tres, quatorze.*' I look up, but instead of the silhouettes of the hippie wanna-bes bouncing around in the iPod commercial, I see my boys. *Oh my God! They've sold out!* Now, what I know about the iPod is this: It is a device that plays music. Of course, the new song sounded great, my pals were doing great, but methinks I hear the footsteps of my old tape operator Jimmy Iovine somewhere. *Wiley. Smart.*

"Now, personally, I live an insanely expensive lifestyle that my wife barely tolerates. I burn money, and that calls for huge amounts of cash flow. But, I also have a ludicrous image of myself that keeps me from truly cashing in. You can see my problem. Woe is me. So the next morning, I call Jon Landau, or as I refer to him, the American Paul McGuinness, and I say, 'Did you see that iPod thing?' And he says, 'Yes—and I hear they didn't take any money.' And I say, 'They didn't take any money?' And he says, 'No.' And I think, 'Smart. Wiley Irish guys. Anybody can do an ad and take the money. But to do the ad and *not* take the money—that's smart. That's wiley.'

"I tell Jon, I say, 'Hey, Jon, I want you to call up Bill Gates, or whoever is behind this thing, and float this: a red, white, and blue iPod, signed by Bruce "the Boss" Springsteen. And remember—no matter how much money he offers, *don't take it!*'

"At any rate, after that evening, for the next month or so, I hear emanating from my lovely fourteen-year-old son's room, day after day, down the hall, calling out in a voice that has recently dropped very low, '*Uno, dos, tres, quatorze.*' The correct math for rock & roll. Thank you, boys.

"This band has carried their faith in the great inspirational and resurrective power of rock & roll with them. They've never faltered, only a little bit. They've believed in themselves, but more importantly, they've believed in you, too."

## U2:

**Bono:** "Born in the USA, *my arse*. That man was born on the northside of Dublin. He's Irish. His mother was Irish—the poetry, the gift of the gab, I mean, isn't it obvious? In fact, I think he's tall for an Irishman.

"It's an Irish occasion this evening. Paddy Sledge, the O'Jays—they're a tribe from the west of Ireland. Chrissie Hynde—we'd like her to be Irish. The Rock and Roll Hall of Fame is a bit of an Irish wedding. Beautiful girls, beautiful frocks, fights in the bathroom, managers and clients again, lawyers with bloody noses—it's a great occasion. I even like it when it gets dirty. And I've seen it get really dirty over the years here. But rock & roll is the sound of revenge. So make your enemies interesting, I would say, ladies and gentlemen. *But not tonight.* When we look out into the audience tonight, we don't see any enemies. We just see friends. This country has taken this band into its bosom all the way from the very beginning. . . .

"Chris Blackwell—what an incredible man he was to have looking after you. I mean, can you imagine, your second album, the difficult second album—it's about God? And everyone was tearing their hair out, and Chris Blackwell was, 'You know, it's okay. It's Bob Marley, Marvin Gaye, Bob Dylan—it's kind of a tradition. We can get through this.'

"Without Premier Talent's Frank Barsalona and Barbara Skydel, and that kind of long-term vision of Chris Blackwell, there would be no U2 after that second album.

We would have been dropped. No 'Beautiful Day,' no 'Sunday Bloody Sunday,' no 'Unforgettable Fire,' no 'One,' no 'Where the Streets Have No Name,' no 'With or Without You.' And that's the thing I want to take away from tonight. I would like to ask the music business to look at itself, and ask itself some hard questions after tonight. Because there would be no U2, the way things are right now. That's a fact…

"Lots of bodyguards around here. No bigger bodyguards than Jimmy Iovine and Doug Morris, who have continued in the tradition of Chris Blackwell, which is letting us get away with pretty much everything we want. The biggest bodyguard of all—it's got to be our manager, Paul McGuinness, the reason why no one in this band has 'slave' scrawled on their face.

"I won't go on, but just three Kodak moments over twenty-five years, I'd like to share with you. One: It's 1976, Larry Mullen's kitchen; it's about the size of the drum riser he uses now. There's a big, bright-red—scarlet, really—Japanese kit, and he's sitting behind it in his kitchen, and he's playing, and the ground shakes. And the sky opens up, like Bruce was saying earlier. And it still does, but now I know why. Because Larry Mullen cannot tell a lie. And his brutal honesty is something that we need in this band.

"Second Kodak moment: I think it's 1982—New Haven, I believe. Things are not going very well. There's a punk-rock band onstage, trying to play Bach. A fight breaks out. It's between the band. It's very, very messy. Now, you look at this guitar genius, you look at this Zen-like master that is the Edge, and you hear those brittle, icy notes, and you might be forgiven for realizing that you cannot play like that unless you have a rage inside you. I had forgotten that on that particular night when he tried to break my nose. And I learned a very great lesson: Do not piss off somebody who, for a living, lives off hand-eye coordination. *Not a good idea.* Dangerous, dangerous man, the Edge!

"Third Kodak moment: 1987, somewhere in the South. We'd been campaigning for Dr. King—for his birthday to be a national holiday. In Arizona, they're saying no. We've been campaigning very, very hard for Dr. King. Some people don't like it. Some people get very annoyed. Some people want to kill the singer. Some people are taken very seriously by the FBI, and they tell the singer he shouldn't play the gig, because tonight, his life is at risk, and he must not go onstage. The singer laughs—of course we're playing the gig, of course we go onstage. I'm standing there, singing 'Pride (In the Name of Love),' and I've got to the third verse, and I close my eyes, and I know I'm excited about meeting my Maker—but maybe not tonight. I close my eyes, and when I look up, I see Adam Clayton standing in front of me, holding his bass like only Adam Clayton can hold his bass. There's people in this room who tell you they'd take a bullet for you, but Adam Clayton would've taken a bullet for me—and I guess that's what it's like to be in a truly great rock & roll band. I know Chrissie Hynde knows what I mean!"

**The Edge:** "What U2 have tried to avoid over the last twenty-five years is not being completely crap. But next on the list, down from that, was to avoid being typical, predictable, and ordinary, because it's so very hard to avoid the clichés. Everyone else's, of course—but most of all your own. It's so hard to to keep things fresh, and not to become a parody of yourself. If you've ever seen that movie *Spinal Tap,* you will know how easy it is to parody what we all do. The first time I ever saw it, I didn't laugh. I wept. I wept because I recognized so much and so many of those scenes.

"I FEEL LIKE WE'VE JUMPED THE QUEUE SOMEPLACE ALONG THE WAY. WE WOULD NEVER HAVE GOTTEN OUT OF MY KITCHEN, IN OUR TOWN, IN DUBLIN, HAD IT NOT BEEN FOR PEOPLE LIKE THE SEX PISTOLS, TOM VERLAINE AND TELEVISION, ROXY MUSIC, AND PATTI SMITH. THESE PEOPLE ARE IN OUR ROCK AND ROLL HALL OF FAME."
—LARRY MULLEN

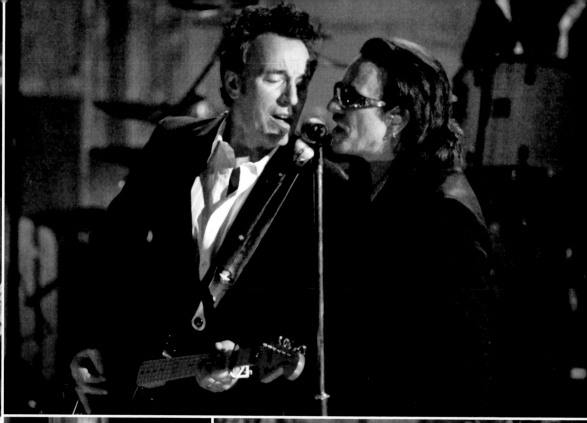

This page: Hall of Fame induction highlights, March 2005. Clockwise from top left: Buddy Guy; Bruce Springsteen and Bono; Chrissie Hynde and Neil Young; B.B. King and Buddy Guy; the O'Jays; Stevie Nicks and Chrissie Hynde.

"I used to see *Billboard* and its competitor, *Cash Box,* in those stores, and I would read them cover to cover. I was determined to get through the doors of *Billboard*'s offices at the old Palace Theater building. I wanted to learn everything I could about the music business. Thanks to the kindness of Tom Noonan, *Billboard*'s chart editor, those doors were thrown wide open.

"For the next four years, I devoured everything—filled countless notebooks with pop chart info, from hundreds of bound volumes of old *Billboard* magazines. When I was fourteen, Tom, Paul Ackerman, and Bob Rolontz took me under their wings, and I had my first job in the music business, in *Billboard*'s chart department. I even got to write an occasional live review. At fourteen, I was watching, and even partaking in, the birth and early history of rock & roll. It was unfolding before my very eyes. Paul Ackerman, *Billboard*'s legendary editor, was my first great mentor, and responsible for bringing my love and knowledge of country and blues music up to speed with that of my first love, doo-wop and rhythm & blues. Paul invited me to attend the weekly review sessions at *Billboard,* where I met my second great mentor, Syd Nathan, founder of King Records. When I was fifteen and sixteen, Syd changed my life by taking me to Cincinnati for two summer vacations, and helped educate me about running a record label.

"After I graduated from high school, I continued at *Billboard* and helped compile the Hot 100, then spent three years in Cincinnati at King, doing just about everything, including traveling on the road with James Brown and Hank Ballard. The next job was at Redbird Records, with George Goldner, my fourth mentor. These were equivalent to my college years, and my campus was the Brill Building at 1650 Broadway. During this period, and thanks to a very dear friend, Roberta Goldstein, I met Ahmet Ertegun and Jerry Wexler, my latter-day mentors. I felt unbelievably lucky at this point. I was learning from the greatest legends in the music business.

"It was at Redbird, in the Brill Building, that I met Richard Gottehrer, songwriter, producer, and partner at FGG Productions. In 1966, Richard and I formed Sire Records. Without him, there's no way I could have gotten through some of the tougher times in the sixties and seventies. Despite certain hit acts along the way, like Focus and Climax Blues Band, and Sire's 50 percent ownership of Blue Horizon Records, the English label that launched the career of Fleetwood Mac, it was not until the mid-seventies and the discovery of punk and the new-wave scene on the Bowery, that Sire really took off.

"I took up residency at CBGB's, or so it seemed, and with the Ramones, Talking Heads, Dead Boys, and Richard Hell in tow, Sire landed a new distribution deal with Mo Ostin at Warner Bros., which has been home to Sire since 1976, and is still our home after nearly thirty years. Things seemed to fall into place once Sire got to Warner Bros. Spending so much time in the U.K., it was not difficult to realize a new indie scene was growing up around me. From labels like Rough Trade, Mute, Beggar's Banquet, Fiction, 4AD, London, and later, Creation, Sire signed the Cure, the Cult, Depeche Mode, the Smiths, Erasure, Yaz, Soft Cell, Modern English, Primal Scream, Everything But the Girl, My Bloody Valentine, and on our own, through the Sire office in London, Echo and the Bunnymen, Madness, the Rezillos, and a band we honor tonight, the Pretenders.

"While Sire, in the late seventies and eighties, has been synonymous with punk and new wave and alternative indie rock, it was actually quite diverse. We added Madonna, Ice-T, k.d. lang, Barenaked Ladies, the Replacements, Tommy Page, Seal, Ministry, all to the label. The eighteen years between 1976 and 1994 were magical, and accomplished with a small staff of never more than ten, all of whom I thank for their toils and their loyalty.

"I want to thank my sister Ann, whose radio was always on in our small apartment, and gave me my first taste of pop music in the days just before rock & roll. My parents never understood me, but they never stood in the way of my goals—for that I thank them most of all. I'm proud to be a music man, and I've loved every moment of it—well, almost every moment of it. On April 18, I turn sixty-three, and that will make fifty years in the music business. But it seems like yesterday that I came home to my parents in Brooklyn with my first check from *Billboard,* and I said, 'Can you believe they pay me to do this?' Sometimes I still feel that way. While I don't look the same, I still feel the same. Rock & roll keeps me young in spirit, and my passion for music is the same as it was when I was thirteen."

## MUSICAL HIGHLIGHTS

The O'Jays cooked up a set of their best-loved songs, "Backstabbers," "For the Love of Money," and "Love Train," setting the stage for Percy Sledge's still heartbreaking ballad "When a Man Loves a Woman." Gutbucket blues were also part of the program, with inductee Buddy Guy being joined by B.B. King and Eric Clapton on "Let Me Love You Baby," after his searing solo attack on "Damn Right, I've Got the Blues." Showing his stuff, Jerry Lee Lewis kicked over his piano stool during his raucous "Whole Lot of Shakin' Going On."

The Pretenders set was briefly delayed while drummer Martin Chambers fiddled with his kit, seemingly aimed at pissing off Chrissie Hynde, who had to tell a joke while she waited to kick out the jams. But any spite only went toward fueling the band's high-octane versions of "Precious," "Message of Love," and, with Neil Young adding his licks, "My City Was Gone"—Hynde's ode to her hometown of Akron, Ohio.

U2 turned their segment of the show into an all-out love fest. Bono introduced the gorgeous "Until the End of the World" as a "little pop ditty—a conversation between Jesus and Judas," then leapt from the stage to shake hands with those VIPs seated in the front row, including Jann S. Wenner, Catherine Zeta-Jones, and Robbie Robertson. On his way back to the stage, the singer grabbed a bottle of champagne, gave it a shake—drenching those in the line of fire—and slurped down the bubbly. Segueing from "Pride (In the Name of Love)" into Springsteen's "Promised Land," Bono began a rap, "When I say that America is not just a country but an idea, I'm thinking of people like Bruce Springsteen." The Boss, guitar in hand, needed no further invitation and joined his pal at the mic for a mighty duet on "I Still Haven't Found What I'm Looking For." The mind-boggling, body-shaking set ended with a transcendent "Vertigo," leaving people weak at the knees.

## INDUCTEES

**PERFORMERS** Black Sabbath ✦ Blondie ✦ Miles Davis
Lynyrd Skynyrd ✦ Sex Pistols
**NONPERFORMERS** Herb Alpert & Jerry Moss

Though no one knew it at the time, this would be Ahmet Ertegun's last Hall of Fame induction ceremony. Looking back to this March 13 night at the Waldorf-Astoria, his opening words celebrating jazz pioneer and inductee Miles Davis seem particularly moving—since jazz was Ertegun's first love and entrée into the music business. Said Ertegun, "There was a marvelous article today in the *New York Times* about the induction of the great jazz artist Miles Davis. Among the great rock & roll artists who have been inducted here, and who are here tonight, it's important to point out that there's a gray area where jazz and rock & roll overlap. And there's also an area where rock & roll overlaps with country music, and where rock & roll overlaps with rhythm & blues, and where rock & roll overlaps with mainstream pop music, and where rock & roll overlaps with hip-hop and rap music, and that's what makes rock & roll a very, very special kind of music that envelops the styles of so many different kinds of music. It's this diversity, which is evidenced by the great diversity of artists inducted so far."

As Ertegun pointed out, inductees ranged from heavy-metal progenitors Black Sabbath to new wavers Blondie to Southern rockers Lynyrd Skynyrd to punks the Sex Pistols, who sent a nasty fax and refused to accept their induction. As Jann S. Wenner read the band's missive to the audience, the moment was reminiscent of Johnny Rotten's taunt from the San Francisco stage after the band's last gig in 1978: "Ever get the feeling you've been cheated?"

On a happier note, A&M Records founders Herb Alpert & Jerry Moss were inducted by Sting, who was originally signed to the label with his band the Police. The night ended with an emotional tribute to the Katrina-torn city of New Orleans, featuring the spectacularly garbed Wild Magnolias, along with Hall of Famers Allen Toussaint and Elvis Costello.

> ## "DON'T ACCEPT THE OLD ORDER. GET RID OF IT."
> ### —JOHNNY ROTTEN

## THE 21ST ANNUAL INDUCTION

> "OVER THE PAST TWENTY YEARS, REMARKABLE TALENT HAS BEEN HAILED ON THIS SPECIAL NIGHT— TALENT WHOSE NAMES HAVE AND WILL FOREVER DEFINE THE BROADER TERM *ROCK & ROLL.*"
> —LARS ULRICH

### AHMET ERTEGUN:

"I would like to especially thank one person—and there are so many people who have been responsible for our success—who's contributed to our annual ceremony ever since we first began: our musical director Paul Shaffer. He has been an incredible support for all those who have appeared on these many memorable occasions. Paul is a musician who understands and knows all styles of music, the history of all the performers celebrated on this stage, and is able to deliver an incredibly authentic sound to so many different types of artists. He also, among other things, can deliver a very good impersonation of me, and I wish that he had played me in a couple of recent motion pictures! I am proud to say that Paul has been a great friend to me for so many years, and I personally thank him very warmly for all he's done for the Rock and Roll Hall of Fame, as well as the splendid musicians who always accompany him."

### JANN S. WENNER:

"Tonight we begin our third decade here at the Rock and Roll Hall of Fame, and now we face new ideas, new musical trends, new audiences. To begin with, we now are honoring music from an era when rock began to mutate into new genres and forms, where variety overcame sameness. We are also evolving and trying to update our institution, to prepare for a future that's different from the past. We're strengthening our board, we're trying to bring in new talent, bring in people from beyond the record business, people from other aspects of music and music institutions, people who come from outside even that, who know how to raise funds, market, how to bring new media. We want to look to find new ideas and new people to bring us into our future. We want to keep our old-fashioned values, but we don't want to be stuck in old-fashioned ways. This year we happen to be breaking ground for the library and the archives in Cleveland, so finally the history of the music business and the history of music itself will be put on display and disseminated."

### METALLICA ON BLACK SABBATH:

**Lars Ulrich:** "Let me start out by saying that if I'm doing my math right, we are here to celebrate Black Sabbath tonight a decade or so late; but that's another conversation or another argument. I wonder how many times on this very night, and the last twenty years, that the words 'If it weren't for you, we wouldn't be here,' have been uttered. Well, here we go once more: Bill, Geezer, Ozzy, and Tony—if it weren't for you, we wouldn't be here. Obviously, if there was no Black Sabbath, there would be no Metallica, and if there was no Black Sabbath, hard rock and heavy metal as we know it today would look, sound, and be shaped very, very differently…

"It's really interesting to me how few of [those inducted into the Hall of Fame] are synonymous with a single particular subgenre of music, and as one who's fought labeling at any opportunity given, I hereby not only acknowledge, but scream from every fucking rooftop that Black Sabbath is and always will be synonymous with the term *heavy metal. Damn right!*

"Sabbath's joined what I consider a very short list of artists who can claim to be synonymous with their specific genre of music—one being Bob Marley with reggae, Bob Dylan with folk, Johnny Cash with country, perhaps Bill Haley with rockabilly. But no matter how you fuckin' slice and dice it, when you say 'heavy metal,' the words

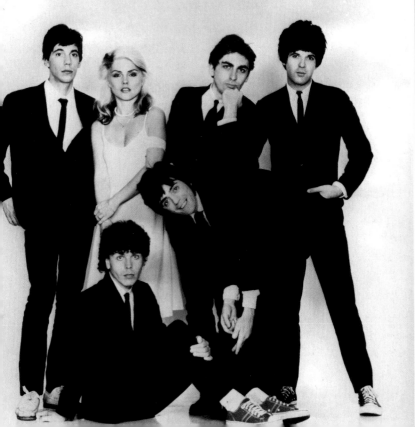

Previous, page 202: Johnny Rotten, 1978. This page, clockwise from top: Black Sabbath: (from left) Geezer Butler, Tony Iommi, Bill Ward, and Ozzy Osbourne; Blondie: (from left) Gary Valentine, Debbie Harry, and Chris Stein, 1977; (clockwise from left) Blondie's Jimmy Destri, Harry, Stein, Clem Burke, Frank Infante, and Nigel Harrison.

Black Sabbath hover in the shadows, fighting for pole position. On any given day, the heavy-metal genre might as well be subtitled 'music derivative of Black Sabbath.' Sure, we're all respectful to Blue Cheer, we're enamored with Led Zeppelin, we're in awe of Deep Purple, and of Steppenwolf and John Kay's first uttering of the words 'heavy metal,' but when it comes to defining a genre, within the world of heavy music, Sabbath stand alone.

"They took pre-existing elements of blues, rock, and soul, threw in the right amount of darkness and street cred, and fused those elements with a previously undiscovered X factor—whatever the fuck that was—creating something unheard, unexperienced, unique, and utterly groundbreaking with their huge hymns of doom. Black Sabbath are an entity of their own; in my mind, the only word that fits is *pioneer*.

"They were, and much more importantly still are, considered pioneers of all things heavy. All the metal bands, and all the so-called subgenres of metal still trace their lineage to one place: four kids in their late teens, from the black country of Birmingham, who named their band after a 1963 Italian horror movie starring Boris Karloff. Subsequently, they changed hard rock, and by doing so, the entire family tree of metal, and everything that metal—for better or worse—stands for, was, and will be forever both invigorated and elevated.

"The question, 'Are they taking the piss?' still rumbles in my mind. It's 1986, and we're fortunate enough to land the much-coveted support slot on Ozzy's Ultimate Sin Tour. We would, when given a sound check, start jamming on any number of Sabbath songs, be it 'Symptom of the Universe,' 'Fairies Wear Boots,' 'Sweetleaf,' or what have you. Apparently as the hallowed sounds of our meek attempt at Sabbath music reached into Ozzy's dressing room, his first reaction, so I was told, was, 'Are they taking the piss?' And as we were later threatened with, if indeed we were 'taking the piss,' we would be at the receiving end of—something I was unfamiliar with at the time—namely, a 'Birmingham handshake.' I wish I could only imagine the horrors. So I can now answer Ozzy's question face-to-face.

"No, Ozzy, we weren't taking the piss. We were just four snot-nosed kids on our first go-around in the big leagues, hoping that one of the key people responsible for bringing us to that sound check, to that stage, on that tour, would honor us in a moment of the planets spontaneously aligning, by joining us onstage and singing the words to the music—the very music that forever changed our lives; also the very music that is directly responsible for us being here tonight, celebrating your triumphs. And in our turn, we are honored to be the ones chosen from the thousands of bands you have spawned in your wake, to honor you, Black Sabbath, and induct you into the Rock and Roll Hall of Fame on this night, a decade late or not. And with that, Bill, Geezer, Ozzy, and Tony, I salute you with much love, respect, appreciation, and gratitude. And now, the fifth coolest person in this room."

**James Hetfield:** "That was good. You did good."

**Ulrich:** "Thank you. You should see all the bits I left on the floor."

**Hetfield:** "It's hard to keep it short. Black Sabbath is: mammoth riffs with menacing lyrics that make me oh-so-happy. That was going to be my speech—that was pretty much it, but Springsteen kind of upped the ante last year. I'll go a little deeper. Picture a nine-year-old boy, quiet and well-behaved on the outside, but on the inside, boiling and dying for life to burst open with any sort of stimulation, and the discovery of music was what was to burst it wide open. But not just any music.

> "HOPEFULLY OUR INDUCTION TONIGHT WILL ADD FURTHER VALIDATION—AS OTHER BANDS INDUCTED IN THE PAST YEARS HAVE ALREADY BEGUN TO ESTABLISH, WHICH IS THAT HARD ROCK AND HEAVY METAL MAY HAVE AN ENDURING AND EVERLASTING PLACE IN ROCK HISTORY. THAT'S WHAT WE HOPE FOR."
>
> —BILL WARD

This was more than just music: a powerful, loud, heavy sound that moved his soul. This timid nine-year-old constantly raided his roommate's/older brother's record collection, and going against his older brother's wishes, played those off-limit records on the forbidden record player. Out of all the records he could have worn out, there was no choice. The very moment he saw their earliest album cover, he knew they were going to offer him a different kind of ride. He was drawn to them like a magnet to metal. That's pretty lame. Okay, I'll try again. More like a shy boy to his own loud voice. Those monstrous riffs lived inside him and spoke the feelings he could not put into words. Sending chills of inspiration through him, from those gloomy lyrics and outlaw chords and all. They helped crack the shell he was stuck in. Also, scaring his mom and sister was an extra bonus.

"And now, as the former nine-year-old speaks to you here, as an adult musician—I know those two words really don't go together—I realize that without their defiant sound, there would be no Metallica, especially with one James Hetfield. Never have I known a more timeless and influential band. They have spread their wonderful disease through generations of musicians. They are always listed as an influence by heavy bands to this day; they are loved and highly respected as the fathers of heavy music. It truly is a dream come true and an extreme honor for me, and the nine-year-old still inside of me, to induct into the Rock and Roll Hall of Fame such a significant group of musicians. And in the words of our fearless leader, Ozzy Osbourne, '*Let's go fucking crazy!*'"

## SHIRLEY MANSON ON BLONDIE:

"Blondie put it this way once: 'Dreaming is free.' For many of us, myself included, Blondie was the dream. Yet if anyone had told me fifteen years ago, when I was unemployed and desperately frustrated in Edinburgh, Scotland, that I'd be up on a podium, in New York City, in preparation to induct Blondie into the Rock and Roll Hall of Fame, I'd have peed myself laughing, and told them to fuck right off. But here I am, and it's thanks in no small part to Blondie themselves, who've played such an important role in the realization of my own dreams.

"I don't think I'm remiss in observing that Blondie enjoyed a deep respect and heartfelt affection in the musical community that crosses all genres of music. It's no doubt that they enjoy this particular honor as a result of their fearless and freewheeling approach to making music. Touching on influences as diverse as punk and disco, to sixties girl-group trash and reggae, they fashioned a new sound, keeping one eye fixed on the past, and another focused on the future. They started over thirty years ago, here in New York City. Of all the bands that came out of CBGB, they're still here, still making records, and still having hits. They were the band that first carried the idea of punk into the U.S. charts, and they were the musical visionaries who first mixed rock with another rebellious New York City sound—hip-hop. With 'Rapture,' they introduced millions of us to a sound that was to later revolutionize the world. As fearless as ever, Debbie Harry got on the mic and rhymed about Fab Five Freddy, Grandmaster Flash, and the Man From Mars.

"As one of our most beloved musical originators of the twentieth century, sitting pretty with an astounding catalogue of classic songs under their belt, and a career that has already spanned four decades, with no imminent end in sight, Blondie will enter the Hall of Fame as one of the coolest, most glamorous, most stylish bands in the history of rock & roll. Which leads me, of course, to pause at the feet of Debbie Harry, the most beautiful girl in any room, in any city, on any planet. The girl who invented the archetype by which all other stars who have followed in their footsteps have been measured. Her influence can still be detected today in the style of every self-respecting rock & roll queen, from new bloods like Karen O., modern icons like the divine Gwen Stefani, and of course, the indomitable Madonna. Blessed with the looks of an old-school Hollywood movie star, and in possession of some golden pipes, she carefully subverted her mind-blowing beauty with her punk spirit and her gladiator heart. She combined a peerless integrity with intelligence, with a unique and cutting-edge style that was so ahead of its time, it wouldn't look out of place on MTV today. And she speaks a universal language that endears her to men and women alike, and secured her unassailable position in rock history.

"I should, of course, mention that there were a few others involved. Behind Debbie was a band dressed like the killers in *Reservoir Dogs*—a rock & roll street gang with a sound just as deadly. Chris Stein, a master conceptualist, whose guitar was the sneaky surprise in so many Blondie songs. Jimmy Destri, who could look backward and forward with the same keyboard line. And the handsome Clem Burke, who, like all great rock drummers, made the hard work of keeping a band moving sound easier than it really is.

"Of course, you know all this already, because that's why we're here. But perhaps what you don't already know is that the members of Blondie also happen to be some of the loveliest, most self-effacing people you could ever hope to meet. There's no posturing, there's no need for flash cars or flanks of bodyguards. When they turn up to play, there are no ridiculous demands, no outrageous riders, no bling, no flash, no ego. There's just coolness, and sweetness, and integrity, and grace. And that is what makes them so very precious, for they truly are a rare breed. They're great artists, but they're also great people."

## HERBIE HANCOCK ON MILES DAVIS:

"'You know how you can play some notes on your horn, and make a sound like you've never played a horn before?' Miles Davis said that to Wayne Shorter, back in the mid-sixties. What did he mean? Sounds like innocence, vulnerability—Miles? A man who had such a searing solo sound for much of his work that it would grab you by the throat and threaten to yank it away? Miles was all over that, and everything in between. Passion—Miles did that, too. The courage to consistently explore territory on the cutting edge. The courage to define in his notes his sound, what he stood for, what he believed in. Being completely in the moment—meanwhile knowing that what he wore that night would also be noticed.

"The man had style. He was primpin' and pimpin'. Miles ran the voodoo down. He was a man of mystery, magic, mystique. It was often said that he was an enigma. I would venture to say that many who said that just didn't get it. He was accused of turning his back on his audience, showing disdain for the people, that he was a racist that hated white people. How shallow are the viewpoints of some? Miles didn't turn his back. He faced the band, like any conductor. Simply because he wanted to present the best music that he could. He cared about people that much.

"He cared for the band members, too. One time, when I had the flu, on tour with him, he called my room five times a day to see how I was doing. The compassion

The
ENVIRON
MENTAL
ISTS

**ROLLING STON**

ROBBIE
ROBERTSON

MILES
DAVIS

Next to the SEX - PISTOLS
rock and roll. and that hall of fame
is a piss stain. Your museum. Urine
in wine. Were not coming. Were
not your monkey and so what? Fame
at $25,000 if we paid for a table,
or $15000 to squeak up in the gallery,
goes to a non-profit organisation
selling us a load of old famous.
Congradulations. If you voted for us,
hope you noted your reasons. Your
anonymous as judges, but your still music
industry people. Were not coming.
Your not paying attention. Outside
the shit-stem. is a real SEX

PISTOL

Previous, page 206: Ozzy
Osbourne, 2000. This page,
clockwise from top left: Miles
Davis, 1986; the Sex Pistols,
1977, Miles Davis's *Rolling Stone*
cover, 1969; the Pistols' fax to
the Rock and Roll Hall of Fame;
Lynyrd Skynyrd, 1976; Black
Sabbath, 1970; Herb Alpert and
Jerry Moss.

was there, and it came out in his music. A racist? Who was he closest to? Gil Evans, a gifted white collaborator. Miles always called Gil Evans to get a second opinion about things. They were like spiritual brothers. His bands were often mixed with all races and ethnicities, 'cause Miles was open. He listened to everything—classical music, flamenco, rock, all kinds of folk music. These were like the spices on his palate that gave his approaches to music so much variety. . . .

"He played the meanest blues that you could ever want to hear. Blues that would knock your socks off—that would get right to your bones. And man, could he groove. Sometimes, his phrases just got inside your bones. And he didn't have to play a lot of notes, either. One time in Spain, I had a day off from working with my band, and it was the night that Miles was playing a concert. Doing Cyndi Lauper's 'Time After Time,' he played the tag at the end of the song over and over and over again, with short phrases that were so inventive, so arresting, so masterful, that I couldn't contain myself. I started laughing and crying real tears, because it was so fresh and beautiful. I found out later that he had a fever that night. Miles once said to me, 'You only need to play one note: the right one.'"

---

# "LYNYRD SKYNYRD WERE WHAT A LOT OF THE OTHER GUYS IN BRITAIN WHO ABSORBED THIS BLUES MUSIC SO WELL WANTED TO BE—THEY WANTED TO BE POOR WHITE BOYS FROM THE SOUTH THAT KNEW HOW TO PICK AND PLAY LIKE THAT."

### —KID ROCK

---

### KID ROCK ON LYNYRD SKYNYRD:

"Let me just say that Lynyrd Skynyrd simply is the shit, to me, period. Ronnie Van Zant was the truth to me; he was a true Southern poet. He was the simple man that he sang about. Lynyrd Skynyrd is Ronnie Van Zant's house, but man, it was built by a lot of hands—great hands. I'm talking about the west side of Jacksonville, Florida, not rich people, the wrong side of town. . . .

"One of the most amazing things that I've learned about Ronnie is that he never wrote his lyrics down, including the national anthem of the South, 'Free Bird' and 'Sweet Home Alabama,' the greatest song ever written, pound for pound. . . .

"The three-guitar army—three-part harmonies on guitar. Those that they've influenced—not only myself, but people like Hank Williams Jr., Charlie Daniels, Gretchen Wilson, Metallica. And the way the tradition is carried on today, with his younger brother, Johnny, who's out there singing those songs every night now. That's pretty incredible to me. 'Cause the hardest thing to do, I imagine, in life, is to stand in the shadows of somebody very famous, to try to fill those shoes, and I think he's done it with class and diginity, and I'm sure his brother would be very happy that they're carrying on.

"There's been over twenty-five members in this fucking band. They have more members than the frickin' YMCA. I love it to death, I live by it, and I think of one of Ronnie's greatest lyrics, 'If I leave here tomorrow, would you still remember me?' We do remember."

### JANN S. WENNER READS A FAX FROM THE SEX PISTOLS:

"As I'm sure many have heard, the Sex Pistols declined to join us tonight. But they did send us this letter, and I thought I'd read it to you. This is a fax to the Rock and Roll Hall of Fame.

"'Next to the Sex Pistols, rock and roll and that Hall of Fame is a piss stain. Your museum. Urine in wine. We are not coming. We're not your monkeys, and so what? Fame at twenty-five thousand dollars if we paid for a table, or fifteen thousand dollars to squeak up in the gallery, goes to a nonprofit organization selling us a load of any old famous. Congratulations [sic]. If you voted for us, hope you noted your reasons. You're anonymous as judges, but you're still music industry people. We are not coming. You're not paying attention. Outside, the shit-storm is a real Sex Pistol.'

"So, for Johnny Rotten and the rest of them, these [*indicates awards*] will be in Cleveland at the Hall of Fame, should they come and want them, they can have them, or come and smash them to bits, they can do that too. Welcome to the Hall of Fame, Sex Pistols."

### STING ON HERB ALPERT & JERRY MOSS:

"The music business is full of famous partnerships: Lennon and McCartney, Leiber and Stoller, and Goffin and King—songwriters in the main, who shared the workload and the credits of some of the greatest songs of the twentieth century. The partnership we are honoring tonight is not a songwriting partnership, but what they forged together is as enduring and influential as any of those songs in the history of music. Herb Alpert and Jerry Moss created A&M Records in 1962. A Los Angeles musician and a New York promotion man, having each invested a hundred dollars—I'll say that again, they each invested a hundred dollars. They started out distributing records from a garage in Hollywood and ended up with the largest and most successful independent record company in the world.

"The label first began distributing the first Tijuana Brass hit 'Lonely Bull,' and then within a few years, boasted artists as various as the Carpenters, Joe Cocker, Cat Stevens, Peter Frampton, the Sex Pistols—for a riotous nine days—and the Police. In 1966 the company moved to Charlie Chaplin's film lot at 1416 North LaBrea Avenue, and it was there that I first met them, in October of 1978.

"I'd never been to California before; I'd never seen a palm tree or the sun in winter. I was very excited to meet Mr. A. and Mr. M. I wasn't disappointed, nor was my girlfriend Trudie, who, I remember, went weak at the knees when she met the debonair Mr. Alpert. He is, and he was then, impossibly handsome, unusually talented, and rich. Mr. M. wasn't bad-looking either. I realized I was going to have to compete and survive in this highly rarified atmosphere of success, wealth, artistic excellence, and not to mention sex appeal.

"Despite my initial fears, I have never, to this day, met two finer gentlemen. Elegant, urbane, sophisticated, intelligent, and most of all, sensitive to the needs of fellow artists to such an extent that they became celebrated, not just for their

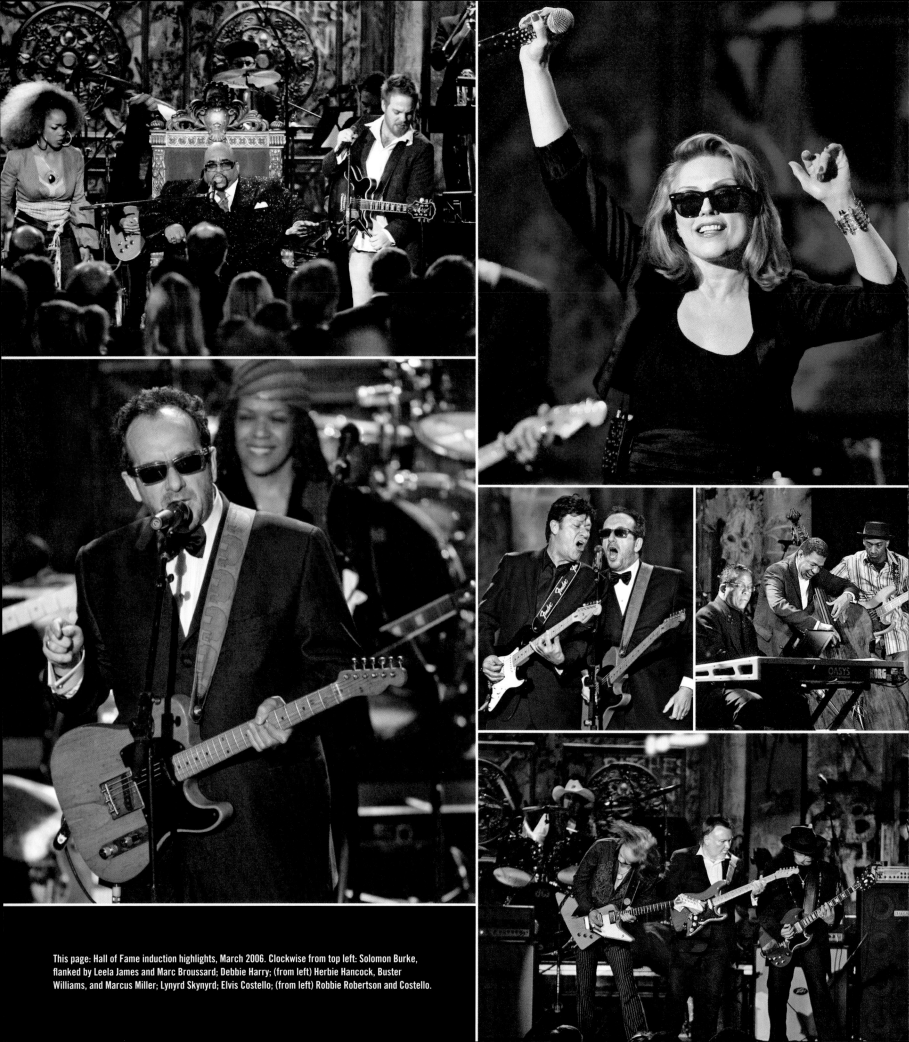

This page: Hall of Fame induction highlights, March 2006. Clockwise from top left: Solomon Burke, flanked by Leela James and Marc Broussard; Debbie Harry; (from left) Herbie Hancock, Buster Williams, and Marcus Miller; Lynyrd Skynyrd; Elvis Costello; (from left) Robbie Robertson and Costello.

success, but the nurturing and encouragement of new talent with a patience and care that was unusual then, and even rarer now. The fact is, as artists on A&M, we all felt that we were family, unafraid to express our individuality, given license to be unique, to experiment, to grow, and then to succeed. We all of us owe an enormous debt to Mr. A. and Mr. M. for creating that unique and generous climate that led in turn to the creation of such wonderful, innovative, and enormously successful music."

## HERB ALPERT:

"I haven't seen this many people since I played Bar Mitzvahs years ago! This acknowledgment is certainly due to the great artists that we've had at A&M, and the tremendous staff that was with us all the way. Sting really typifies the type of artist that we were always looking for at A&M: innovative, smart, musical, dedicated, passionate. And he's one heck of a musician.

"Prior to A&M Records, I was recording as a vocalist for a major record company, and I learned, at that time, what *not* to do. I was in the studio, I was '38257, take one.' I go into the control room, after we did a take. I'm listening to the take, which wasn't bad; I felt it just needed a little bit more bass. So I reached over to the board and lifted the bass up, you know; the engineer slapped my hand and said, 'Don't you ever touch that board again. This is a union house, and I could, blah blah blah blah blah.' And I thought, 'My goodness, shouldn't the music industry revolve around the artist?' So that's when the *aha* hit me: If I ever had a chance to have my own company, that would be one of the priorities.

"Truthfully, this night would not have been possible had it not been for my partner, Jerry Moss. His honesty, his integrity, his way of doing business with people, his way of talking to people—he's just a wonderful human being, and I'm so lucky and blessed to have found Jerry. We started in 1962 on a handshake, and we ended up hugging each other, and it's been a beautiful ride."

## MUSICAL HIGHLIGHTS

The late Wilson Pickett's music was celebrated early in the program by the formidable Solomon Burke, while Herbie Hancock and his band honored the legendary Miles Davis. Debbie Harry, Chris Stein, and Clem Burke, with new Blondie members, played charged versions of "Heart of Glass," "Rapture," and "Call Me." Former Blondie members Frank Infante, Gary Valentine, Nigel Harrison, and Jimmy Destri were in attendance, but were left out of the performance. From new wave to heavy metal, the musical diversity was astounding, punctuated by Metallica's attack on "Hole in the Sky" and "Iron Man," as they stood in for Black Sabbath, who begged off playing.

From metal, the sonics turned to Southern rock, for the reassembled Lynyrd Skynyrd's two greatest songs, "Sweet Home Alabama" and an emotive "Free Bird," on which they were joined by Kid Rock.

Finally the moving performance of "Who's Gonna Help Brother Get Further" by Elvis Costello and Allen Toussaint segued into the joyous Big Easy anthem of "Walkin' to New Orleans," with Big Chief Bo Dollis and his Wild Magnolias decked out in their Mardi Gras Indian headdresses and festive beaded costumes.

## BLONDIE'S (MUSICAL) AMBITIONS

◆ ◆ ◆

From their beginnings in the mid-seventies, Blondie explored a grab bag of pop-culture sounds and styles, from girl groups and garage bands to punk and B-horror movie motifs. Their style would expand and evolve to include disco, reggae, and rap—way ahead of the curve. Here's a smorgasbord of Blondie delights, exemplifying their sonic explorations:

◆ ◆ ◆

### PUNK
**"X-OFFENDER,"** n/a, 1976
**"IN THE FLESH,"** n/a, 1976
**"RIP HER TO SHREDS,"** n/a, 1976

### NEW WAVE
**"DENIS,"** Number Two, U.K., 1978
**"(I'M ALWAYS TOUCHED BY YOUR) PRESENCE, DEAR,"** Number Ten, U.K., 1978

### GARAGE
**"PICTURE THIS,"** Number Twelve, U.K., 1978
**"HANGING ON THE TELEPHONE,"** Number Five, U.K., 1978

### POP
**"SUNDAY GIRL,"** Number One, U.K., 1979
**"DREAMING,"** Number Two, U.K. and Number Twenty-Seven, U.S., 1979

### DANCE POP
**"CALL ME,"** Number One, U.S. and Number One, U.K., 1980

### DISCO
**"HEART OF GLASS,"** Number One, U.S. and Number One, U.K., 1979

### REGGAE
**"THE TIDE IS HIGH,"** Number One, U.S. and Number One, U.K., 1980

### HIP-HOP
**"RAPTURE,"** Number One, U.S. and Number Five, U.K., 1981

## INDUCTEES

**PERFORMERS** Grandmaster Flash and the Furious Five ✦ R.E.M. ✦ The Ronettes
Patti Smith ✦ Van Halen

Perhaps one of the most emotionally wrenching induction ceremonies occurred on March 12 at the Waldorf-Astoria. Ahmet Ertegun had passed away in December 2006, and an emotional Jann S. Wenner spoke eloquently about his colleague; Aretha Franklin's magnificent voice helped ease the pain, as she sang "I Never Loved a Man the Way I Love You," the perfect eulogy for her champion at Atlantic Records. The late James Brown's life was also celebrated, with a rousing speech by the Reverend Al Sharpton.

For the first time, the induction was broadcast live on AOL. com and VH1 classic. The nearly annual dysfunctional band drama unfolded again, this year with Van Halen; one minute the original lineup had reunited, then bassist Michael Anthony was out; followed by the sudden rehab sojourn by Eddie Van Halen, with David Lee Roth planning to front Velvet Revolver, which fell apart when Roth and the band members couldn't agree on which songs to include in the set. Rumors flew back and forth prior to the ceremony about who would or would not attend, and finally Anthony and Sammy Hagar were the sole members to arrive.

Old friendships abounded, particularly among Patti Smith, Ronnie Spector of the Ronettes, and Michael Stipe of R.E.M., all of whom had rallied around one another over the years. There was also a sense of celebration in the first-ever induction of a hip-hop act, Grandmaster Flash and the Furious Five, who showed solidarity in their status as "old-school" rappers, the music's pioneers. In a speech much shorter than the one he gave for the Ramones (a fact he acknowledged), Eddie Vedder inducted R.E.M. with grace and humor. And, finally, stalwart Keith Richards showed up to everyone's relief, since he'd recently suffered a severe head injury after falling out of a tree: "Giant strides have been made in medical science lately," he announced glibly, "and this is why I'm able to be able to say to you, once again, 'Good evening ladies and gentlemen, welcome to the Rock and Roll Hall of Fame.'"

> ## "THERE ARE THINGS I FEEL DEEPLY ABOUT INSIDE THAT MICHAEL STIPE PUT IN THERE HIMSELF."
>
> —EDDIE VEDDER

## THE 22ND ANNUAL INDUCTION

# HOMAGE TO THE GODFATHER OF SOUL

### ◆ ◆ ◆

## A TRIBUTE TO JAMES BROWN BY REV. AL SHARPTON

"On Christmas night, the world lost a truly great, innovative, and musical genius. I met James Brown when I was sixteen. His son and I were very close. When his son was killed, James Brown became the father I—coming out of a Brooklyn project with no father—never had.

"As I rode with his body to the Apollo Theatre for the first funeral that we would have, I thought on that long ride about one of his proudest nights was when he was inducted here at the Rock and Roll Hall of Fame. He was proud because many people that are trendsetters and innovators never get their due until long after they're gone. He would want me to say tonight that long before the Kennedy Center and long before others gave him honor, this Hall of Fame made the world respect and regard the contributions of a poor shoeshine boy from Georgia that changed the beat of music from a 2-4 to a 1-3 and made a half-beat something that the whole music world is now built on.

"There are those that are transitional stars—they make hits—but then there are those that are transformational artists. They change music, they change the whole genre that we've come to know and respect. James Brown was a transforming agent. I remember that night when we came in 1986 for his induction. They asked some of the same questions the media asked tonight [about Grandmaster Flash]. 'Why is James Brown getting inducted?' Like they asked 'why is hip-hop getting inducted?' But real rock & roll is about self-expression and self-definition. You can't limit who's going to rock and you can't limit who's going to roll. When James Brown fought his way back in the eighties, it was rock & roll clubs like the Lone Star Cafe that gave him a stage when others wouldn't give it to him. He built his way back in rock & roll clubs. That's why it meant so much to him to be inducted. James Brown had the nerve, the guts, the will power, and the self-definition; he opened the door to a new world of music that has changed the world."

## JANN S. WENNER:

"It did not seem so long ago when it began, but this is the first time we will have this dinner without the man who founded the Rock and Roll Hall of Fame, Ahmet Ertegun. Now it seems as if the years have passed too quickly. Tonight we'll pay tribute to Ahmet and also to James Brown, who are two men who are so responsible for everything here. Ahmet was the greatest record man who ever lived. He signed the greatest rhythm & blues, jazz, pop, and rock artists of all time. He guided their careers and their education, and their recordings, and he built Atlantic Records into the historic label that was the home of all those treasures. His knowledge and involvement span seventy years of American music, and he loved it all, and he brought it into our lives.

"I knew Ahmet in his world of international travel and in New York nightlife. I traveled across oceans with him. I stayed at his homes. I met his friends. I earned the blessings of his very special and talented wife, Mica. And I became part of his family. Ahmet was always turned out with a precisely trimmed goatee, never a wrinkle in his clothes. The glee, as he would tell a story based on some prank for the twentieth time, was irresistible. He could outlast anyone at the bar or any other place you would care to name. He had very little interest in sleep. He was one of those people who knew exactly what the right thing to do was at all times, and he dazzled.

"In 1983, Ahmet asked me to help him start the Rock and Roll Hall of Fame, which was then a vague idea which had been tacked onto a television show proposal. No one was really sure what a museum about rock & roll should be. We had long discussions about the nature of art and music and business, during which I was able to soak up Ahmet's wisdom, his learning, and his feel for the historic nature of what we were doing. It was Ahmet's sensibility and his sense about what was right which guided all of our decisions in doing this. To work as his right-hand man on the Hall of Fame, and to watch him in action as he brought all the personalities and elements together was where I really saw what a great man he was. I learned how important elegance is—elegance of thinking, of character, and personal style.

"I learned above all, that he held the artists in the highest regards, and that was the essence of the Hall of Fame and the essence of what made Atlantic such an historic institution. It was that, and his love of music and his integrity; it was a lifetime of laughter, a grace in learning that came with the pleasure of his company. To live a life so filled with music, to have been so deeply a part of it, and to contribute so greatly to it, to have always been insistent on doing the right thing, and to have lived so fully and to have so much fun—how lucky we have been to have had such a man, and how lucky for me to have had such a friend. I dedicate this evening to the memory of Ahmet Ertegun."

## STEPHEN STILLS ON AHMET ERTEGUN:

"I remember a night at Sunset Sound with Neil [Young] and Richie [Furay], and we were trying to record a song; basically it was down to a Mutt and Jeff version of 'My Cousin Vinny.' Anyway, this personage comes gliding into the control room, dressed in a Savile Row suit, but looking very much like the sultan that he was. After we played for a while and he heard one of the fellows producing us say, 'Could you play it faster? It's too long'—that's the first time I ever saw Ahmet look askance at anyone. I came into the studio and he was actually sitting there on a real magic carpet.

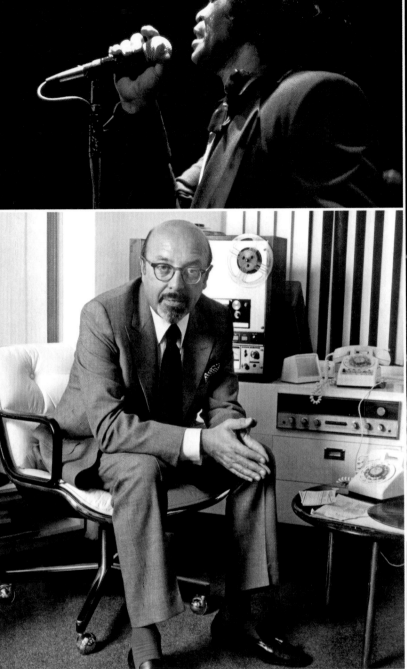

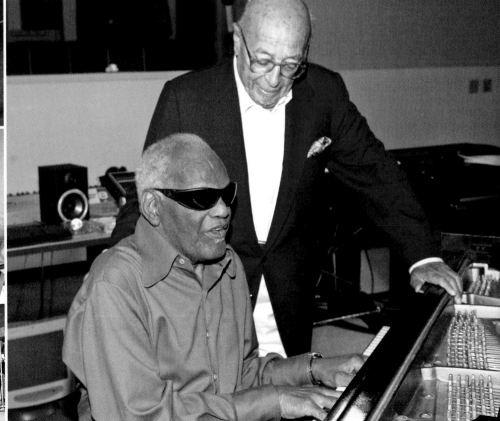

Previous, page 212: Michael Stipe.
This page, clockwise from top left:
James Brown, c. 1972; Brown,
c. 1960; Ray Charles and Ahmet
Ertegun, 2003; Brown, c. 1969;
Ahmet Ertegun.

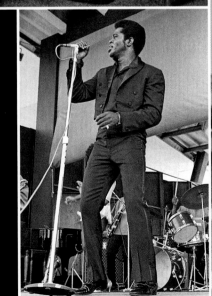

Clockwise from top left: R.E.M.: (from left) Peter Buck, Mike Mills, Bill Berry, and Michael Stipe, 1986; David Lee Roth, 1980; Grandmaster Flash and the Furious Five, 1988; Ronettes single, 1964; the Ronettes; Van Halen: (from left) Michael Anthony, Eddie Van Halen, Roth, and Alex Van Halen, 1981.

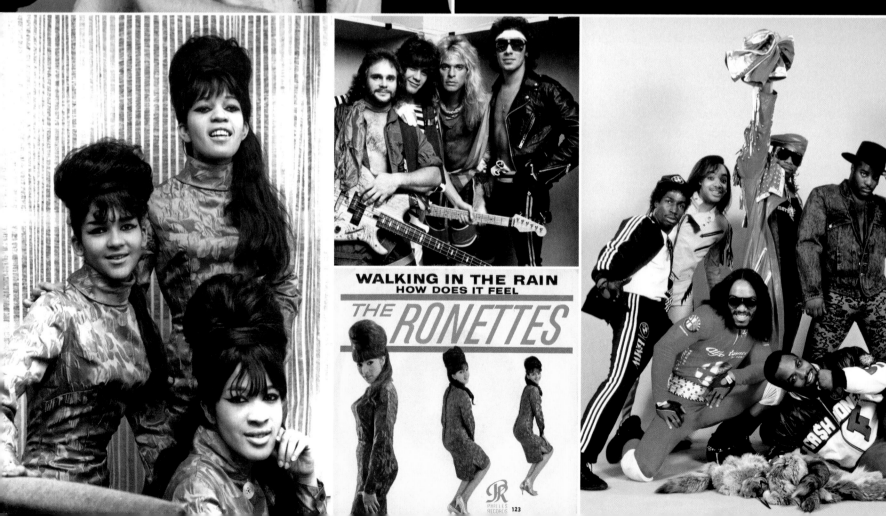

WALKING IN THE RAIN
HOW DOES IT FEEL

THE RONETTES

And he said, 'Come here, let's go for a ride.' Now, these many years later, I just want to thank him for what a fabulous ride it has been, and what a fabulous ride he gave us all."

## JAY-Z ON GRANDMASTER FLASH AND THE FURIOUS FIVE:

"Thirty years ago the shot heard around the world was fired out of the South Bronx that would change our musical and cultural landscape forever. The sting was called hip-hop. We credit three bold pioneers for its creation, DJ Kool Herc, Afrika Bambaataa, and the man we celebrate here tonight as hip-hop's first inductee into the Rock and Roll Hall of Fame: Grandmaster Flash. What Les Paul and Chuck Berry did for the electric guitar, Flash did for the turntable. He was not only creating the technique of seamlessly looping the breaks on the record—for those of you who don't know, that's called cutting—he did so with style and flair no one had ever seen before or since. From rocking parties at the South Bronx's legendary Black Dog, to the release of hip-hop classics like 'The Message,' Grandmaster Flash and his crew were trailblazing in the Furious Five: Cowboy, Melle Mel, Kid Creole, Rahiem, and Scorpio became hip-hop's first supergroup pioneers and the legends for a musical genre that would become a cultural revolution.

"Thirty years later, rappers have become rock stars, movie stars, leaders, educators, philanthropists. None of this would be possible without the work of the men I have the honor to induct into the Rock and Roll Hall of Fame tonight. Ladies and gentlemen, you're witnessing history: Grandmaster Flash and the Furious Five."

## GRANDMASTER FLASH AND THE FURIOUS FIVE:

**Melle Mel:** "I'd like to say to all of the industry people out there that have control of what we call hip-hop, I'd like for people to put more of an effort to make hip-hop the culture of music that it was—instead of the culture of violence that it is right now. There's a lot of people like the breakdancers that put in a lot of time. I've been into hip-hop, and I ain't never shot nobody, I ain't never stabbed nobody. I'm forty-five years old, and I ain't got no criminal record. Why aren't we teaching people about trying to grow up and come up out of the ghetto? Hip-hop need to grow up."

## EDDIE VEDDER ON R.E.M.:

"R.E.M.'s music is truly all encompassing. They have used every color in the palette and they've invented colors of their own and they've painted this huge mural of music, sound, and emotion that's as big as buildings . . . Peter Buck and Michael Stipe first [met] in a record store in Athens, Georgia, where Peter was working, and their first conversation was about Patti Smith's first four records . . . Bill Berry and Mike Mills got to know each other in high school and were playing in a band together; they all met when they were going to college in Athens, Georgia, and twenty-seven years later are being inducted into the Rock and Roll Hall of Fame.

"How do you explain the dialogue between Michael and the listener? . . . Such wisdom in the feelings of these songs that have helped us find things that we knew were inside us and things we didn't know we had inside us. There are things I feel deeply about inside here that Michael Stipe put in there himself. What's really incredible about this is that this all happens without being able to understand a fuckin' thing he's saying! . . . It's so open to interpretation. It's beautiful with intent

and passion and Michael's incredible set of pipes. . . . He's a true poet. He can be direct, he can be completely abstract, he can hit an emotion with pinpoint accuracy or he can be completely oblique, and it all resonates. There's so much to Michael . . .

"Peter Buck plays guitar like a guy who worked in a record store . . . it's not necessarily derivative of all this music that he knows so well, but he plays through the holes and invents things, and hits spots that have not yet been covered thereby pushing the progression of rock & roll. From a record store in Athens to the Rock and Roll Hall of Fame is a tremendous journey."

## KEITH RICHARDS ON THE RONETTES:

"I'll take you back to a dark, dank little theater in northern England, in 1964. I climbed out of our little cubicle and I'm walking down that corridor and it's green and it smells, and it's damp and it's dark. As I get to the stairwell, I suddenly hear these voices, this beautiful little chant sent up from Nedra and Estelle. I realize I'm listening to the Ronettes and then that pure, pure voice over the top singing 'Be My Baby.' I got a command performance all to myself, and I realized despite Jack Nitzsche's beautiful arrangements, that they could sing all their way right through a wall of sound. They didn't need anything. They touched my heart right there and then, and they touch it still."

## THE RONETTES:

**Ronnie Spector:** "We grew up a hundred blocks north of here, in Spanish Harlem. All my life, all I ever wanted to do was sing rock & roll. Now, to be honored this way, it feels like [sings] 'this is the way I always dreamed it would be.' I never thought for a minute that I would be in the Waldorf being recognized for what I love to do—sing and perform. From amateur night at the Apollo Theatre to dancing on the rails at the Peppermint Lounge and singing with Joey Dee and the Starliters, the early sixties were as great as they looked.

"Thanks to Stu Phillips, our first producer, and I want to thank my sister Estelle and cousin Nedra for being there at the beginning, Cher for being my girlfriend in the sixties, and taking me around to all the cool places to shop in L.A., and Jack Nitzsche, who arranged all of our hits. Murray the K, the Brooklyn Fox before we had any hit records. My mom, who toured with us, my dad who took me to baseball games. Ellie Greenwich and Jeff Barry, Barry Mann and Cynthia Weil, thanks for the great material. George Harrison, who produced my first solo recordings on Apple Records. Then, when I came back in the early seventies, all the people who tried to be there for me: my dear friend John Lennon, who introduced me to Jimmy Iovine, who got me involved with Springsteen and the E Street Band. Springsteen, Southside Johnny, and Miami Steve—I love you guys. And Eddie Money: [sings] 'Take me home tonight, I don't want to let you go till you see the light.' And my friend and producer Joey Ramone. I love you, Joey. I also want to thank Patti Smith for contributing to my new CD and being so supportive. Thanks to Frankie Lymon, my idol, for the inspiration.

"For three years, from 1963 to 1966, we had the best times getting ready to go onstage: our dresses slit up the sides, our beehives up to here with Aqua Net hairspray so it would stay up, the excitement from the crowd. When we would walk onstage, a riot broke out, or boys were rolling around on the floor having orgasms. When we performed live, I always said we weren't better, we were just different.

"Keith Richards, whenever I see you, it feels like it's 1964 and we're traveling through the fog together in the U.K. Like you said to me, 'Ronnie, they never thought we'd live to see this.' I guess we fooled them! I recorded a song in the seventies with the line 'so many faces in and out of my life, some will last, some will just be now and then.' So true. My last and biggest thanks goes to my partner for the last twenty-eight years, through the ups and downs, he never left my side: Jonathan Greenfield. And to all my fans, thanks for remembering. It's been a long journey getting here, but now that I am here, let's rock!"

**Nedra Talley:** I would like to thank each and every one of you for being a part of a dream of three young girls . . . fifteen, seventeen, eighteen . . . those years in New York City, which is a very big city. We were born and raised here. We had a dream, but with dreams you need to have people behind you. For us, my mom knocked on doors when people didn't want to hire us and sign a contract for three young pretty girls who could change their minds down the road. Show business is a thing that can be great, but it can be bad, too. We had a family that gave us a core that helped stabilize us in a very difficult, crazy world. It was a fun time. I thank God that I'm here tonight and that we, as the Ronettes, are being acknowledged for what we gave, but I didn't have any idea what we were giving. I was very, very young and I didn't know that we were setting styles for girls. I thank every fan that kept us in their hearts and in their minds for all these years. Thank you for playing the music to your children and to your children's children."

## ZACK DE LA ROCHA ON PATTI SMITH:

"I read an article recently where some critic identified the very moment that the cultural revolution died—if you can believe that. According to the stats, the spirit passed in 1969 when violence broke out at a free Rolling Stones concert at the Altamont Speedway. How such a ridiculous conclusion could be drawn escapes me, when you consider that the seventies would produce some of the most revolutionary art that the world had ever seen. If there was even a grain of truth to what this guy had to say, somebody forgot to tell Patti Smith—one of the sparks that set the punk prairie fire and left south Jersey for the Lower Eastside of Manhattan.

"In 1975, with Lenny Kaye, Ivan Kral, Richard Sohl, and Jay Dee Daugherty, Patti Smith released *Horses*. The opening to 'Gloria' might be one of the greatest moments in American music. The shadow line and the space within it speaks to us like a dark gospel, and then you hear that voice, and you think 'nothing can be this haunting and nothing can be this healing at the same time.' Then the words 'Jesus died for someone's sins but not mine'—delivered like someone who'd left the church that was repressive America and burned it to the ground. The body of the song becomes a celebration of the outsider. It possesses a chaos that only Patti can summon and only she can control. She sings, screams, howls, chants—so attuned to the moment that anticipating the next one is an impossibility. The breath between her words is as powerful as the words themselves, and by the end of the song, a couple of things remain apparent. Punk seeds have been planted, the culture will be changed forever and it would be hard for me to ever listen to Van Morrison [whose band Them did the original "Gloria"] again.

"In 1976 Patti released *Radio Ethiopia*. Songs were a little more refined, but still daring and still carrying that outsider's dignity. In 1978 she released *Easter*, and

"THE SIGNIFICANCE OF THE SONG WAS TO TAKE A WORD [NIGGER] THAT HAD BEEN USED IN A DEROGATORY FASHION AND REDEFINE IT AS A WORD FOR THE ARTIST AND THE OUTSIDER. MY IDEA AT THAT TIME WAS THAT IN RE-DEFINING IT, IT WOULD NO LONGER BE A DEROGATORY WORD IN TERMS OF ANYONE'S RACE OR PERSUASION, BUT BE A WORD OF HONOR FOR THE OUTSIDE ARTIST. AND THAT'S WHY I SAY INSIDE THE SONG, 'GANDHI WAS A NIGGER, JESUS CHRIST AND MY MOTHER, TOO.' THEY ARE THREE OF MY FAVORITE PEOPLE, SO THAT'S THE IDEA, WHICH MIGHT SEEM NAIVE OR IDEALISTIC. A LOT OF THE MOST BEAUTIFUL AND LOVING THOUGHTS ARE FROM THE NAIVE AND IDEALISTIC."
—PATTI SMITH

with the Bruce Springsteen cowrite, she would have her first hit with 'Because the Night.' Patti's spirit ultimately proved too restless for radio and far too threatening. She seemed far more interested in creating transcendent, poetic moments than fashionable hits because she had already carved her legacy into something much deeper. The movement she helped define reached people like me, who related more to the Bad Brains than we did to the Eagles, explained why we championed the Clash and hated Ronald Reagan, and why we dropped our textbooks and picked up Sonja Sanchez, Allen Ginsberg, and Langston Hughes. Expanding rock's boundaries, Patti Smith the poet revealed truth regardless of the political and social consequences. Patti once said, 'I stand in front of a microphone and I'm not afraid.' And she remains just that—fearless throughout her losses, fearless as a mother, fearless when she put the Bush administration up on a firing line for this illegal war and pulled her poetic trigger, fearless in prose, and fearless in her life."

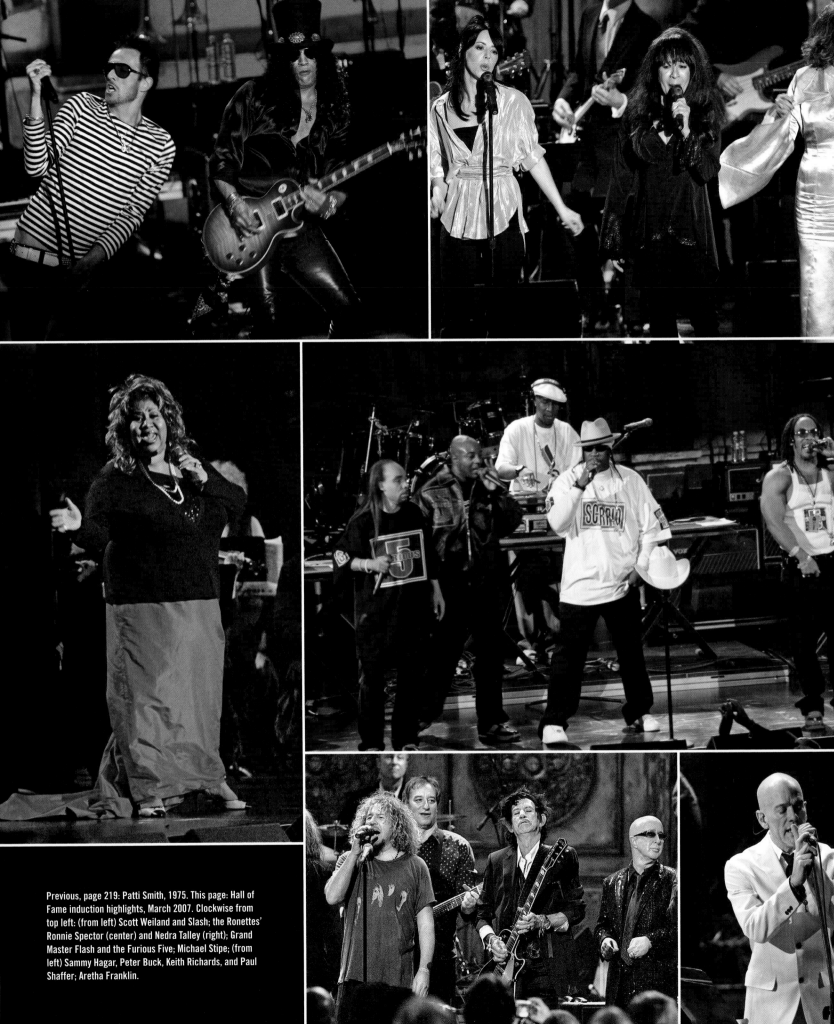

Previous, page 219: Patti Smith, 1975. This page: Hall of Fame induction highlights, March 2007. Clockwise from top left: (from left) Scott Weiland and Slash; the Ronettes' Ronnie Spector (center) and Nedra Talley (right); Grand Master Flash and the Furious Five; Michael Stipe; (from left) Sammy Hagar, Peter Buck, Keith Richards, and Paul Shaffer; Aretha Franklin.

## PATTI SMITH:

"I'm really very happy and if it seems like I'm not, it's just that so many people that I love who are so happy for me have a different scene; they're a bit higher up, but I know that my mom and my dad and my brother and Fred and so many people that I love are with us. First, I would like to thank Clive Davis. When I came to Clive, I was really awkward, arrogant, couldn't really sing, I had pretty clumsy movements, I had a lot of guts, not a whole lot of talent, but he had faith in me and let me go out of the gate, just a colt, and stayed with me. I want to thank my present company, Columbia, who's being so kind to me at this time. And the three women who shepherded me all through my years: Jane Friedman, Ina Meibach, and Rosemary Carroll.

"I want to thank all of the musicians that I have collaborated with—it's a collective, a brotherhood: My musicians in the seventies, especially the late Richard Sohl and Ivan Kral. In recent years, Oliver Ray and Tom Verlaine. I have a very small crew, probably the smallest crew in rock & roll, but they are very loyal—God bless our crews. . . . And my present band, Tony Shanahan, Jay Dee Daugherty, who has played drums with me since 1975, and [chokes up] my good friend and collaborator and champion, Lenny Kaye.

"Lastly, my late husband, the great Fred 'Sonic' Smith, once predicted a long time ago, actually right before he passed away at the end of 1994—we had an argument in the kitchen while I was peeling potatoes, and he said to me, 'Tricia, one day you're going to get into the Rock and Roll Hall of Fame.' And I said, 'No way,' and he said, 'Yes, you will, and you're not going to like it, or you might feel rebellious, or you might feel guilty because I'm not in it, and I'm clearly the better one.' And he was. But he asked me please, to accept it like a lady and not to say any curse words, and to make certain to salute new generations. . . .

"I thank everyone who has encouraged me through the years and all the people that come to our concerts and help me when I forget the words, which is all the time. And I accept this wonderful honor in the name of Fred 'Sonic' Smith.

"Some people say that it took a long time for me to get here. I have to say, I never expected to get here, so it seems like it was just a second. But my mom really, really wanted to be here with you. She loved rock & roll. She loved it so much, she answered all my mail for over twenty-five years and right before she died—hours before she died—she said to me, 'Tricia, did they save the Stone Pony?' I said, 'Yes, mommy.' She said, 'Good. Did you get in the Hall of Fame yet?' I said, 'Not yet, mommy.' And she said, 'Oh, I'm not going to make it, but when you do, sing your mother's favorite song [Rock 'n' Roll Nigger"], the one I liked to vacuum to.' So Mommy, this is for you!"

## VELVET REVOLVER ON VAN HALEN:

"When we were first asked to induct a band into the Rock and Roll Hall of Fame, it was the Sex Pistols, and let's just say that a little bit of drama ensued. And when we were asked this time to induct a band into the Rock and Roll Hall of Fame, let's just say that a little bit of drama ensued. It's only rock & roll. We feel proud to honor Van Halen into the Rock and Roll Hall of Fame. They're one of the biggest-selling rock & roll bands of all time. When they hit the L.A. scene, they blew it wide open, when rock needed a real kick in the ass. Their Pasadena backyard house parties are a part of legend. Upward of a thousand people would cram and slam to see an unsigned band. Eddie Van Halen, guitar genius innovator, to fans and musicians alike. David Lee Roth, the ultimate frontman, golden god to women. But it began again with Sammy Hagar. Sammy driving 55, motherfucker. Millions of more records sold, even bigger tours, even bigger hits. Bottom line, Van Halen was a party band. They would steal your girlfriend and your tequila. Let's not forget the thundering bass of Michael Anthony and the devil kick-drum playing of the drummer Alex Van Halen."

## VAN HALEN:

**Michael Anthony:** "First off, I'd like to say God bless you to Edward Van Halen. I wish you were here, buddy. It was like thirty years ago we were playing this little club called the Starwood out in Hollywood, and Mo Ostin and Ted Templeman from Warner Bros. came in and saw us play and liked what they saw and what they heard, and from there it was like joining a family with Warner Bros. They believed in the band and they took us and they grew the band into what it would become. It was one big family. I also would like to thank everybody who's been with the Van Halen family through all the years and have endured, toured, partied, worked, and the whole ball of wax. It was a lot of hard-working times, but the partying kind of outweighed that, once we took it out and brought it out to the people."

**Sammy Hagar:** "I wish everyone was here tonight; it's out of our control, and it's out of some other people's control. I think Eddie's going to come out the other side a better person, and we'll get our buddy back. This is just hard for Mike and I to stand to do this, but you couldn't have kept me from here with a shotgun. I especially want to thank the powers that be from the Hall of Fame for including me, because they really didn't have to do that, and man, like James Brown, 'I feel good!'"

## MUSICAL HIGHLIGHTS

*Rolling Stone* put it this way: "Some of the most unpredictable moments in music history play out at the Rock and Roll Hall of Fame induction ceremony. . . . During the jam session that traditionally closes the night—this year, Patti Smith's 'People Have the Power'—the onstage scene was beautifully bizarre. Sammy Hagar sharing vocal duties with Eddie Vedder, Michael Stipe, Ronnie Spector, and Smith, with members of the Furious Five chiming in on choruses, Stephen Stills and Keith Richards trading guitar leads behind them."

Prior to the jam, groups reconvened to replay their past hits, including Grandmaster Flash and the Furious Five with "The Message," and the Ronettes with "Be My Baby," and "Baby, I Love You." Velvet Revolver backed up Sammy Hagar on Van Halen's "Ain't Talkin' 'Bout Love," with Slash delivering Eddie Van Halen's guitar leads.

After Eddie Vedder's induction of R.E.M., the group launched into "Begin the Begin" and "Gardening at Night" with their retired drummer Bill Berry behind the kit, and Vedder traded verses with Stipe on "Man on the Moon." A nod to Iggy and the Stooges came by way of the Patti Smith Group's "I Just Wanna Be Your Dog"—a Stooges classic.

## INDUCTEES

**PERFORMERS** The Dave Clark Five ✦ Leonard Cohen ✦ Madonna ✦ John Mellencamp ✦ The Ventures
**SIDEMAN** Little Walter
**AHMET ERTEGUN AWARD FOR LIFETIME ACHIEVEMENT**
**NONPERFORMER** Kenny Gamble & Leon Huff

"I t was a little looser when it wasn't televised, I'll say that," John Fogerty pointed out at the March 10 induction ceremony at the Waldorf-Astoria. Fellow veteran Billy Joel agreed, "You know, it used to be a lot more fun before it became a TV show. People would come up to me under the influence of all sorts of stuff and really go off on everyone and everything. Now we have to be all nice and polite so they can sell ads for VH1." Still, while there may not have been the loose cannons like back in the days of Phil Spector and Mike Love, Justin Timberlake and Madonna didn't let anything get in the way of their innuendo-filled speeches.

Once again, Ahmet Ertegun was remembered; this time with Jann S. Wenner's announcement that the nonperformer award would be named after Ertegun, beginning with this year's recipients, producers, songwriters, and label owners Kenny Gamble and Leon Huff. Iggy Pop was called upon by Madonna to conjure her songs after her induction: "I would now like to introduce another ass-kicker from Michigan." Iggy also took a cue from Bono and pranced among the audience, the shirtless muscleman perching on Justin Timberlake's lap at one point.

The Lou Reed–Leonard Cohen segment was more like a literary reading than an induction, with Reed primarily quoting from Cohen's lyrics and writings, and Cohen quoting his own "Tower of Song" by way of an "acceptance" speech. And Tom Hanks's dramatic induction of the Dave Clark Five was the emotional equivalent of an all-star jam, which, when it ensued, featured a DC5 song, "Glad All Over," featuring Joan Jett.

## "'MADONNA WILL BE OUT OF THE BUSINESS IN SIX MONTHS. . . .' THAT'S WHAT THEY WERE SAYING ABOUT [HER] TWENTY-FIVE YEARS AGO. I DON'T THINK ANY OF THEM ARE AROUND TO SAY IT TONIGHT."

—JUSTIN TIMBERLAKE

> ## "THE SWORD IS A MIGHTY WEAPON, BUT IT AIN'T NOTHING COMPARED TO THE SONGS AND THE WORDS TO THE SONGS THAT WE SING."
> —JOHN MELLENCAMP

### JANN S. WENNER:

"Last year, we inducted our first rap performer, and this year's inductees continue to reflect the music's diversity. We'll be celebrating the folk-based writing and singing of Leonard Cohen, the guitar-centric tunes and the influence of the Ventures, the classic old-school hit singles of the Dave Clark Five, the provocative power of the imagery and music from Madonna, and the politically and emotionally eloquent rock & roll of John Mellencamp.

"Many extraordinary talents have been inducted on this stage in the Nonperformer category. This year, we have re-named that category in honor of one of its most distinguished recipients, the founder of Atlantic Records and the founder of the Rock and Roll Hall of Fame, the greatest record executive of all time, an A&R man and producer, Ahmet Ertegun. The winners of the Ahmet Ertegun Award for Lifetime Achievement tonight, appropriately enough, are one of the greatest production teams to ever come from rhythm & blues."

### TOM HANKS ON THE DAVE CLARK FIVE:

"Say you are a kid living in an odyssey of rental houses and relatives' sofa beds and cheap but clean apartments, and your family history and that of the world is swirling around you, making your first decade no walk in the park for anyone. So you attach yourself to popular culture, seeking distraction from your day.

"KYA-1260 and KAWB Channel 91 blare from a speaker the size of the bottom of the soda can on your sister's clock radio, connecting you to a world beyond that cheap but clean rental apartment. You become a participant in the moment-by-moment edge-of-the-bunk-bed drama of waiting for the next song, suffering through the commercial jingles, the station IDs, longing for a reprieve you get from no source other than K.O. Bailey's turntable. You want a pounding rocker of a record, a rip-it-up song that will rattle your world in the bedroom you share with your dad and your brother. You want to hear a song that will make you feel 'glad all over' by the Dave Clark Five!

"If you have any spare change, your spare time is spent leaning over a jukebox—your community iPod—holding a hundred songs! Fifty hit records and their B sides: You're in the Roaring Twenties Pizza Parlor in Red Bluff, California, or the Island Lanes in Alameda, or best yet the coffeeshop where your mom or your dad work, and right there in the booth is this little satellite version of your very own jukebox. God bless if your parents don't slide over a twenty-five-cent piece so each of you can pick out a song—one play for a dime, three for a quarter. Your sister, she punches in F-7 for a trip to Motown. Your brother . . . E-12 for a ride in 'The Little Deuce Coupe,' but man, you keep flipping those frayed pages inside that little dome, inside that little crystal ball and *bang!* There, you find them: DC5, and for two-and-a-half minutes, you run off to a little place down the tracks and 'the name of the place is 'I like it like that.' . . .

"Why do you need this music so? Because on a specific day, a definitive moment in the history of the world, in November of 1963, a terrible storm pounded your classroom in your town and your country, and for weeks and for months, for the longest time, your heart and your world have been wrapped in black, and the head of every single person you look up to is still bowed in mourning. It was the bleakest winter of your discontent. But then mourning became morning, as the sun rose in

Previous, page 222: Madonna, 1990. This page: John Mellencamp.

the East, coming out of England. So many of those Sunday night bands were from England: four guys for three weeks in a row in February. Then in March, the Dave Clark Five for two weeks in a row. And then some other U.K. band, and then the Dave Clark Five again, and then another U.K. band, and then the Dave Clark Five again—we were being invaded!

"And our shores were spontaneously welcoming these Brits. . . . The true product was joy, unparalleled, unstoppable, undeniable joy—the joy to be alive, the joy to be young, the joy to get a transistor radio for your birthday so you could carry the British Invasion with you, the joy as Ed Sullivan introduced the boys so you could sing along and pretend to play along. The joy that gave permission to believe that any way you want it, that's the way it will be. Joy, youth, and glory unleaping. 'Lust lasts but a thousand days, but joy is eternal,' said the old lady from Cleveland.

"And joy was in the music of the Dave Clark Five. The Dave Clark Five were sensations in particular ways, not the least of which was their eschewing of animals or minerals in their choice of names. The Dave Clark Five are one of the few British bands of the day that never replaced their drummer. True, the quintet never became household names, but they did display unforgettable if simple mise-en-scènes: Rick Huxley on bass, blond Lenny Davidson on guitar, Denis Payton on tenor sax—and how we miss him, as well we miss Mike Smith. Boy, how we wish he was here tonight, standing behind his organ with a perfect dancehall screech to his vocals.

"And, let's see, who else was there? Oh, yes, oh yes, Dave Clark on drums—blasting with so much power and élan you'd stomp your hands and clap your feet if you could. The Dave Clark Five achieved the requisite needs of pop sensations: fifteen consecutive Top Twenty hits; eighteen appearances on *The Ed Sullivan Show*. They sold out Carnegie Hall for twelve performances over three days. You may think the band made two feature films, but it was only one, titled *Catch Us if You Can* in the U.K. but called *Having a Wild Weekend* in the United States—a brilliant marketing decision.

"And speaking of brilliant decisions, in the business of show, here's something that will give most of the people in this room a headache when they hear it, because they are going to slap themselves upside the head at the news. Dave Clark never ever signed a piece of paper giving someone else his publishing. He never had to write a check to buy back his publishing either. He had always owned his own publishing. Now, is there a Hall of Fame for that?

"Music reaches the soul. The Dave Clark Five lifted ours, with a concussive beat and a reverb tremolo echo chamber of sound that commanded you to lean over from the backseat the moment you heard the rumbling percussion of the Dave Clark Five on the radio, and demanded you to yell at your dad, 'Turn it up! Turn it up, dad, this is my favorite song!' And he'd say, 'Why, why? This ain't music, this ain't music.' And you'd say, 'Oh, yes, yes, it is dad, yes, this is music. It's the Dave Clark Five and this song is going to take our confusion, and our sadness, our loss and our despair—it's going to take all the bleak days we've been through and all the heaviness of our hearts; this three-minute record is taking our joylessness and smashing it to pieces—to bits and pieces! So turn up the radio, dad!' Before we go into that tunnel and lose our AM signal, which is also true for satellite radio.

"Dave, Mike, Denis, Lenny, and Rick voluntarily called it quits in 1970. You did not read that headline, but their records still jump out of any speaker and are still good to kindle a party fire. In fact, the next time your New Year's Eve shebang ain't banging, well, put on the Dave Clark Five string of hits on 'shuffle mode' and I guarantee you that everyone in that room will get up and dance. Everyone will get up and sing, because everyone knows all the words. And how is that? *Because over and over and over again, the Dave Clark Five made a joyful sound!*"

## THE DAVE CLARK FIVE:

**Lenny Davidson:** "This week, Saturday the eighth of March, we came to New York, in 1964, and we were on *The Ed Sullivan Show*. Then, that week, we were invited to come here [to the Waldorf], and we sat in one of those boxes up there. Ella Fitzgerald was on this stage, but unfortunately the curtain caught fire and we had to evacuate the building, but ever since then it's been a fantastic journey."

**Dave Clark:** "We are honored to be inducted into the Rock and Roll Hall of Fame and especially by such a respected movie icon, but deep down inside I believe Tom is a rock & roller at heart. I firmly believe that without American music, there would not be the sixties British Invasion. We were inspired and influenced by Elvis Presley, Little Richard, Jerry Lee Lewis, Fats Domino, Sam Cooke, Ray Charles, to name but a few. An amazing array of talent to get one's creative juices flowing. The DC5 started out as a live band inspired by these American legends.

"I would like to take this moment on behalf of the DC5 to thank Denis for his beautiful friendship and for being a big part of our lives. Five years ago, Mike Smith broke his neck in a tragic accident which left him paralyzed. Mike tried desperately to be here tonight with his wife, Charlene, but sadly he passed away just a few days ago. But at least he knows he's a Hall of Famer. Mike, you're with us in spirit, my friend, and always will be. Mike was one of the great sixties rock singers and an integral part of the DC5, an incredible talent that will be greatly missed. What Mike and Denis achieved—along with Rick, Lenny, and I—will now live on forever for future generations, thanks to the Rock and Roll Hall of Fame. It's so sad for all of us to lose loved ones, so I'd like to ask you, if I may, to give them all the biggest applause because I'm sure they can hear us—and let them know that they are still part of our lives."

## LEONARD COHEN:

"Thank you, Lou [Reed], for reminding me that I wrote a couple of good lines. I inducted you into my own ghostly Hall of Fame many, many years ago. You flourished there from then until this very day. This is a very unlikely occasion for me. This is not a distinction that I coveted or even dared dream about, so I'm reminded of the prophetic statement of Jon Landau in the early seventies. He said, 'I have seen the future of rock & roll and it is *not* Leonard Cohen.'"

## JUSTIN TIMBERLAKE ON MADONNA:

"A strange thing happens when you're asked to induct Madonna into the Rock and Roll Hall of Fame. You become aware that every single word you can possibly imagine saying about Madonna, suddenly sounds much hotter, much dirtier, and a whole hell

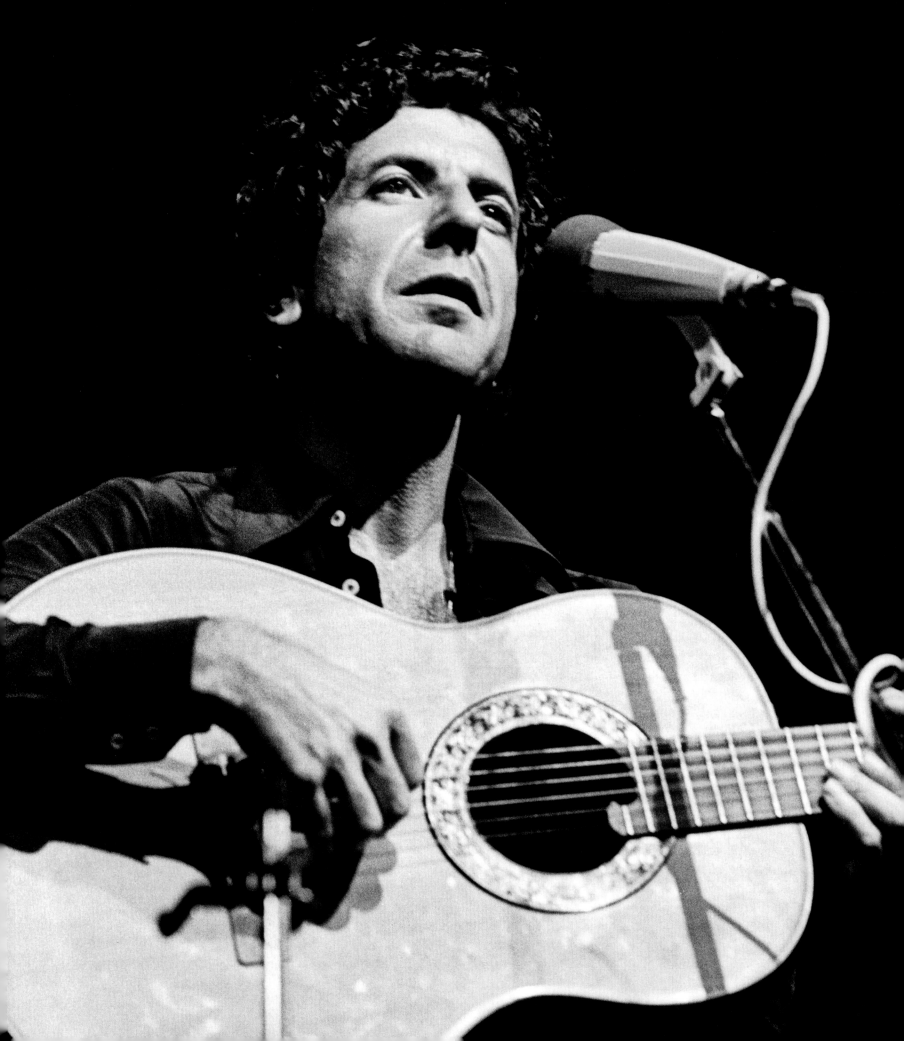

> ## "I FIRST MET MR. LEONARD COHEN IN THE CHELSEA HOTEL AND A PLACE CALLED MAX'S. OUTSIDE THE CHELSEA WE WERE TALKING AND HE SAID, WHICH I THOUGHT WAS REALLY SWEET, 'YOU WROTE A SONG CALLED "I'LL BE YOUR MIRROR" AND IT MADE ME WANT TO CONTINUE BEING A SONGWRITER.'"
>
> —LOU REED

of a lot more fun. Induct her? Why yes, I'd love to. Enter the Hall? Every chance I get. With all due respect to the fine city of Cleveland, even that place sounds slightly erotic knowing that Madonna is going to be entering the Hall. Though I'm pretty sure Little Richard would disagree, the truth is that nobody has ever gotten into the Rock and Roll Hall of Fame while still looking this damn fine. . . .

"When she first appeared on the scene, a sultry, dance-pop act dressed in lace and fishnet stockings, Madonna captured the attention of women and men with a certain downtown thriftstore chic that was all her own—until millions tried to jump on her bandwagon. Back then, few would have predicted that all these years later—and she politely but firmly forbade me to count—she would remain one of the most popular and crowd-pleasing acts all around the world.

"Yet Madonna hasn't become one of music's greatest stories ever told just by shocking us at regular intervals. She's done it by working harder and being smarter than everybody else. She made MTV the place to be seen. She racked up the greatest track record in music history—forty-seven Top Forty hits: That's almost one for every year that's she's been alive, give or take a few. Anyway, the point is, this is a singing, dancing, writing, promoting, achieving superstar who became the biggest name on the planet the old-fashioned way. She earned it. . . .

"I cowrote and coproduced half of the tracks on her new record entitled *Hard Candy*. When I tell people that, they're always asking me what it's really like to work with Madonna: Is she the control freak that everyone says she is? I'm going to tell you, *Hell, yeah!* As a matter of fact, one day in London I showed up to the studio, and it's probably because of the freaking schedule she had us under, but I was feeling a little ill, and she could tell and she said, 'You're not feeling too well today,' and I said, 'No.' And she said, 'Well, would you like a B-12 shot?' And I said, 'Yeah, I'd love a B-12 shot!' I'm thinking that we're going to call a doctor, but then she proceeds to reach into her designer handbag and pull a ziplock bag of B-12 syringes out, and then she looks at me, with *that* face, and says to me, '*Drop 'em.*' I don't know what you say to that, so I immediately drop my pants. So she gives me the B-12 shot in my

ass, and she looked at me and said, 'Nice top shelf' and that was one of the greatest days of my life.

"I figured that's exactly what Madonna is and will continue to be for all of us—a shot in the ass when we really need it. Her upcoming single from her new album is called 'Four Minutes to Save the World,' and in a sense, that's what Madonna has always done—save the world one great four-minute song at a time."

### MADONNA:

"I can't decide what I need to recover from—all my bad hairstyles from the previous video, or all of Justin's innuendoes. Everything he said is basically true, but I didn't say, 'Drop 'em,' I said, 'Pull your pants down.' Okay? I just like to be accurate, because you know I am a control freak. . . .

"I have always been fortunate to have people around me who believed in me. Starting with my ballet teacher, Christopher Flynn from Detroit, Michigan, who told me at the age of fourteen that I was special, that I needed to believe in myself, that I needed to go out into the world and pursue my dreams. Those words meant everything to me because I can assure you at the time, I didn't feel special.

"Then there was Dan Gilroy—he lived in an abandoned synagogue in Queens with his brother Ed. They played in a band together. I was sick of being an out-of-work dancer, so he taught me how to play guitar. But every day when Dan and Ed would go to work on their day jobs, I would sneak down to the basement, and I taught myself how to play the drums listening to Elvis Costello records. I practiced those four chords that Dan taught me over and over and over again. I wrote my first song in that synagogue. It was called, ironically, 'Tell the Truth.' I remember that moment so vividly—the hair standing up on the back of my arms and I thought to myself,

Previous, page 226: Leonard Cohen, 1972. Page 227: Madonna, 1984. This page: the many faces of Madonna. Clockwise from top left: "Like a Virgin," 1984; "Erotica," 1992; "Sex," 1993; Blond Ambition tour, 1990; "Hard Candy," 2008.

'Who just wrote that song? That wasn't me.' I felt like I had been possessed by some magic, and luckily for me I have been miraculously and continually possessed by some kind of magic. . . .

"There's no way that I could ever have imagined that my life would unfurl as it has. In one way, it feels like a series of 'suddenly's': One day I was a struggling dancer in Manhattan, and then suddenly I was teaching myself how to play the drums in a synagogue in Queens. And then suddenly I was in a band, and I was doing gigs at CBGB and Max's Kansas City, and then suddenly I met Seymour Stein hooked up to an IV drip in a hospital bed. And then suddenly I got signed to Sire Records, and then suddenly I was rolling around on the floor at the MTV Awards, with my ass hanging out. What nobody knows is that I had lost one of my high heels and I was groping on the ground to find it, and suddenly it was a dance move. Yikes! And then I had to go backstage and look at my manager, who was white as a ghost, freaking out, telling me I just ruined my career. What did he know? Then suddenly I was on a stage at Madison Square Garden and I looked out into the audience and every girl was dressed like me. It freaked me out. Anyway, suddenly, and suddenly and suddenly . . . that's one way of looking at it.

"The other way of looking at it is that everything happened exactly as it was supposed to happen. That I worked with the amazing people I was supposed to work with, that I traveled to the amazing places that I was supposed to travel to, that I made the mistakes that I was supposed to make. That the universe would conspire to help me and guide me all the way up to this moment, where I am standing in front of you. . . .

"Does any of this sound strange? Hospitals, synagogues . . . The next person I have to thank is Liz Rosenberg—she's been and still is the head of publicity for my entire career. Now, does anyone understand the insanity of being my publicist for the last twenty-five years? Well, I think Liz was smoking a joint when I first met her. I walked into her office and she very politely snuffed it out in the ashtray. We hit it off right away—she was my kind of girl: tough, irreverent, and funny. We've had a long and amazing chunk of time together. After dealing with all the nutcases she's had to deal with and putting out all the fires that she had to put out, it's kind of amazing that she's not shooting up heroin. I don't mean to gross everybody out and make it sound like everybody I hooked up with was like a drug addict or anything. The fact of the matter is that I ended up with a group of very responsible and hard-working people who gave me an enormous amount of love and support, along with everyone else at my record company. And I don't have time to thank all of you, but thank you.

"Then, of course, I needed a manager, right? So I asked myself, 'Self, who is the most successful artist in the business today?'" And Self answered, 'Michael Jackson.' So off I went to L.A. to find the man who managed Michael Jackson and make him my manager. Cut to Freddy DeMann, another man I want to thank—the ultimate Mac-daddy manager, slicked-back hair, tan, smelling of expensive cologne, big desk, smoking a cigar. Yeah, he drove a Porsche. He gave me a ride back to my hotel in that Porsche, and by the time we got there, he was my manager. There was no monkey business, okay? So we had an amazing fifteen years together and I learned a lot from him, so thank you, Freddy. . . .

"But what's a record without the music, right? I feel so lucky to have been able to have worked with such amazing songwriters and producers. . . . To my teachers, my friends, and my family, I thank you all for facilitating this journey which, for me, has

only just begun. And for reminding me that I am only the manager of my talent—not the owner. I've gone on to do so many things in my life, from writing children's books to designing clothes, to directing a film. But for me, it always does and it always will come back to the music."

---

## "AND EVEN THE NAYSAYERS—THE ONES WHO SAID THAT I WAS TALENTLESS, THAT I WAS CHUBBY, THAT I COULDN'T SING, THAT I WAS A ONE-HIT WONDER—THEY HELPED ME, TOO. BECAUSE THEY MADE ME QUESTION MYSELF REPEATEDLY AND THEY PUSHED ME TO BE BETTER. I AM GRATEFUL FOR THEIR RESISTANCE."

—MADONNA

---

### BILLY JOEL ON JOHN MELLENCAMP:

"John Mellencamp called me up back in 1985 about the first Farm Aid concert—it was out in the boondocks in Southern Illinois somewhere. I said, 'John, you're crazy. I'm a New York Jew—they hate people like me. They'll kill me.' John said, 'All the more reason for you to show up proving that you care about them. These people are losing their farms, their livelihoods, they need to know folks like you want to help.' So I said, 'All right, look. Let me see if I can get another Jew for you. Let me see if I can get somebody from the West Coast.' Because I didn't want to be the one token Jew. So I call up Randy Newman and I say, 'Randy, you want to play at this Farm Aid thing?' And Randy says, 'You're crazy—I'm an L.A. Jew. They hate people like me.' And I said, 'All the more reason for you to show up proving you care about them.' He said, 'Where is it?' And I said, 'Peoria.' He goes, 'It sounds like a urinary disease. You can't even get a good steak in the Midwest, where they grow 'em.' I said, 'Come on, Randy,' and he actually showed up. So in the afternoon on the day of the show, I'm standing next to the stage and Randy, before he goes on, he did not look happy. We looked out in the audience and saw what looked like about 100,000 Children of the Corn wearing John Deere hats. Randy turns to me and he mutters, 'I hate you. They're going to kill me just like I told you, and they're going to kill you, too.' Well, Randy went over just fine, but as he was leaving the stage, he glanced at me and gestured as if to say, 'Don't ever call me again!' Anyway, Farm Aid turned out to be a big success. . . .

"I call John 'the little bastard' and since some of the people who tour with John also go on tour with me, I asked them if they had any nice things to tell me about John, so I could tell you about it tonight. Here's the response I got. 'Uh, nice things?

No, I can't think of any nice things about John.' 'It's about John Mellencamp? Let me think about that. I'll get back to you on the next tour.' 'You're kidding me, right? This is a joke, right?' 'Don't tell him I said that or I'm toast!' But they still said they love you and they don't know why. Maybe it's because you're a fighter, John. You can talk the talk and you walked the walk. You've lived the life . . . you didn't take any shit from anybody.

"Now, you know, in this business they only really love you when you die young. People don't like it when we get old and start aging. I guess it reminds them of their own inevitable decrepitude. See, if we die young we become icons. Unfortunately, we also become dead. And while old age is not a glamorous prospect, it still beats the shit out of being fertilizer.

"Now you scared me a couple of times when I heard we might have lost you, John. Even though it might have seemed like a good career move at the time. You know, in this line of work the only thing sexier than a hit record is death, but I should have known you were too ornery to die. And nowadays, you don't have to worry about being called a 'pop singer' or a 'pop star'—because let's face it, nobody's selling records anymore. The record industry died before you did. Congratulations, John! You outlived the music business!

"What do you know—now they induct you into the Rock and Roll Hall of Fame. Well, welcome to the club, although I still don't know what the big deal is—there's no golf, no tennis, no horseback riding, no picnics, no barbecues, no poker games, no softball games, no flag football games—hell, they don't even have a swimming pool. Anyway, don't let this club membership change you, John, stay ornery, stay mean. We need you to be pissed off and restless, because no matter what they tell us, we know this country's going to hell in a handcart. This country's been hijacked. You know it, and I know it. People are worried, people are scared, and people are angry. People need to hear a voice like yours that echoes the discontent that's out there in the heartland. We need to hear stories about it. They need to hear stories about frustration and alienation, desperation. They need to know that somebody out there feels the way they do in the small towns and in the big cities. They need to hear it. And it doesn't matter if they hear it on a jukebox in the local gin mill, or the goddamn truck commercial, because they ain't going to hear it on a radio anymore. They don't care how they hear it—as long as they hear it—good and loud and clear, the way you've always been saying it all along.You're right John, this is still our country. And someone's gotta tell 'em, 'Don't take any shit,' and John, you do that very well. So now it's time for me to present you with this shiny little tchotchke and welcome you to the Rock and Roll Hall of Fame."

## JOHN MELLENCAMP:

"There's no doubt that nobody has put themselves behind the eight-ball more than I did. I came to New York after reading an article in *Creem* magazine that said MainMan Management was looking for new talent. That was my plan. I was twenty-two years old and I was a barroom singer, a very pretty kid. I had never been on an airplane, never been in a building more than four stories tall, and I was ripe for the picking. So I made a deal with the devil and I didn't even know it. If they wanted to call me Rumpelstiltskin, I would have done it to have the opportunity to make records. *Johnny Cougar, indeed.*

"But I knew something that they didn't know. I was born very lucky, and this might sound obtuse, but I was born with a disease called spina bifida. I had a birth defect on the back of my neck the size of a man's fist. Spina bifida is when the spinal column doesn't fully form around the spinal cord. Back then, it was fatal. I should have been paralyzed from the neck down. In 1951 they operated with pinking shears and a screwdriver; my parents were only twenty years old when they heard this prognosis. It was grim. It was unheard of back then to operate on a newborn so they waited six weeks and they performed the high-risk operation on me. It took eighteen hours; a young surgeon carefully worked on my spinal cord without damaging it, or damaging any of the nerves, and he charged my parents, who didn't have any money, a dollar. So my parents took me home, and twelve years went by, and I was sitting in class and some kid said, 'Hey, John, what's that big pink scar on the back of your neck?' And I said, 'What scar?' My parents had never even told me anything had ever happened to me.

"I'm lucky to be standing here for any number of reasons. The last fifteen years I've had about fifteen guys in my band, and I take great pleasure and pride in seeing these musicians grow into passionate, powerful performers. Their dedication and determination have shaped them into world-class musicians whose hard work and performances make it look effortless. I'm proud of their accomplishments, and I thank them for putting up with me all these years. . . .

"A few days ago, for the first time I saw a picture in a newspaper from 1942 that showed my mom, who was a young girl at the time, picketing in Austin, Indiana, to get a union in a canning factory. And there was a guy sitting there—a folk singer, looked like Woody Guthrie—and there was my mom, a seventeen-year-old girl singing with him. So that made me proud and I want to thank my mom and dad, who introduced me to music and taught me the value of hard work and dedication.

"When I came to New York, I was the unwashed, unwanted immigrant worker who showed up every day, who wanted my ticket to go to work. Some days I was on top of the coffee bag, and some days I was down in the hole. I had to create my own job because New York and Los Angeles didn't have a job for me inside the music business, so I created a job outside the music business. I was fortunate enough to write a couple of songs that connected with people, and people thought the songs were about them. I want to thank those people.

"I have been a total walking contradiction my entire career and I intend to stay that way. I've never cared about money, but I always wanted to get paid. I never cared about having hit records, but I always wanted to hear my songs on the radio. I never cared what the critics had to say, but I always paid close attention to what they wrote. After thirty-two years of having the opportunity of playing in the back rooms and the bars and the barns and getting an education from the farm workers and the factory workers—the people who built this country—watching the struggle of the people far away from the interstate that the public eye no longer sees, who this country [has] slowly and silently left behind, I'm the guy who rolls the ball up the hill, who wakes up every morning to find that the ball is back at the bottom of the hill. I'm that guy, and as long as I can hear a song that puts a tear in my eye and a lump in my throat, I know there's still hope and I've got a job that's unfinished. There's still work to be done."

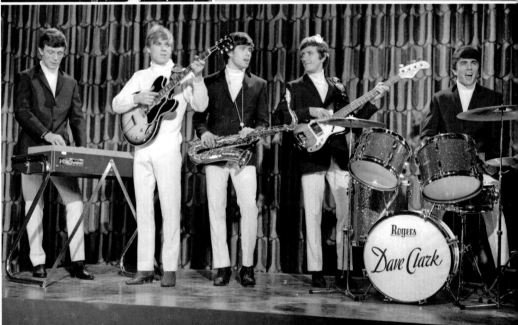

Clockwise from top left: John Mellencanp, 1985; teen magazine, 1964; Leon Huff and Kenny Gamble; the Dave Clark Five: (from left) Mike Smith, Lenny Davidson, Dennis Payton, Rick Huxley, and Dave Clark, 1964; Little Walter, 1954; the Ventures: (from left) Howie Johnson, Don Wilson, Nokie Edwards, and Bob Bogle.

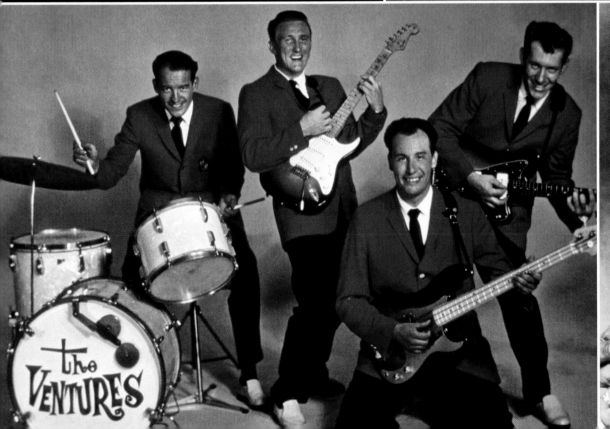

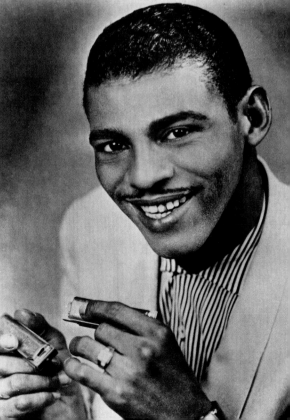

This page: Hall of Fame induction highlights, 2008. Clockwise from top left: Patti LaBelle with Sid McGinnis; Joan Jett, John Mellencamp, John Fogerty, James Cotton, and Billy Joel, with the Hall of Fame orchestra; Jett, Mellencamp, and Fogerty; Iggy Pop; the Ventures; Mellencamp.

## JOHN FOGERTY ON THE VENTURES:

"It is my very great honor to be introducing the Ventures, and every guitar player on this planet knows what I'm talking about. It all started about fifty years ago when Don Wilson and Bob Bogle got together and talked about maybe getting some guitars and starting a band. They were two construction workers with a dream. My kind of guys. Soon they found Nokie Edwards . . . and they cut a couple of vocal songs, as a matter of fact. They were singing. They didn't have much success with that. The next step is pretty interesting. With the help of Don's mom, they formed their own record company, they cut an instrumental that they'd heard on a Chet Atkins record—'Walk, Don't Run.' It gets picked up nationally and makes it all the way to Number Two.

"Much more importantly, that record kicked open a whole movement in rock & roll. That's something I still wonder at and am amazed at all these years later. The sound of it became surf music. The audacity of it empowered guitar players everywhere. Imagine four guys playing rock & roll in their garage, and getting paid to do it. With my old band, we would sit around and try to learn all these songs—you can imagine me and Doug [Clifford] and Stu [Cook] in a garage in El Cerrito, picking apart all these Ventures songs and trying to figure out what made it work, and we were getting a great education along the way. When the Ventures first hit the radio, I was gone.

"The Ventures have gone on to record over 250 albums. Good lord, think about that! Nowadays, some of us would be happy to *sell* 250 albums! These guys gotta love Japan—over there they are gods. They created several of the most important songs of all time in that country. In this country, there was a time when they had five albums in the Top 100 at the same time. The Ventures are the most popular instrumental rock & roll band of all time. This is long overdue, and guys like me sure appreciate this."

## THE VENTURES:

**Don Wilson:** "My partner, Bob Bogle, and I started an instrumental group called the Ventures in 1959. Bob couldn't make it tonight, which is a shame. Who would have thought that after recording 'Walk, Don't Run' forty-eight years ago, we would be going through this honor tonight? Not bad for two former bricklayers. Also, my mom, Josie Wilson, who was a big part of our early success—if she could have lived just one more year, she would have seen this. I'm sure she's here in spirit."

## BEN HARPER ON LITTLE WALTER:

"What flesh is to bone, what sorrow is to a tear, what touch is to someone alone, what bravery is to fear, Little Walter is to the blues. Fate has no enemies, and death knows no jokes, there is no other way around it—to pass through life, you must pass through the blues, and to pass through the blues, you must pass through Little Walter. It is a historical occurrence and a cultural achievement when the word 'immortal' finds its proper home. Such is the case with Little Walter. He defined an instrument, he defined a sound, he defined a genre, and played an immeasurable role in helping define music history and music's future."

## JERRY BUTLER ON KENNY GAMBLE AND LEON HUFF:

"The world knows these two guys as the Sound of Philadelphia. I know them as the soul of Philadelphia. Beyond the music, they committed to the community, so I think the Creator gave them some extra special help when it came to writing songs. It is my pleasure to present, and to introduce this magnificent writing team, production team and entrepreneurs—Kenny Gamble and Leon Huff."

## KENNY GAMBLE:

"I'd just like to say 'peace,' everybody. Because that's exactly what our music represented—peace. I'm very fortunate to be able to stand here today with my partner of over forty-five years; it's a miracle we met. We couldn't have done it without our great team: the sound of Philadelphia MFSB. A lot of people thought it meant something else, but it only meant Mother, Father, Sister, Brother."

## LEON HUFF:

"We worked hard. Me and Gamble met on an elevator, and we didn't really even know each other. He came over to my house and we must have wrote about five or six songs the first time we ever met, so I looked at that as a spontaneous moment, and from that moment on we just kept writing, we kept writing, we kept writing. This award is very special to us because we're the first recipients of the Ahmet Ertegun Award, and to mention Gamble and Huff in the same breath that you mention Ahmet Ertegun is just wonderful and an honor to us."

## MUSICAL HIGHLIGHTS

Powerful vocals from Patti LaBelle and Jerry Butler ignited the musical proceedings, and paid tribute to Philadelphia International's Gamble and Huff. And though Leonard Cohen only spoke his lyrics, Damien Rice did a phenomenal job with Cohen's "Hallelujah." It was a kind of night of stand-ins—with others presenting the artists' work for them. But as Iggy and the Stooges added muscle to "Ray of Light," Joan Jett did the same with the Dave Clark Five's "Bits and Pieces." Blues tributes to Little Walter came from James Cotton, who knew Walter back in Chicago, and upstart Ben Harper, who relished his spot.

There were two bands of inductees that powerfully played this night: The Ventures, who presented a fantastic version of their classic "Walk, Don't Run," and John Mellencamp and his band, who rocked hard. The Dave Clark Five's "Glad All Over" provided the finale, with an all-star jam including Jett, Mellencamp, Cotton, Billy Joel, and John Fogerty—the latter of whom no longer seemed to care that they were being filmed for TV.

## INDUCTEES

**PERFORMERS** Jeff Beck ✦ Little Anthony & the Imperials ✦ Metallica
RUN DMC ✦ Bobby Womack
**EARLY INFLUENCE** Wanda Jackson
**SIDEMEN** Bill Black & D.J. Fontana ✦ Spooner Oldham

On April 4, the red carpet was rolled out in Cleveland, literally and figuratively, for the first-ever induction ceremony open to the public. In addition to the exclusive guest list comprised of artists, recording industry insiders, and inductees and their family and friends, five thousand tickets were snatched up by fans. The induction was held at Cleveland's venerable Public Hall, where the Beatles, the Rolling Stones, and the Jimi Hendrix Experience performed in the sixties. To celebrate the induction ceremony returning to the home of the Rock and Roll Hall of Fame and Museum for the first time in twelve years, special musical events took place all week in Cleveland, leading up to the big night.

Having three tiers of seats filled with enthusiastic fans greatly increased the emotional power of the evening. Throughout the night, applause and cheers ringing from the rafters brought even more excitement to those artists taking the stage. The event was simulcast in other locations in Cleveland, and broadcast nationally on the FUSE television network.

More than half of the artists inducted had spent a half-century making music: Little Anthony & the Imperials, rockabilly queen Wanda Jackson, sidemen D.J. Fontana and the late Bill Black, soulful keyboardist and songwriter Spooner Oldham, and Cleveland-born Bobby Womack, who started as a child in his family gospel group, then moved on to the Valentinos. Tremendous performances by the Imperials, Jackson, and Womack proved that these vocalists could deliver, though in their seventies and, in Womack's case, mid-sixties.

Emotional speeches inspired by deceased inductees also in evidence: Both Metallica and RUN DMC had lost founding members to tragic early deaths: bassist Cliff Burton died in a van accident in 1986 and Jam Master Jay, a.k.a Jason Mizell, was shot to death in 2002. Teal-haired bassist Flea, of the Red Hot Chili Peppers, gave a moving eulogy to Burton, though his expletive-sprinkled superlatives caused James Hetfield, seated with his family, to clamp his hands over his young daughter's ears. Eminem gave profuse thanks to Mizell for discovering his close friend, 50 Cent. Bill Black's son tearfully remembered his father, who died in 1965, and "Little" Anthony Gourdine dedicated the night to his recently departed son.

It was also a night of homages to musical comrades: Jeff Beck was visibly moved by the speech made by his former Yardbird colleague Jimmy Page; former Metallica bassist Jason Newsted, previously estranged from the group, earnestly thanked his band mates; and Metallica's founders Lars Ulrich and James Hetfield hugged each other like brothers. There to give support was Aerosmith guitarist Joe Perry, whose band collaborated with RUN DMC on the groundbreaking rock-rap hit, "Walk This Way." Anthrax guitarist Scott Ian showed up for Metallica. Other guests included former Cleveland mayor and presidential candidate Dennis Kucinich, songwriter Dan Penn (Oldham's frequent cowriter), and Hall of Famers Sam Moore (of Sam and Dave), and Al Jardine (of the Beach Boys). Music permeated the evening, with Paul Shaffer tickling the ivories on many keyboard parts originally played by Oldham, from Aretha Franklin's "I Never Loved a Man" to the Box Tops' "Cry Like a Baby."

Along with the spirited performances, there was a hint of the spiritual, too—from Wanda Jackson remarking that she felt Elvis's presence in the room, to Bobby Womack calling out before his performance, "All ya'll ready to have church?," to Hetfield giving thanks to his higher power. Later, while inducting Metallica, Hetfield said, "This is living proof that it is possible to make a dream come true!" And for many of those 6,200 people in attendance, dreams did come true that night.

> # "IF YOU ASK, WHY DOES IT ROCK? THE ANSWER TO THAT QUESTION, TO QUOTE THE GREAT LOUIS ARMSTRONG, IS, 'IF YOU HAVE TO ASK, YOU WILL NEVER KNOW.'"
>
> —FLEA

## JIMMY PAGE ON JEFF BECK:

"Jeff and I go back to our really early teens. And let me tell you that was a long while ago. But we must have been about thirteen, fourteen, when we first met, and we stayed friends all the way through. I did session work, and Jeff was in bands. Then Jeff was in the Yardbirds, and then I was in the Yardbirds with Jeff. Jeff started making solo records, and I carried on with the Yardbirds for a while. And we both continued in our own way. I had Led Zeppelin, and Jeff kept goin'.

"You'd listen to Jeff along the way, and you'd go, 'Wow, he's gettin' really, really good, Jeff.' You'd hear him a few years later, and he'd just keep gettin' better and better and better. He still has, all the way through. Jeff's whole guitar style is just totally unorthodox from the way that anyone was taught. He's really developed a whole style of expanding the electric guitar and making it into something with sounds and techniques totally unheard of before. That's an amazing feat, believe me.

"He's done some amazing fusion records. *Blow by Blow*, for start, was a solo record that established him as the most incredible soloist of our time. He just doesn't stop. I'm really honored to be here, to induct Jeff into the Rock and Roll Hall of Fame, 'cause he's done so much for rock & roll—he always will."

## JEFF BECK:

"Oh dear, I've been naughty all my life and I don't deserve this at all. But I shall continue to be naughty, I think. [*Someone shouts from the balcony.*] What's that? Oh, I'm sorry, I've lost a bit of hearing. It's all Pete Townshend's fault. I've gotta mention Ernest Chapman, who looked after my finances and boy, did he look after them, for thirty years. He steered me through the minefields of financial trouble. He knew nothing about rock & roll, but he had a kind of Colonel Tom Parker quality about him. He sorta knew that if he hung around me long enough, I might do something worthwhile. He's no longer my manager, because I think he prefers golf, so we'll let him do that. . . . There's so many people that have helped me and I'd like to extend a huge thanks to them, and a huge thanks to those that didn't. [*Rubs forehead and extends his middle finger.*]"

## SMOKEY ROBINSON ON LITTLE ANTHONY & THE IMPERIALS:

"We were backstage talking about how quickly time goes by. Time has gone by like [*snaps fingers*] *that*! We were on the road together as kids and hangin' out, havin' a good time. So, it is a *joy* for me to be here, for what I consider to be a *long* overdue event. I absolutely love these guys. They are one of the greatest groups to have ever decided that they were gonna sing together. They are still awesome. If you haven't had the chance to see them anywhere live lately, give yourself a treat. Go see them wherever they are in your area, because they are the *bomb!* It gives me great, great, great, *great* joy, and I feel it's such a blessing to say: Anthony, Clarence, Sammy, Ernest, and Nate, come on up here and get what you deserve."

## LITTLE ANTHONY & THE IMPERIALS:

**Anthony Gourdine:** "Amazing grace, how sweet the sound, to save a wretch like me. For this moment here, and the Rock and Roll Hall of Fame. Ladies and gentlemen, we stand on the shoulders of giants. People who came before us: The Flamingos, the

Previous, page 234: James Hetfield of Metallica, June 2009. This page: Flea, 1995. Opposite: Jeff Beck.

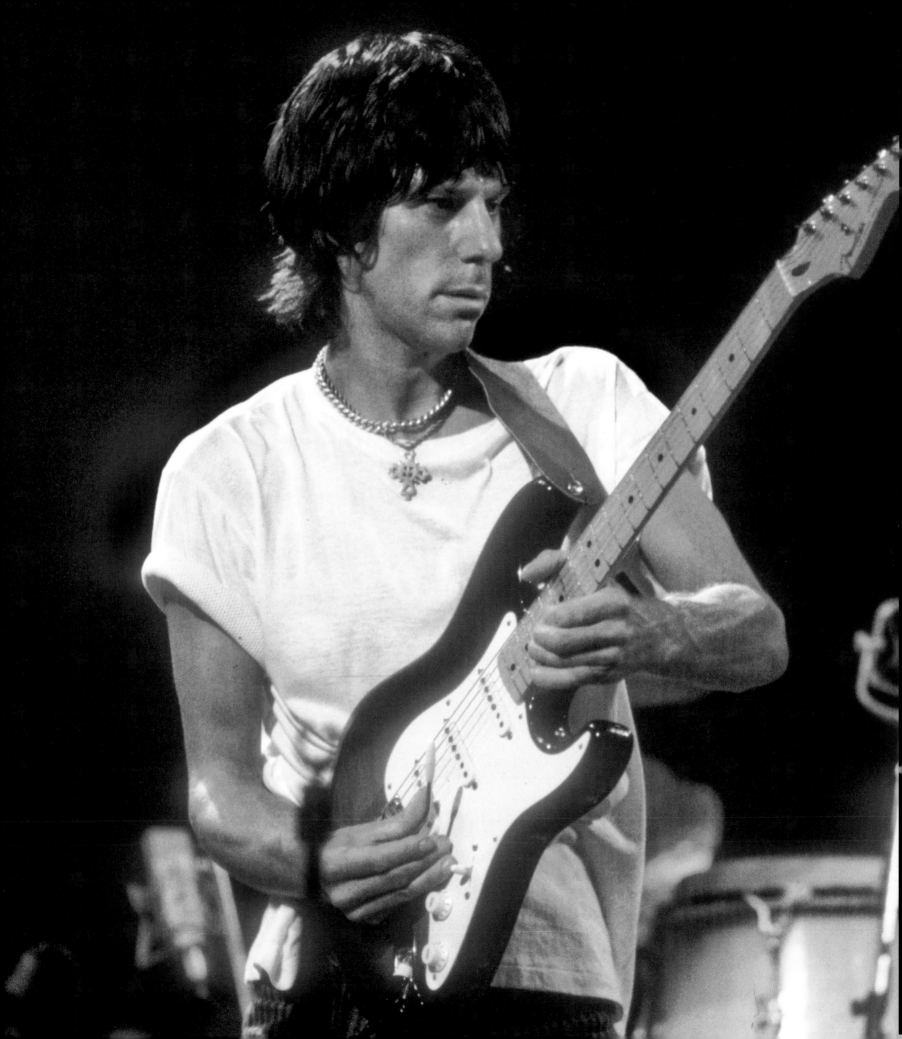

Clockwise from top left: Metallica, 2004; James Hetfield, 2009; Hetfield and Kirk Hammett, 1984; Metallica's Robert Trujillo, 2003; Hetfield, 1992.

Moonglows, and all those groups who inspired us as young kids in Brooklyn. And to be able to know Smokey Robinson and the Miracles, and all the guys at Motown—we hung around there a lot! To the late Richard Barrett, who opened the door for us in 1958, and the late Teddy Randazzo and the late great Don Costa, with that era of 'Goin' Out of My Head' and 'Hurt So Bad.' Some of these other people you won't know, but we know who they are. To my music teacher, Mrs. Mannix, wherever you are, thank you. . . . And Kenny Seymour. Kenny *is* the voice of Little Anthony & the Imperials, and no one knows that. He's the guy that taught us all about four-part modern harmony, and how to structure harmonies. And last but not least, my son. I have eight children, one of them passed on, and he was the biggest fan of all. He always hung around us as a little boy, all the way up to now, and then it was his time to leave this earth. But I have to say this: 'Casey? This is for you. Good night, Casey.'"

**Ernest Wright:** "We started out as young kids back in Brooklyn, singing in the church, the community centers, also singing on the street corners. Being inspired by Nat King Cole, I always hoped that one day I would reach the greatness that he had reached, as one of the great voices in American music."

> ## "I ALSO SHARE THIS WITH A BUNCH OF GENTLEMEN THAT I TUNED UP WITH ALONG THE WAY, TRYING TO GET HERE, A LONG TIME AGO. ONE OF THE GROUPS FROM BROOKLYN WAS CALLED THE CHIPS, AND WE MADE A SONG CALLED 'RUBBER BISCUIT'— THAT'S FOR YOU, TERRY [STEWART]."
> —SAMMY STRAIN OF LITTLE ANTHONY & THE IMPERIALS

## FLEA ON METALLICA:

"Sometime in 1984, I was on tour with my band, in the middle of America somewhere, and it was around 3 or 4 o'clock in the morning. We're all crammed into our van, with all our equipment; it was raining outside. Tired, been on the road, and this music comes on the radio. I couldn't believe that it *fuckin'* existed. It was like I had been living in this normal world where I knew what everything was that came on the radio, and all of a sudden, my mind was being blown by this beautiful, violent thing that was unlike anything I had ever heard before in my life. I was just riveted to the radio, and I'm sittin' there with Anthony [Kiedis], I'm sayin', 'Dude! This is amazing!' I was totally floored by this music, I just didn't know what to make of it.

"It had loud guitars and hollerin', and it was fast as lightning, but it wasn't punk rock. It wasn't heavy metal—it was precise and explosive and heavy, but quick on its feet. It just totally stood by itself, and it was standing boldly. It was aggressive and intense, and it had these really wild and bizarre rhythm changes, but it still held together as a bitchin'-ass song. I was singin' along with it by the end, though it certainly wasn't using any conventional pop song pattern that I had ever heard. I didn't know what it was, but the only thing I knew for sure was it was a *mighty* thing! That song was 'Fight Fire With Fire,' and it opened up my mind to the mighty force of nature that is Metallica!

"As time went by, I discovered this genre of music known as speed metal, thrash metal, whatever you wanna call it, and I heard lots of other bands tapping a similar vein, but none of them came close to putting it all together like Metallica. Some might have more virtuosity, some might be crazier, and some are just really good and interesting bands, but whatever the intangible elements are that make a band the *best*, Metallica has 'em. They're for real!

"You can put all the best musicians in the world together in a room, create your dream fantasy band, and it doesn't mean that the sparks will fly when they start playin' together. There are divine forces at work that make magic things happen, and in the rare instances, when that magic happens in a band, it's not something that you can add up with regular math. It's a cosmic chemistry and it is inexplicable. If it was merely a matter of a list of certain ingredients to make the amazing band, then anyone could do it, but that is impossible, because it is truly a holy and magical fucking thing, and it only happens when the spiritual powers that be say so.

"When Metallica started in 1981, they didn't really take your typical path to success. I don't know if massive stardom and selling a zillion records was on their mind when they were gettin' the ball rolling, but if they were aiming to become one of the most successful rock bands of all time—that they have become—they sure were goin' about it in a kooky way. In the world of three-minute-long, catchy pop songs that dominated the radio, these Metallica guys were writing and playing ten-minute-long songs that blasted your face off. I don't think they were sittin' around wondering how they could be a bunch of fancy rock stars. I just think they wanted to do some rockin'. Their motivation was, and is, pure.

"The fact that they have connected with the world in the way that they have is phenomenal. They have become a household name with music that is anything but mainstream. This is *outsider* music. And for it to do what it has done is truly mind-blowing. One thing I know for sure is that they must have been thinkin' they were gonna break into Casey Kasem's Top 40 Countdown on their debut record, *Kill 'Em All*. They were really goin' straight for the hit single with the song, '(Anesthesia) Pulling Teeth.' Now, I gotta tell ya, a five-minute-long bass solo, it's a ticket to commercial success. That song is one of the great moments in rock history for the electric bass guitar.

"Cliff Burton was an outstanding, *superb*, *deep,* and wicked virtuoso of a bass player. In rock music, the majority of bass solos you hear are self-indulgent, overly technical, show-offy, and mostly kind of boring. Every Cliff Burton–based solo I've ever heard is a soulful, psychedelic, head-banging expression that rocks your world, trips your brain out, and gets the house rockin'—a beautiful piece of music played by an awesome rocker of a young man, a masterpiece of a human being. He was a serious musician who delved into it with love and passion. The worst tragedy that could ever happen to anyone, in my opinion, is that when they die, they never sang their song that was inside of them. They never gave the gift that was inside of them. But the beautiful opposite of that is that when you pass away, and you know that

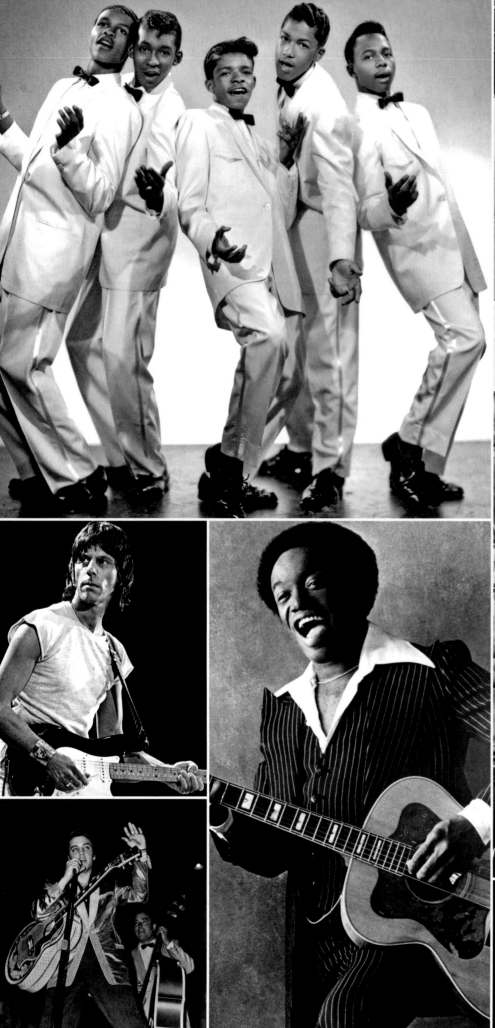

Previous page, 241: RUN DMC, 1999. This page, clockwise from top left: Little Anthony & the Imperials, 1961; D.J. Fontana, Bill Black, Scotty Moore, and Elvis Presley, 1956; Wanda Jackson, c. 1957; Bobby Womack, 1977; Bill Black with Presley, 1957; Jeff Beck.

Adidas, dark Lee denim, leather jackets, and black fedoras represented the look of the streets, in a way that rappers had not yet done before.

"They broke away from the pack by being the pack. In 1985, a year before the first induction ceremony of the Rock and Roll Hall of Fame, RUN DMC dropped a video for 'King of Rock.' The group set themselves up as the gatecrashers of popular music, by forcing their way into a museum very similar to the one that we're inducting them into tonight. RUN DMC were told in the video that they didn't belong in the rock & roll museum. And twenty-five years later, man, here we are. They didn't take no for an answer, much the same way they wouldn't give up when much of the world refused to recognize rap as real music.

"They were the first rock stars of rap. They were the first movie stars of rap. They were the first rap group played on MTV. They were the first rap group to go platinum. They were the first rap group with their own sneaker, and the first to sell out arenas worldwide. They were the first hip-hop artists to infuse rap music with rock & roll. They were the baddest of the bad, the coolest of the cool. Two turntables and a microphone.

"Now, when I was a kid growin' up in Detroit, I didn't know what I wanted to be yet, and then came RUN DMC. I had never seen or heard anything like 'em, but somehow I knew it was right for me. They made me realize that you could write your own rules, which is something that still inspires me, as well as every other rap artist, constantly. None of us would be here without them. Two turntables and a microphone.

"I remember being in ninth grade when *Raising Hell* came out. Two years later, I remember being in ninth grade when *Tougher Than Leather* came out. I had skipped school, if you can believe that, to go buy *Tougher Than Leather* on cassette, the day it came out. As soon as I heard 'Run's House,' man, it was pretty much a wrap for me. Marshall Mathers became Eminem. It was the first time RUN DMC had changed my life, but it wouldn't be the last. Two turntables [*the audience yells in unison*] *and a microphone!*"

"If it weren't for RUN DMC, particularly Jam Master Jay, the world wouldn't know about a scrappy young hustler named Curtis Jackson. Jay mentored and molded Curtis into the superstar named 50 Cent. Jay shaped the way 50 wrote, the way he rapped, and the way he thought. Again, RUN DMC changed my life. Without them, I wouldn't have met one of my closest friends.

"RUN DMC's effect on popular culture cannot be overstated. Whether you know it or not, you encounter them every day. In the music you hear on the radio, in the sneakers you wear, in the videos you see, in the attitudes of the people you meet. . . . All this from two turntables and a microphone. To be up here inducting them is one of the biggest honors of my career."

## RUN DMC:

**Run [Joseph Simmons]:** "So much help, so many smart people around me. Jam Master Jay's mother . . . let us create routines in her living room. She'd come home from work and we'd be there with the turntables. She never told us, 'Turn the music down,' once. She never said that we couldn't be there. We spent the night, we made the music there. I came up with the rhymes for 'Rock Box' and 'Jam Master Jay's House.' I would like to thank you, Mrs. Mizell, for not turnin' the music down; we wouldn't be here.

"Russell Simmons, my brother, who's here: He's the guy that's the big visionary, that says [*mimics Russell Simmons*] 'Joey! We could take rock music and mix it with rap music and we could come up with this thing,' and he was always drinkin' screwdrivers and comin' with crazy ideas and smokin' weed. I'm not sayin' that the weed created it, but he was high. And these are the things that would come out of his mouth. He came up with the name RUN DMC. . . . 'He's the MC and you're Run! We'll call it . . .' and this was crazy back then, right, D? 'We'll call it RUN DMC!' And we looked at him like he was crazy."

**DMC [Darryl McDaniels]:** "First of all, I have to thank two of the greatest people in the world that actually made this possible, besides Run. If he didn't put me in the crew, I wouldn't be here. But there was a beginning before that union of me and Run. I gotta use this time to thank my mother and father, Byford and Bannah McDaniels. It's like I say every day, when I go to speak to kids, 'Don't let your situation define who you are,' especially the foster kids and the homeless kids. Because a lot of them go through life just thinkin', 'Oh, I'm just a foster kid, nobody loves me.' But I'm livin' proof, as I stand before you—not as a celebrity or as a famous rapper—but what I represent here tonight is purpose and destiny. You're lookin' at what can happen when you take time out of your life, and give love to a kid. Because if my birth mother never gave me up, my real mother would have never came and got me. I would have never, ever met Joseph Simmons. . . . I would have never met Jason Mizell. I would have never met any of the people who were there on this magnificent ride of hip-hop. If my birth mother didn't throw me away, give me away, abandon me, Byford and Banna would have never took me to Hollis; there would be no RUN DMC. There would be no rap music the way it is today.

"But forget about all of that celebrity stuff. The best thing y'all can do is give love to a kid, because that kid may grow up and be in the Rock and Roll Hall of Fame!"

## RON WOOD ON BOBBY WOMACK:

"I am very happy tonight to induct somebody that's been my pal for many years, and he's been a great inspiration to my band and all of the musicians that I know. Anybody that started with Sam Cooke has got to be all right with me. I wish I could say, 'And here he is now, Sam Cooke.' But we do have a living embodiment of Sam in Bobby's voice, because nobody [else] brings a tear to your eye, literally, or carries the spirit of life in their singing and their music and guitar playing. His first band with his lovely brothers, the Valentinos, whose 'It's All Over Now' was the Stones' first number one. People tend to forget, but Bobby cowrote that, man!

"I'm not gonna go rattlin' on, but I'm not gonna give this to Bobby Womack unless he comes out. And it's about *time*, 'cause he's been trying to crossover for years. And this time he's crossing *back* over! Where's that Womack?"

## BOBBY WOMACK:

"It's great for me being back home in Cleveland. Been gone a long time, but I'm glad to be back tonight . . . I'm not gonna stay up here too long tryin' to preach, 'cause tomorrow's Sunday. First of all, let me just say, my mother's here tonight, and the Womack brothers—the Valentinos—are here tonight. God is in the house, too. You can't go wrong.

"Back in the day, I was a guitar player for Sam Cooke, who was a great artist. And he wrote and sung some great songs. With the last song that he wrote, he made a statement, and that statement was a song called 'A Change Is Gonna Come.' It was so crazy back in those days, we couldn't even check into motels. But a change *has* come. And the biggest thrill for me, more than anything that I ever could do, or have ever done, was to see the world change. And Father Time has changed the song from, 'Gonna Come' to 'Has Come.' I'm a livin' witness. As I stand here today, I can look up at Sam and say, 'Sam, we have our first black president, his name is Barack Obama. And do me a big favor, Sam. Let *all* of the soul singers know and give them the news.'"

### ROSANNE CASH ON WANDA JACKSON:

"Wanda Jackson. Even her name sounds like a declaration and a promise. *Wanda Jackson.* I asked Wanda what she most wanted people to know about her, and she said, 'Number One: I can *rock.* Number two: I was a lady, and reputations are important. And number three: Rock & roll and God are not mutually exclusive.'

"As one writer noted, 'Wanda was there at the beginning of rock & roll, and for girls with guitars—myself included—Wanda *was* the beginning of rock & roll.' Everyone who cares about roots music and rock & roll reveres Wanda, but in particular, every young woman I know, musician or otherwise, worships her as the prototype, the first female rock star, as she so modestly acknowledges herself. But this is not a woman who used her staggering beauty to manipulate an audience, this is not a coy woman, this is not a woman who used her powerful energy as a means to just become famous. She was vibrant and edgy without being abrasive, and sweet without being saccharine. This is a woman who has rhythm and joy in equal parts, to the depth of her soul. As Marshall Grant, one of the original Tennessee Two, my dad's bass player, said about her, 'She was the only woman back then who could hold her own with Elvis's crowd. She came offstage every night to a standing ovation. She was a little *tiger* out there.' And as Bob Dylan noted, this 'is an atomic fireball of a lady.'

"When her husband, Wendell Goodman, first met her, he was dating her best friend, but he said that he was so impressed with this 'beautiful, gorgeous, sexy thing who never talked about herself. She was so humble.' Wendell gave up the best friend and married Wanda in 1961. He also gave up his career as an IBM programmer to manage Wanda and travel with her. They have now been partners in love, marriage, spiritual faith, and rock & roll for forty-seven years.

"She started her career when she was a junior in high school, in 1954, and she said it was a 'family affair.' Her father drove her to performances, and managed her career, and her mother sewed her outfits. She was put on package shows in the South with Elvis, Carl Perkins, Jerry Lee Lewis, Roy Orbison, and my dad, among others—her 'buddies,' as she calls them. It occurred to me to ask her how many times my dad had knocked on her motel room door on those tours. She paused and said, 'Well, honey, you know *my* daddy was out on the road with me, so I don't believe he knocked even once.' If so, given Wanda's breathtaking beauty, this shows unprecedented restraint on the part of my father. And as Marshall pointed out with a sigh of remembrance, 'There were a *lot* of people knocking on her door.'

"But even if they did knock, as Wanda herself says, 'I was always a lady.' Indeed she was, but she may be the only lady in history who had that kind of rocking rhythm

and raw sensuality and not only didn't self-destruct, but had fun, and kept her soul intact in the process. She's not a red-carpet, celebrity-hangout, rehab, tabloid kind of person. She's a person of strong religious conviction, deep integrity, a road warrior, and a rock & roll queen.

"In the beginning, Wanda was a country singer. One day on the road, Elvis said to her, 'You should do this new kind of music like I'm doing.' Wanda said, 'But I'm just a country singer.' And Elvis said, 'Well, I am, too.' And that was that. Wanda was equally authentic in rockabilly as she was in country. Elvis let the genie out of the bottle with that one little exhortation. She told her mother, who was making her stage clothes, that she didn't want to wear those big skirts anymore, and she and her mother created the fringed dresses, high heels, and long earrings that brought her image and her musical style into an electric, cohesive, sharp focus. But she never gave up doing country as well as rockabilly. Sometimes she would release a record with a rocker on Side A, and a country song on Side B.

"She had, and still has, enormous international popularity. 'Fujiyama Mama' was a huge hit in Japan as well as the U.S. in 1958, and it was followed by her Top Forty smash 'Let's Have a Party.' She followed that with a couple of Top Ten country singles, and then topped the German charts in 1965 with 'Santo Domingo,' which she sang in German. She followed with more success on the pop charts in America, a television show, stints in Las Vegas, and in the 1980s had a resurgence of popularity in Europe and Australia that borders on fanaticism. Today, she still tours about eighty dates a year.

"She has been recording for fifty-four years, and has recorded in four languages. She's made around fifty albums. She's toured the world, and inspired legions of people with her grace and her fire. She said she wants to keep doing this 'as long as my health holds up, as long as the fans want to come out and see me. But it's not falling away yet.' No, it's not.

"And about tonight, she said that 'it feels good to be up there with my buddies. It's come full circle.'

"So Wanda, you *are* now up there with your buddies, Carl, Elvis, Jerry Lee, and Johnny, and among so many others of your peers and those who have followed you. You are, as Wendell always introduces you, 'the first lady of rock & roll and the queen of rockabilly' and now, a member of the Rock and Roll Hall of Fame."

### WANDA JACKSON:

"What can I say but, '*Wow!* I'm really here!' Oh, what an exciting time for me. Rosanne, I'd forgotten I'd done all those things. Your dad and I were very good friends for a good many years. He was a special person. Just as she has mentioned all these wonderful people, standing here tonight, I realize, for sure, I'm not standing here alone. I didn't get here by myself. I had so much help that I probably wouldn't have made it at all without the help.

"For instance, my mother and daddy sacrificed some time together, their energy, their resources—just so that my dreams could come true. What a mother and daddy. And my mother is still alive, bless her heart. Age ninety-five!

"Hank Thompson heard me as a little old snotty-nosed kid, about fourteen years old, on the radio. He believed in me enough to ask me to sing with him and his number one western swing band at the time, the Brazos Valley Boys. He became a mentor and a friend for life. And as Rosanne mentioned, Elvis Presley, just for that

bit of encouragement and that push that I needed . . . I don't know about y'all, but with D.J. [Fontana] and Scotty [Moore] here tonight, I feel the presence of Elvis very strongly. So, I just say, once again, 'Thank you, Elvis, for encouraging me to try it.'

"Ken Nelson, who was my producer at Capitol Records for many years, was the type of producer that believed so much in his artist that he never held us back. Capitol Records didn't know what to do with me. They signed me as a country artist; now all of a sudden I'm singin' this new music. But he just gave me the freedom to choose my own material and do it however I wanted to do it.

"Thank you for sayin' the great things you did about my *wonderful* husband, Wendell Goodman. Folks, he's such a wonderful person, I'd be here till Tuesday if I tried to tell you just a little about him. I know for sure that he has spent days, hours, even years, spreading the word that I wasn't in the Rock and Roll Hall of Fame, and that I should be. He just kept talkin' until he got enough people on the bandwagon to make it happen . . .

"This award is special to anybody who receives it, and stands in this spot, but to me, it's so extra special. Because in the fifties, when I had the nerve to jump out there and be the only girl recordin' this stuff, and singin' this wild stuff, and with my fringe flyin' and my guitar twangin', and breakin' strings, I didn't ever get any recognition for that then, which was okay. But now with a whole generation of rockabilly fans of fifties rock music, I have a new career at this point in my life. It doesn't get any better than that, does it?

"Rosie Flores, a gal who in her own right is a fantastic artist and a rockabilly guitar player and singer and songwriter, is the one who introduced me to this new generation of rock & roll people. So, thank you, Rosie, for doing that for me. And Elvis Costello is so fantastic. He was inducted a few years ago, and when he found out I wasn't there, he just thought it was a real injustice. So he became an advocate for me, for this cause. Another Elvis in my life. And Patti [Scialfa] and Bruce Springsteen have contributed a lot to my bein' here tonight. They came out to see me when I was in their hometown in New Jersey a couple of years ago. The manager came into the green room and he says, 'Wanda, Patti and Bruce Springsteen are here. They'd like to come back and say hi to you.' I said, 'Oh, yeah! Send them on back. When the president gets here, he can come, too.' But they were there just to hear my little performance.

"Vinnie Kralyevich and Joanne Fish, two wonderful television producers, got together to make a documentary on my life. They did such a wonderful job of it, and, they named my documentary, *The Sweet Lady With the Nasty Voice.* They asked me what did I think about that. And I said, 'Well, I'm not sure it's really accurate—I'm not at all sure I'm a sweet lady.' [*Applause, cheers.*] Does that mean you agree with me?"

## MAX WEINBERG AND GARY TALLENT ON BILL BLACK AND D.J. FONTANA:

**Max Weinberg:** "My friend and E Street band mate Garry Tallent and I have the privilege and, I'd say, the distinct thrill, of saying a few words tonight about drummer D.J. Fontana and bassist Bill Black, both of whom helped create and perform on timeless recordings. We honor them tonight as they take their well-deserved place alongside guitarist Scotty Moore, who himself is here tonight—the man who played the guitar that changed the world—and, of course, in the Rock and Roll Hall of Fame, Elvis Presley.

"As musical descendants of the tradition that these two rock & roll pioneers established, Garry and I have always considered D.J. and Bill as headliners in our own personal rock & roll hall of fame. To several generations, and for many reasons—musical, of course, but historical and cultural as well—to all of us, Elvis *was* the King. For the astounding music he left us, created largely with his original band, he remains the King of Rock & Roll. And D.J. Fontana, Bill Black, and Scotty Moore, were with Elvis every step of the way, when the only thing that mattered was the music. *They* were the King's men!"

**Garry Tallent:** "In the summer of 1954, as race music was morphing into rhythm & blues, and country music was finding its way into the urban honky-tonks, Bill Black was already a seasoned professional. His abilities as a musician and performer were well known in the music circles of his hometown, Memphis, Tennessee. His stage antics were steeped in country-music traditions. The role of the bassist was quite often that of the clown, complete with the silly costume and blackened front teeth. When Sam Phillips needed some help sorting out the merits of the young truck driver-slash-fledgling singer Elvis Presley, it was Bill and guitarist, Scotty Moore, that he asked to put the kid through his paces. After their first practice session together, Bill was 'not too impressed' with the singer. After all, Elvis had had zero experience in performing, save a school talent show.

"At Sam Phillips's insistence, Scotty and Bill continued to work with the singer, both performing live and in the recording studio. Bill was the one who encouraged Elvis to learn the value of showmanship. They'd bring Elvis onto the bandstand with their group, the Starlite Wranglers, to give him some experience. When the early audiences were not digging Elvis, it was Bill's antics of shaking, doing stunts atop his bass, and generally hamming it up, that would get things goin' and save the show.

"Elvis learned the value of these stunts and keeping the audience entertained. As time went by and Elvis developed his stage persona, eventually Colonel Tom Parker came to Bill and he insisted that he can the upstaging of the star of the show.

"In the studio the three men worked tirelessly with their producer Sam Phillips to develop the sound of their group. After coming up with the first single, 'That's All Right Mama,' they were in need of another song as a B side. It was Bill who started slapping the bass and singing 'Blue Moon of Kentucky,' a bluegrass waltz by Bill Monroe, although Bill Black gave it a rocking four-four rhythm. They instantly had both their B side and their group name, the Blue Moon Boys. Scotty and Bill toured with Elvis as they built a strong following in the South. And with the addition of D.J. Fontana on drums, they made the transition from rockabilly trio to the prototype—two guitars, bass and drums—rock & roll band. With Bill switched to the newly invented Fender electric bass, the transition was completed.

"One of the classic Bill Black stories begins with the fact that Bill did not completely love his new Precision bass at first. During the recording of the *Jailhouse Rock* soundtrack, they were working on the song 'You're So Square, Baby I Don't Care,' when Bill threw the bass down on the floor in frustration and stormed out of the studio. At that point, Elvis picked the thing up, dusted it off, and proceeded to play the part on the record. Bill did finally get to accept the different approach that the new electrified instrument presented. It was this very electric bass sound that became the basis of his post-Elvis group, Bill Black's Combo. Their sound was a simple combination of popular tunes set to an electrified

honky-tonk beat. Their first single, 'Smokie,' went to the top of the charts and was followed by a succession of chart makers.

"The *biggest* influence, however, was the string of instrumental dance LPs that found their ways into millions of homes. The untouchable sound of the Bill Black Combo paved the way for a multitude of instrumental groups, including the Ventures. The Combo was requested by the Beatles to be the opening act for their first U.S. tour; although, unfortunately, Bill was too ill to make the trip. He had developed a brain tumor and died in surgery in October of 1965. His influence on the following generations of bassists remains profound, if somewhat under-appreciated. Tonight, all that changes.

"In my view, a great artifact that would be a prize in the Rock and Roll Hall of Fame Museum collection, would be the road-worn, pin-striped bull fiddle Bill played on *The Ed Sullivan Show*. Of course, it would have to be pried from the hands of its current owner, Sir Paul McCartney—one of the many kids so influenced by Bill Black that he picked up the instrument and decided to start a band."

**Max Weinberg:** "The historical implications of the meeting between Elvis, Scotty Moore, and Bill Black are *immensely* significant in the transitional development of rock & roll music. But their little rock & roll band was not complete till, as Garry pointed out, drummer D.J. Fontana, came swinging their way in 1954. At the time of their meeting in 1954, D.J. was the staff drummer at the legendary Louisiana Hayride, next to the Grand Ole Opry, the most popular so-called 'hillbilly' radio program of the late forties and early fifties, which was broadcast from the Municipal Auditorium in Shreveport, Louisiana, D.J.'s hometown . . .

"To Scotty, Bill, and Elvis, D.J. Fontana brought the power. As a young teenager, Levon Helm, the esteemed drummer, singer, and actor, witnessed first-hand the power and majesty of D.J.'s big beat as he watched in awe as Elvis and his band played a dance at the high school gym in Marianna, Arkansas. Levon recalled, 'Well, I'd seen Elvis about two or three months before, when it was just Elvis, Bill Black on bass, and Scotty Moore on guitar. It was fantastic! But when D.J. showed up on the scene, boy *that* was something. He would just plant those drums, start stackin' verses against each other with his fills, building up to the solos. D.J. gave the music some architecture. He was a helluva drummer.'

"Now, as important as was their musical gifts, with their careers, alongside Elvis onstage and in the movies, D.J. Fontana and Bill Black and Scotty certainly stretched the definition of the term *sideman*. Because we, the audience, *knew* who they were. Ringo agrees. Ringo told me, 'D.J. Fontana was the first rock & roll drummer who people *knew*. They knew that he played on Elvis's records. D.J. preceded me as a known drummer within a group.'

"Everyone has their favorite Elvis, Scotty, Bill, and D.J. stories. The stories are legendary and they're many, and we have too little time tonight to even make a dent in retelling the history that these four men created. But let me tell you a favorite story of mine. Recently, as D.J. was informed of his nomination to the Rock Hall, and told of tonight's event and the date, April 4, his reaction was, 'Well, hell, I can't make it! I'm working!' I thought that was perfect. D.J. has never stopped working as a drummer, all these years. And that's because

This page: Hall of Fame induction highlights. From top: Metallica's Kirk Hammett and Robert Trujillo; (from left) Jeff Beck, Jimmy Page, Ron Wood, Joe Perry, Hammett, Flea, and James Hetfield; Wanda Jackson and Sid McGinnis.

he's not only a seminal character in rock & roll's story, but because he's a *great* drummer!

"D.J. Fontana's discography is most impressive, and the list of singers and instrumentalists with whom he has performed and recorded, is long and varied. Again, too lengthy to recount. Thank you, D.J., for the inspiration you gave *me* and succeeding generations of rock & roll drummers, all of whom carry a bit of the beat you laid down."

## PAUL SHAFFER ON SPOONER OLDHAM:

"Brought up in Northwest Alabama, Lindon 'Spooner' Oldham cut his teeth playing keyboards with the famed house band at FAME Studios—the band that became the Muscle Shoals rhythm section. These cats were so funky, producers came from all over the world to record their artists with that great Muscle Shoals band. Was there something in the water? Or did Spooner just happen to play with the stankiest feel around?

"Well, that stankiness was put to the test the day that Oldham showed up for a session crosstown, and found himself confronted with that cheesiest of cheesy combo compact organs, the dreaded Farfisa. Well, damned if Spooner didn't coax a mellow sound out of the thing and proceed to have church right there in the studio. Is there anything more divine than 'When a Man Loves a Woman?' 'I'm Your Puppet' by James and Bobby Purify, and the Box Tops' 'Cry Like a Baby' are two soul anthems that Spooner cowrote, with his partner, Dan Penn; and he played keyboard on *both* with his usual grace. With five chords, Oldham kicked off one of Aretha's greatest hits, '(You Make Me Feel Like ) A Natural Woman.' Here is Spooner's style at his apex, for he played not one single extraneous note, nothing to take away from the beauty of the melody. In his hands, it wounded up sounding like a symphony.

"Bob Dylan and Neil Young are just two of the musicians who have benefited extensively from Spooner's soulful subtlety. They know the meaning of the musician's mantra, 'It's not what you play, it's what you don't play.' Easy words to say, not so easy to put into practice. And no amount of practice will help you learn what Oldham's playing preached. Because Spooner's got soul, and from listening to Spooner, I learned that when it comes to soul, sometimes the silence is more powerful than the sound."

## SPOONER OLDHAM:

"I love music. When I was a toddler, my dad, Dewey Dodd, and his brothers sang harmonies and played the mandolin and guitars. One day a friend of theirs brought an upright bass. They made music in the living room; I was mesmerized by the sounds they made. And as an eighth grader, my friend and I were walkin' the hall at junior high school, and we spotted an upright piano, in an empty room, and I asked him if he ever sang. He says, 'Sometimes.' We went to the piano and did a song popular on the radio, 'Whole Lot of Shakin' Going On.' We got through it fairly well, then started practicin' every Thursday night at my cousin Bruce's house; he had a 1957 Telecaster. Roger Hawkins played drums; he was thirteen years old. We learned some tunes of the day, and started playin' at high school dances. I've been playin' with studio bands and tourin' bands ever since."

## MUSICAL HIGHLIGHTS

Music dating from a half-century ago to the nineties kept the evening rocking all night long. Little Anthony & the Imperials hit every high note on their medley of the doo-wop era's "Tears on My Pillow," their sixties' hit "Hurt So Bad," and the gospel-tinged "I'm Alright." Wanda Jackson proved that at age seventy-one she could rock with the best of them, and strapped on her pink guitar for the self-penned "Mean Mean Man," followed by her signature "Let's Have a Party"—the night's theme song.

Bobby Womack's "Crossing 110th Street" and "If Ya Think You're Lonely Now" were spine-tingling, and when Ron Wood joined him on guitar for "It's All Over Now," the crowd went wild. More guitar electricity followed with Jeff Beck's masterful "Beck's Bolero" seguing into "Immigrant Song," on which he was joined by Jimmy Page's twelve-string guitar, then a swing by both guitarists back to "Bolero." Beck finished his incendiary set with a long, exciting "Peter Gunn." Guitars blazed again after Metallica's induction, when Jason Newsted yelled, "*Metal!*," followed by James Hetfield taking on the MC role: "And here they are, *Metallica!*"

With both bassists Trujillo and Newsted on board, Metallica took "Master of Puppets" and "Enter Sandman" to the limit of thrash 'n' burn, earning an explosive reaction from the audience. How could a finale top that?

But it could: The finale kicked off with D.J. Fontana, Wanda Jackson, Rosanne Cash, Spooner Oldham, Garry Tallent, and Ron Wood performing a spirited "Jailhouse Rock," backed by Paul Shaffer and the Hall of Fame Orchestra. Then, what many of those in three levels of balcony seats had been waiting for: a full-fledged dueling guitars version of the Yardbirds' "Train Kept-a-Rollin'," featuring a mighty army of a half-dozen axemen: Jimmy Page, Jeff Beck, Joe Perry, and Kirk Hammett—all of whom alternated on lead—along with Ron Wood on guitar, Flea and Trujillo on bass, and Hetfield on guitar and lead vocals. That mighty train rolled out of Cleveland's Public Hall, leaving everyone gasping for breath. The ghost of Jimi Hendrix surely smiled.

## AFTERWORD

**M**usic holds a deep place in our lives. The first few notes of a favorite song can rouse the memory and imagination, reminding an individual of a certain place, time, or occasion in his or her life. A song can offer solace in times of need or, depending on the listener, act as a battle cry for celebration. It can inspire visionary thinking as well as genuine moments of emotion and personal reflection. Such is the far-reaching power of rock & roll. Where would we be without it?

From its inception in 1985 to its forthcoming twenty-fifth induction ceremony, the Rock and Roll Hall of Fame has paid homage to rock & roll's proud lineage and lauded the greatest artists of our time—from Jelly Roll Morton and Chuck Berry to Sam Cooke and the Moonglows to U2 and Metallica, and just about everyone else in between. Not every musician, of course, is allowed through the hallowed doors of the Rock and Roll Hall of Fame. To be eligible for induction, an artist or band has to have their first recording out for a minimum of twenty-five years. This quarter-century marker helps determine whether an artist or band was merely a one-hit wonder or if their music has longevity, lasting appeal, and relevance. Every inductee in the Rock and Roll Hall of Fame has proven his or her influence in the world of music, whether as a performer, an early influence, a sideman, or a nonperformer.

The wide spectrum of individuals that makes up the textured mosaic that is the Rock and Roll Hall of Fame is just as far-reaching as the genres of music itself, covering everything from R&B and country & western to punk, hip-hop, and reggae. While music is ever-evolving, with each generation of artists building on the work of their predecessors, "it's still rock & roll to me," to borrow from Billy Joel. Indeed, the face of the Rock and Roll Hall of Fame's future is as multifaceted as rock & roll itself. There is a rich body of deserving artists yet to be inducted, and each year a new class of artists becomes eligible for induction. The pool of possible inductees, then, will always be deep.

Just as Paul McCartney and John Lennon discovered Little Richard and Elvis Presley and were influenced by their music, so today there is a new generation of kids listening to U2, Talking Heads, Grandmaster Flash, Elvis Costello, and at the same time "discovering" the Doors, the Rolling Stones, Led Zeppelin, the Who, and other classic inductees. One day, members of this generation will be inspired to take the stage themselves, creating new sounds and expressions for the next generation to dial into. So while we enjoy the words—and works—of the past twenty-five years of inductees, we look forward to those yet to come.

—Joel Peresman
 President and Chief Executive Officer
 Rock and Roll Hall of Fame Foundation

**1986**

**1987**

**1988**

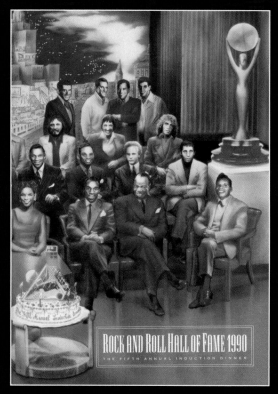

**1989**

**1990**

**1991**

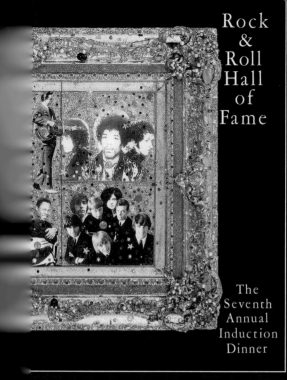

Rock
& 
Roll
Hall
of
Fame

The
Seventh
Annual
Induction
Dinner

**1992**

rock and roll hall
of fame

A
N
N
U
A
L

eighth

induction

dinner

..... SUGAR

**1993**

ROCK and ROLL
HALL of FAME
9TH ANNUAL
INDUCTION
DINNER

SOUND

**1994**

ROCK

AND

ROLL

The *Tenth* Annual Induction Dinner

HALL

of

FAME

r
ock and
r
oll
h f
all of fame

DAVID BOWIE

JEFFERSON AIRPLANE

LITTLE WILLIE JOHN

GLADYS KNIGHT AND THE PIPS

PINK FLOYD

THE SHIRELLES

THE VELVET UNDERGROUND

PETE SEEGER

TOM DONAHUE

THE
ELEVENTH
ANNUAL
INDUCTION
DINNER

1996

ROCK
AND
ROLL
HALL
OF FAME

1997

THE
TWELFTH
ANNUAL
INDUCTION
DINNER

1998

1999

2000

**2004**

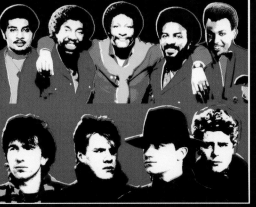

**2005**

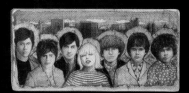

**2006**

**2007**

**2008**

**2009**

# ACKNOWLEDGMENTS

To quote Lou Reed, my life was saved by rock & roll. Well, maybe not saved—but certainly *improved*. It's been a great privilege to attend the Rock and Roll Hall of Fame induction ceremonies for the past thirteen years, and to watch raw footage of those prior to that. There are many people I'd like to thank for giving me the opportunity to be a part of this book commemorating nearly a quarter-century of Hall of Fame inductions. Thanks so much to the Rock and Roll Hall of Fame Foundation's Joel Peresman, who brought me on board, as well as Craig Inciardi for his vote of confidence and Lisa Testa for her immeasurable help. Additional thanks to the Foundation's Jann S. Wenner, Seymour Stein, and Suzan Evans Hochberg. HarperCollins editor Elizabeth Sullivan has been the driving force behind the book since its inception, and Signe Bergstrom has gone above and beyond to shape its contents. Designers Agnieszka Stachowicz and Christine Heslin have turned the pages into a thing of beauty, and HarperCollins's Iris Shih and Lelia Mander have also worked their magic on the book. Nina Pearlman and Robin Aigner contributed their editorial precision. The Rock and Roll Hall of Fame and Museum's Terry Stewart, Jim Henke, Meredith Rutledge, and Howard Kramer gave their time and advice, and Wenner Media's tireless John Dragonetti, Eleni Tzinakos, and Kelly Ann Kwiatek have been indispensable. Special thanks to the photographers whose work is showcased here: Kevin Mazur and his Wire Image crew, Bob Gruen, and Ebet Roberts, and Janet Macoska, as well as those who've assisted in the gathering of images: Dina Greenberg at Getty Images, Sarah Field, Stephanie Huguenin, Ashley Kahn, and *Rolling Stone*'s Jodi Peckman and Deb Dragon. Many thanks to Sarah Lazin, Jeffrey Posternak, Judy Whitfield, Damien Tavis Toman, Judi Bachrach, Laura Claridge, Richard Hoffman, John Milward, and Jeff Peisch, who have all helped in various ways. My husband, Robert Burke Warren, whose rock & roll knowledge and editorial expertise have been a lifesaver, and our son, Jack, watched hours of Hall of Fame footage with me and have been tireless in their support. And, of course, I'm most grateful to all those incredible rock & roll artists, pioneers, and trailblazers who have brought us the music that's changed our world.

—Holly George-Warren

# PHOTOGRAPHY CREDITS

# THE ROCK AND ROLL HALL OF FAME:
## THE FIRST 25 YEARS

HarperCollins books may be purchased for educational, business, or sales
promotional use. For information, please write: Special Markets Department,
HarperCollins*Publishers*, 10 East 53rd Street, New York, NY 10022.

First published in 2009 by
Collins Design
*An Imprint of* HarperCollins*Publishers*
10 East 53rd Street
New York, NY 10022
Tel: (212) 207-7000
Fax: (212) 207-7654
collinsdesign@harpercollins.com
www.harpercollins.com

Distributed throughout the world by
HarperCollins*Publishers*
10 East 53rd Street
New York, NY 10022
Fax: (212) 207-7654

DESIGNED BY CHRISTINE HESLIN AND AGNIESZKA STACHOWICZ

Library of Congress Control Number: 2009932516

ISBN 978-0-06-184045-6

Printed in the United States
First Printing, 2009